D1558355

CHILDREN

AROUND THE WORLD

CHILDREN
AROUND
THE WORLD

A PHOTOGRAPHIC TREASURY
OF THE NEXT GENERATION

PETER GUTTMAN

Skyhorse
Publishing

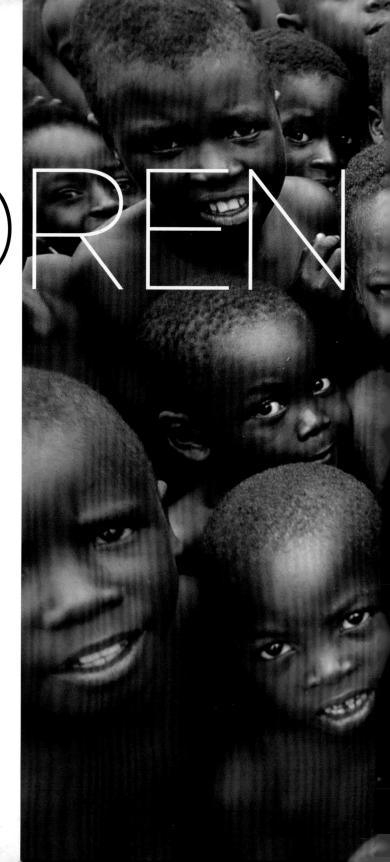

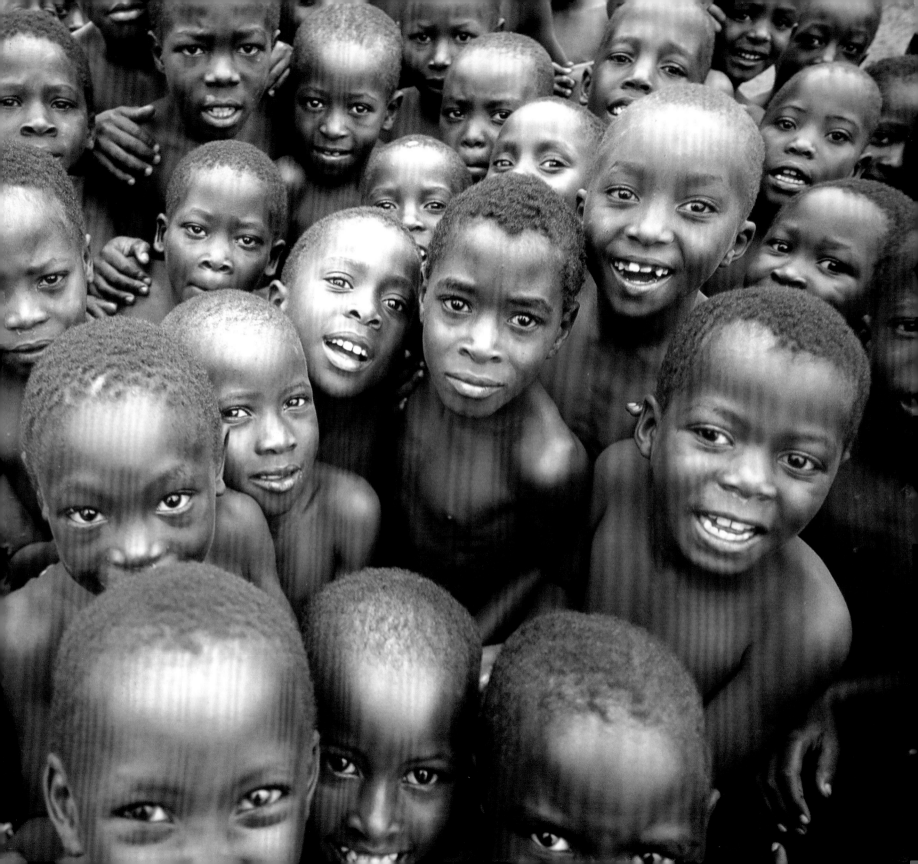

Copyright © 2015 by Peter Guttman

All rights reserved. No part of this book may be reproduced in any manner
without the express written consent of the publisher, except in the case of
brief excerpts in critical reviews or articles. All inquiries should be addressed
to Skyhorse Publishing, 307 West 36th Street, 11th Floor, New York, NY 10018.

Skyhorse Publishing books may be purchased in bulk at special discounts
for sales promotion, corporate gifts, fund-raising, or educational purposes.
Special editions can also be created to specifications. For details, contact
the Special Sales Department, Skyhorse Publishing, 307 West 36th Street,
11th Floor, New York, NY 10018 or info@skyhorsepublishing.com.

Skyhorse® and Skyhorse Publishing® are registered trademarks of
Skyhorse Publishing, Inc.®, a Delaware corporation.

Visit our website at www.skyhorsepublishing.com.

10 9 8 7 6 5 4 3 2 1

Library of Congress Cataloging-in-Publication Data is available on file.

Layout concept: Fabrizio LaRocca
Design and production: Nick Grant

Print ISBN: 978-1-63450-383-9
Ebook ISBN: 978-1-63450-389-1

Printed in China

Title Page
In Kisoro, Uganda, a field of eyeballs represent imagination and passion for a new
generation, populating the planet with unlimited potential for creating a better world.

———

Page 11
A young girl's idyllic Caribbean morning seems anchored by her polite giggle at
an overlook surveying the small boats bobbing in St. Kitts' Basseterre harbor.

Proudly dedicated to Chase, a vivid inspiration whose intrepid ventures plus impressive creativity widened my sense of wonder, taught me all about the joys of fatherhood, and helped stoke burning, never-ending excitement for tomorrow.

INTRODUCTION

Wonder beams through joyful eyeballs. Their owners are invariably brand-new, diminutive members of yet another freshly minted human crop. This Lilliputian army of button-bursting exhilaration has been multiplying quickly and now occupies even the farthest reaches of our planet. They are disarmingly guileless and unashamed ambassadors of the colorful, distinguishing cultures they inhabit. The gaze they emit is an exquisitely crystal-clear window to the soul, projecting a trusting innocence, yet at the same time serving up the fiery seedlings of embryonic wisdom.

From the very outset, most children around the world appear to offer a startling resemblance in personalities. Though they might be wildly distant in geography, their untutored temperaments seem to weave together a borderless similarity. Despite that initial appearance of conformity, each developing identity is a divergent living, breathing genetic container of ancestral instincts and quirky characteristics. As they start to blossom into distinctive individuals, we see their lives slowly drifting down the strikingly different paths that geographical limitations, social circumstances, and serendipitous luck allow. In this poignant irony, it's apparent that they are all growing up on the very same whirling planet that will eventually spin them toward dramatically different directions, perspectives, destinies, and environments.

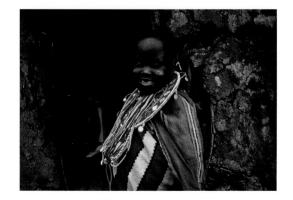

Those wildly diverse stomping grounds host an indigenous franchise of open-air maternity wards and nursery schools, mom-helmed settlements peppering the globe and crawling with spirited tykes. During my encounters with them, in the course of four decades filled by dizzying exploration, I've ventured across distant frontiers on all seven continents. Whether arriving in steamy jungle villages, remote and rugged fishing outports, alpine hamlets, or windblown desert oases, my first personal encounters tend to be with either shy, inquisitive youngsters hungry to satisfy their sprouting curiosity, or swarming hordes of boisterous, pre-testosterone ankle-biters eager to chaperone an attentive visitor. Their enthusiastic fascination and raw exuberance, unguarded even amongst obvious outsiders, reveal precious mortal attributes, ones that are perhaps the purest distillation of mankind's essence. Sadly though, like a huge block of ice on a summer day, that treasured spirit seems to slowly melt away, retreating from most of us as Father Time's calendar pages are incessantly turned. We can, however, make determined strides not to ever let that happen.

Endeavoring to harness that same *joie de vivre*, my life's journeys have propelled me through a kaleidoscopic carnival of global experiences where I painted with photographic light on a canvas of film. I've aspired to capture the anthropological context lurking amidst many tribal playgrounds across a wide swath of earth's newest human populations. By illuminating a colorful stage set diorama of children thriving in their own elements, both striking similarities and bewildering contrasts emerge that draw a compelling portrait of how humanity's shared bonds trump the shifting conflicts of an ever-changing reality. At the same time, I'm fascinated by

documenting a disappearing world where youthful sensibilities connect more authentically with their actual friends and playmates than with the technologically mesmerizing screens and devices that might someday overpower genuine interaction.

In the midst of slowly vanishing cultural diversity and fragile landscapes, these children helped me discover the common thread that seems to weave a hopeful tale of our existential condition. In fact, I've received some of my most prized education observing young minds unschooled by cynicism. Their sheer joy of life, unstained by petty concerns and skepticism, is so instinctively obvious and vibrantly infectious. That contagion, if heartily adopted, can become a valuable template for a richer, more fulfilling adulthood. It occurred to me while wandering across the exotic, unfenced amusement parks of the planet's juvenile populace that there is so much to learn by observing our earliest humanistic impulses.

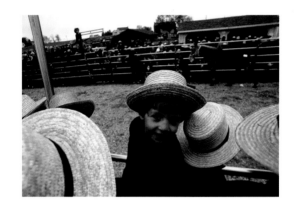

Those lessons eventually boosted my confidence as I personally embarked on the most challenging, yet rewarding voyage of them all: an irreversible plunge into the hair-raising, pulse-quickening, heartwarming world of fatherhood. Invigorated by a lifetime of exposure to the spontaneity and uncanny creativity of kids inexplicably making magic out of less than comfortable habitats, the visceral power of their inventiveness and effervescence galvanized my own parental strategies. I ventured to create an environment for my own offspring that could promote that same bewitching alchemy, and perhaps in the process help rent at least a semblance of immortality.

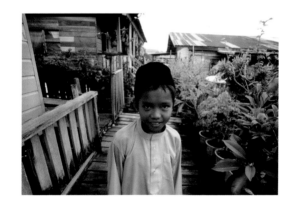

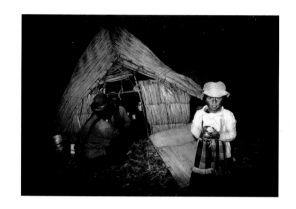

Witnessing the majestic journey of growth in our own kids and their global brethren, we're provided with powerful instruction that can help us all evolve. Indeed, child is father to the man. Those who empathetically harness the youthful vitality and passion of children, are spurred by their persistent inquisitiveness, sparked by their raw creativity, and inspired by their boundless imagination, can most capably build a superior, more compassionate, and effective world for the future. The sunny harbinger of a kinder, yet sharper, society might seem only barely visible on today's distant horizon. Ultimately, that kind of vivid promise will be left firmly in the energetic hands of children around the world, beckoning for tomorrow and to yet another generation of growing wonder.

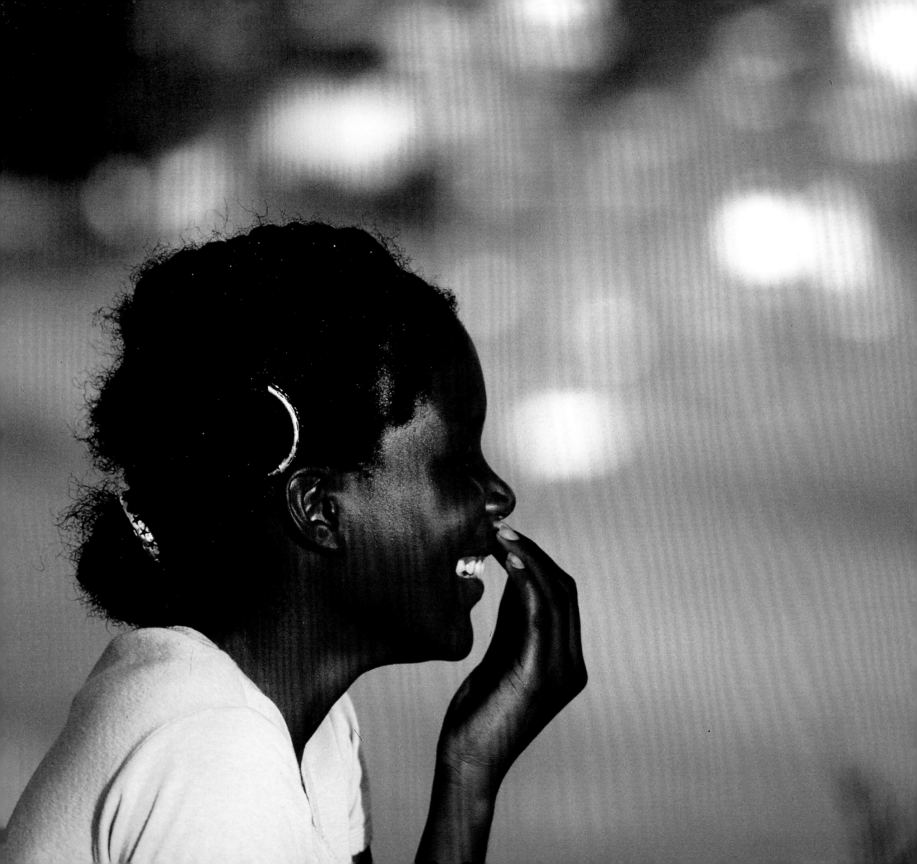

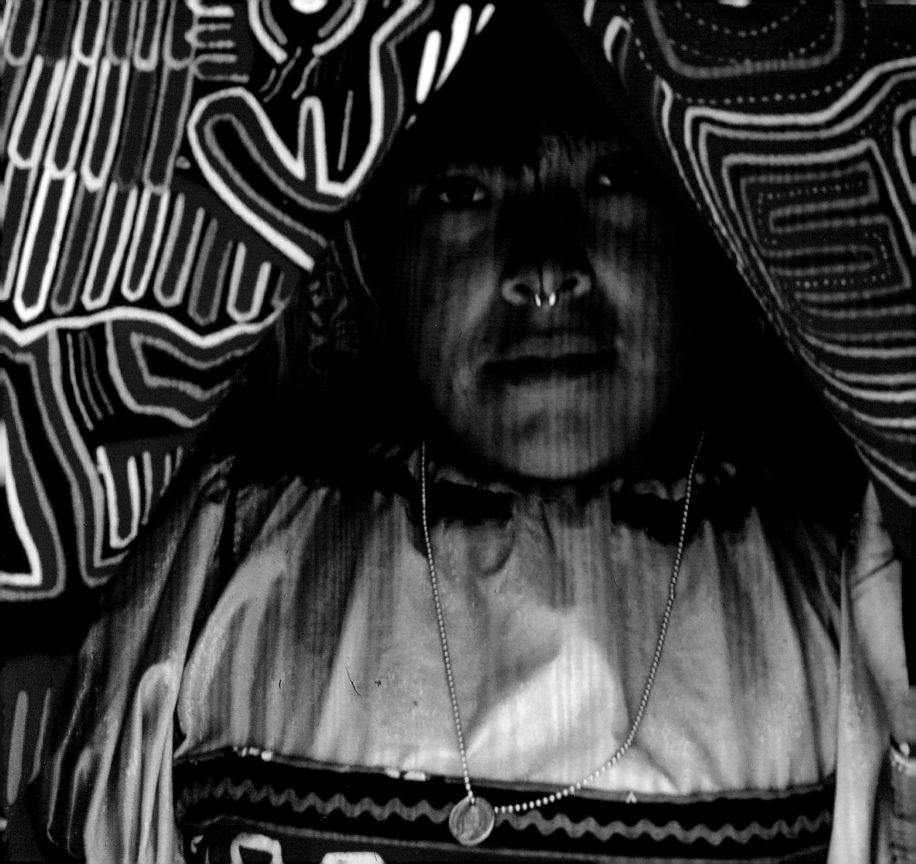

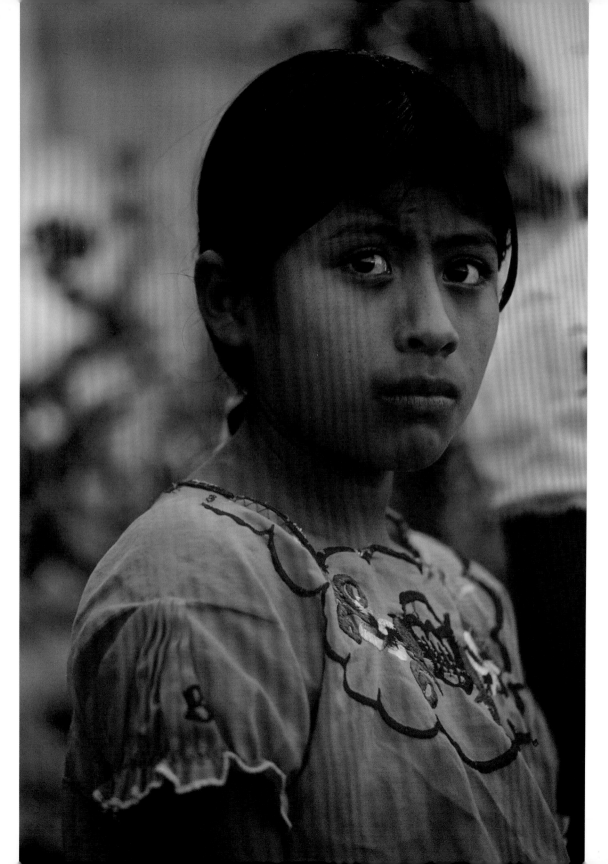

Amongst the San Blas archipelago, off Panama's Caribbean coast, a Cuna girl bedecked with a gold nose ring peers through a cleft of fabric, inverted appliqués known as molas (preceding page).

Near the ancient Central American stones of Altun Ha, an embroidered floral blouse dresses up a Mayan descendant whose ancestors once flourished amidst the steamy, ruin-dotted jungles that pepper Belize.

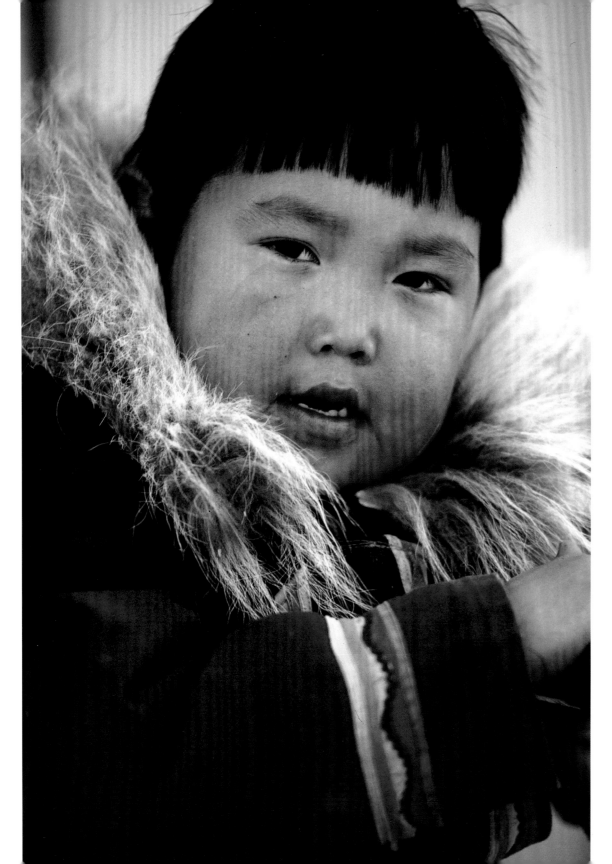

In the odoriferous fishing
village of Togiak, fur-hooded
garb warms an Aleut boy
and is standard gear through
most of the calendar year
in this storm-ravaged
region of western Alaska.

15

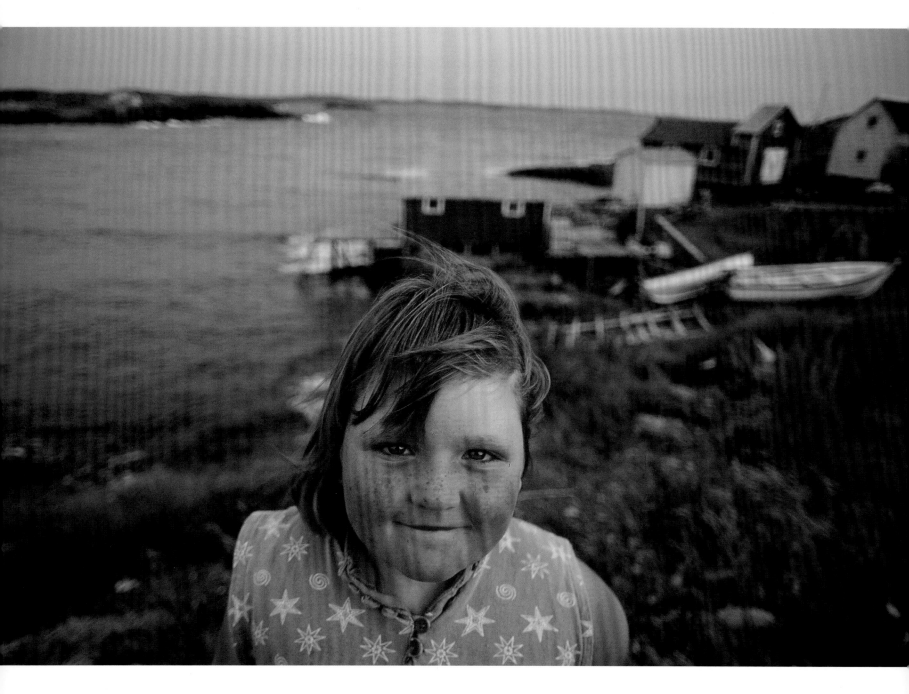

Coastal winds sweep hair and batter Canadian fishing shacks cloistered around a remote outport on Change Island, off the rocky coast of northern Newfoundland.

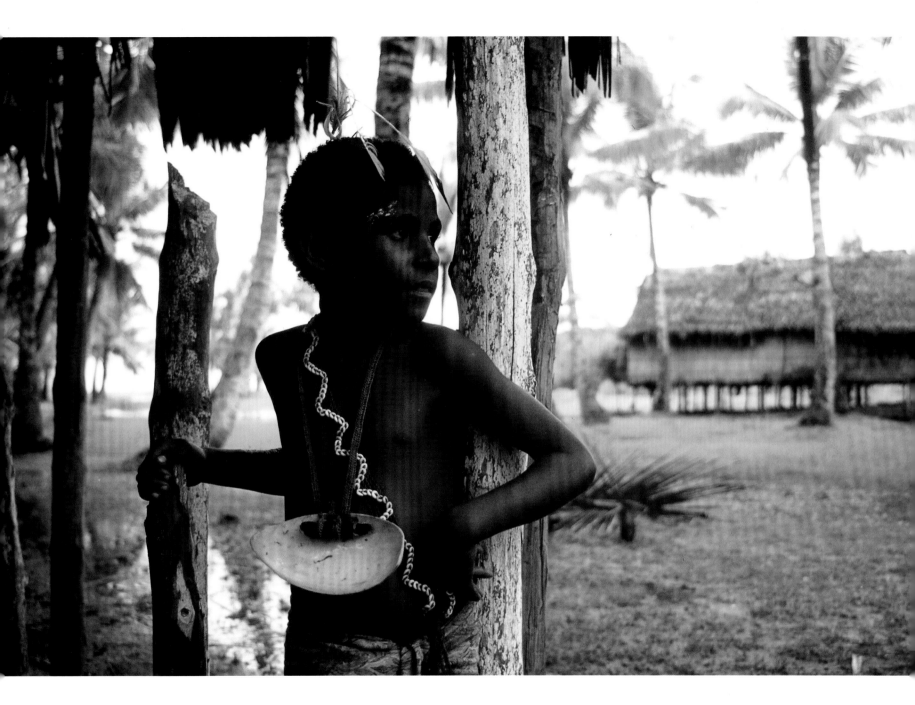

Adorned with a kina shell necklace, a boy returns to his palm-thatched dwelling that provides protection from both marsh rodents and flooding in the waterlogged bogs of Murik Lakes in Papua New Guinea.

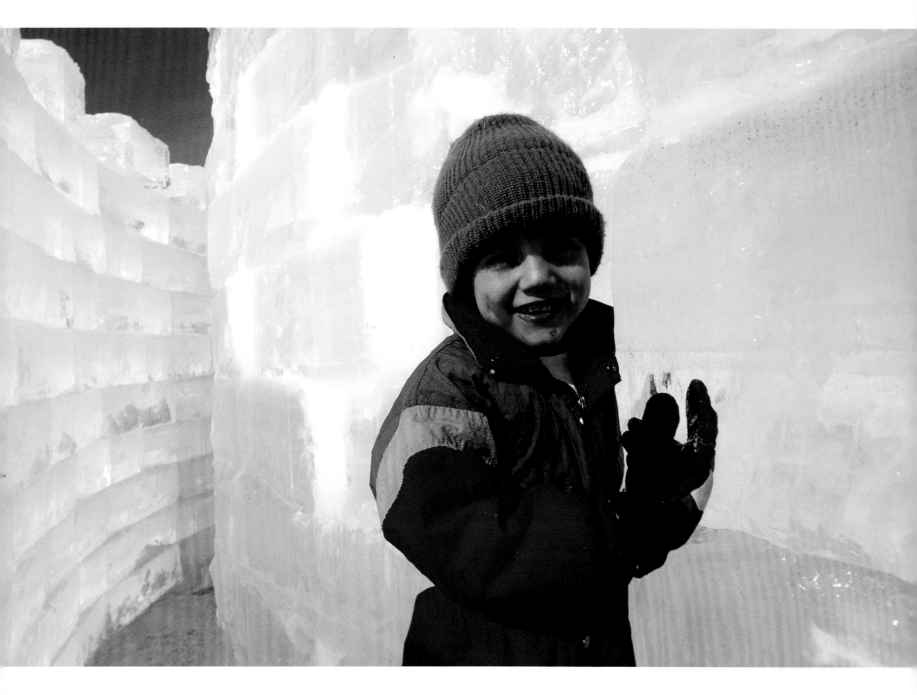

Half-ton blocks of lake ice assemble an arctic playground for
warmly dressed kids exploring the immense crystal palace of
Lake Saranac's annual winter carnival in New York's Adirondacks.

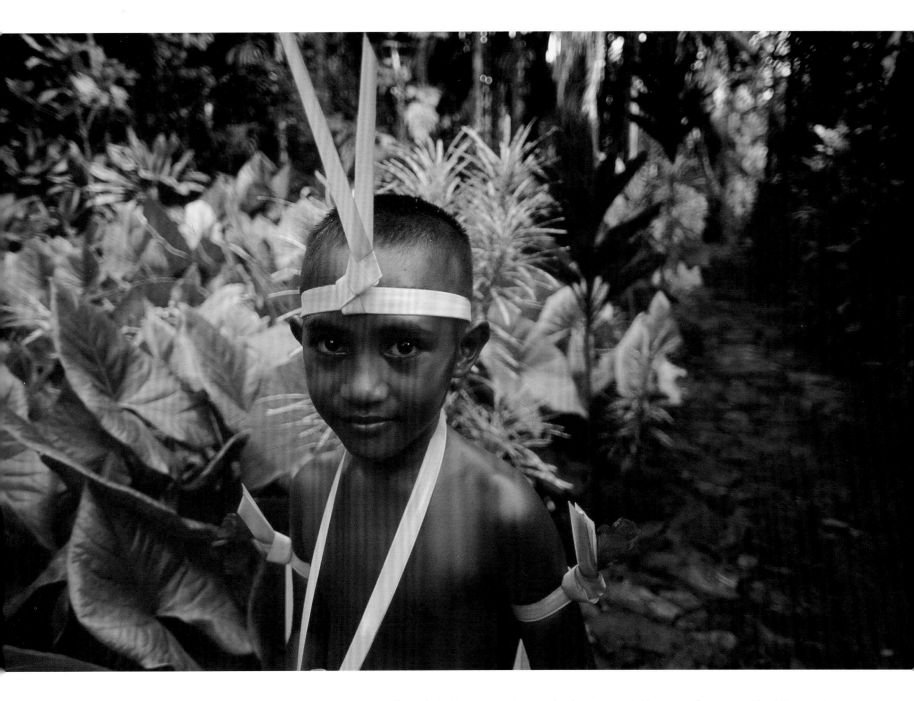

Completed by appendages of origami vegetation, a performer on the Micronesian island of Yap prepares for a traditional dance to be held in a neighboring village.

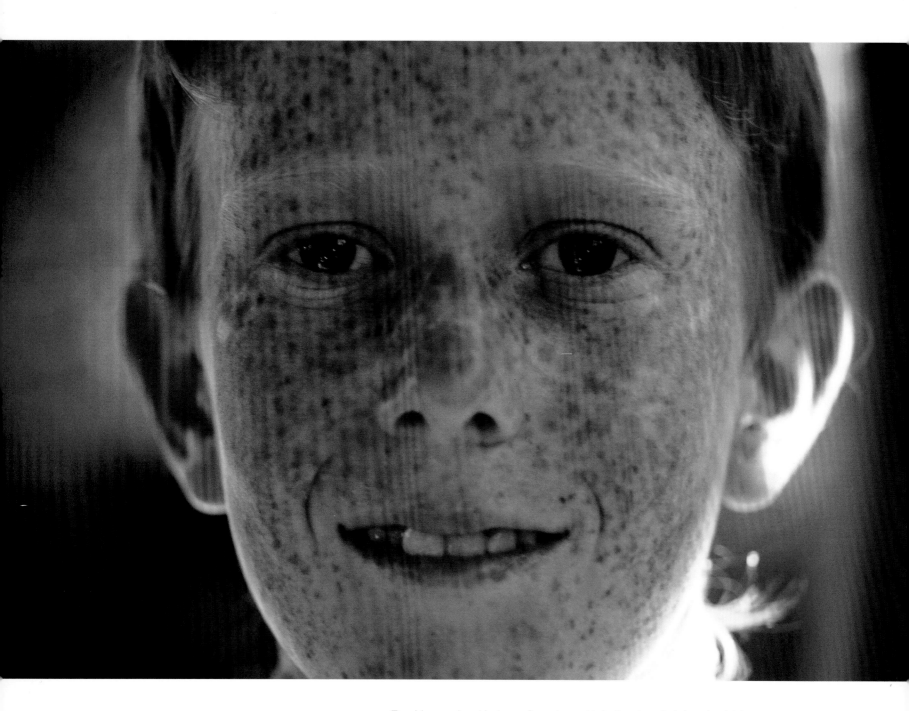

Freckles and red hair are found mostly in lands adjoining the Irish Sea, where scant sunshine negates a genetic selection of dark, protective pigments and tends to minimize the need for keeping an inventory of tanning lotion here in downtown Dublin.

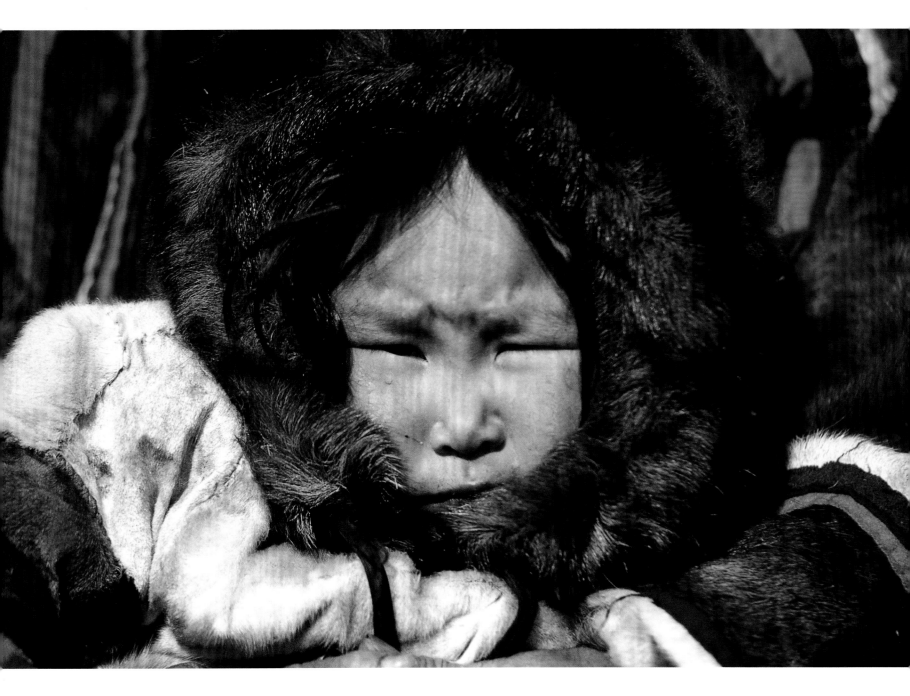

Even in Vaygach Island's summer, the harsh Nentsey life of nomadic reindeer herders often requires sealskin insulation and fur-lined parka, a garment first named by these Siberian people.

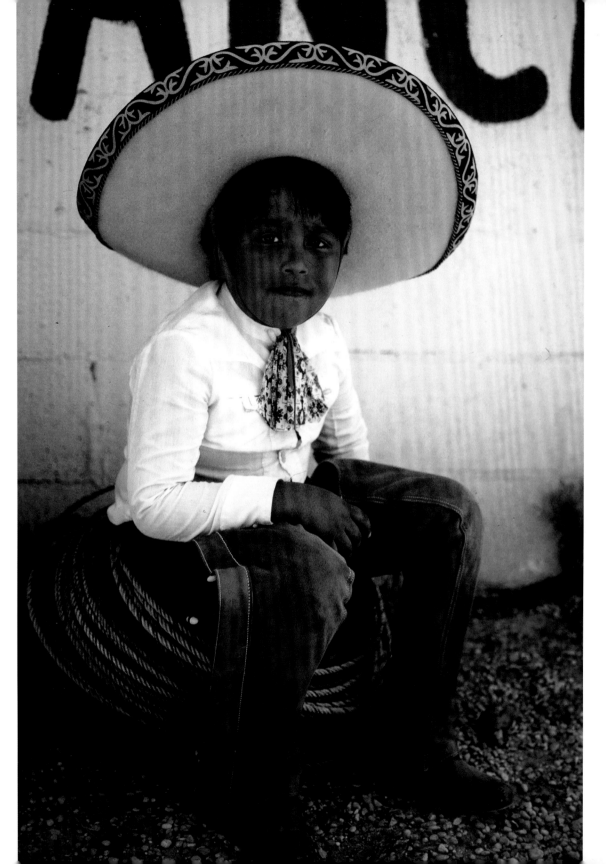

A sombrero, inspiring the invention of the cowboy hat, ensures a cooling rest, cushioned by a coil of lasso at springtime's Fiesta Rodeo in San Antonio, Texas.

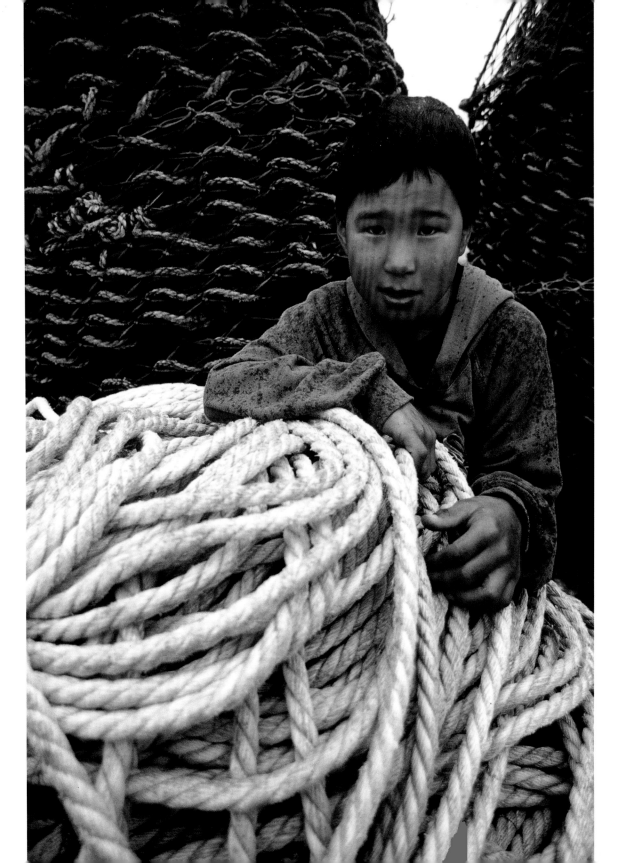

Just a mile and change north of the Arctic Circle, a young sailor relaxes amongst the dock's crowded tangle of fishing gear and anticipates a trawler's reappearance from the Davis Strait to its home port in Itilleq, Greenland.

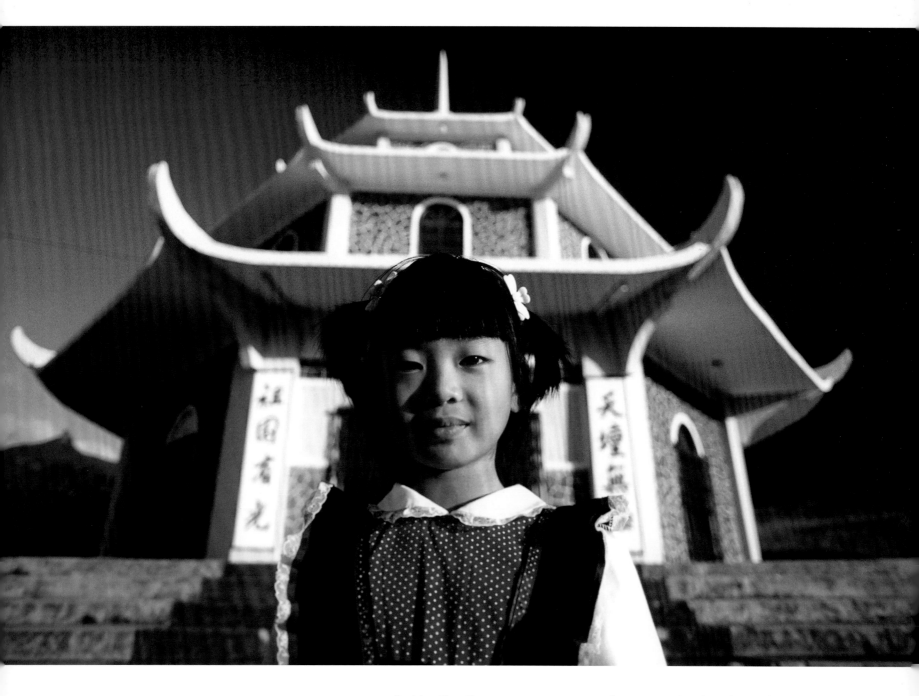

On Mauritius, the serene countenance of a young girl in the village of St. Louis reflects the order and tranquility integral to traditional Chinese society while above, a pagoda signals one portion of the tripartite collage of island culture.

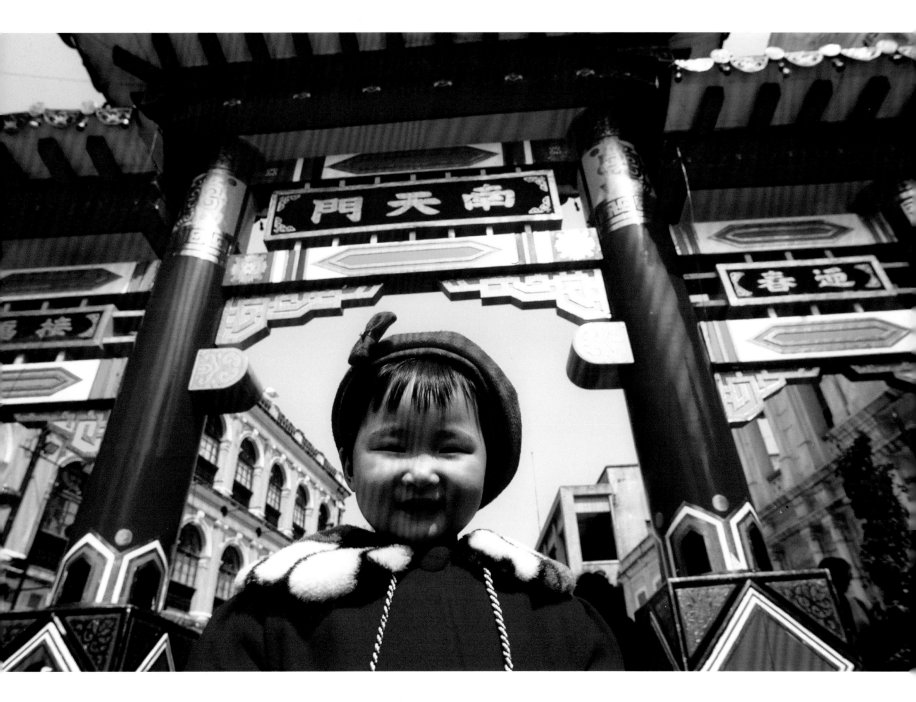

Cherubic Asian grace is evidenced beneath Chinese gates and colonial architecture in Macau, a Portuguese colony for over four hundred years in the world's most densely populated region.

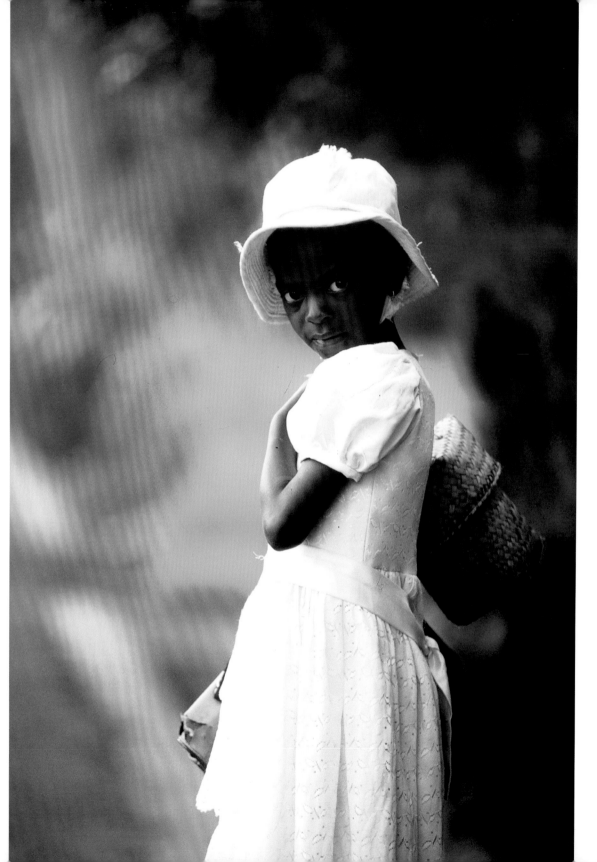

With both book supplies
and shyness stored firmly
away in a hand-woven bag,
a student slowly makes her
way through the sticky Indian
Ocean humidity toward
a distant schoolhouse on
the island of Rodrigues.

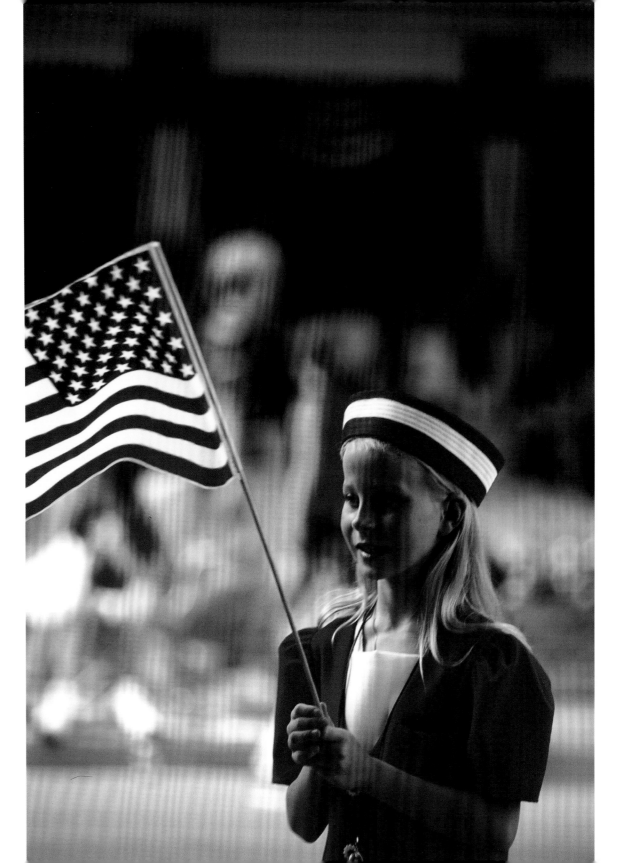

In the Alleghanies of Pennsylvania, patriotic colors hold sway amidst anticipation along the banner and bunting-strewn main street that slices the mountain village of Brockway.

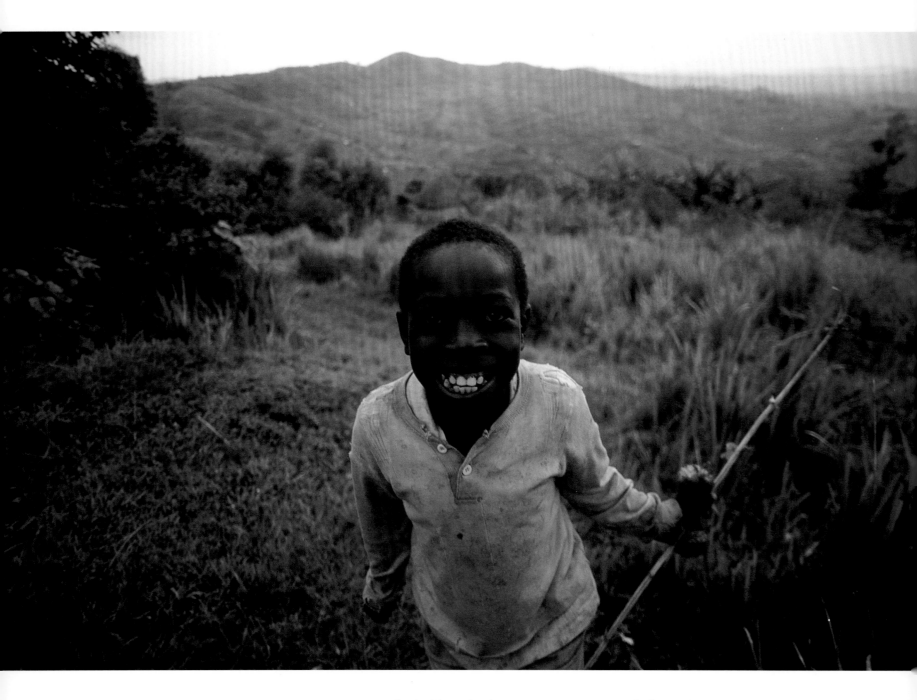

Conical huts dot the mountainous interior of Africa, where an unexpected visit by a stranger from another land creates intense excitement for a youthful villager.

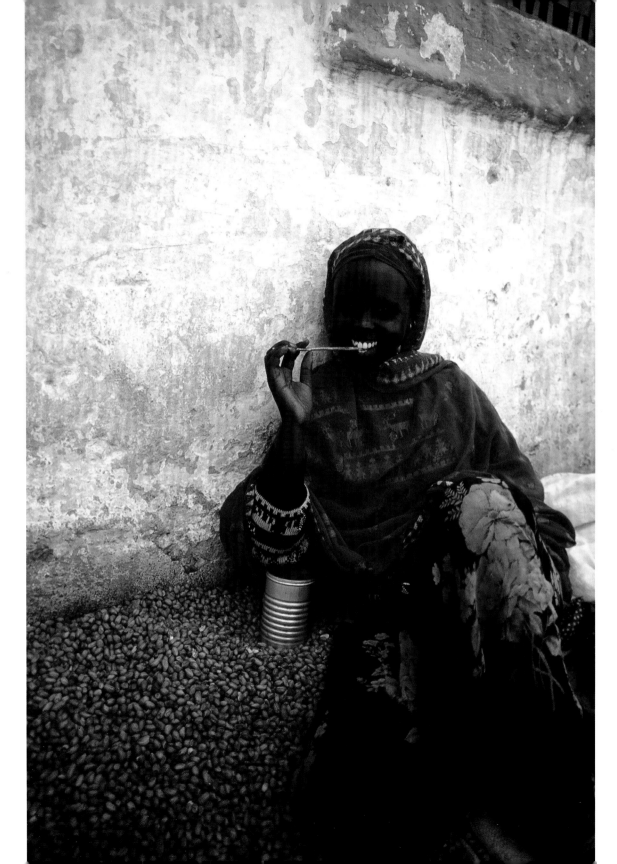

In the nation where coffee was
first grown, a pile of
the fragrant Ethiopian
beans provides a nice spot
for an African toothbrushing.
Here, the walled city of
Harar is said to be the
fourth holiest site in Islam.

29

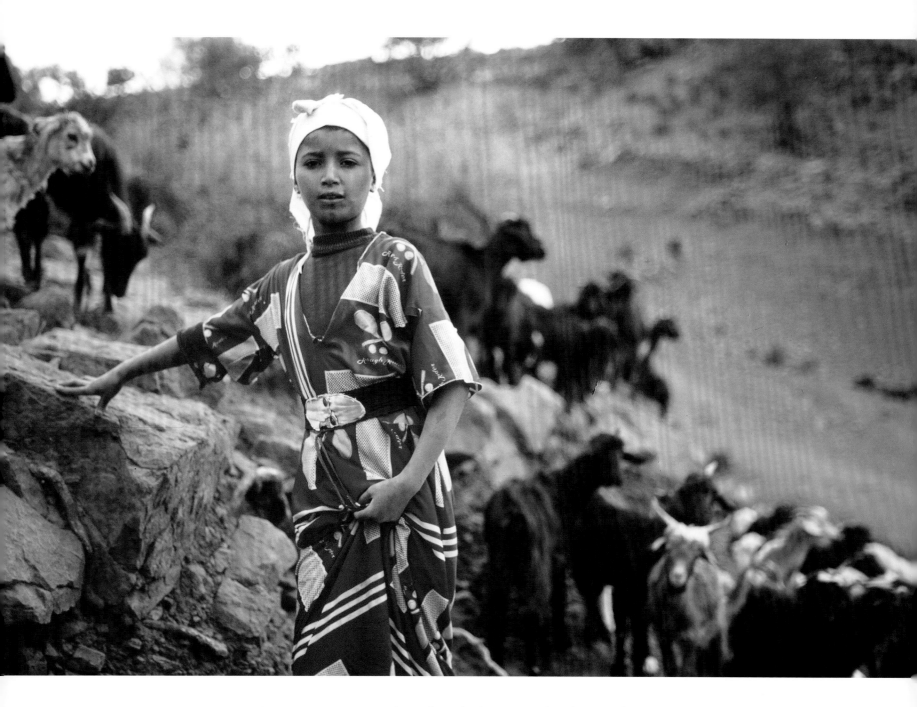

In southern Jordan, sparse desert vegetation strewn across
the rusty dunes of Wadi Rum is a magnet for herds of bleating
goats and the Bedouins who tirelessly tend to them.

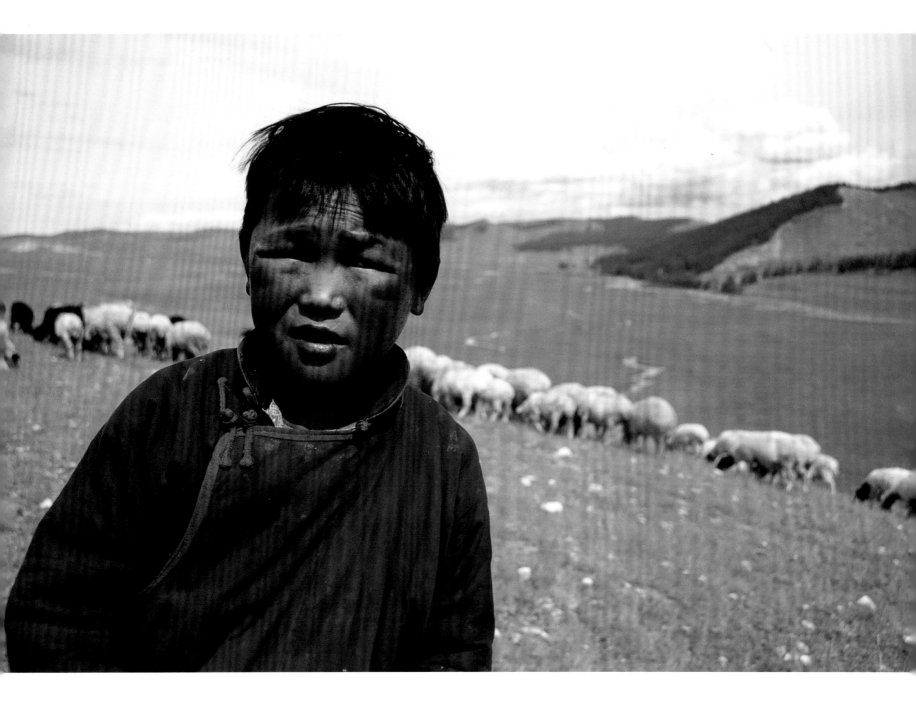

Warmed by his silk khantaaz jacket, a wind-burned shepherd
starts work early in age, but enjoys unlimited movement amongst
the vast steppe grasslands near Hogno Han, Mongolia.

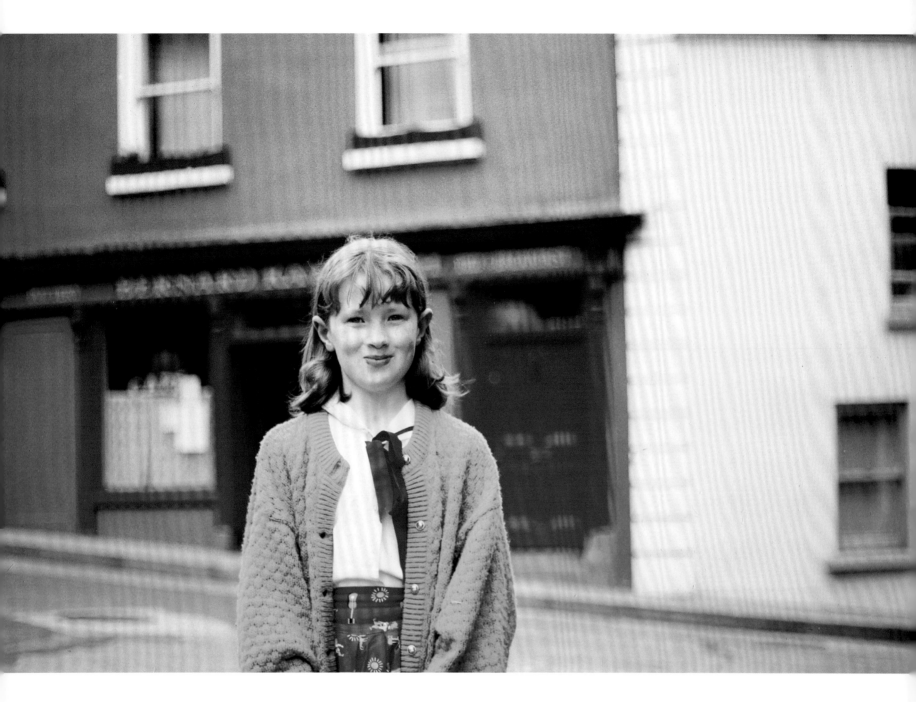

Between rusty hair and a shamrock-colored sweater, Irish eyes are smiling on Galway's pub-lined lane where the toe-tapping sounds of fiddle and mandolin leak into the neighborhood.

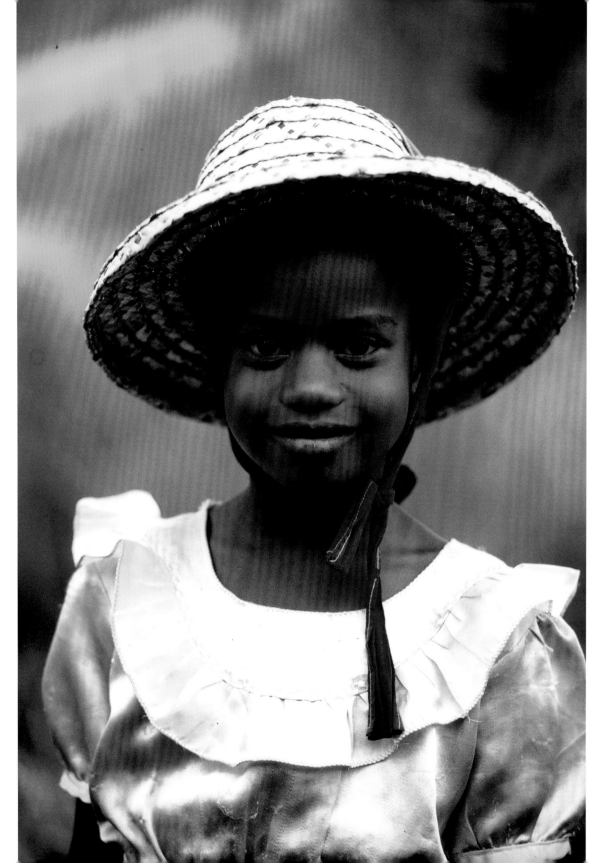

Deep in the Indian Ocean, hats of straw and raffia seem to provide elegant shade as well as a sense of serenity on Rodrigues, an island outpost off of Mauritius. Though considered part of the African continent, the sleepy isle actually lies closer to Australia for transoceanic birds.

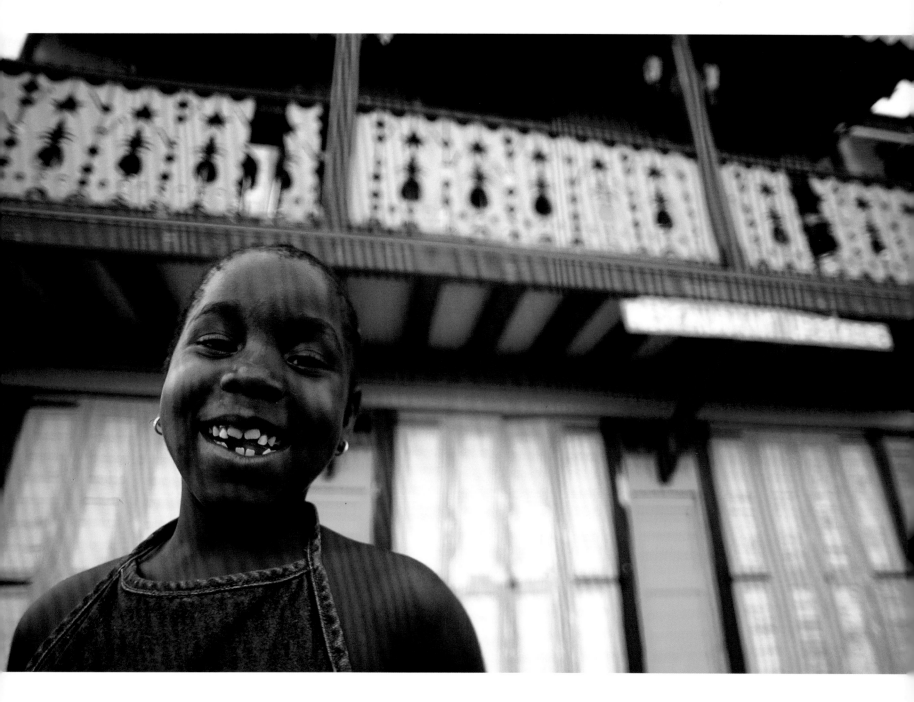

On St. Maarten, a French and Dutch Caribbean island of hybrid cultures, this girl's gap-toothed grin reflects the *joie de vivre* of Phillipsburg's annual carnival celebrations just down the street.

34

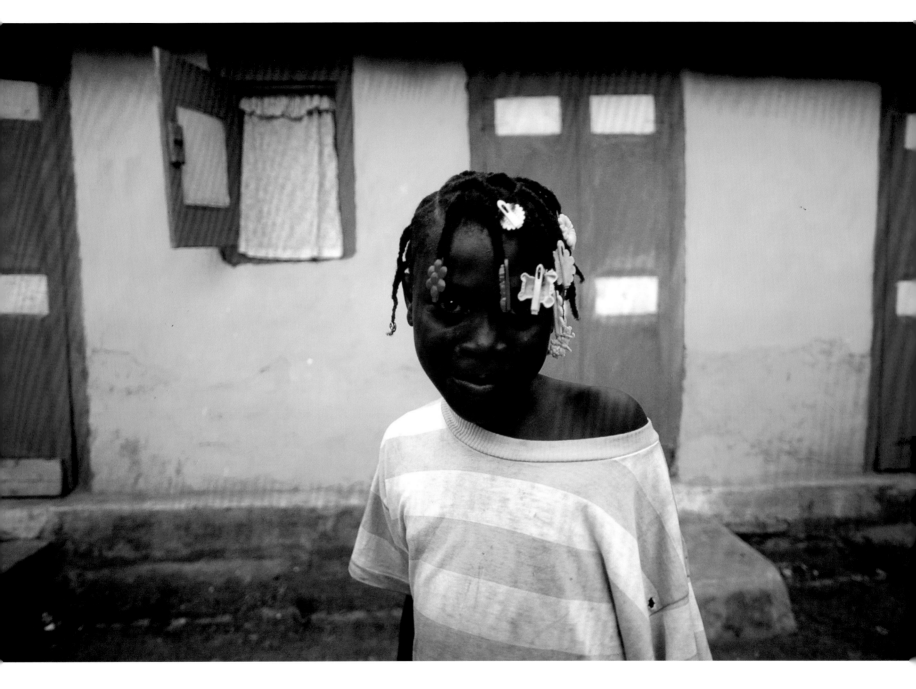

Baring a shoulder blade and cornrows tamed by plastic clips, a child in Milot surrounded by a world of grim Haitian poverty is a model of serene innocence.

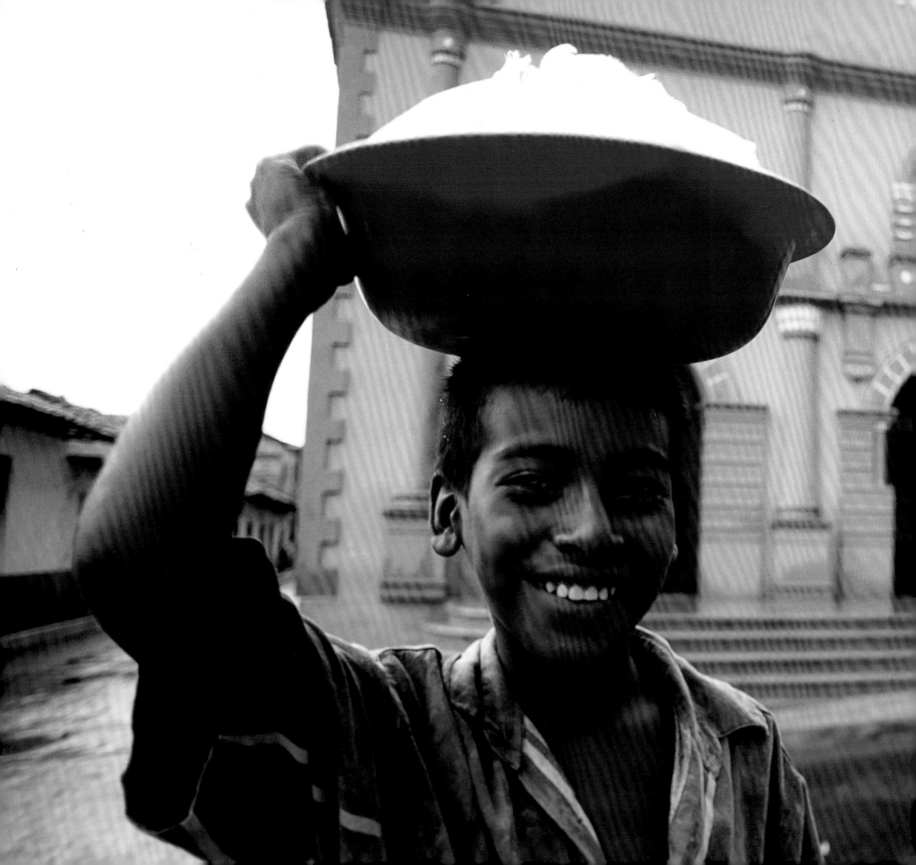

Returning with fresh produce
and an easy smile from
the old Granada market,
stabilized cranial support
makes a journey down
colonial eighteenth-century
Nicaraguan lanes less difficult.

37

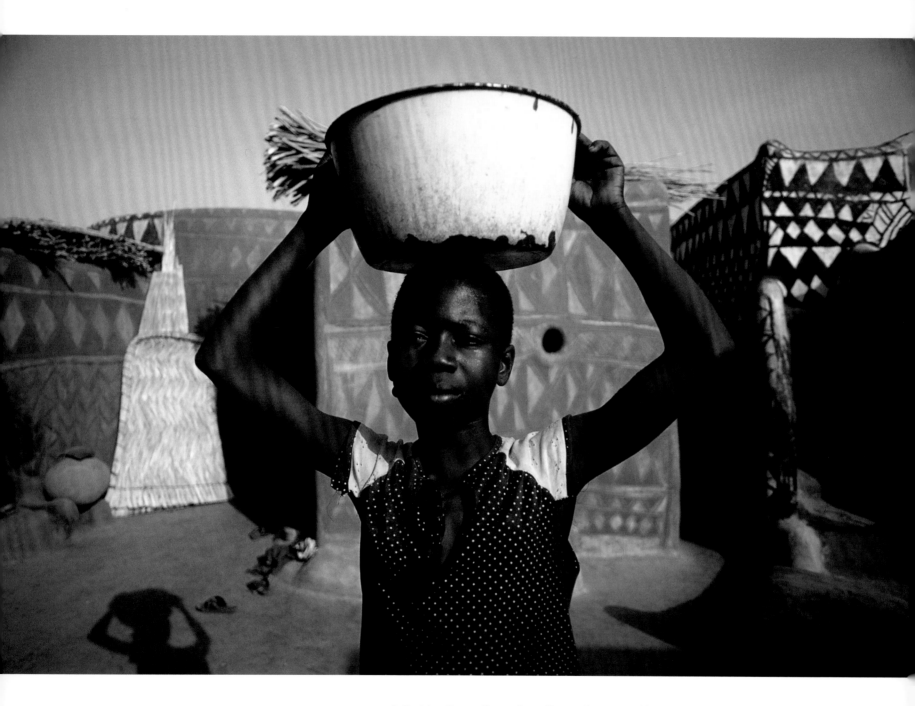

A Burkino Faso villager from Tanga Ssugo and her container of kindling cast a shadow upon the plaza floor and toward a tribal compound decorated in burnished pigments.

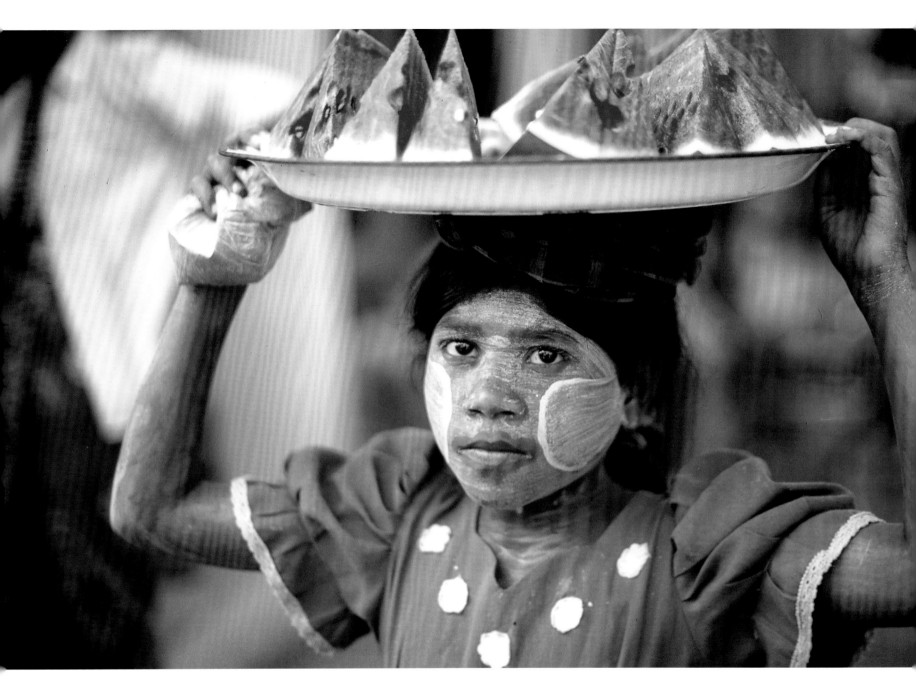

Harsh equatorial sunshine makes watermelon a popular draw in Mandalay and provides incentive for a complete daubing with moisturizing thanakha paste.

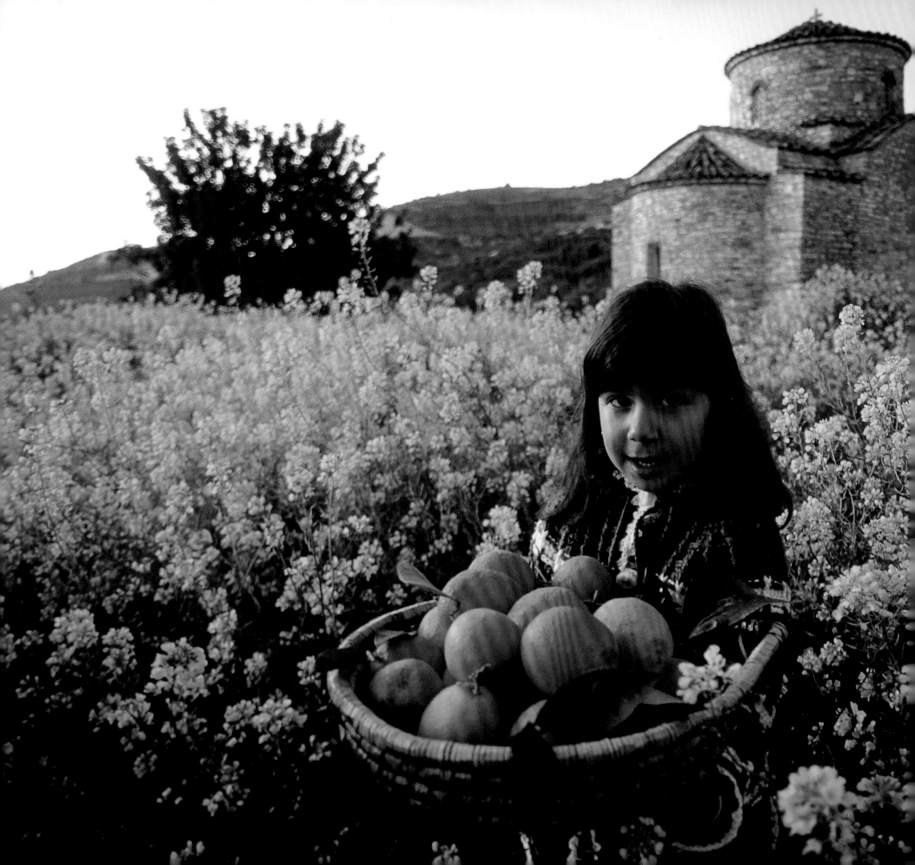

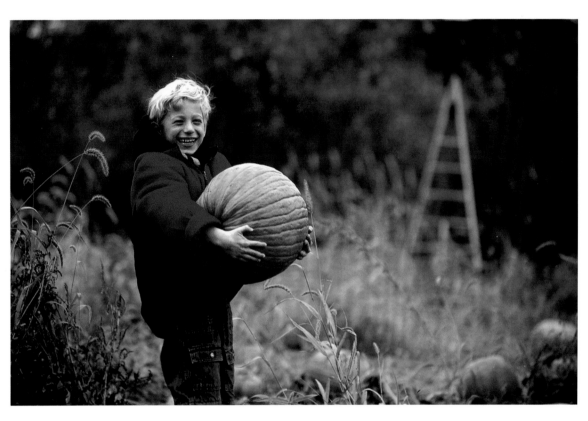

A girl offers freshly picked oranges amidst a field of
fragrance in Kato Lefkara, a Cyprus hill town where the
Byzantine church holds liturgy only twice a year.

Appearing to hoist his weight in gourds, an exuberant youngster
celebrates the find of a perfect Halloween ornament in a
Hudson Valley pumpkin patch near Marlboro, New York.

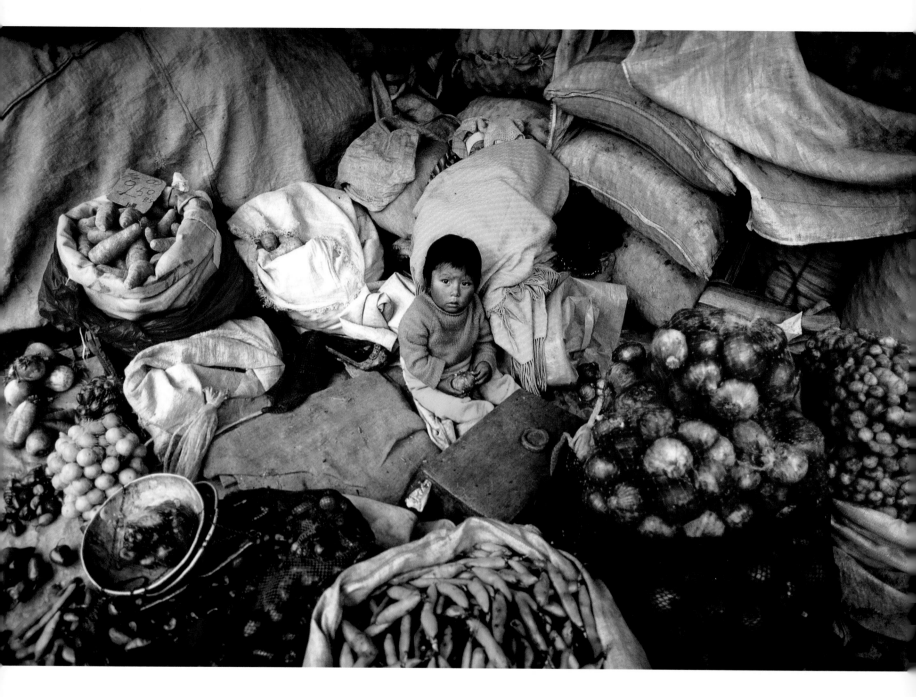

At home amongst bundles of vegetables in South America's poorest country, this Bolivian child monitors her mom's La Paz market stall, wedged into a crammed side street in the world's highest capital.

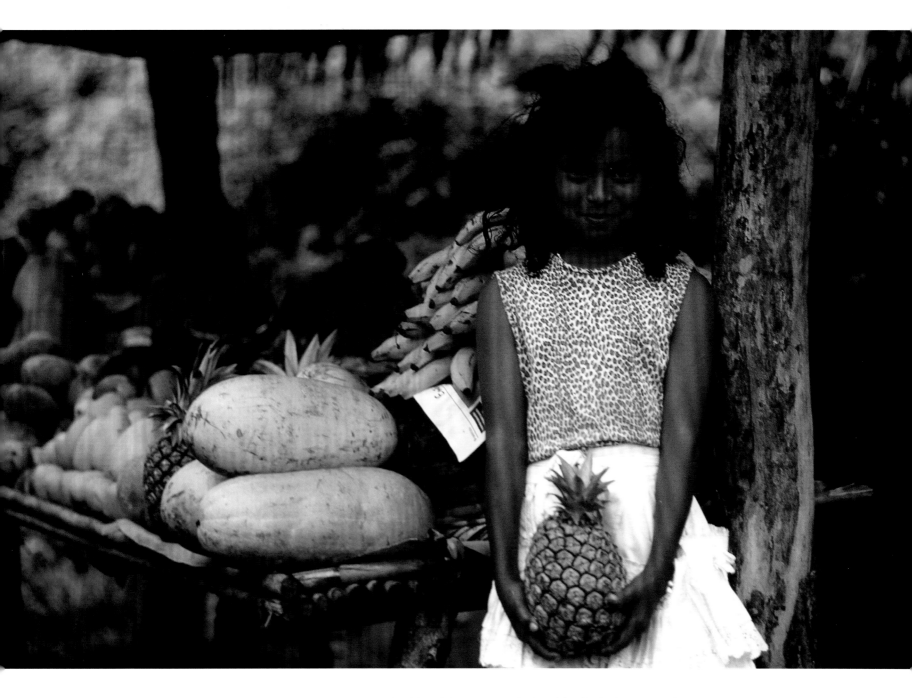

Astride a Managua roadside table displaying tropical native fruits, this Nicaraguan salesgirl proudly displays a ripe pineapple, named for its resemblance to the pine cone.

43

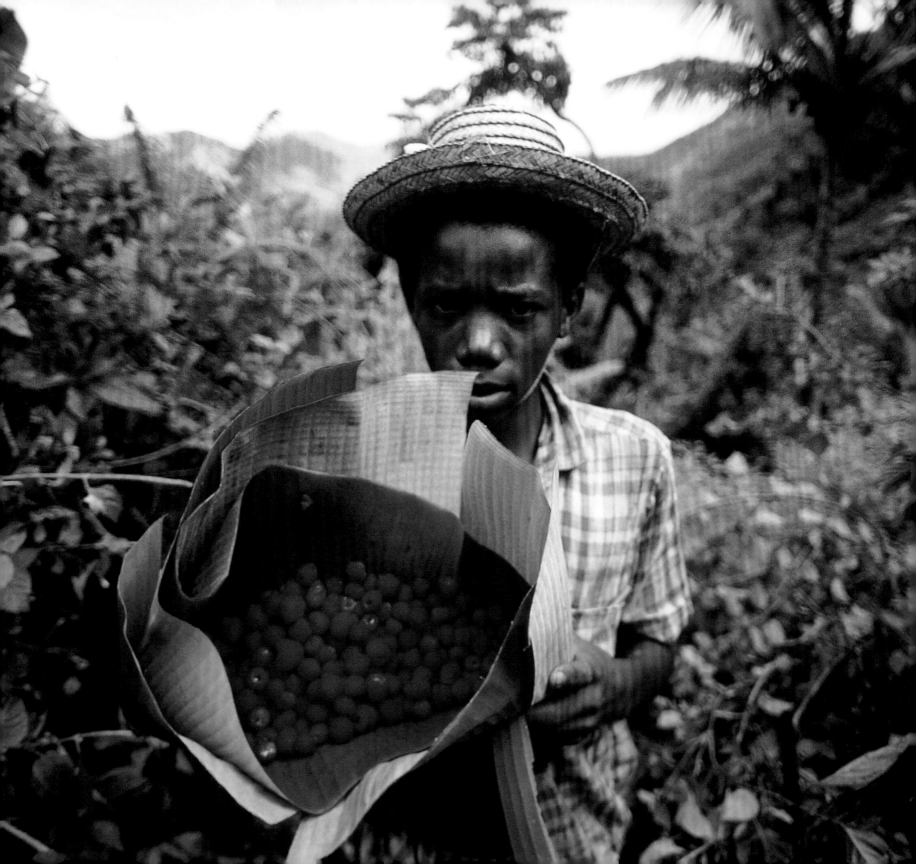

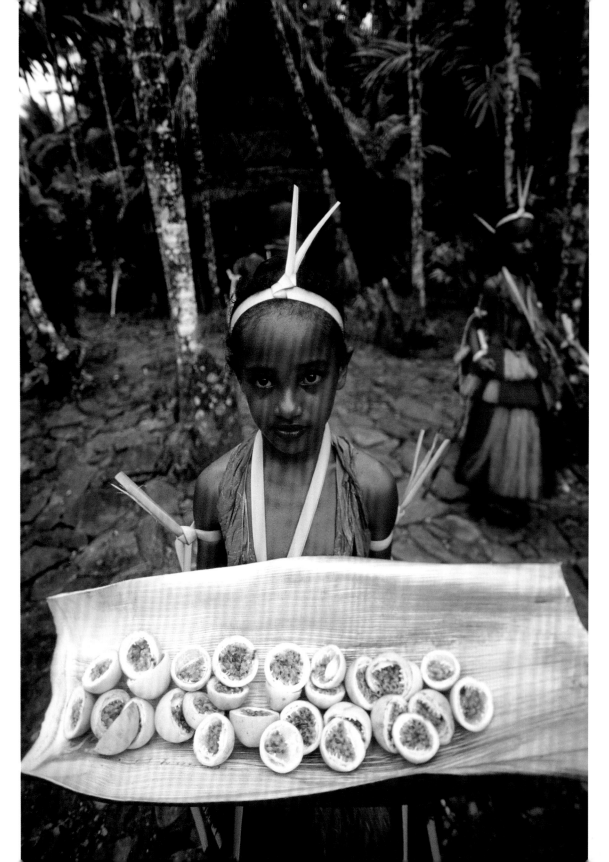

A raspberry vendor with a banana leaf container offers his produce amidst aromatic fields of ylang ylang, an essential perfume ingredient that carpets Anjouan slopes across this Indian Ocean-washed Comoro island.

Covered with nipa palm, a thatched house in Yao overlooks a stone plaza where passionfruit is furnished by girls preparing for a Micronesian village gathering and bamboo dance.

45

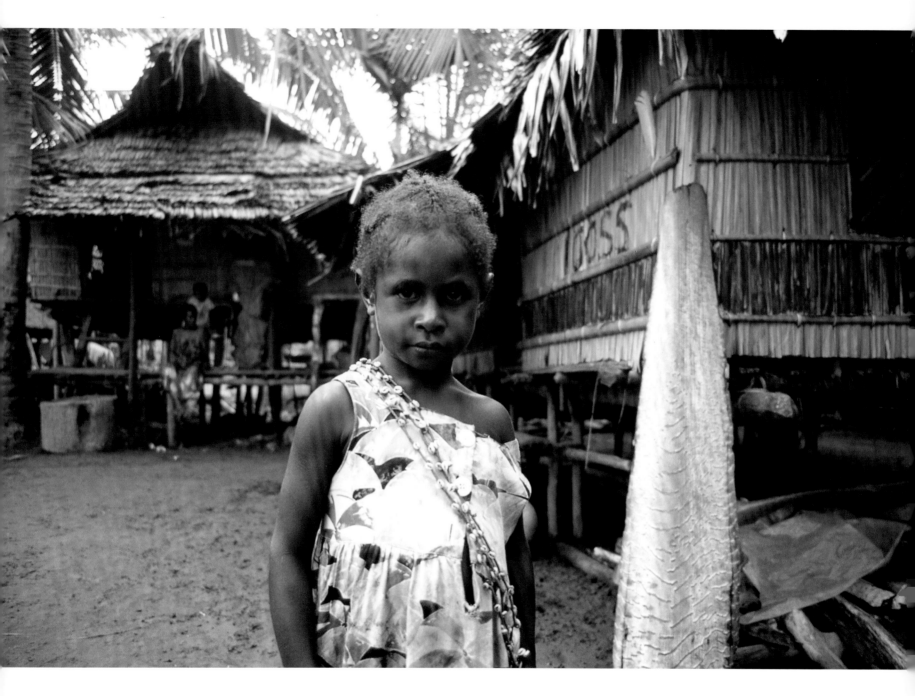

Like her neighbors along Papua New Guinea's riverbanks, she lives in this open-sided bungalow on stilts, which wards off hungry rodents and the Sepik River's wet season flooding, but requires bedtime netting for malarial protection.

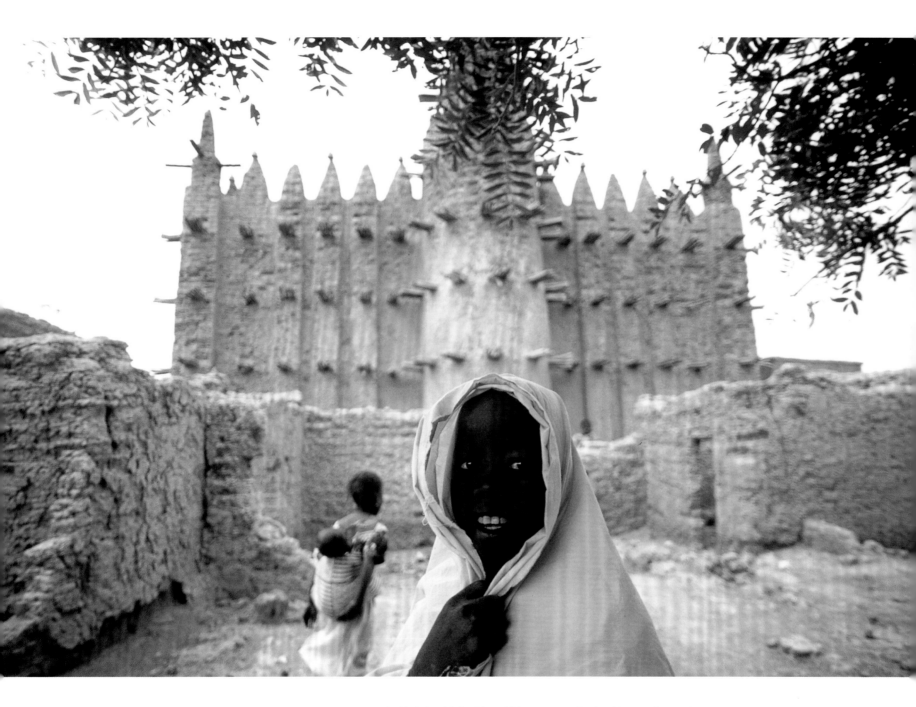

In Kotaka, Mali, shiny African eyes cloaked in a yellow robe
look out toward the Niger River, whose riverbank mud is used
to sculpt soaring mosques studded in scaffolding.

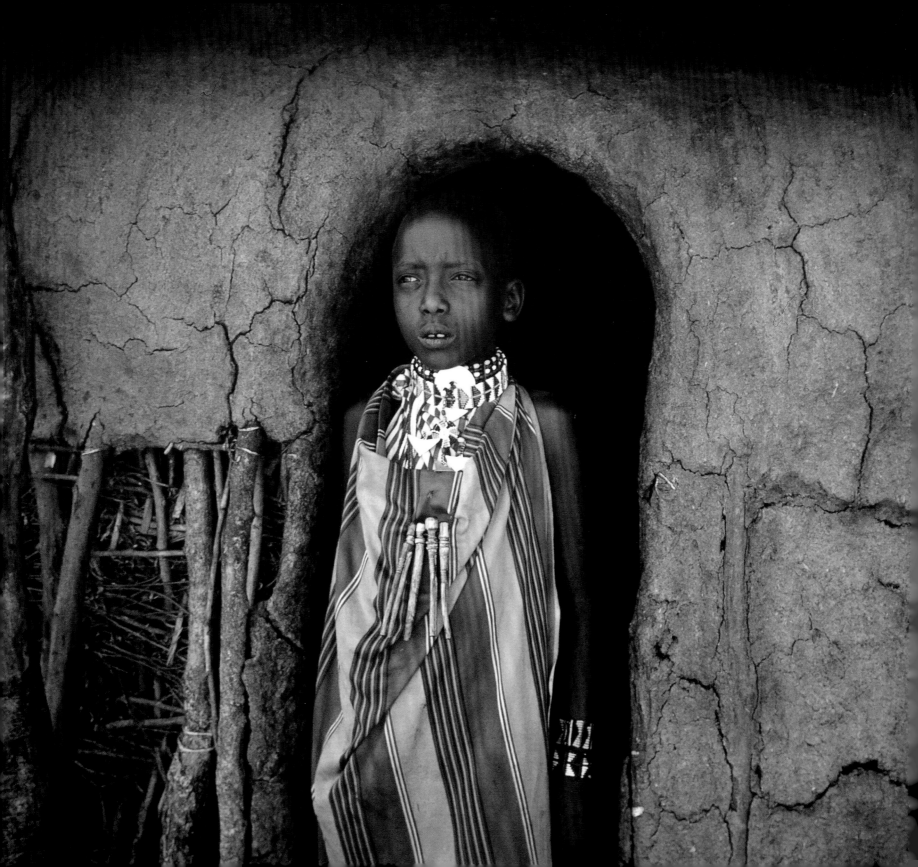

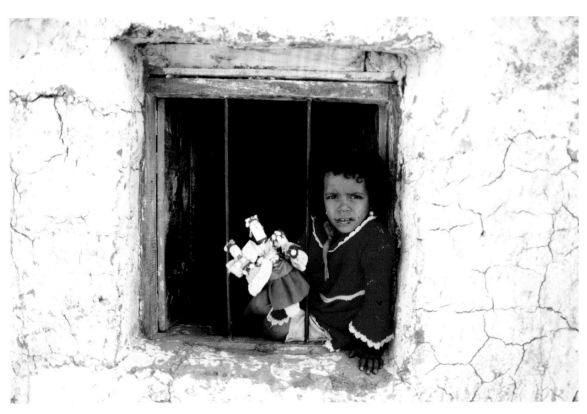

A Maasai boy eyes the Kenyan horizon from his mud
and dung home within a fortified manyatta complex,
meant to thwart the approach of hungry lions.

———

Crammed between window bars in search of early morning air
conditioning, playtime involves sewn dolls, inspired by Egyptian
mummified figures entombed nearby in the Valley of the Kings.

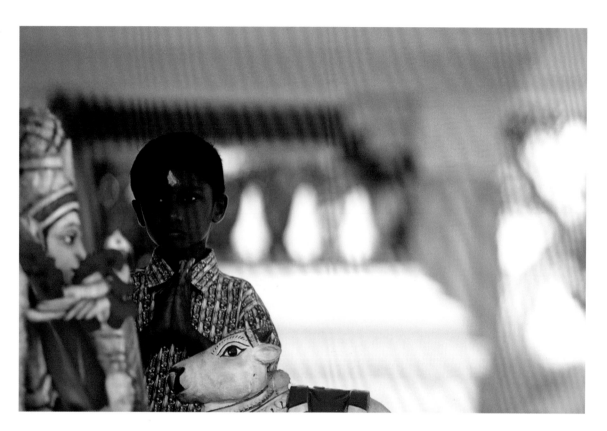

With heavenly assistance from Hindu deities and a wisdom-concealing bindi dot, a solemn Nadi worshipper retreats into private thought at a Fijian temple.

———

Inside the Tiger's Nest, young Bhutanese cheeks glow by the venerating light of a butter lamp illuminated for the figure regarded by some as the Second Buddha.

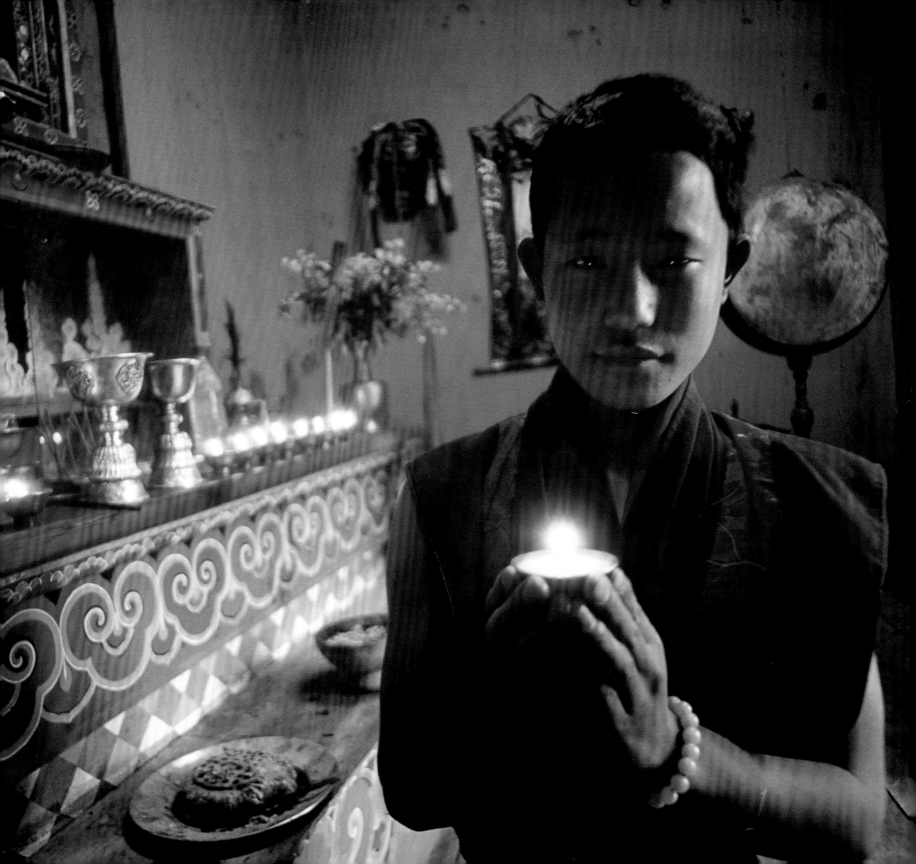

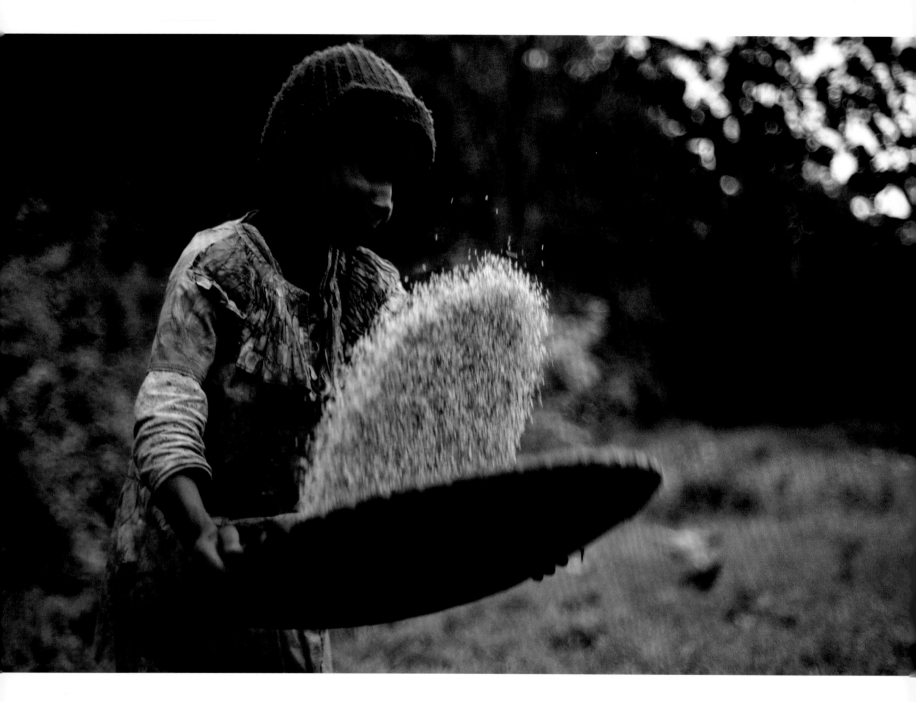

Sounding like maracas, rhythmic percussion emanates from
a wicker plate as rice is sifted and separated from the husk,
another chore in the paddies of Moramanga, Madagascar.

52

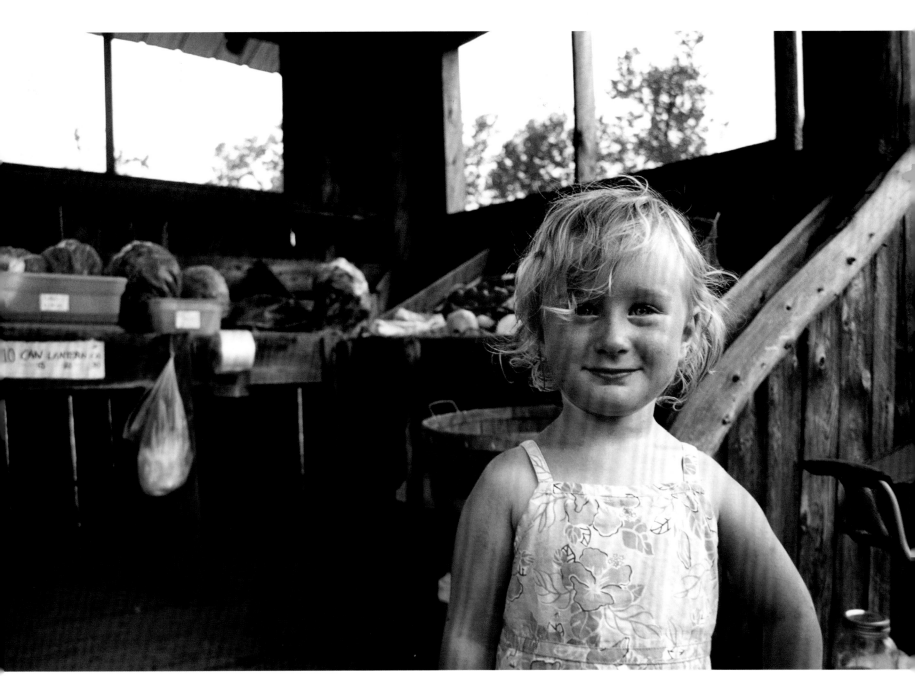

An innocent farm-fresh demeanor oversees a rustic honor-system vegetable stand along the undulating back roads of the Northeast Kingdom in Vermont.

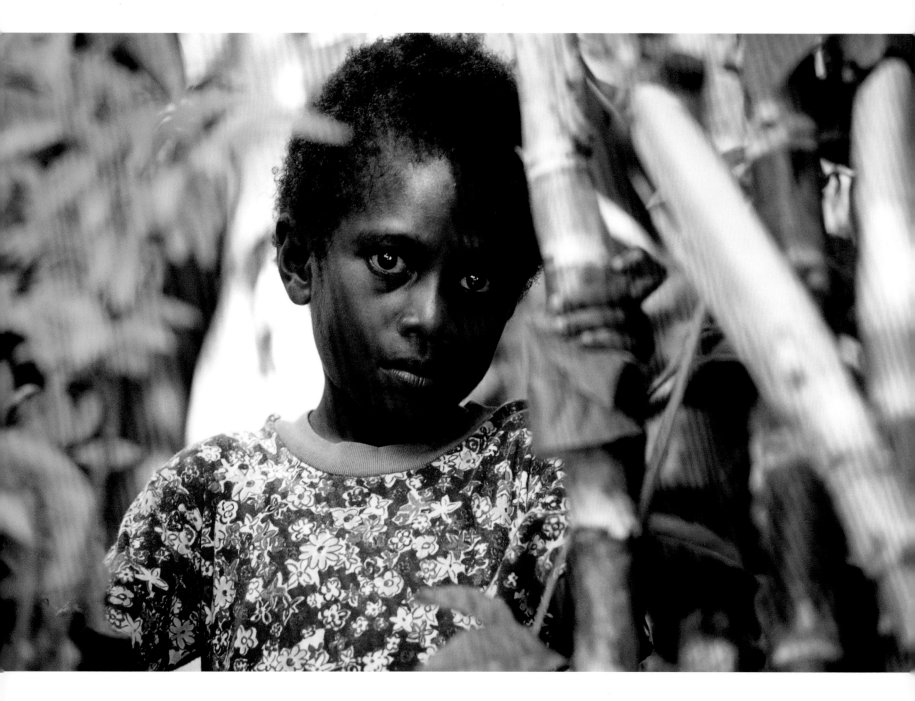

On Vanuatu's Pentecost Island, dark skin pigments and frizzy hair characterize the people of aptly named Melanesia, a volcanic archipelago hosting the world's greatest density of languages per capita.

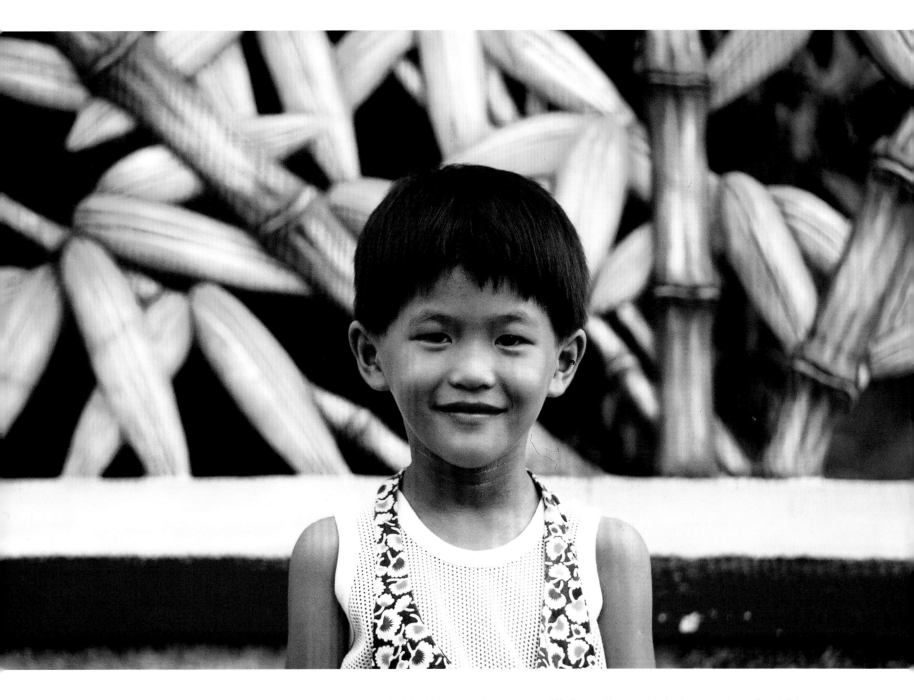

In Kuala Lumpur, bamboo motifs frame the contented expression of a child whose characteristics are indicative of the Chinese influence in Malay society.

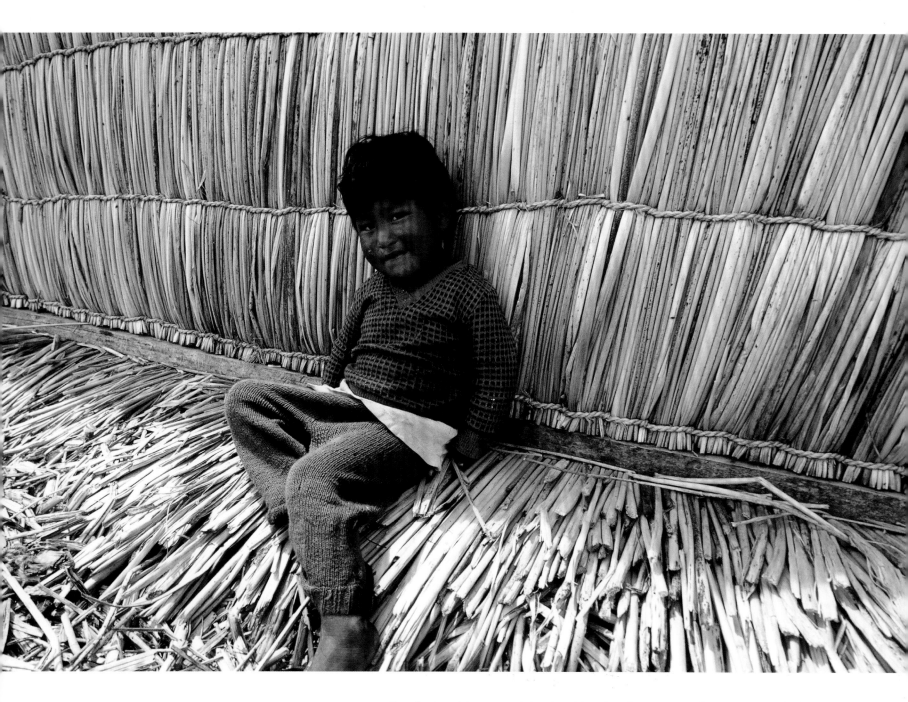

Barefoot on his spongy island, an Uros boy lives among the torturo reeds that built his home and provide the floating island mats on Lake Titicaca in Peru.

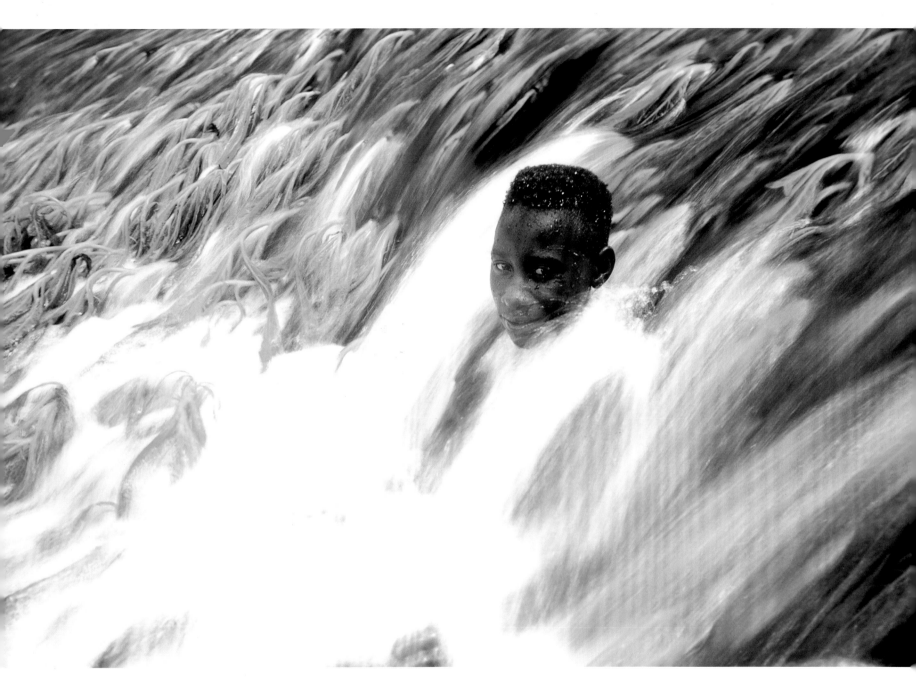

A Saramakan boy enjoys an aquatic back massage and soaks within a vegetation-choked rainforest cascade at Awarradam on Surinam's edge of the Amazon basin.

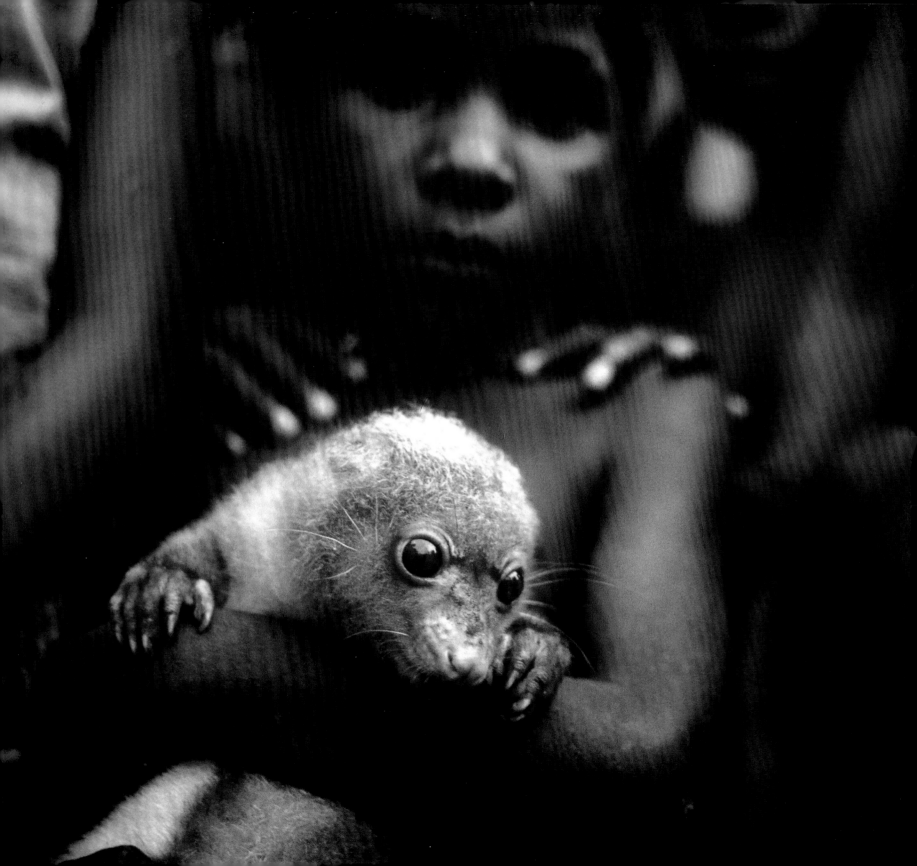

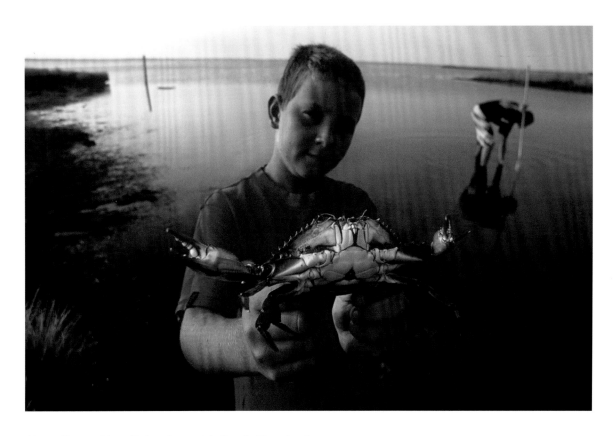

Along Papua New Guinea's muddy Sepik River banks,
wide eyes of both species set the scene around this
village pet cuscus, a tree kangaroo that, while clumsy
on the ground, can leap thirty feet into the trees.

At the edge of the Chesapeake Bay, human claws seem to
prevail as another blue crab is added to the bushel basket for
dinner's Eastern Shore delicacy in Chincoteague, Virginia.

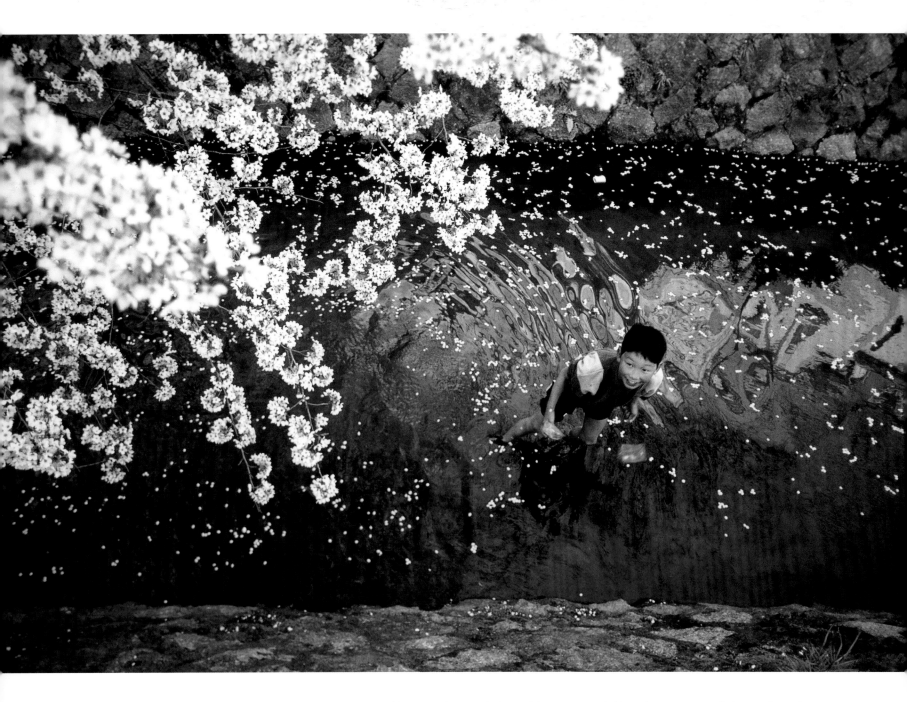

Kanazawa's vernal cherry blossoms sprinkle a Japanese castle's canal moat on a young urban fisherman hoping to catch more than petals in the koi-filled waters.

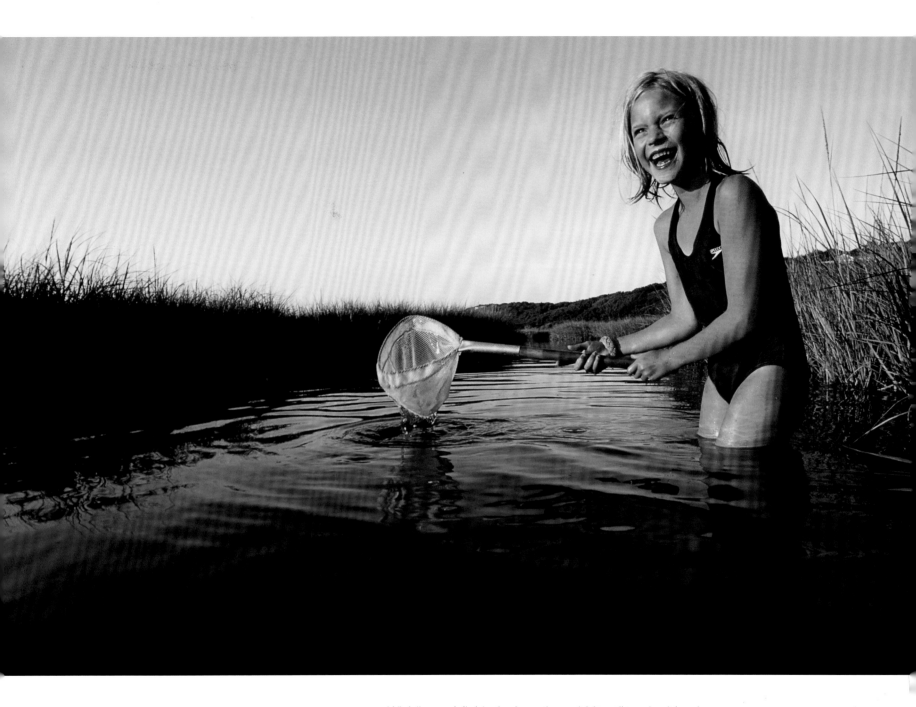

Wielding a delighted grin and a crabbing dip net, a blond lass in Menemsha hunts for crustaceans in a tidal estuary that chisels the indented coastline of Martha's Vineyard.

Sitting on a dock at the bay, an Australian boy bides his time before a
journey down the mocha-colored Adelaide River in Kakadu National
Park, teeming with bull sharks and saltwater crocodiles.

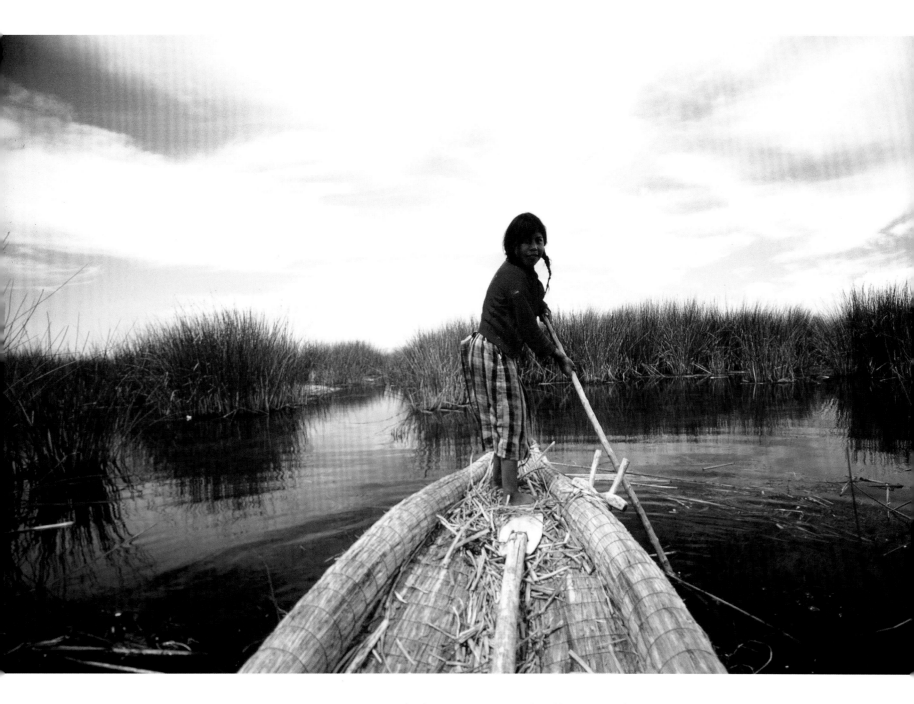

Lashed by torturo reeds, a local boat threads its way though a labyrinthine maze of vegetation amidst Lake Titicaca, the world's highest navigable lake.

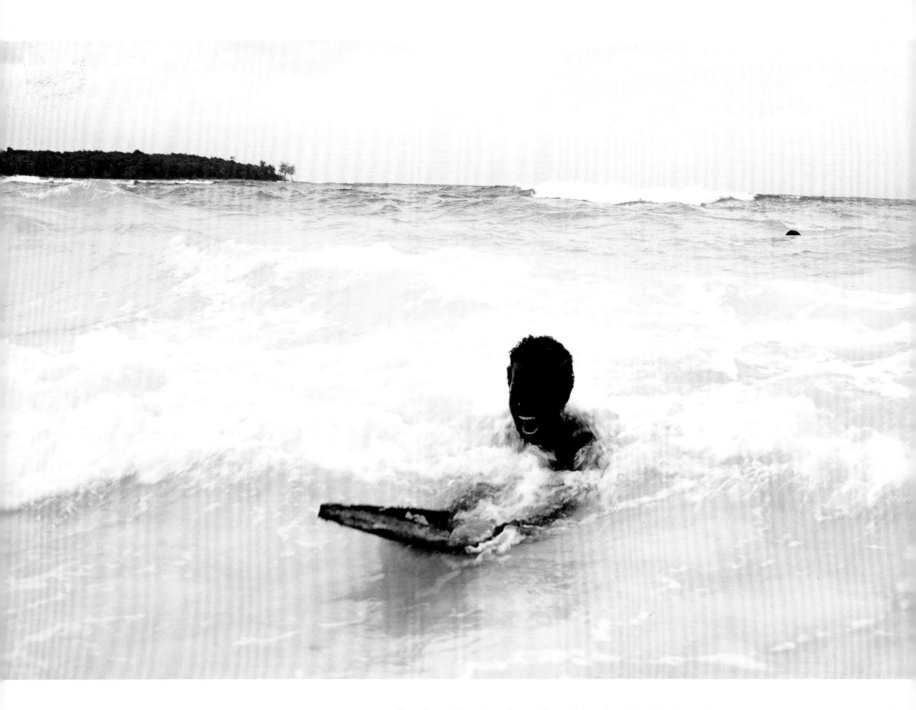

Roaring with adrenaline, a Tuam islander rides the turquoise surf atop a chunk of weathered tree bark and makes his way to the shores of Papua New Guinea's Siassi archipelago.

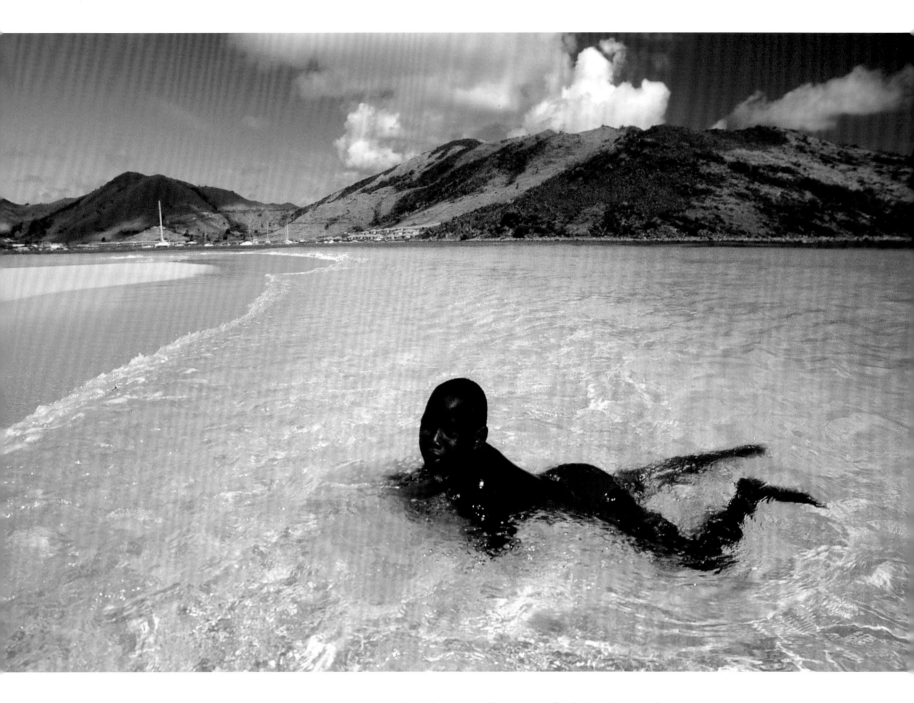

Lolling along the silky shores of a St. Martin's sandbar, a
novice bather enjoys gin-clear waters and the undisturbed
privilege of a pristine beachfront near La Belle Creole.

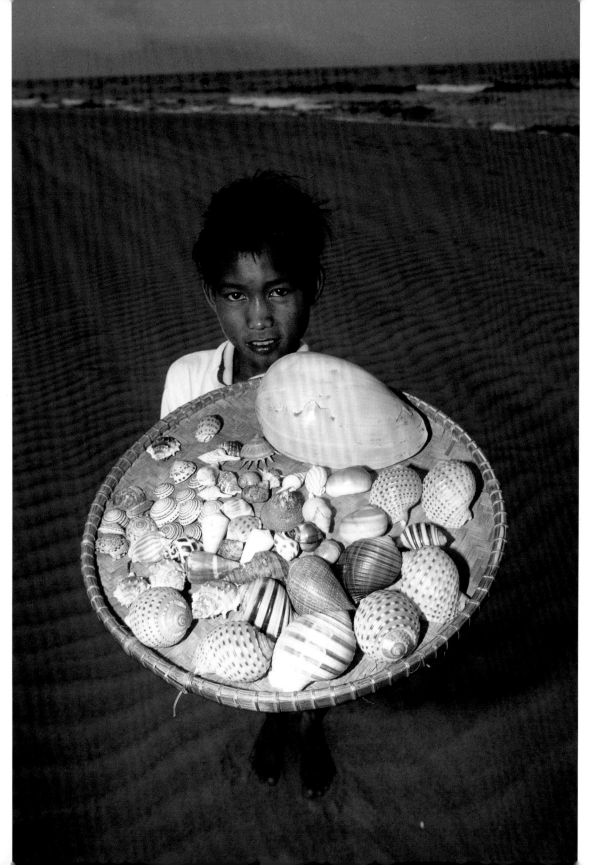

Prideful of the collection, he
sells seashells by the seashore
on Vietnamese sands rippled
by the retreating waves of the
South China Sea as they lap
at the margins of Danang.

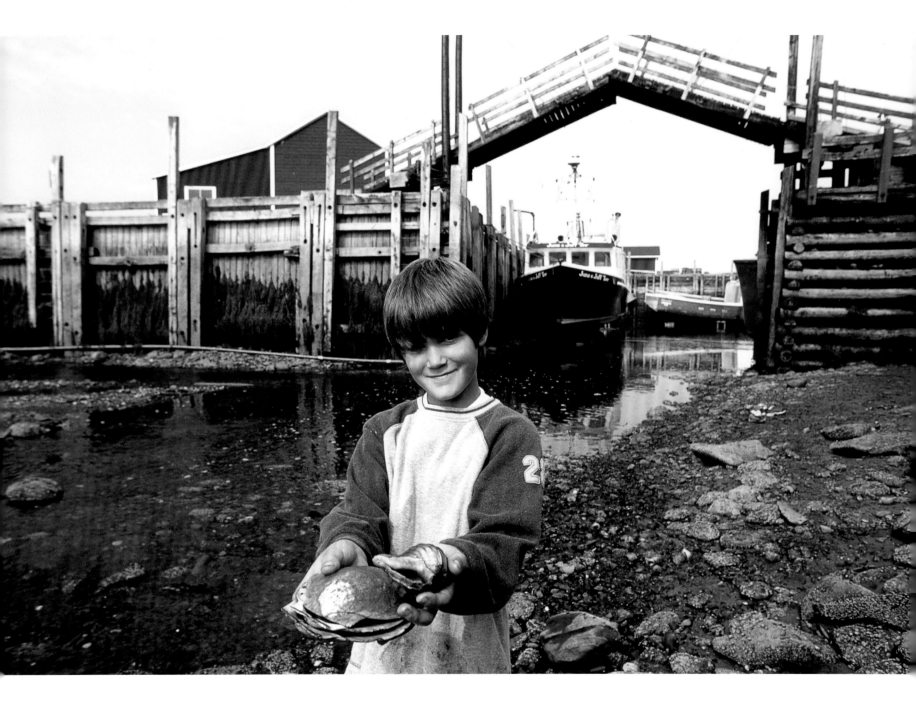

Below a Nova Scotian pulley-operated drawbridge, the world's smallest, nautical treasures from Sandford's exposed harbor floor are briefly unearthed by the planet's greatest tides.

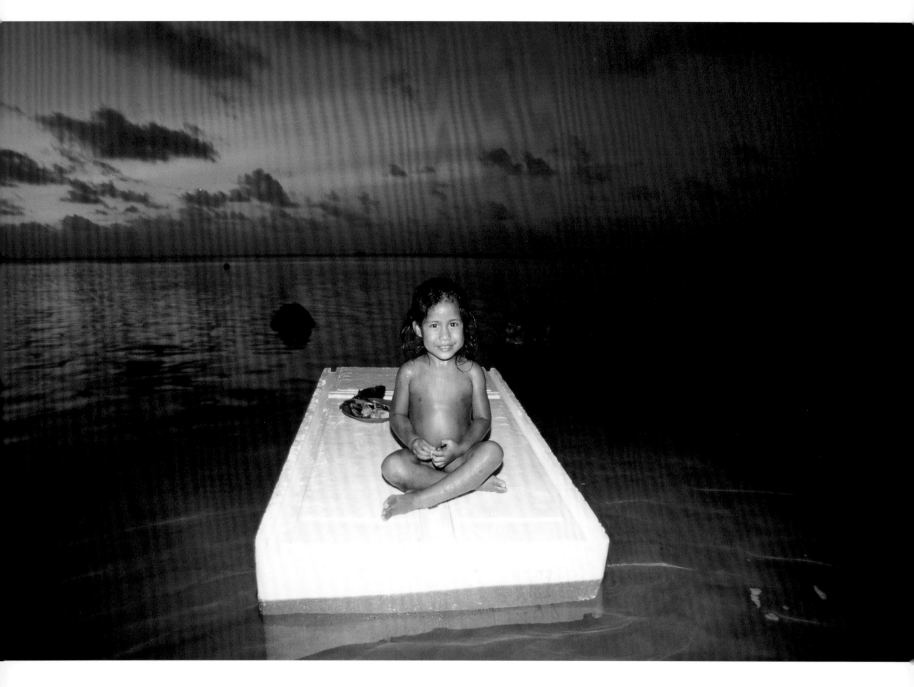

Adrift, but at home atop a discarded refrigerator packing case, a toddler revels in the simple joys of Tuvalu, the country most endangered by global warming. The forgotten Polynesian nation is a mere collection of fingernail-sliver atoll sandbars amongst the vast expanse of the South Pacific.

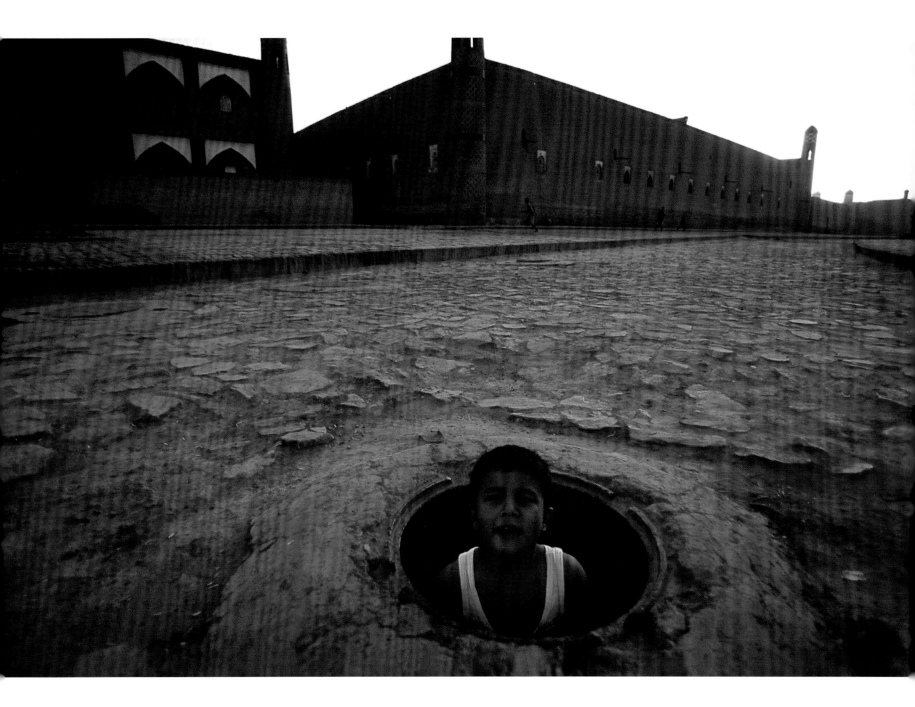

An open manhole provides an irresistible lure for an improvised subterranean playhouse beneath the stony, ancient streets of Khiva, capped by eighteenth-century Uzbekistani minarets and layers of Silk Road history.

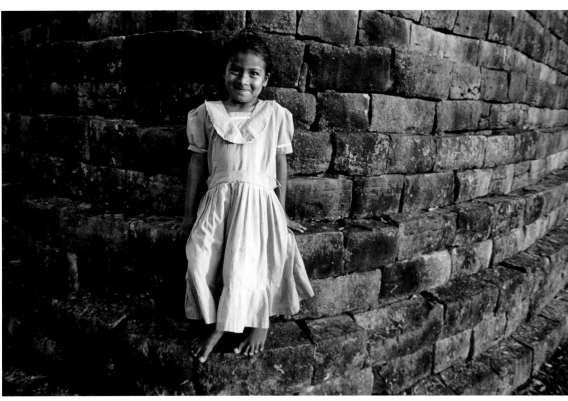

In Kitava, a beached wooden stump provides a sandy perch
for a mischievous grin as well as for watching Trobriand
Island fishermen returning to their South Pacific shanties.

Making herself at home amidst Mayan ruins, a Belizean child's
historical playground in Indian Creek still boasts the stone-fitting
skills that ancient craftsmen employed in highland jungles.

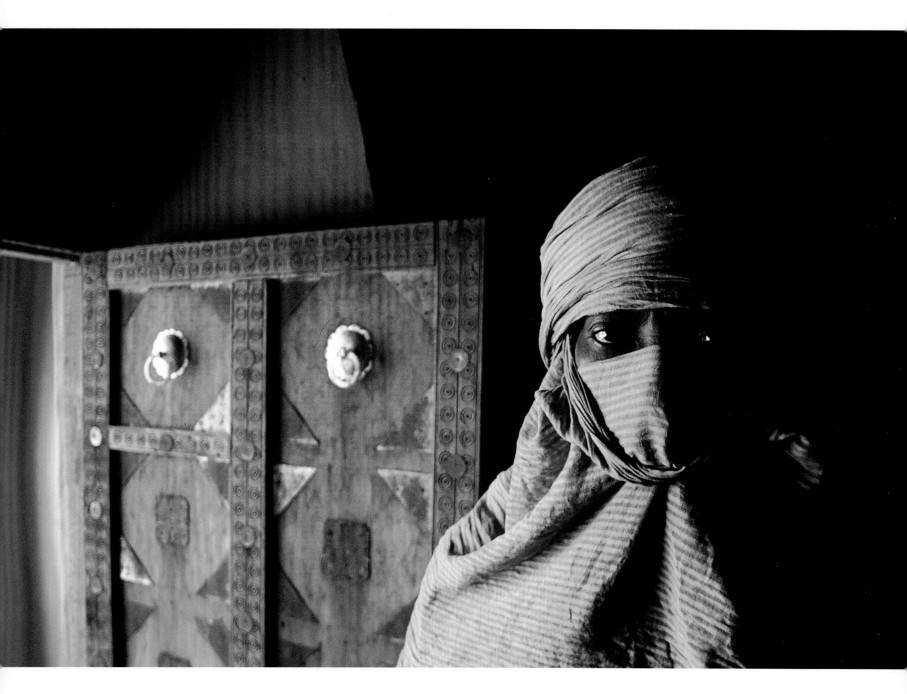

Veiled for protection from Sahara's windy sandstorms, a Tuareg youth
stands by an ornate door hinting at Mali's past Islamic glory and
the ancient hub of intellectuality that flourished in Timbuktu.

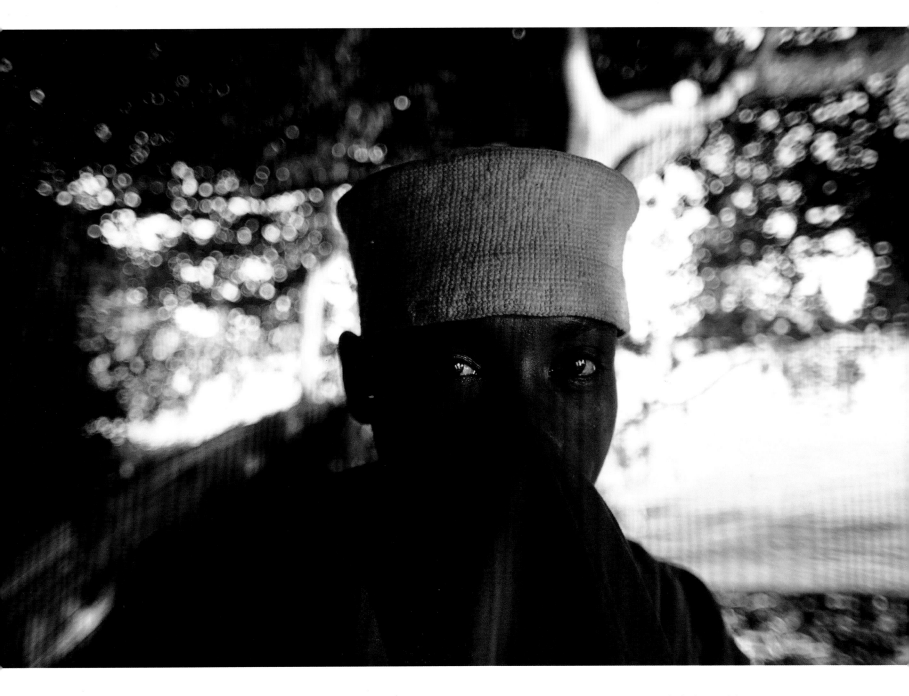

On the Ethiopian shores of Lake Tana, the Queen of Sheba's old stomping grounds, shyness emerges beneath a daishiki robe and koofiyad cap.

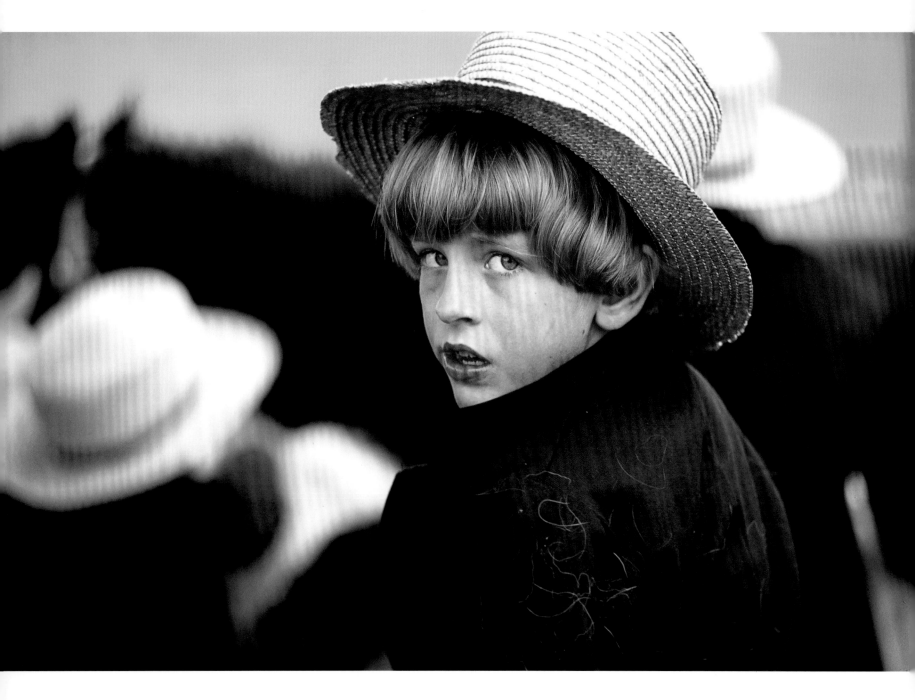

Speckled with livestock hair, an Amish youngster seeks advice at a Pennsylvania horse auction held amidst the Susquehanna Valley's fertile farmland.

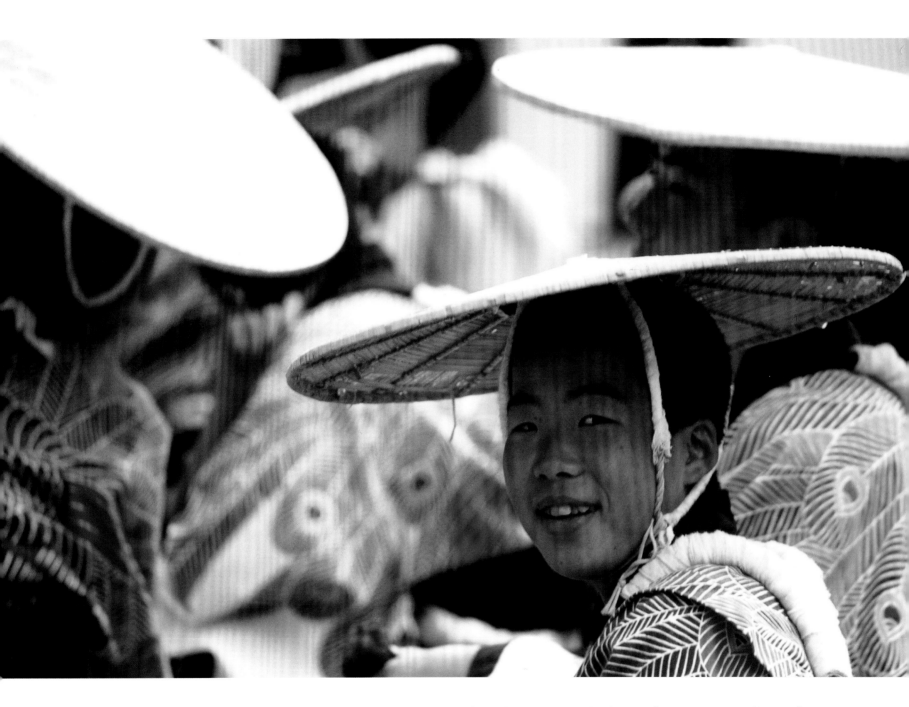

During a break from Shinto prayer, a tilted array of sugegasa conical hats reflect Takayama's ceremonial rice harvest festival held in the foothills of the Japan Alps.

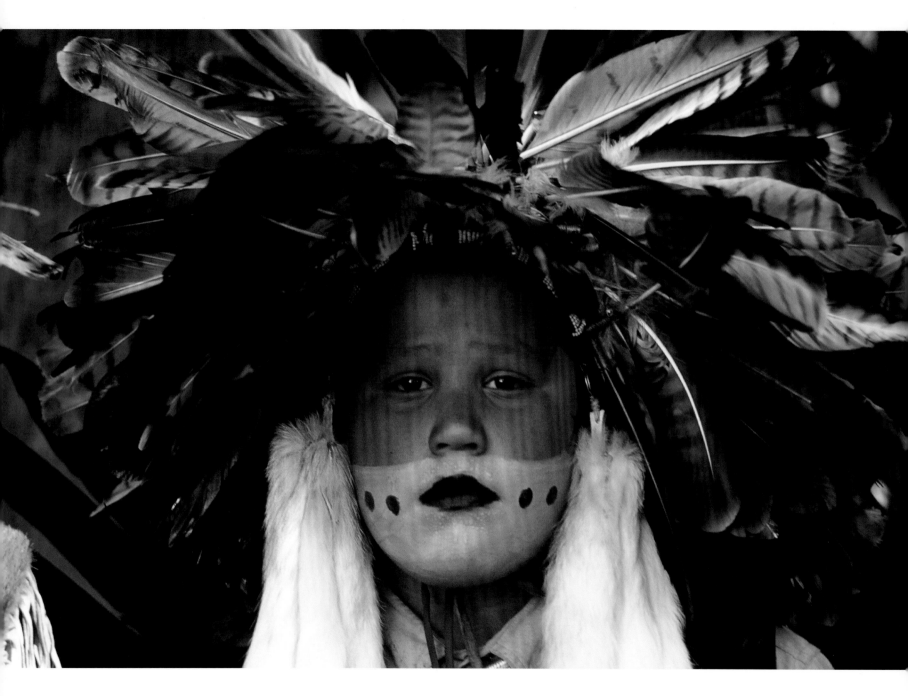

Pounding drums reverberate across the Great Plains as colorful powwows gather in Custer, South Dakota to promote indigenous dancing and display face paints and feathered regalia.

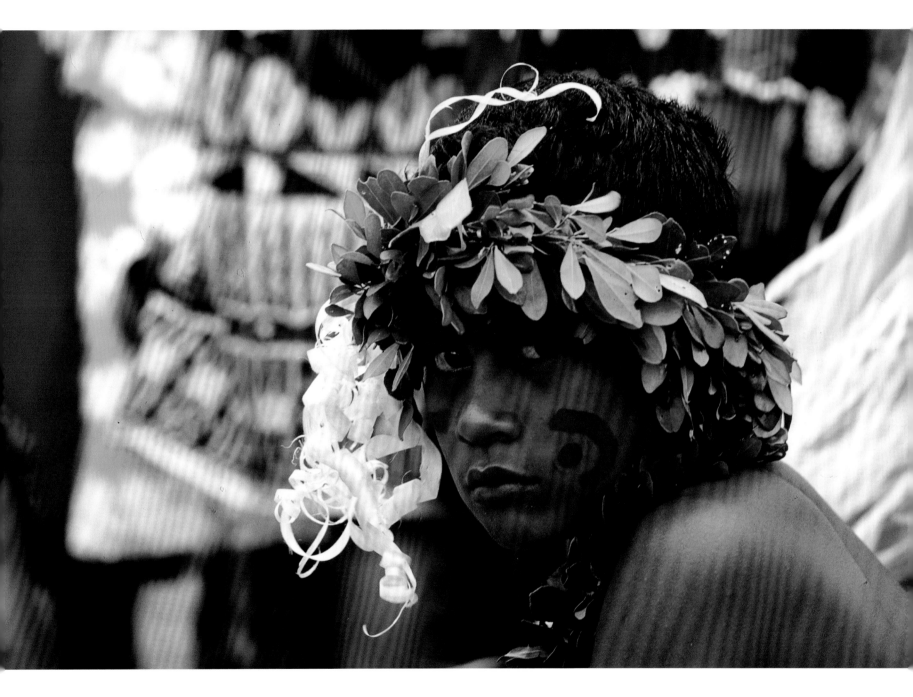

Swaying grass skirts and stenciled tapa cloth frame the intensity of a performer in Nuku'alofa, Tonga, dabbed in crimson and crowned by a wreath of leaves from the local ifi tree.

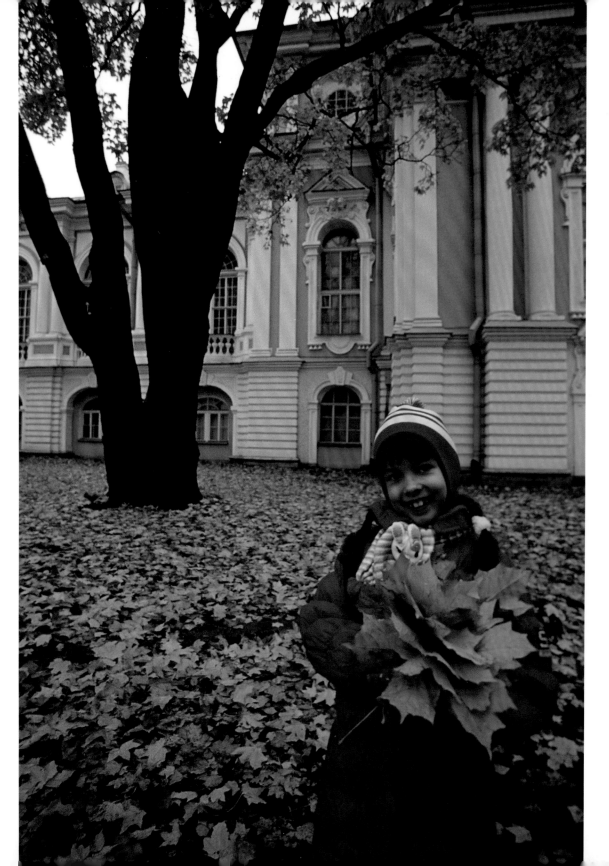

Reveling in the short-lived glories of autumnal splendor, this future Russian babushka enjoys a nature stroll on the grounds of St. Petersburg's eighteenth-century imperial palace.

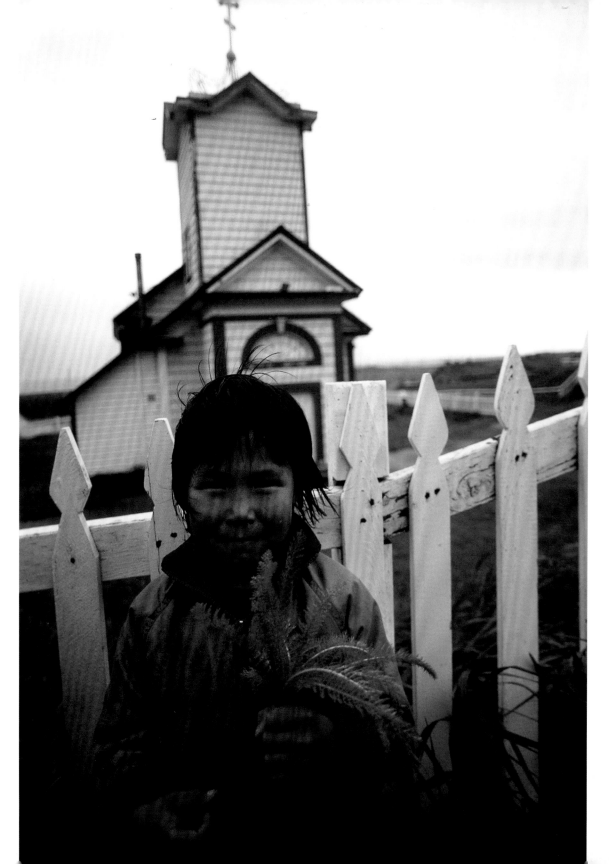

On St. Paul Island, the world's largest Aleut population contends with the birthplace of North America's low pressure systems, where fierce winds blow Alaskan hair and greenery alike.

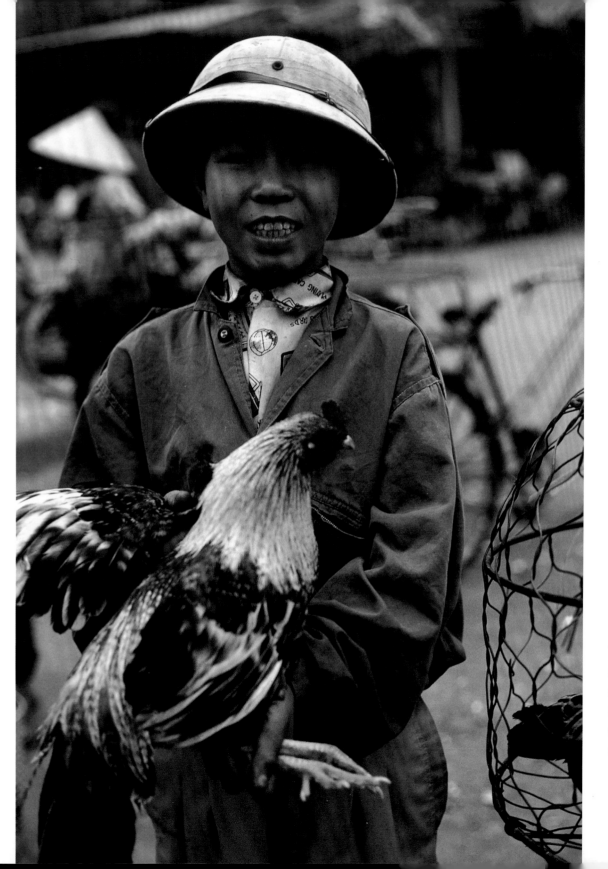

The final stop at Hanoi's poultry market completes a list of chores amongst the crowded bicycle-strewn lanes of Vietnam's thousand-year-old capital.

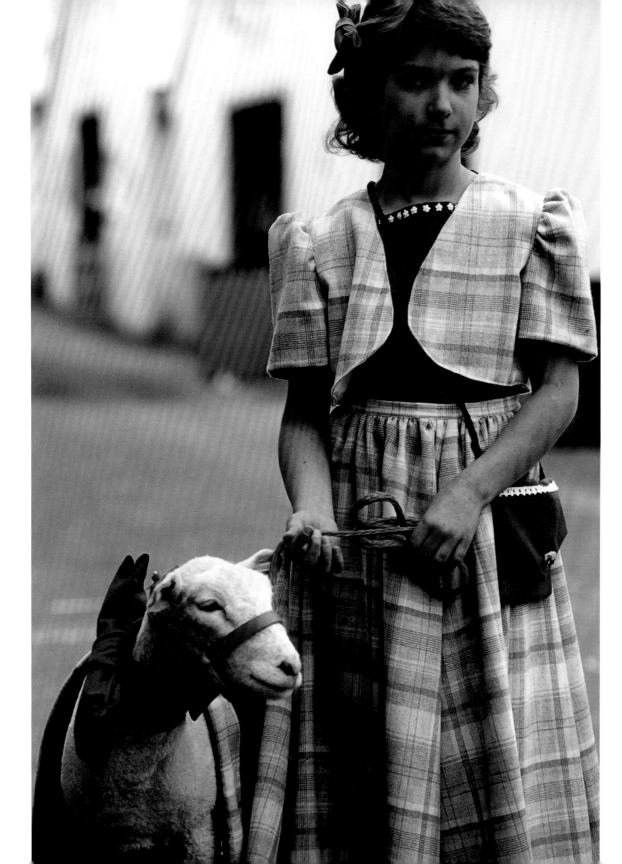

With matching outfits and only slightly differing expressions, a county fair beauty pageant in Cummington, Massachusetts provides enticement for a possible blue ribbon after the parade.

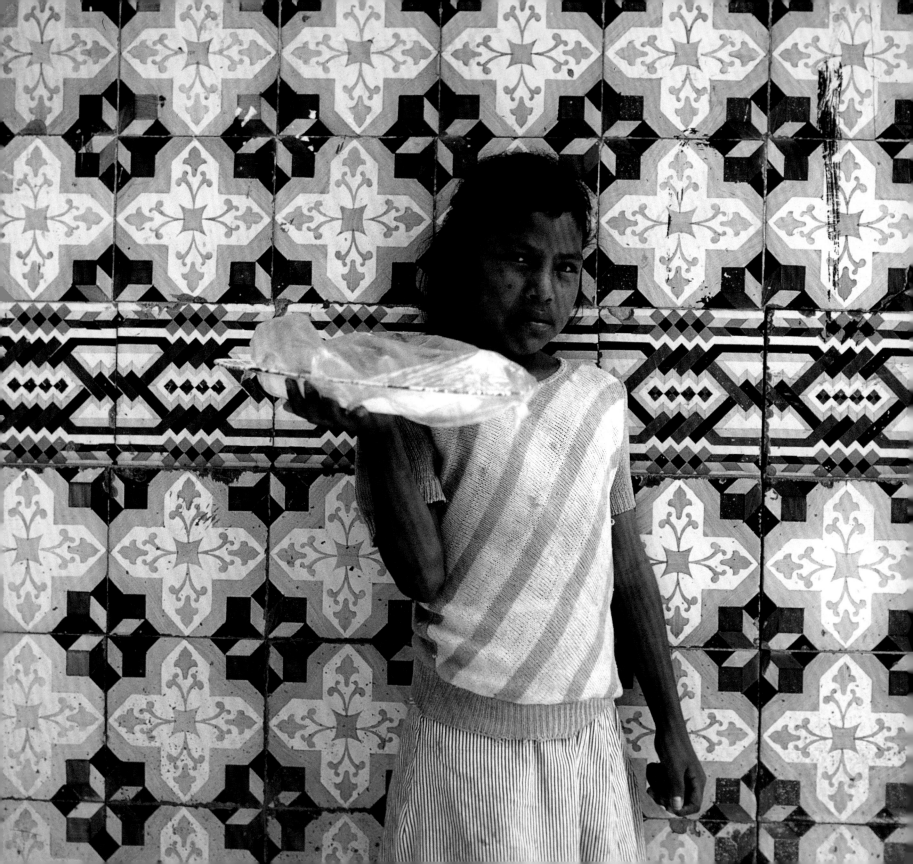

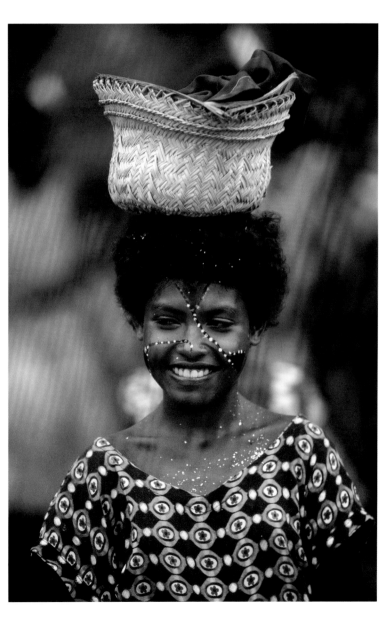

Spanish tiles are ornamental remnants that hint at a colonial past in Iquitos, a hectic, banana-loading Amazonian port where even small Peruvian girls are busy selling fruit.

A basket of woven patterns balances on a face sketched with both painted designs and an expression of bemusement during her visit to the Kitava Island market in the idyllic Trobriands.

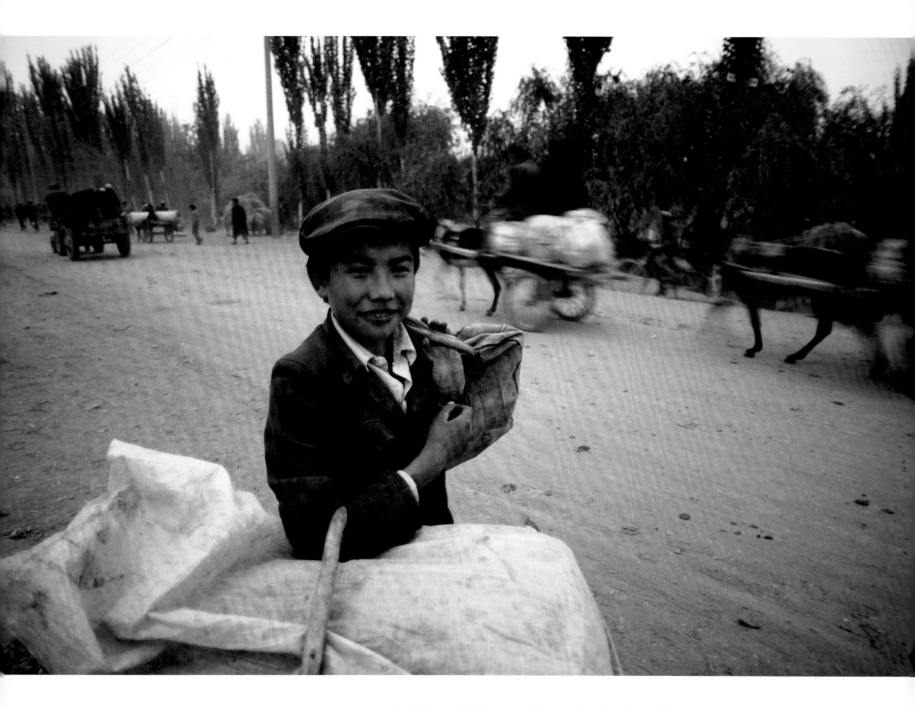

Dodging a Silk Route rush hour of market-bound horse-drawn carriages creates a dusty challenge for armfuls of produce on route toward home in Kashgar, China.

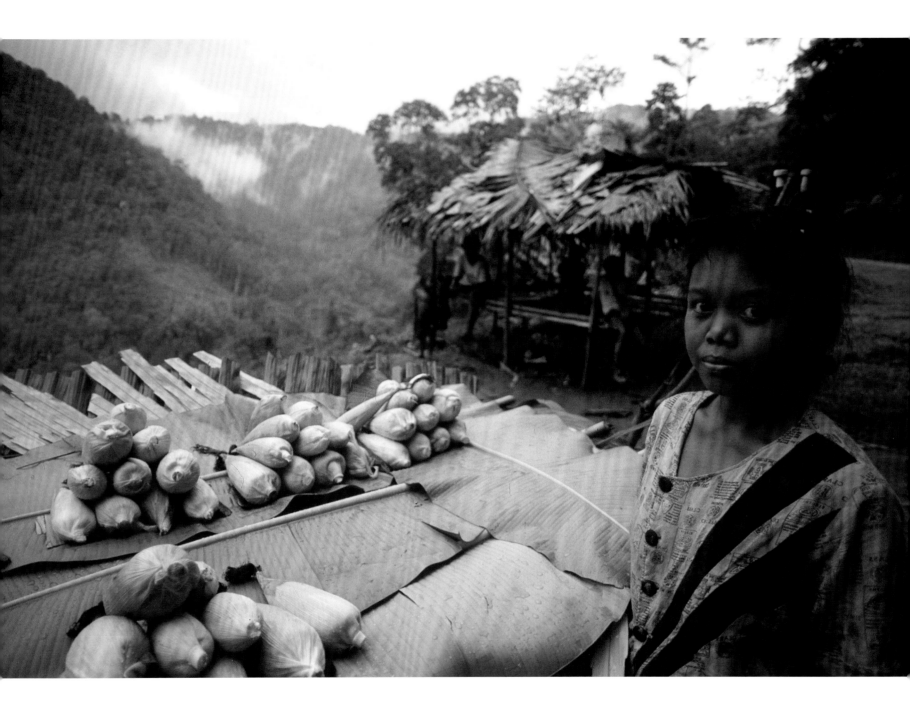

Displayed on banana leaf tablecloth, cultivated corn supplements both the income and diets of Malaysia's aboriginal Orang Asli, earliest descendants of Africa's original people who thrive amongst the Cameron Highlands.

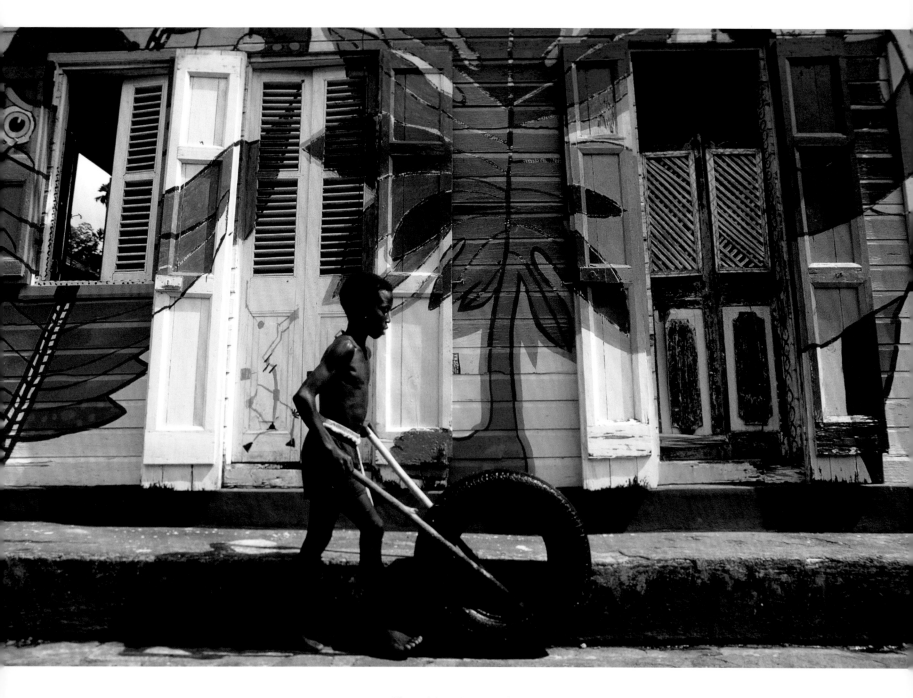

The rubber tire provides some impromptu curbside playtime for a shirtless
St. Lucian boy emerging from his colorfully painted house in Choiseul.

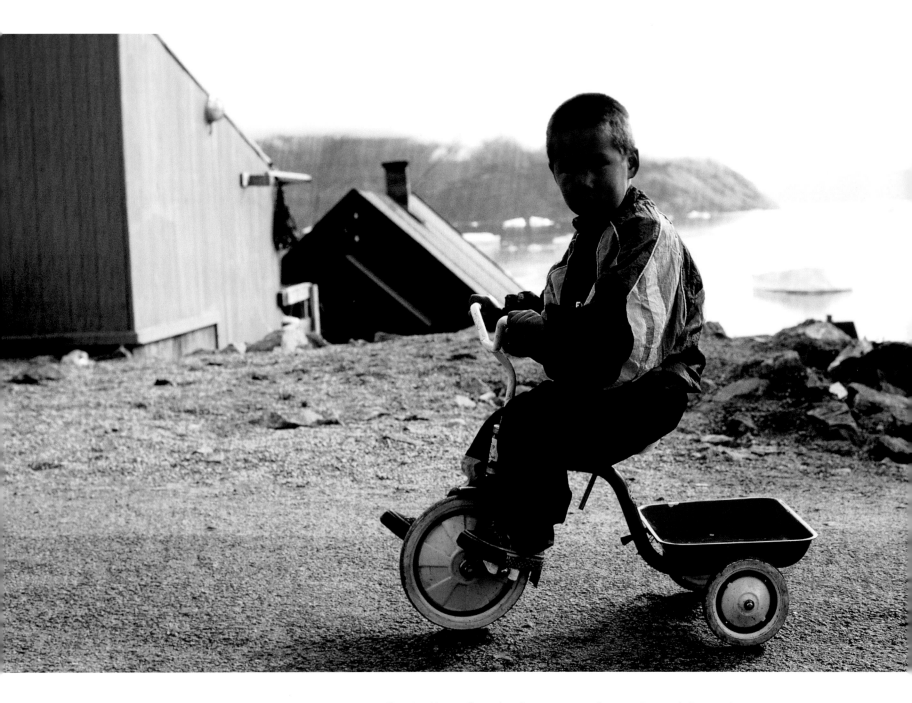

Overlooking a Greenlandic seascape of rugged mountain coast and wandering icebergs, a future boat captain practices his navigation skills on a battered tricycle in Uummannaq.

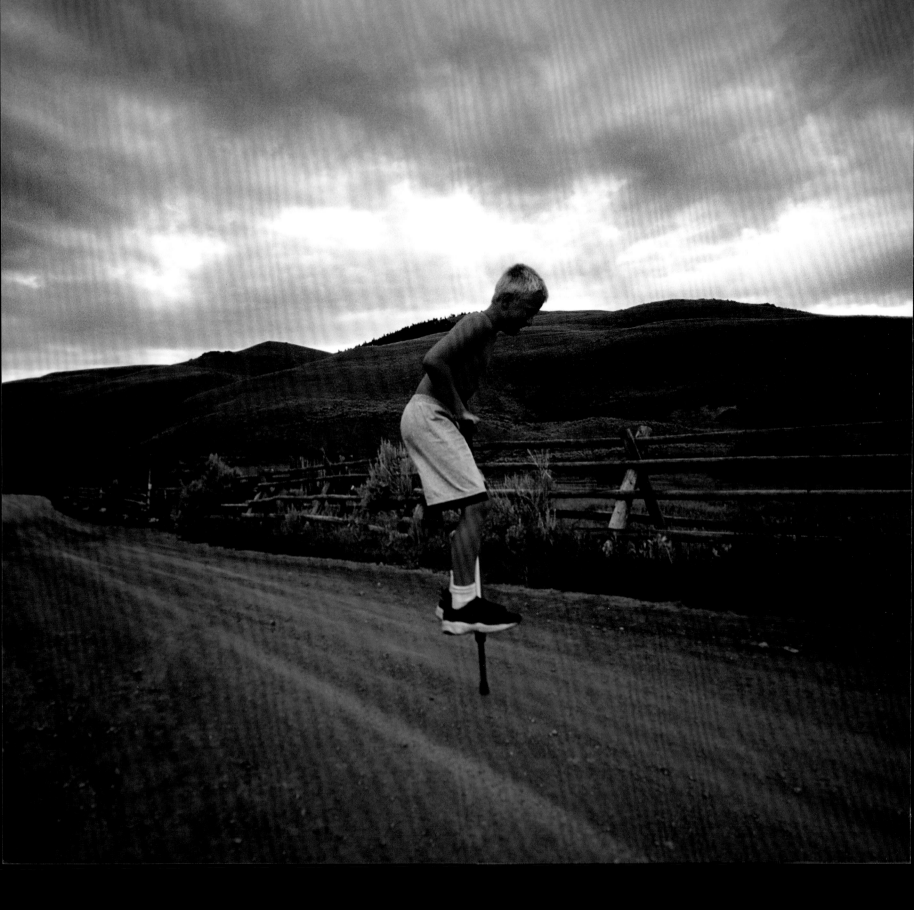

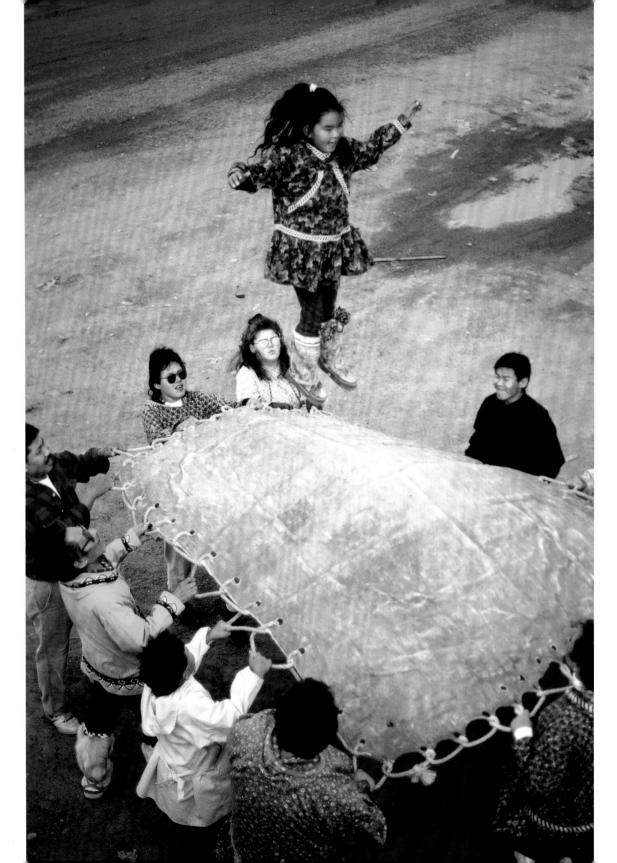

Just below Lolo Pass, which
once allowed Lewis and Clark
their much-sought Pacific
access, an animated youngster
gives his pogo stick a serious
workout and bounces midair
down the dirt road to his
Idaho ranching homestead.

———

Airborne exhilaration is
churned up by the lofty
Alaskan efforts of blanket-
tossing Inupiaq villagers
celebrating their walrus hunt in
Point Barrow, the northernmost
spot in the country.

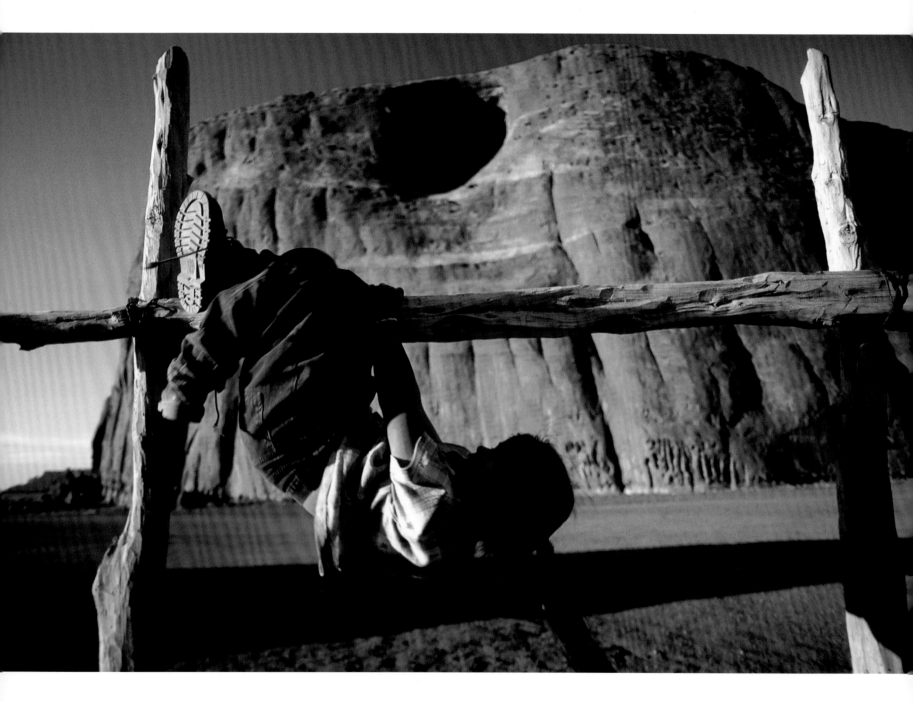

In Arizona, a horse's hitching post serves as a convenient jungle gym for a pony-tailed Navajo amidst the drama of Monument Valley's weathered iron oxide siltstone.

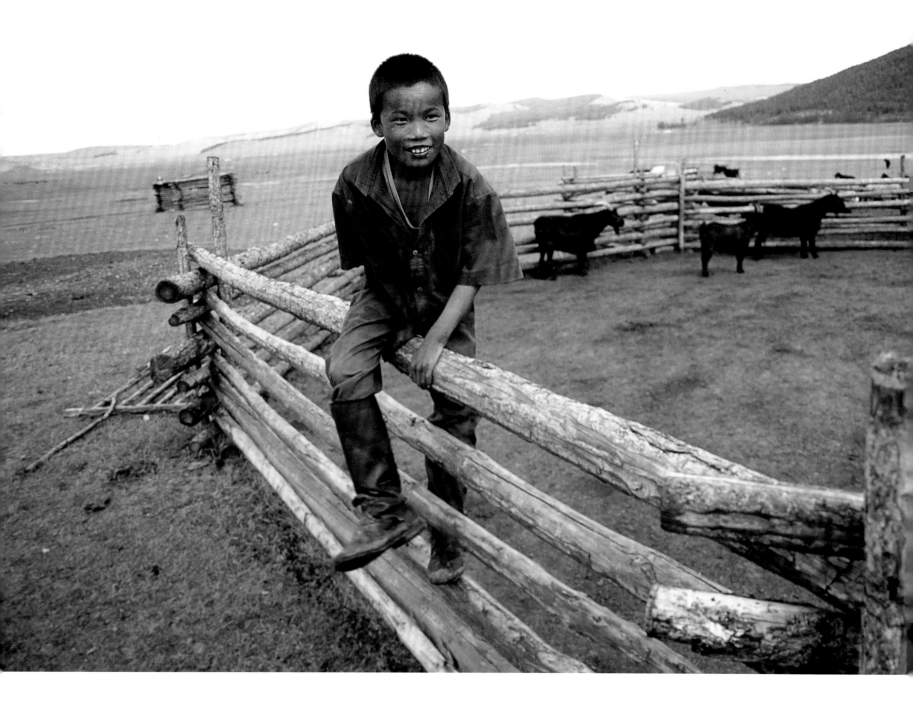

Straddling a wooden corral fence near Lake Khovsgol, a Mongolian descendant of Genghis Khan practices equestrian postures in the heart of the world's largest horse-based economy.

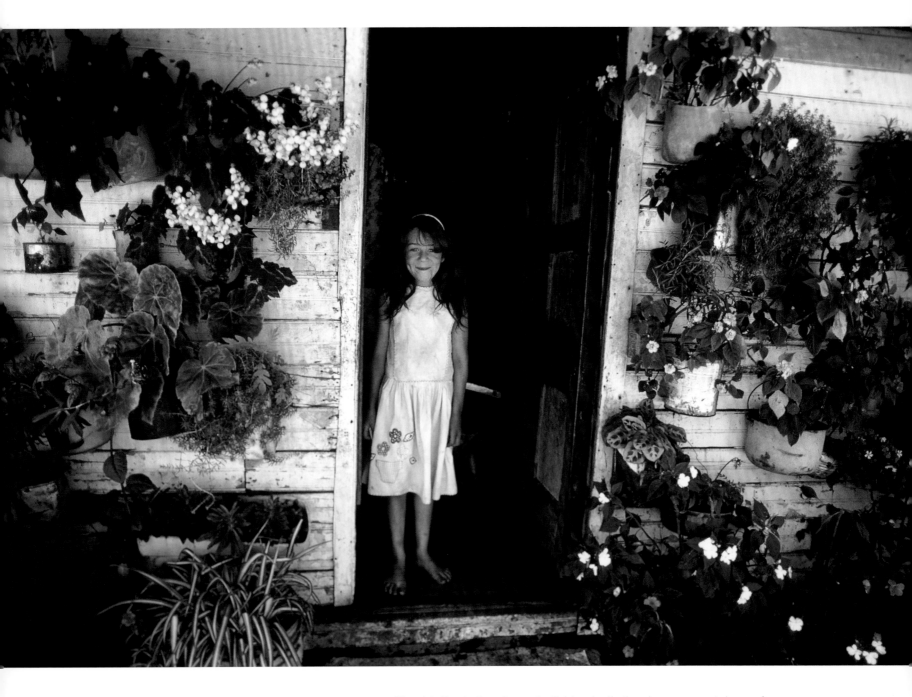

The rich floral diversity embellishing both the doorway and dress of a young Volcan Poas resident speaks to the jungly Costa Rican biodiversity flourishing atop a geological scrimmage of tectonic plates.

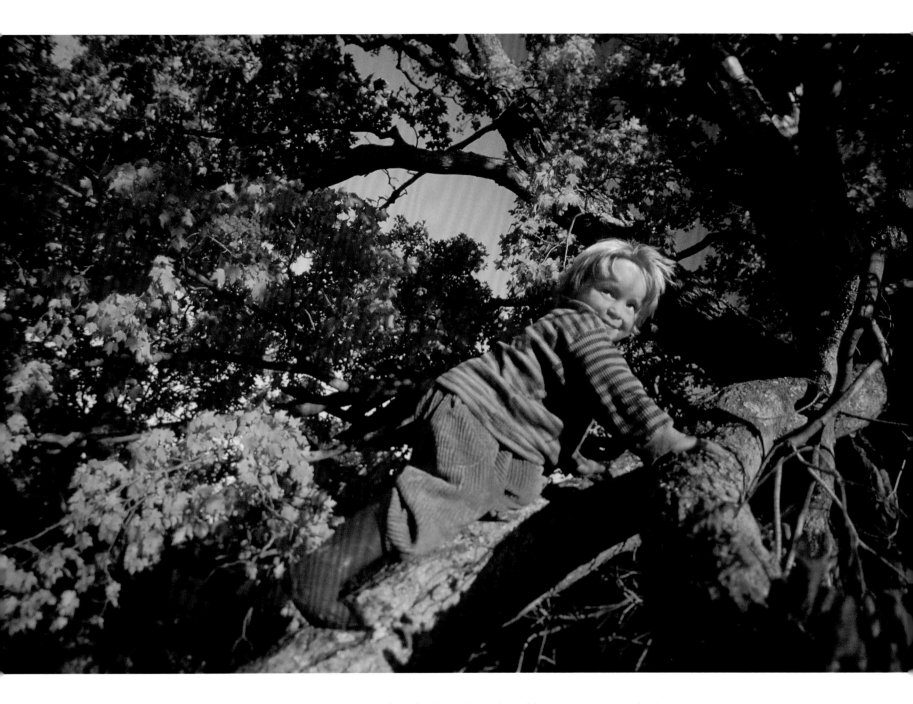

Despite the odd choice of footwear, a young climber seems at home in the Vermont treetops, reaching for arboreal heights at the base of Romance Mountain near Goshen.

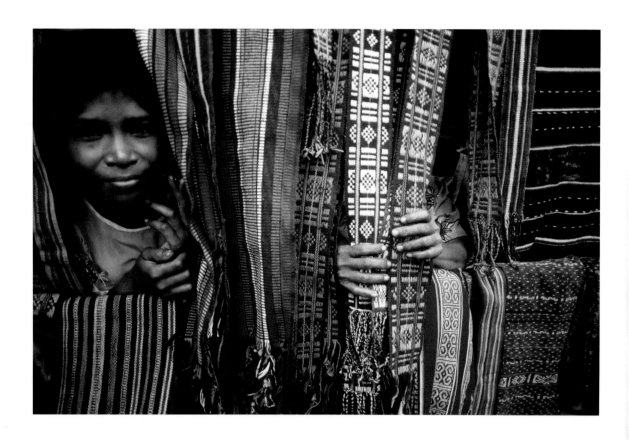

Busy fingers work to create hand-loomed textiles
displayed at a market in Sumba, one of Indonesia's thirteen
thousand islands, the world's largest archipelago.

———

A young girl in Myanmar, her face obscured by both an
iridescent bubble and thanakha moisturizing paste, enjoys
the courtyard of one of Bagan's ancient pagodas.

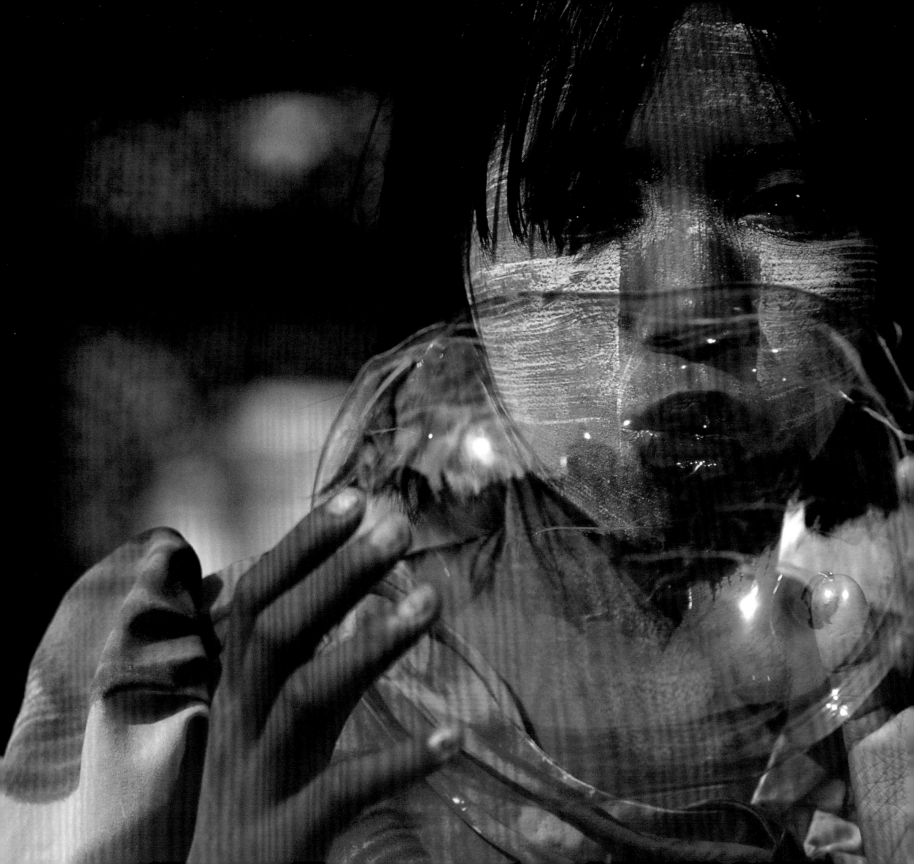

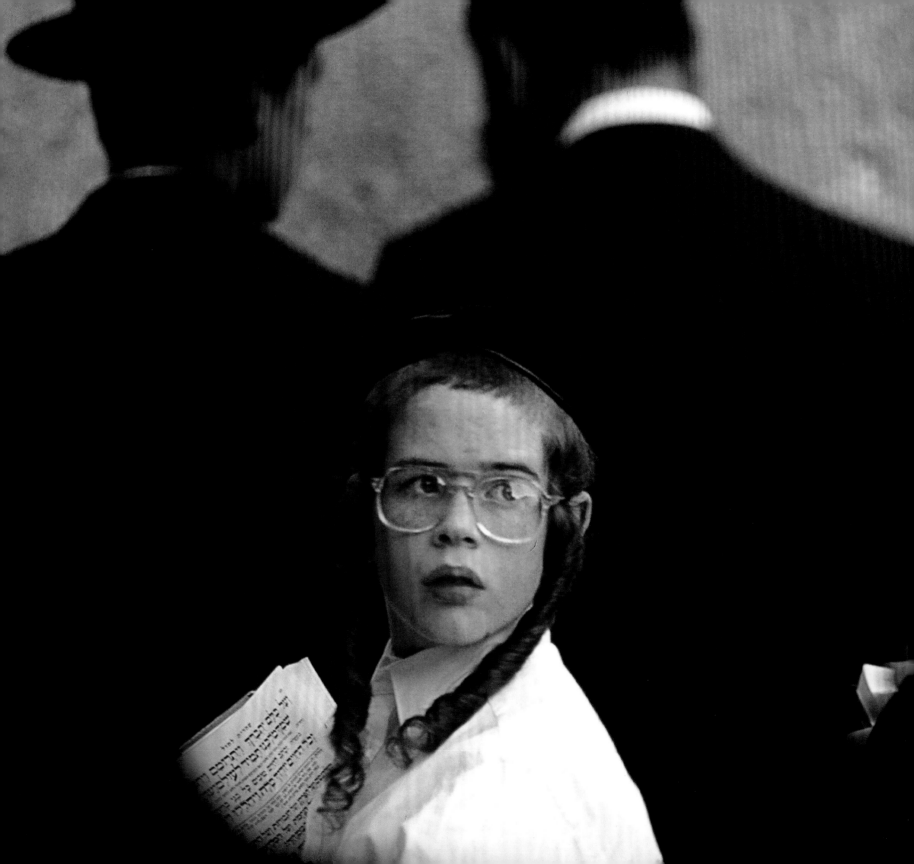

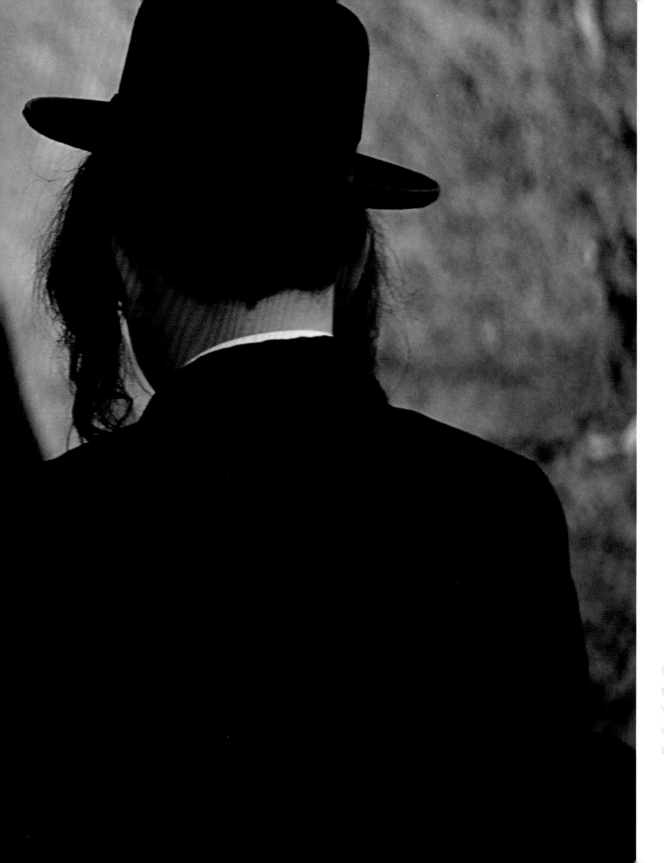

Distracted from morning
prayer at Jerusalem's Wailing
Wall, a Chasidic Jew sports
curly payos sidelocks, ordained
by biblical prohibitions.

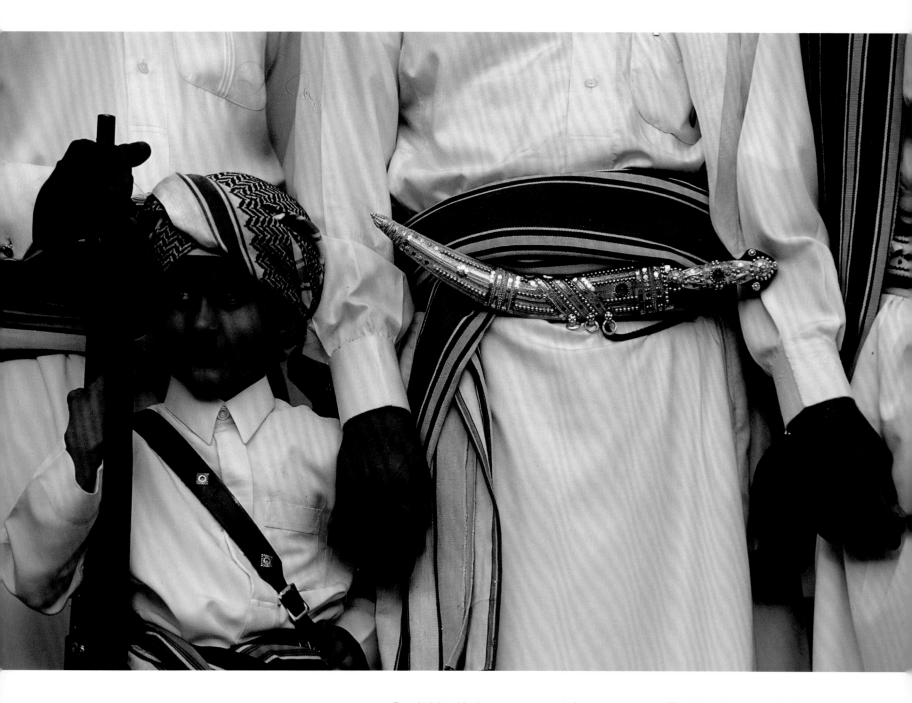

Sandwiched between guns and daggers, a young Saudi awaits a sword dance
chorus line beneath keffiyeh headdresses and village elders in Rijal Almaa.

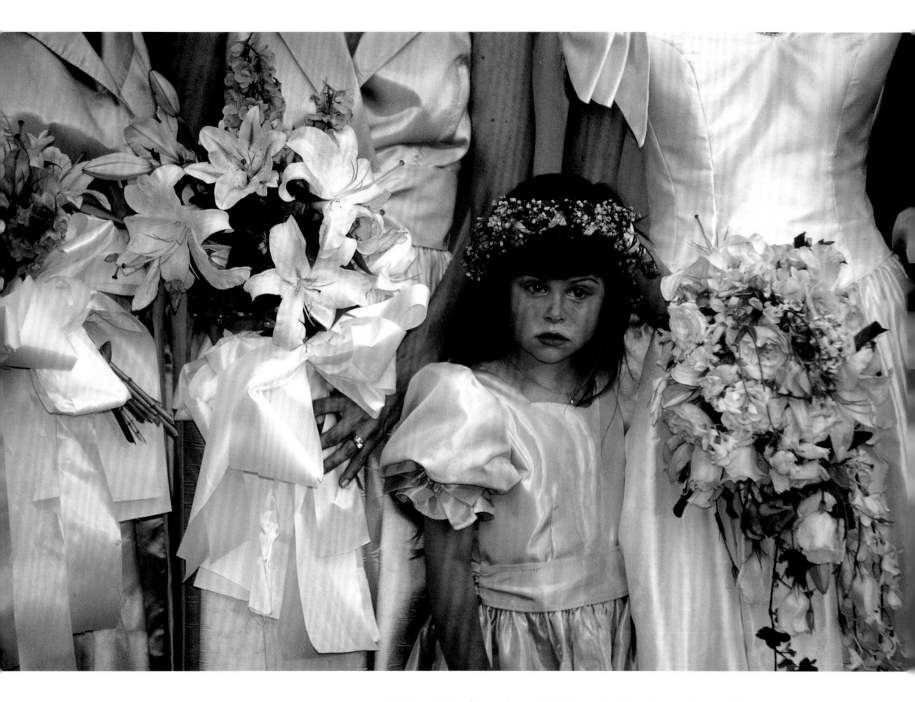

Adrift amidst a fragrant world of silk and satin sashes, a flower girl dreams
of future romance at a country estate's wedding reception in Rhinebeck,
a sophisticated village jewel in the heart of New York's Hudson Valley.

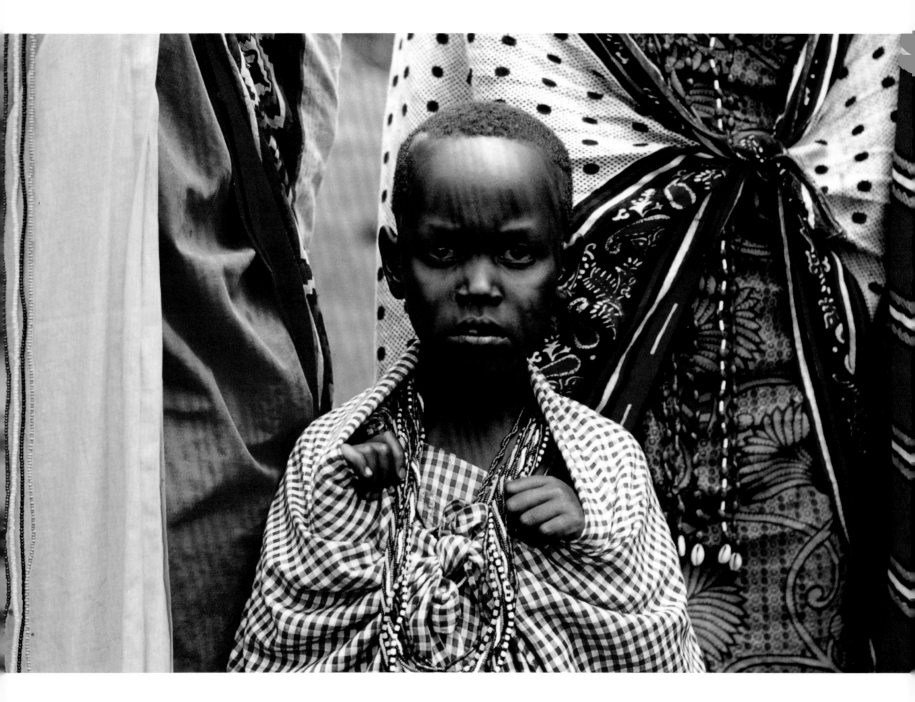

Reds traditionally indicate power and are a favored color for facial decoration and fabrics worn by the Maasai of Tanzania, who augment appearances with beaded ornamentation.

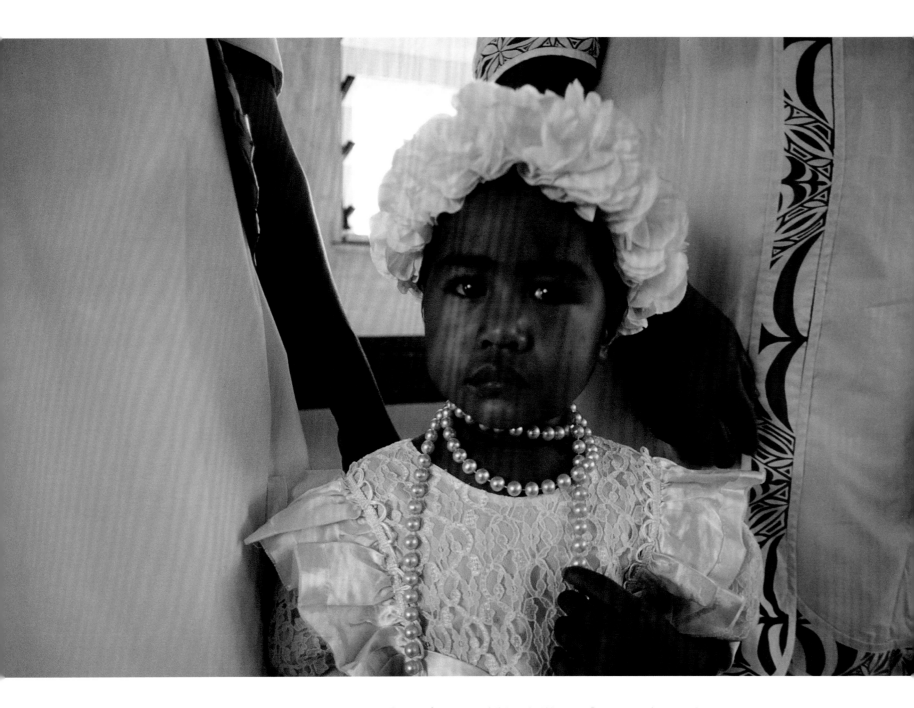

Queen for a day, children in Western Samoa are honored on White Sunday as Apia's churches and streets are filled with South Pacific congregations of ivory-clad celebrants.

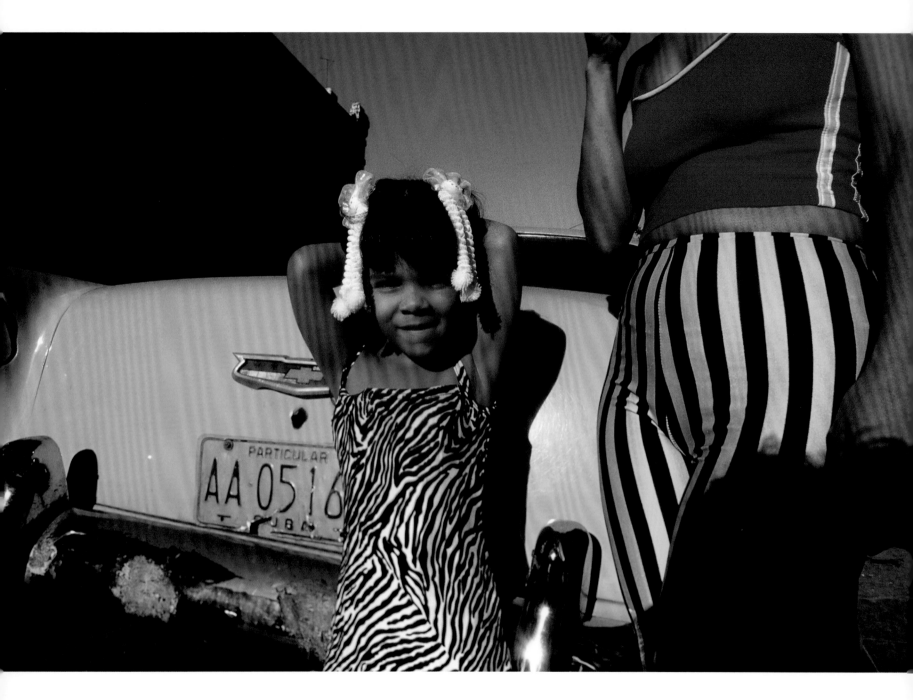

In Old Havana, a Chevrolet from another century provides an
impromptu alfresco lounge for striking poses in striped clothing.

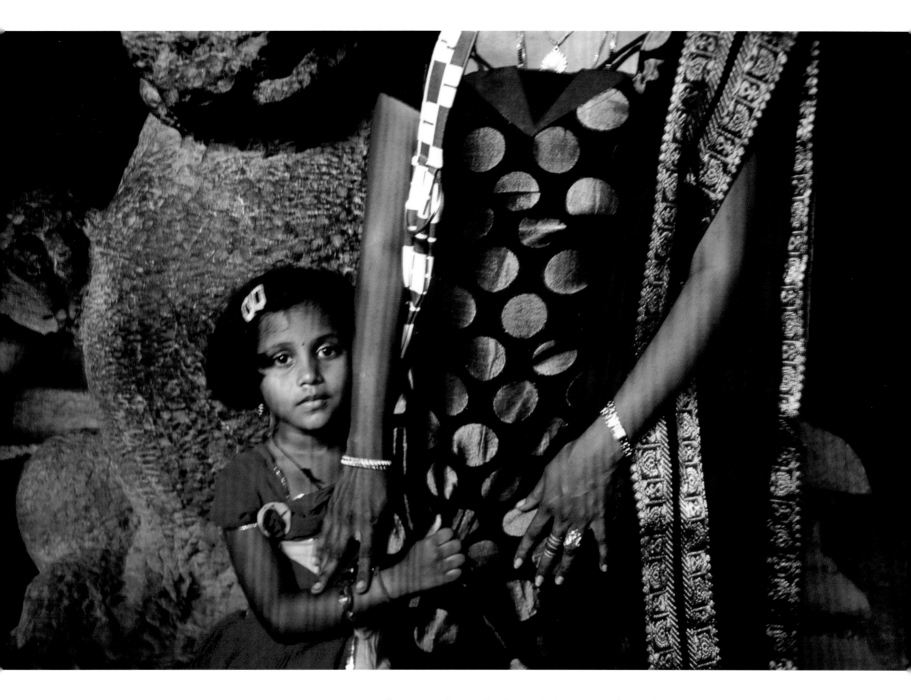

Reassured beneath a brocaded sari, an Indian girl is mesmerized by the basaltic fifth-century Hindu deities haunting the chiseled Elephanta Caves outside of Mumbai.

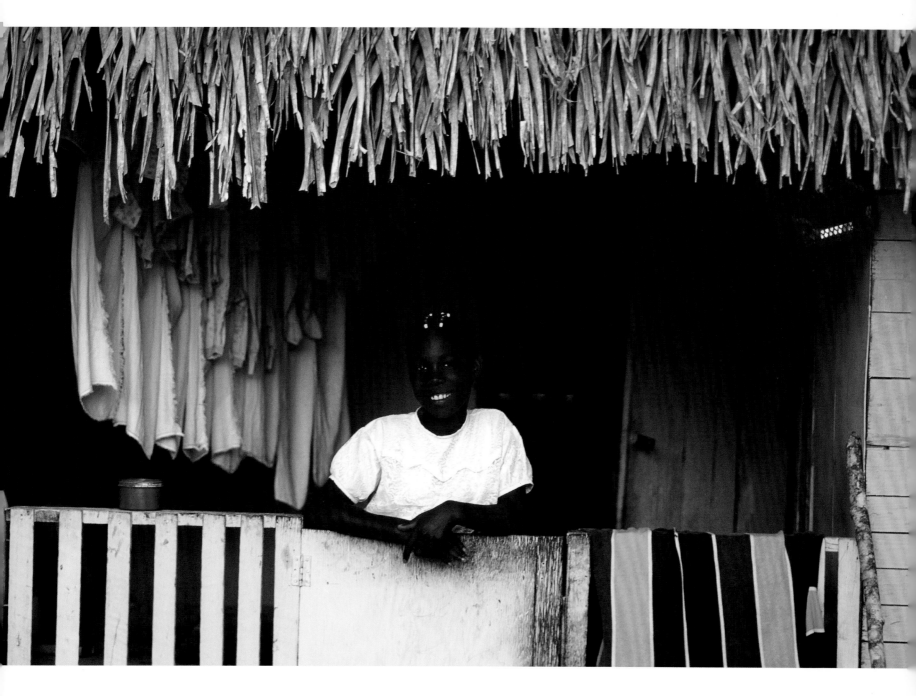

From within a simple thatched and clapboard dwelling, a warm smile connects with the goings-on just outdoors near Punta Gorda, filling vacancies in her window on the world.

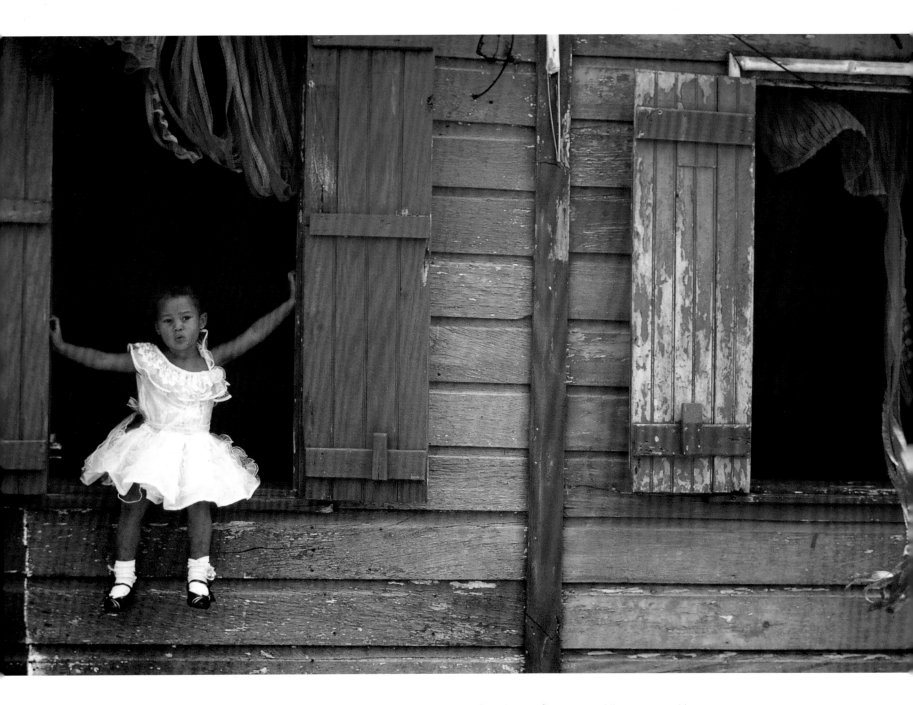

In her very best Sunday outfit, a young Nicaraguan girl
adorns a clapboard house and its blowing curtains in Leon,
an agricultural city chockablock with colonial churches.

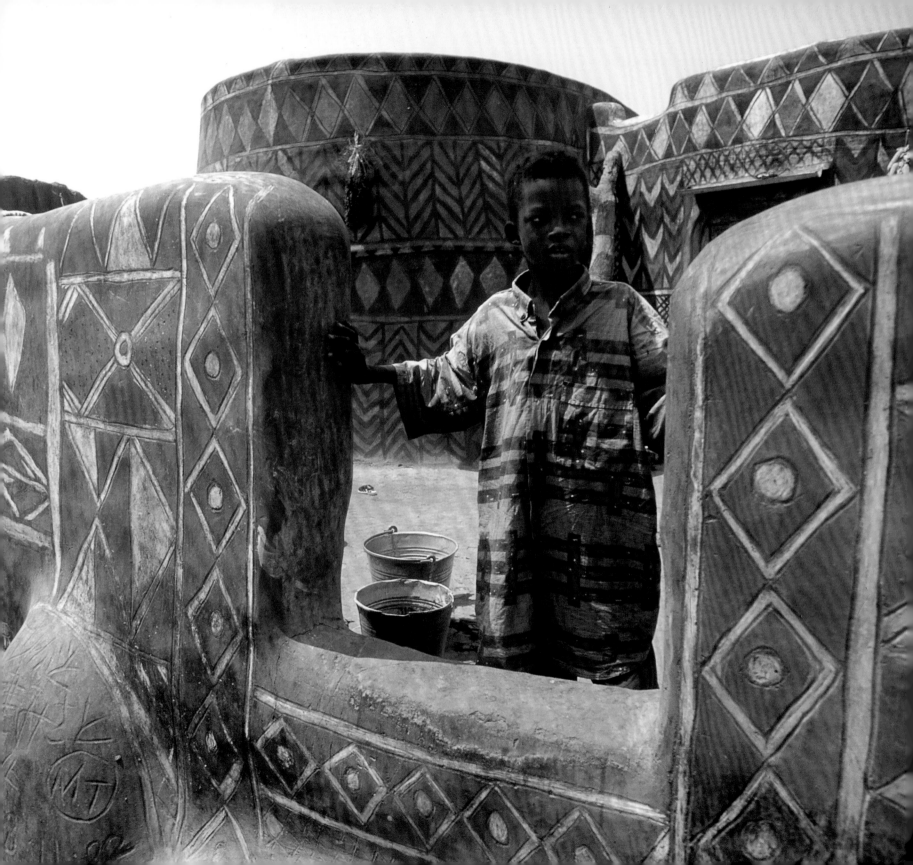

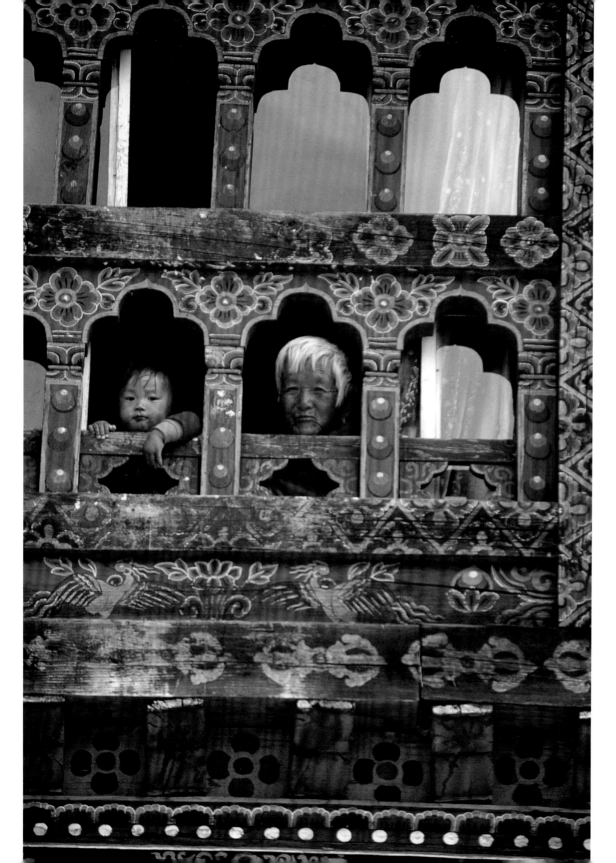

On the outskirts of Tanga Ssugo, a sun-baked Gurunsi village of pottery-like dwellings, a Burkino Faso youngster sports a tunic whose geometric designs echo the hand-drawn architectural decorations.

———

Vignetted by hand-painted floral motifs embroidering their Bhutanese farmhouse, a child and her grandmother check Paro's weather before warming up some yak butter tea.

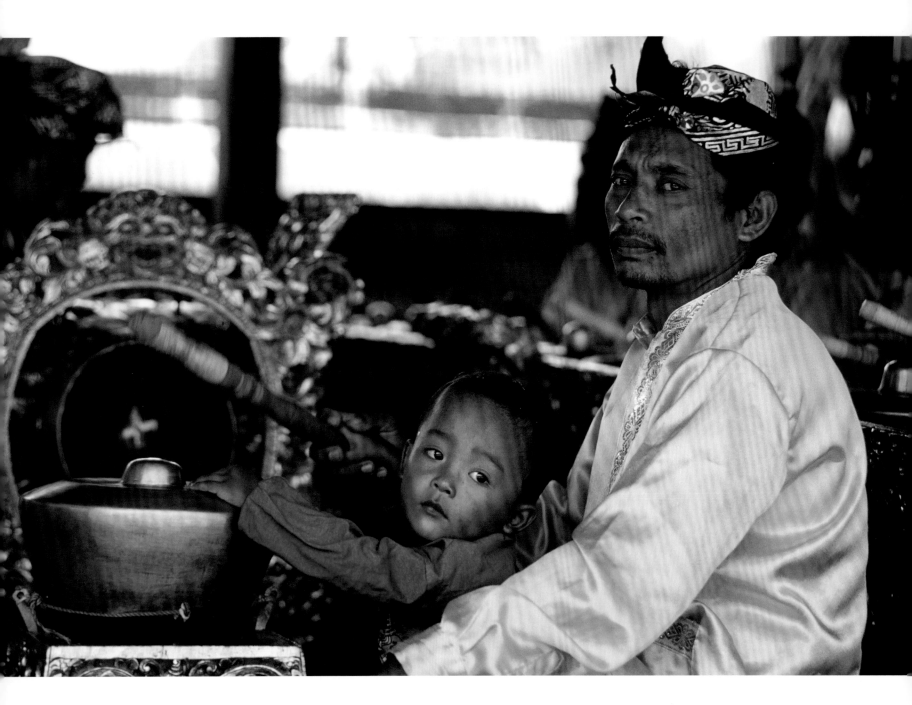

A wide-eyed Indonesian student learns the hypnotic gamelon sounds of a pre-Hindu orchestra featuring tintinnabulation that provide soundtracks for Balinese dancers.

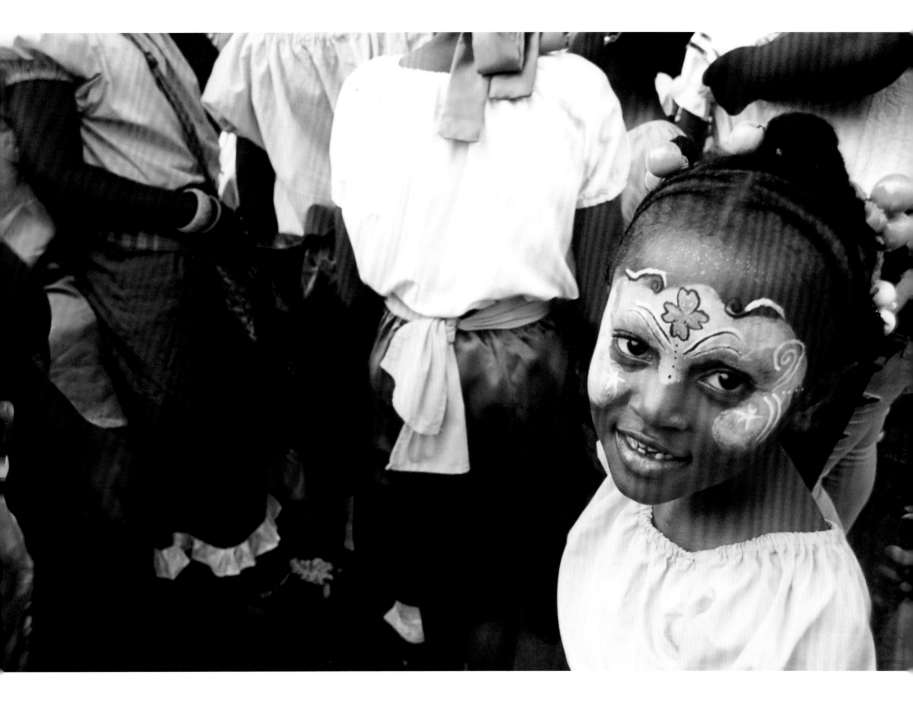

In Montserrat, unlikely Leprechaun motifs adorn the eyes of an Afro-Caribbean girl about to parade into Salem, where St. Patrick's Day revelry will erupt beneath an already smoldering volcanic landscape.

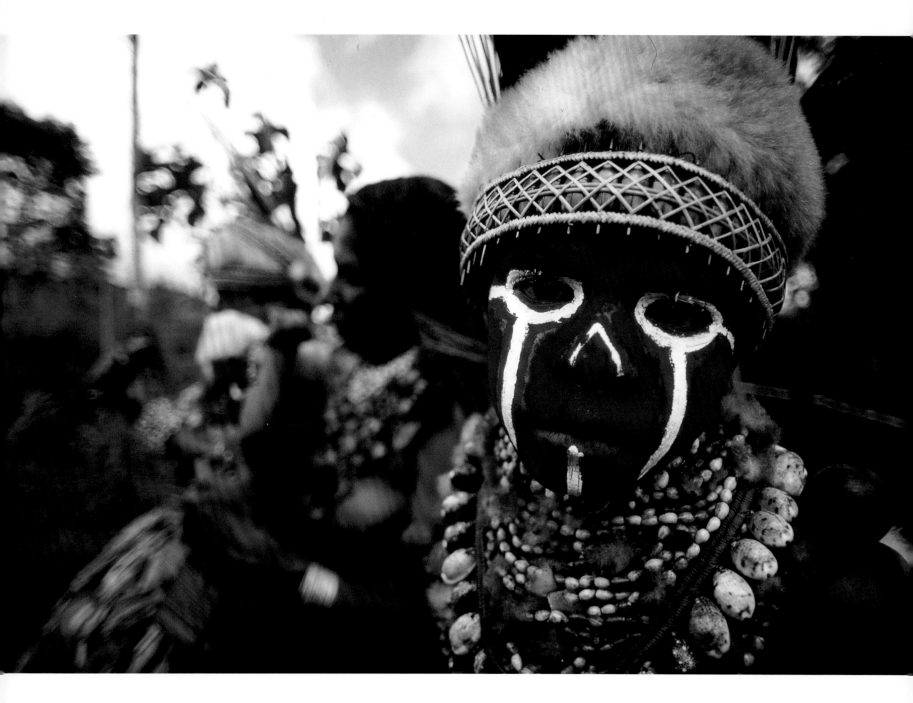

A young Melpa Wigman, unknown to the outside world until mere decades ago, sports a facial canvas reminiscent of modern art, meant to intimidate warring tribal groups in the Western Highlands of Papua New Guinea.

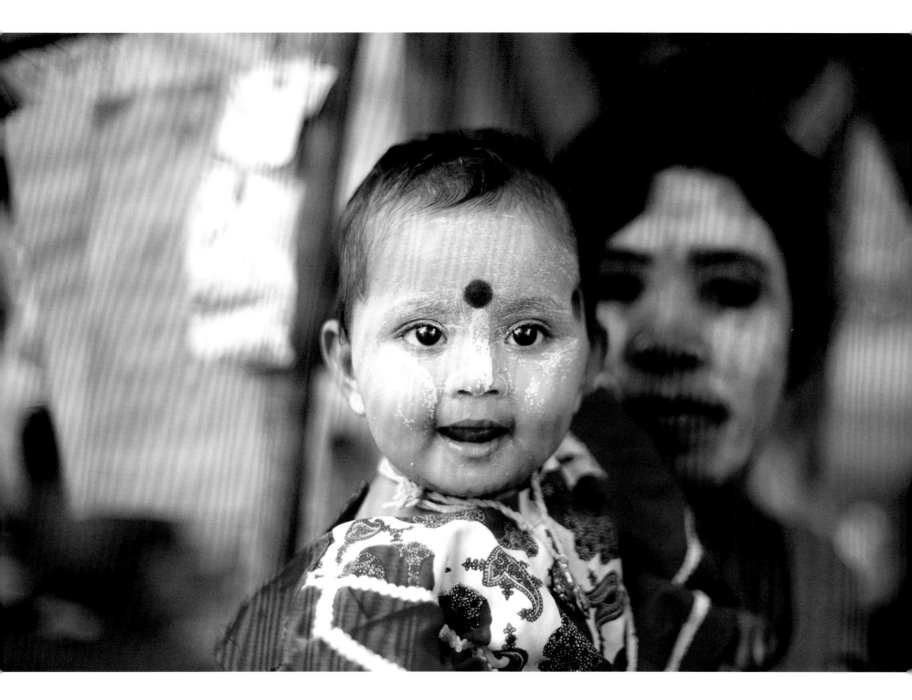

Displaying cultural savvy at an early age, this child in Myanmar wears Mandalay's local thanakha moisturizer and a prominent Hindu bindhi dot, said to retain kundalini energy.

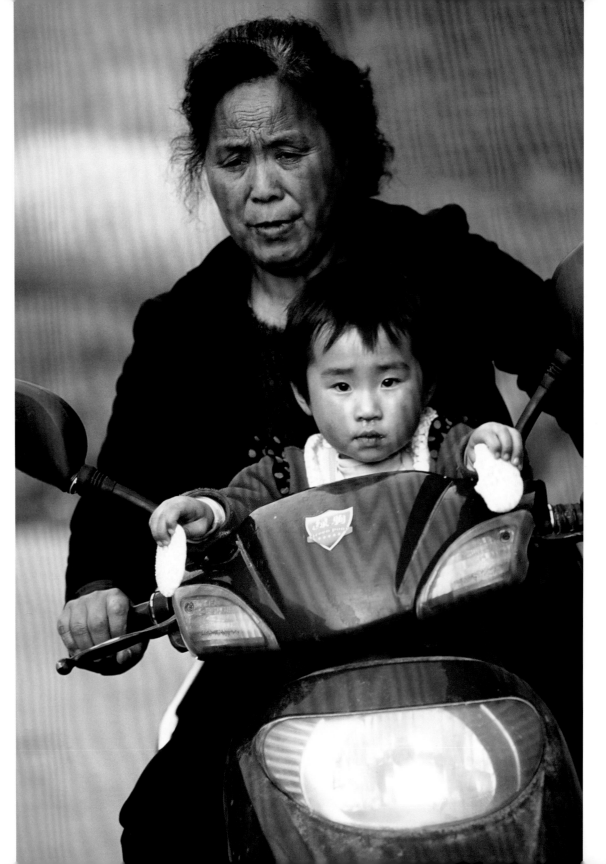

Gripping crackers instead
of handlebars, an intrepid
motorcycle passenger
is chauffeured by her
grandmother through the rural
Qinling Mountain precincts
outside of Xian, China.

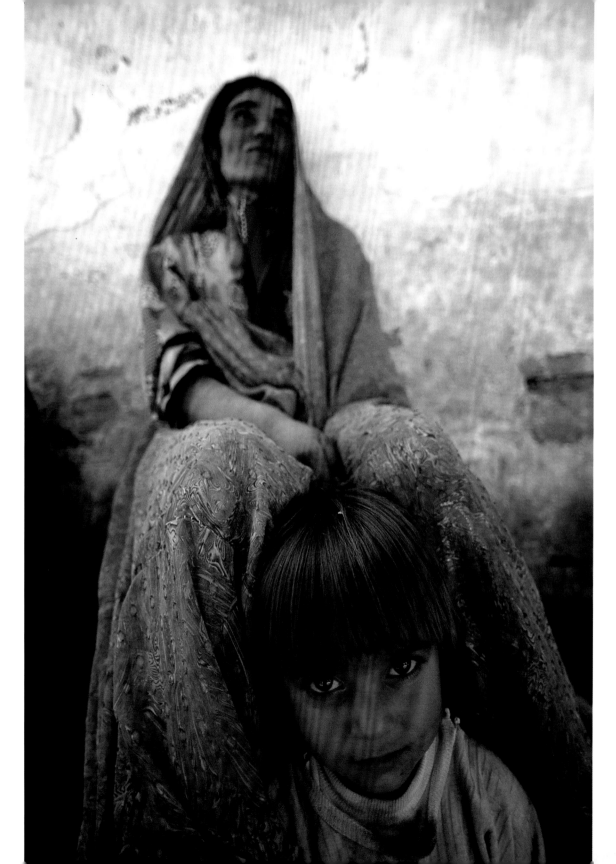

Gazing in different directions
from their dwelling in Yazd,
Iran, two generations with
separate outlooks symbolize
the dueling visions of
Persian fundamentalism
and modernity.

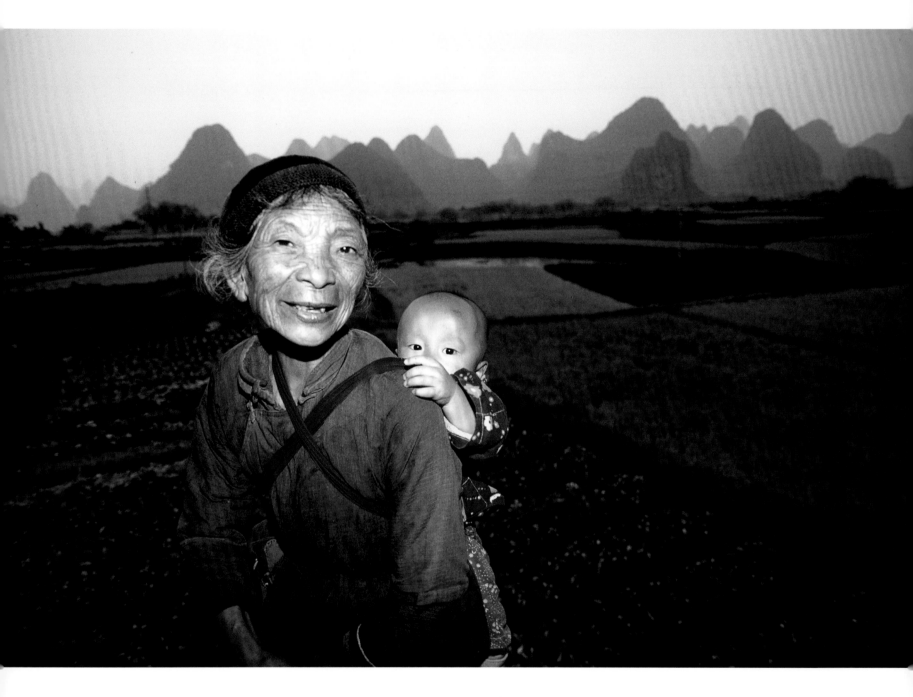

The curious eyes of a great-grandmother's cargo inspect
the dramatic karst topography of limestone spires and
vast fields of Chinese rice paddies in Yangshuo.

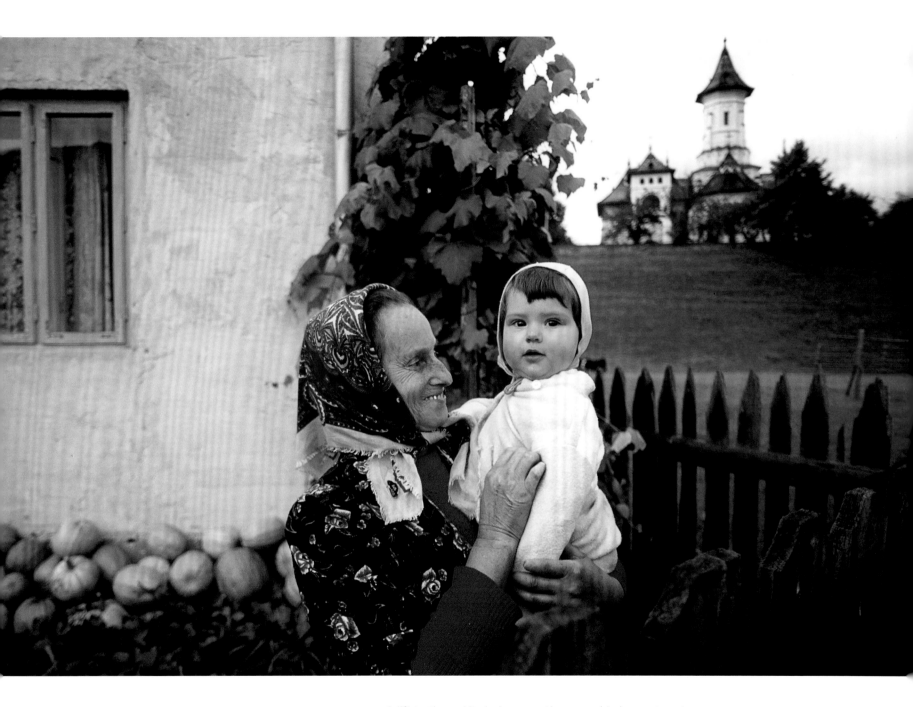

A lift to the spirits helps ease the pumpkin harvest and difficult farm chores of Bucovina's peasant life in the mythic and religious Carpathian Mountains of Romania.

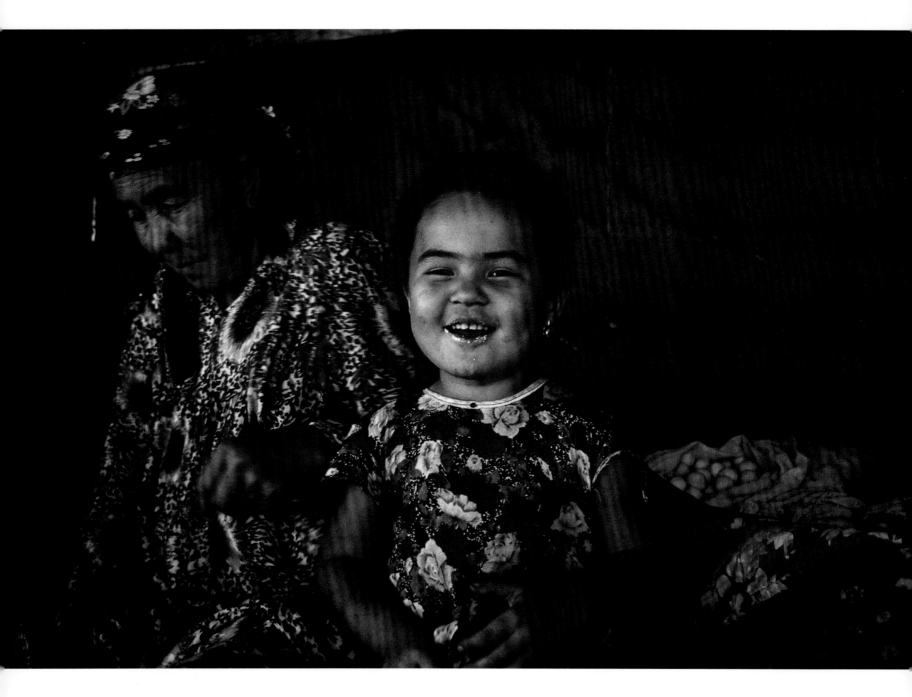

On the Silk Road near Bakhmal, floral dresses seem to glow from the darkened recesses of a felt-covered yurt in the mountainous Uzbekistani interior of a double landlocked country.

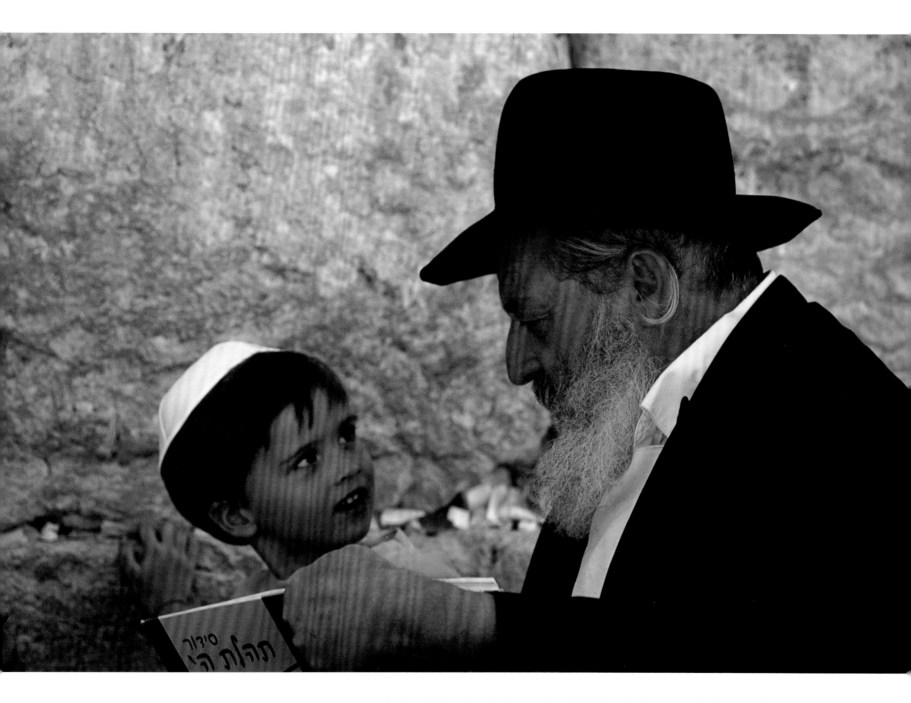

In Israel, Talmudic wisdom and youthful inspiration are traded across the generations at the Wailing Wall, Judaism's contentious epicenter of spiritual fervor.

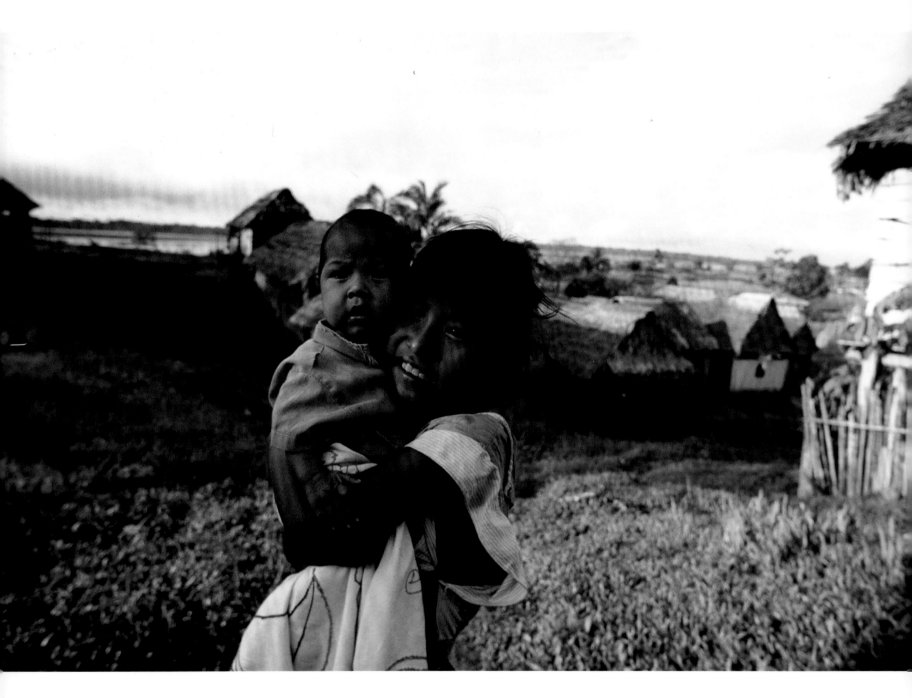

A sisterly hug calms material discomforts and equatorial poverty in an Iquitos fishing village on the banks of an Amazon tributary in Peru.

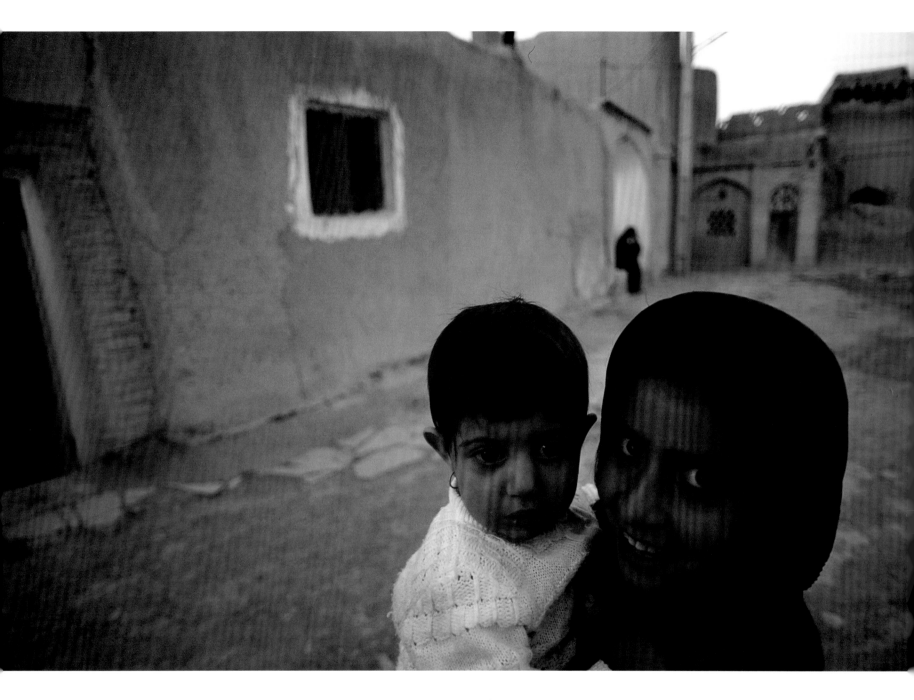

In Abyaneh, three female age groups may be glimpsed with their corresponding requirements for Muslim propriety among their rural Iranian neighbors.

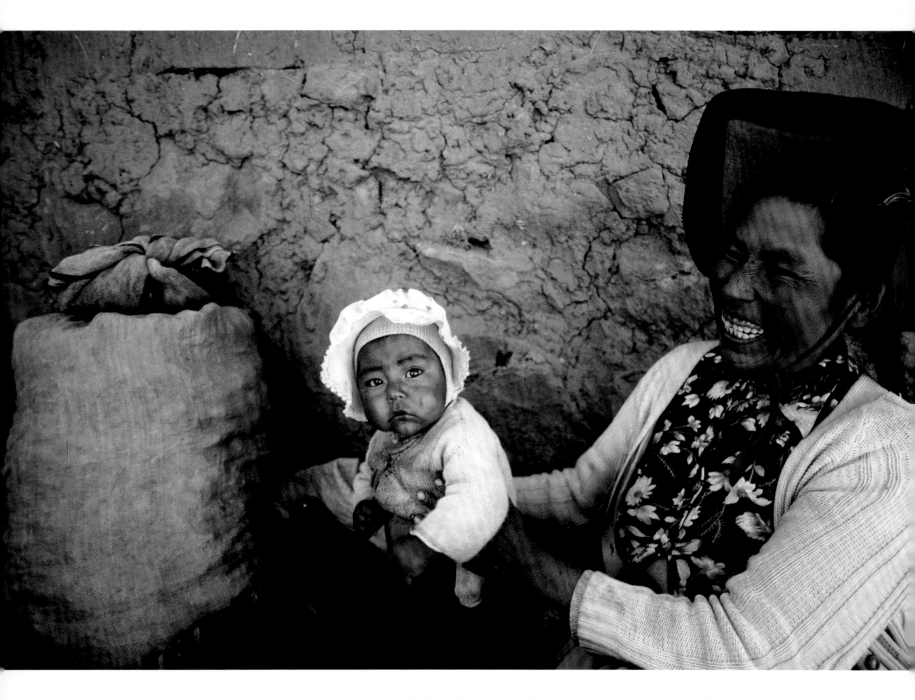

A display of Peruvian pride as the newest addition to the family tree of Incan descendants arrives in Ollantaytambo, deep in the Sacred Valley, carved out by the Urubamba River.

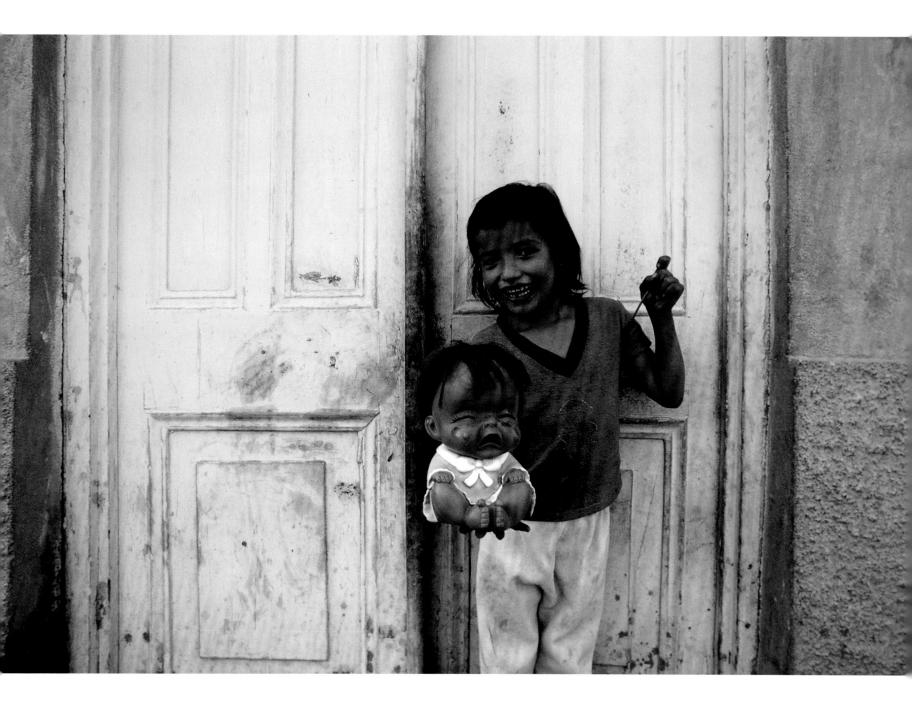

Mixed emotions grace the doorway on this narrow Mexican street in
Puebla as a young girl practices her future skills in parental empathy.

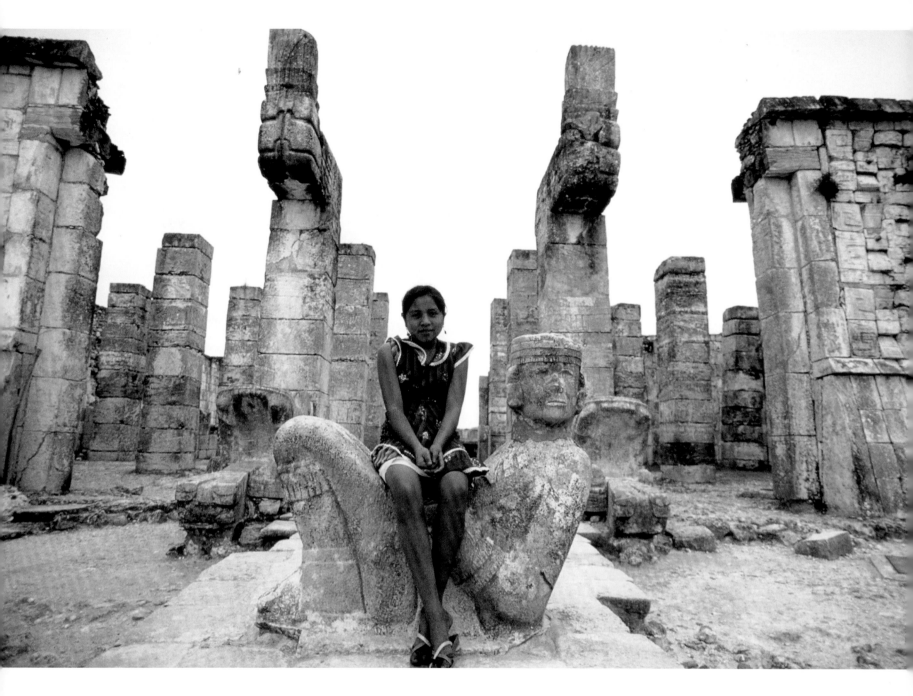

A Mayan heir in Chichen Itza, Mexico seems unconcerned about her seat on a sacrificial altar, once the penalty for losing matches during eighth-century basketball games held nearby.

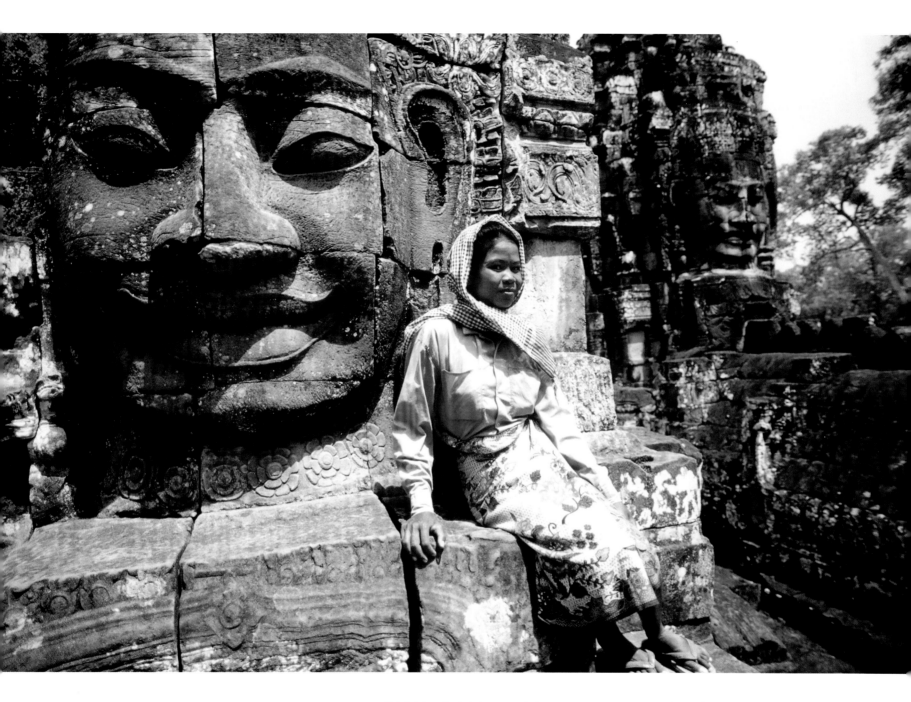

Exhibiting facial characteristics seen on stone reminders of
her ancient Khmer ancestors, a shawled Cambodian youth
finds comfort in Angkor Thom's ghostly forest of faces.

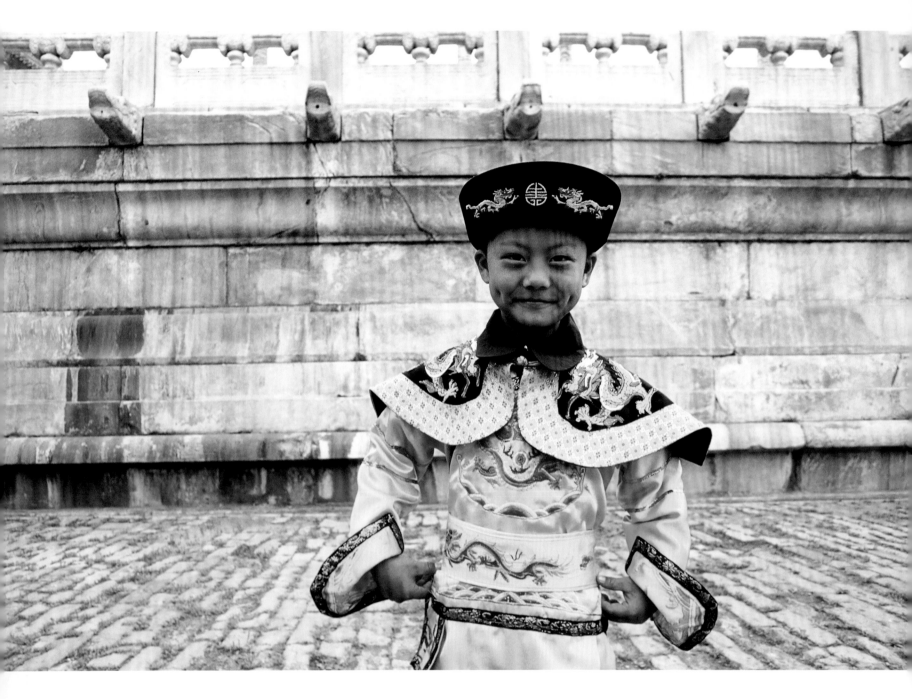

Dimpled cheeks and mythological dragons adorn an embodiment of
pint-sized imperialism paying tribute to the spirits of ancient dynasties
that echo across the cobblestones at the Forbidden City in Beijing.

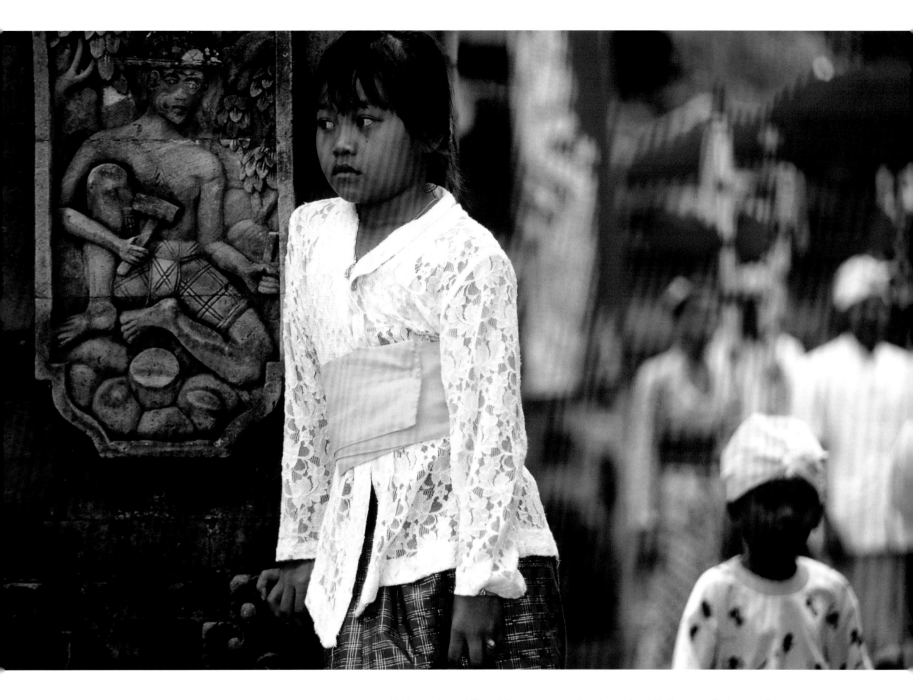

At the gates of Besakih, an appropriately sashed Balinese pilgrim awaits a reunion with her parents after delivering offerings to the mother temple.

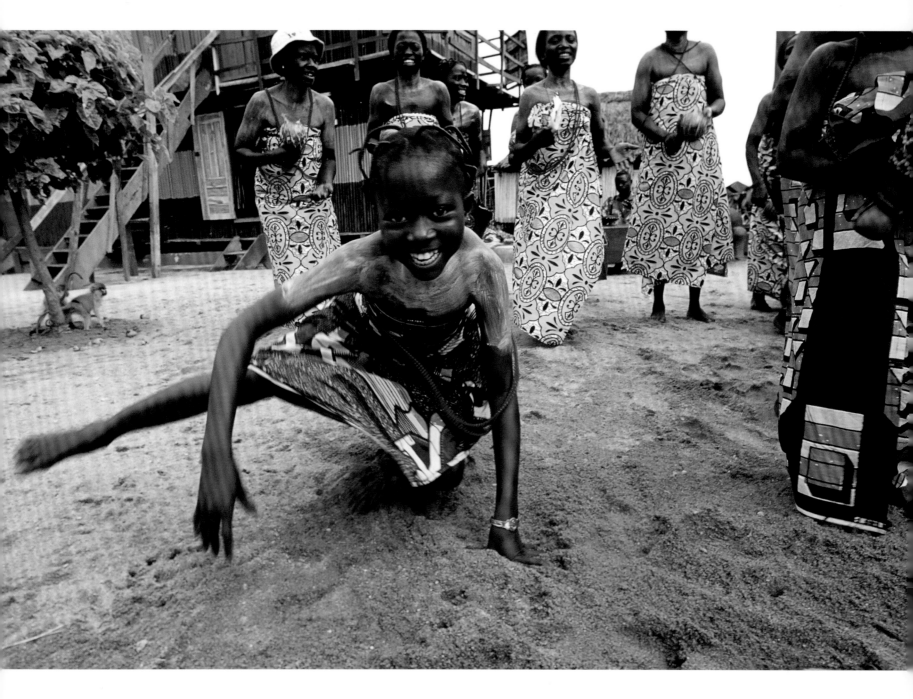

Rattling calabash and swaying Tofinu drummers pound
out a West African soundtrack at Ganvie, a stilted market
village in the middle of Benin's Lake Nokoué.

126

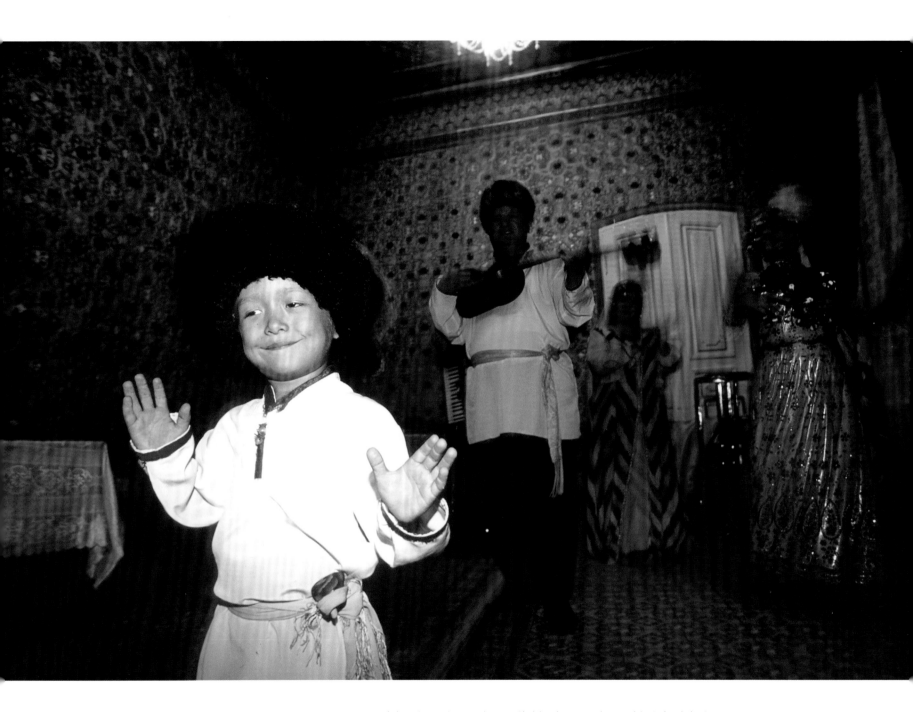

A bantam dancer beneath his shaggy sheepskin telpek hat
mesmerizes a Samarkand restaurant's audience as a rebab
fiddle ornaments the music's Uzbekistani melody.

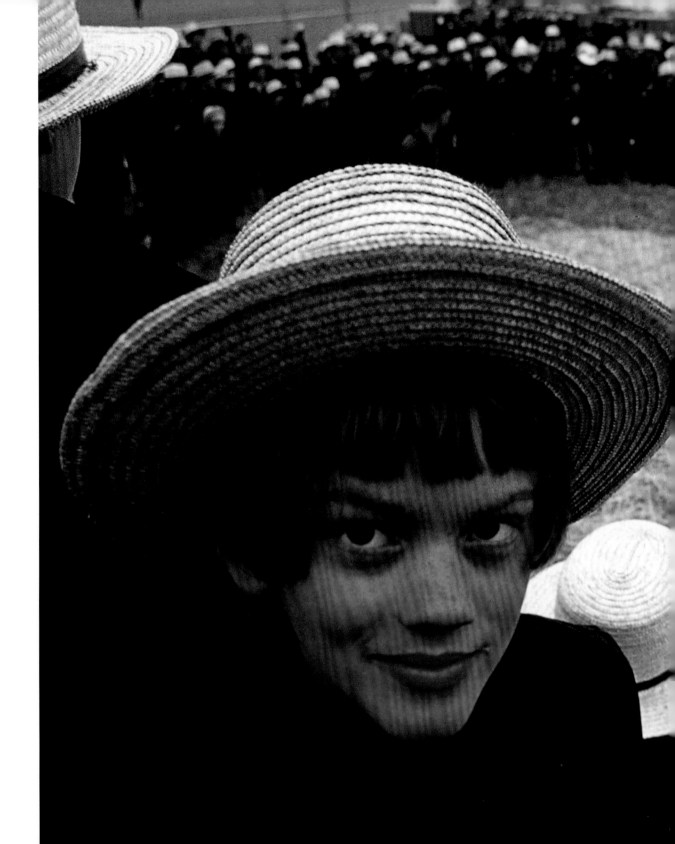

Amongst a congregational sea of straw hats, a friendly Pennsylvanian boy is diverted during a lull in the fevered action of corner ball, a unique Amish mixture of dodgeball and softball played at this mud sale in Peach Bottom, an annual early spring rite for farmers.

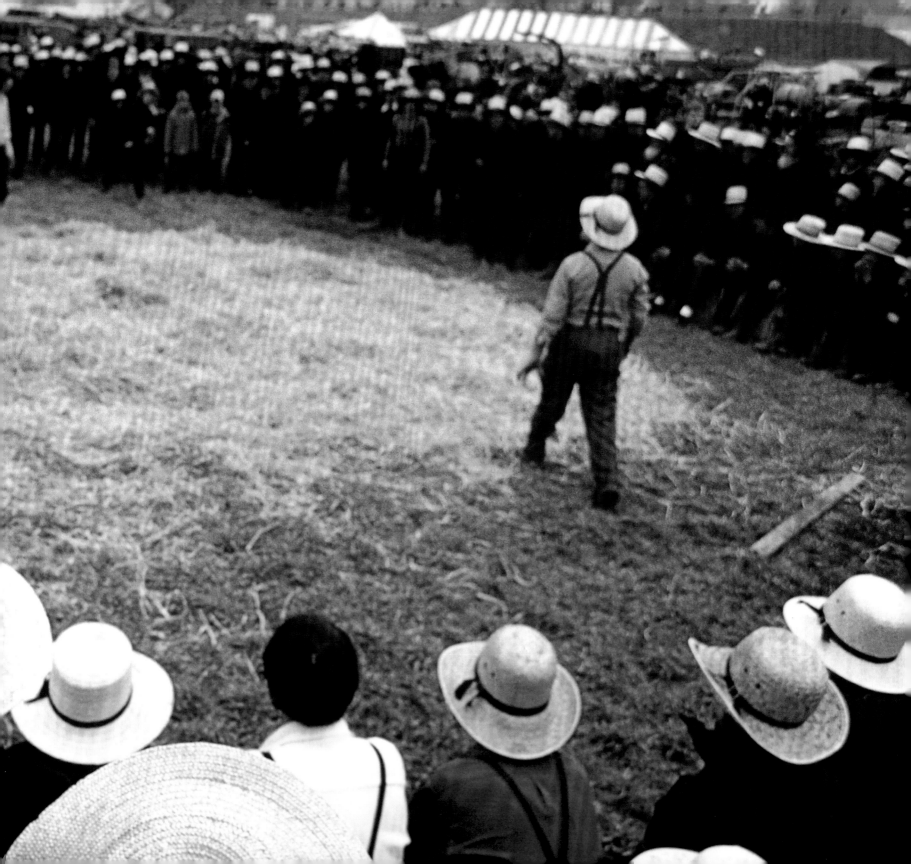

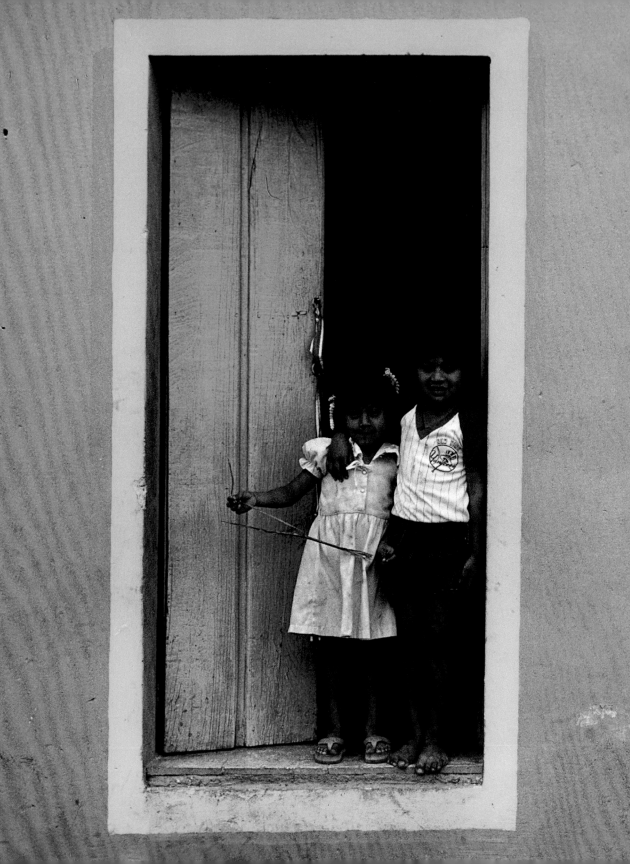

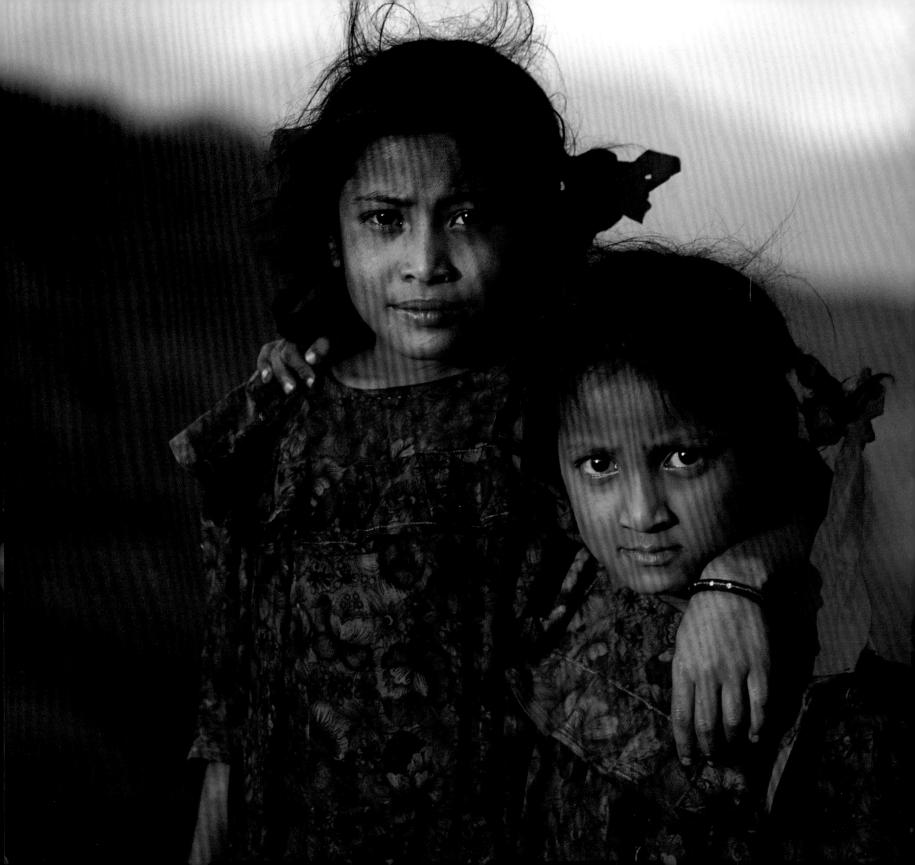

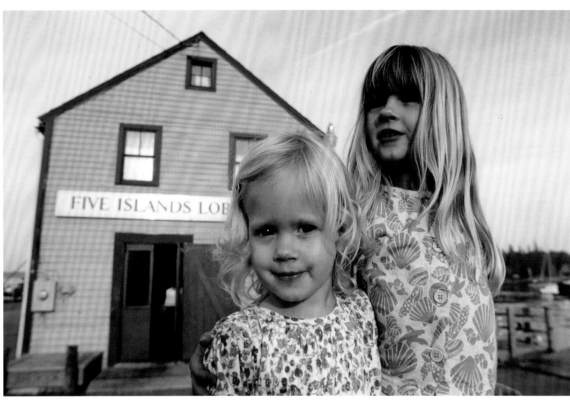

Phosphorescent color frames two children of Mayan descent playing in the doorway of a small Yucatan dwelling in Chichen Itza (preceding page).

———

Floral dresses and bowtied pigtails are overshadowed by the windswept dignity of these Nepali friends guarding a mountain pass trail in the Annapurna foothills.

———

Seagulls squawk as sisters await the return of fishing boats supplying a barrel of crustaceans to a Five Islands rustic lobster pound overlooking Maine's rugged granite peninsula.

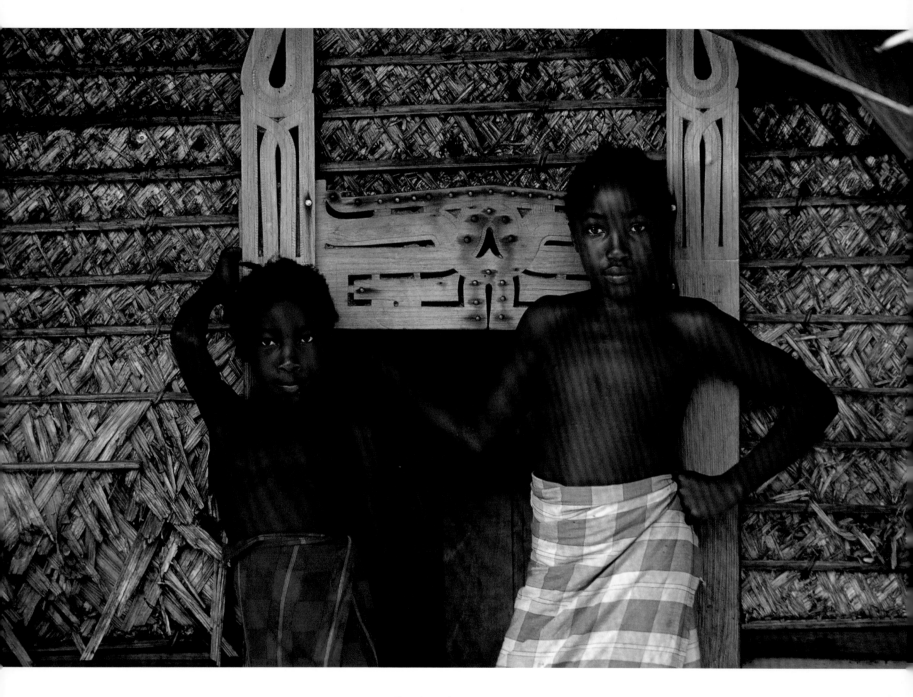

Checkered wraps are standard dress code in Kumalu for these Saramakan siblings awaiting mom's retrieval of wood gathered in the South American rainforest.

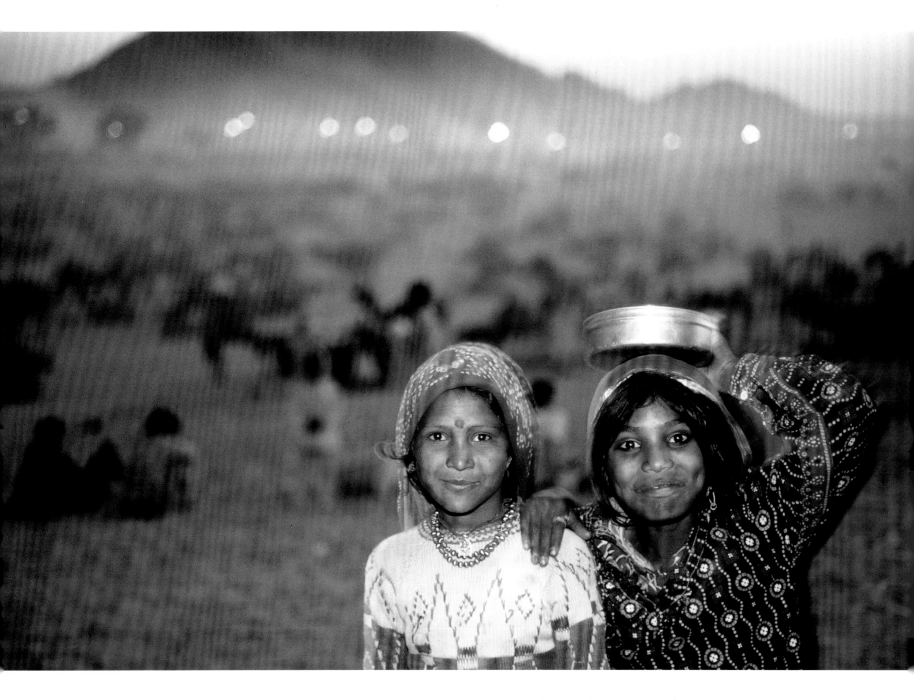

Enthusiastic Rajasthani vendors head out amongst the desert's predawn
Indian throngs gathered for the world's largest camel market in Pushkar.

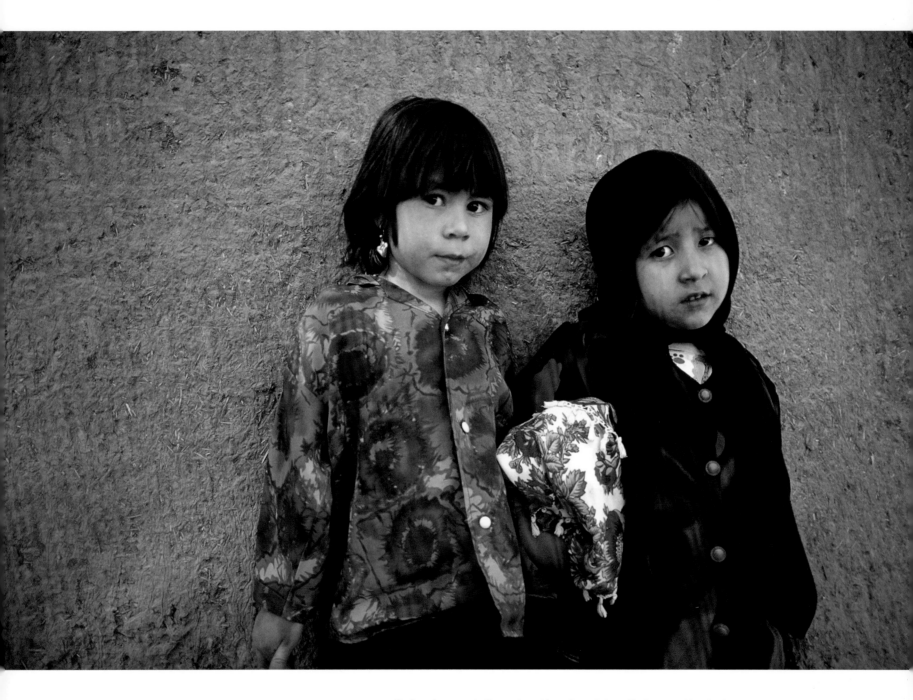

Before long, adulthood and local society will demand both these
Iranian girls cloak all their colored clothing beneath black abayas,
meant to instill Muslim modesty in the village of Abyaneh.

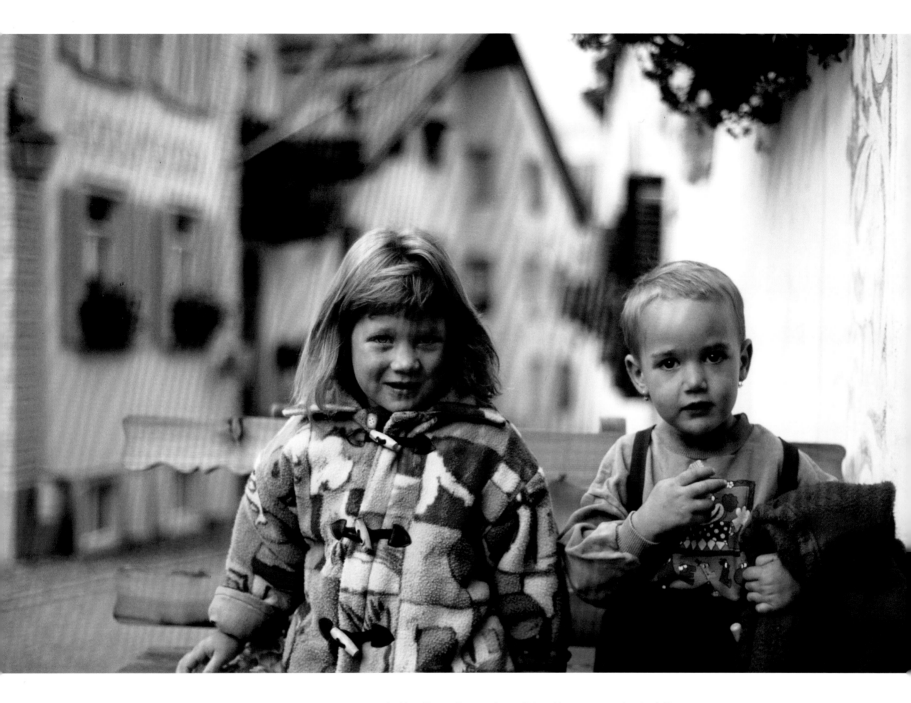

In the Engadine region of the Alps, an evening's chill prompts jackets for a stroll down Guarda's cobblestoned lanes in an impossibly charming Swiss mountain hamlet.

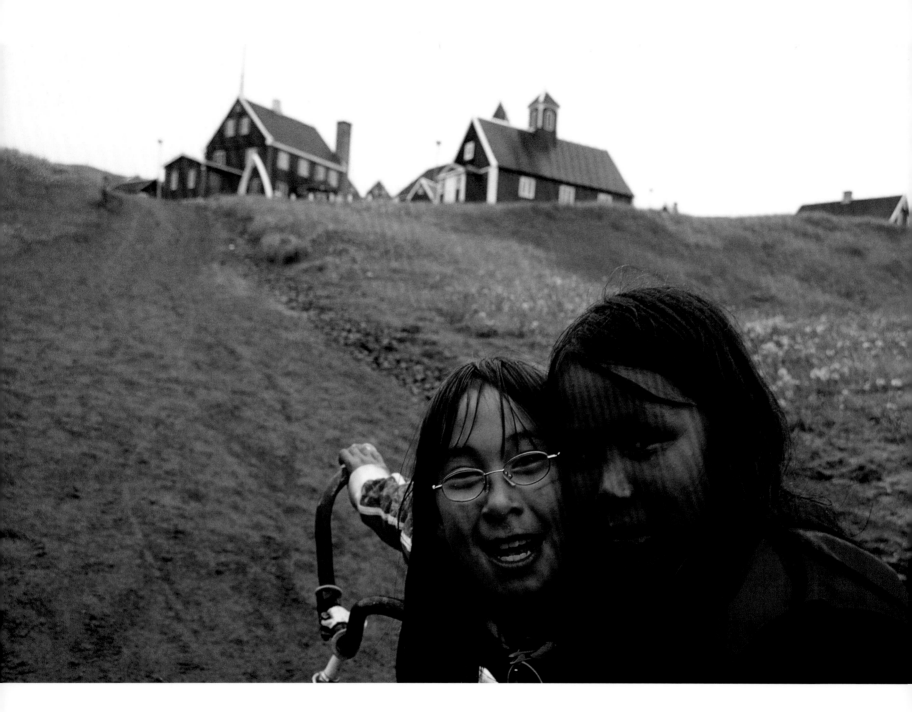

Cheek to cheek in the vast, empty quarters of a Greenlandic backyard, Inuit
girls prepare for an uphill bike ride through Itilleq to the local whalebone arch.

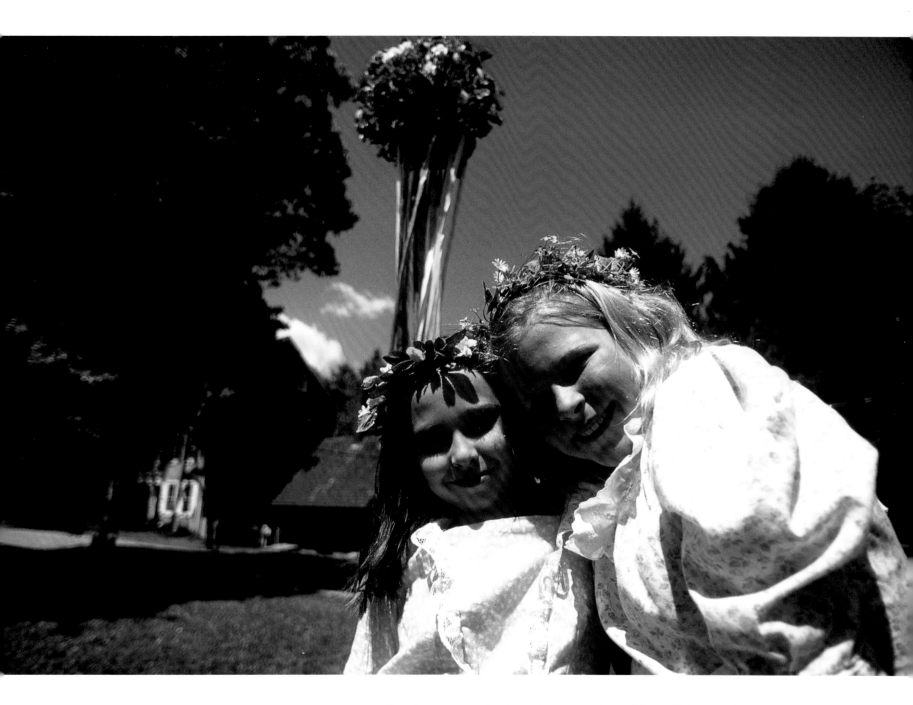

Floral crowns cap the beaming expressions of these Delaware dancers, soon to encircle the maypole with braided ribbons at Dover's Village Green.

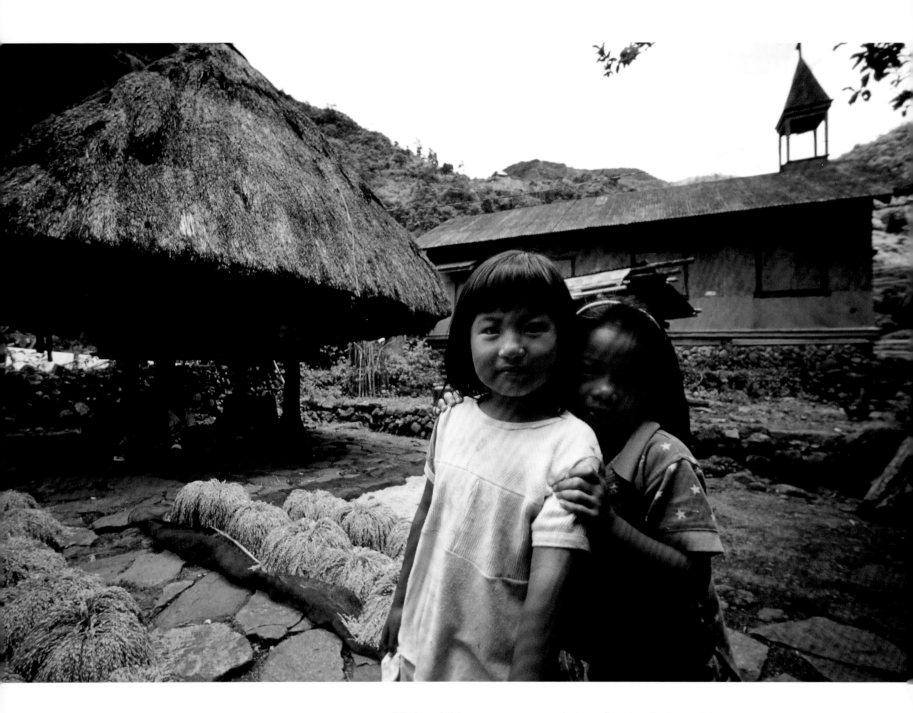

Filipino children pause amongst stone flooring that provides
an effective base to dry bundles of harvested rice, stored
later within Batad's pyramidal thatched pavilions.

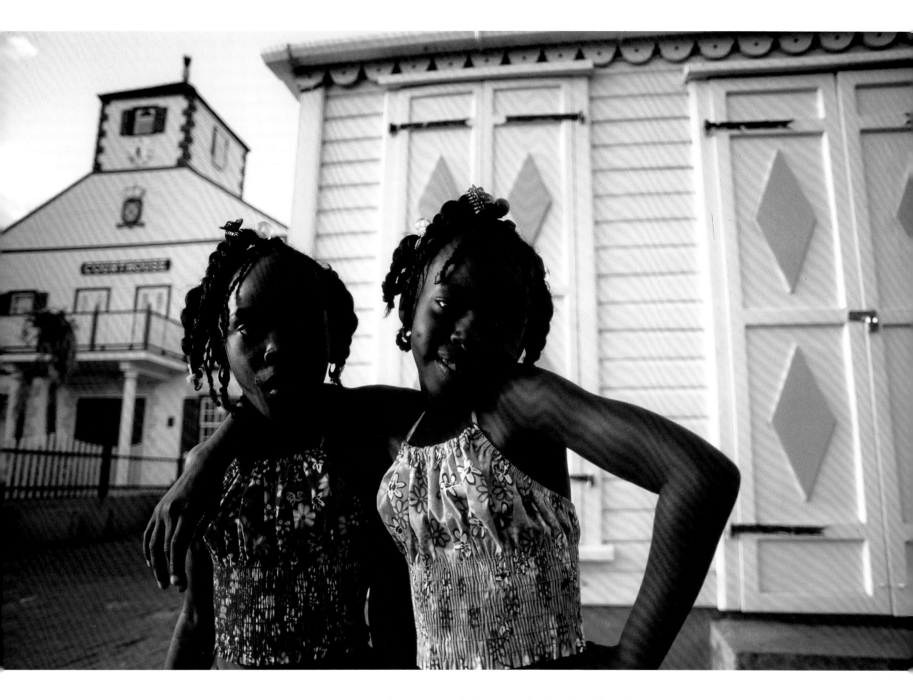

Awaiting carnival season, braided best friends on St. Maarten proudly pose before Phillipsburg's gingerbread doorways and the adjacent courthouse, topped with a wooden pineapple.

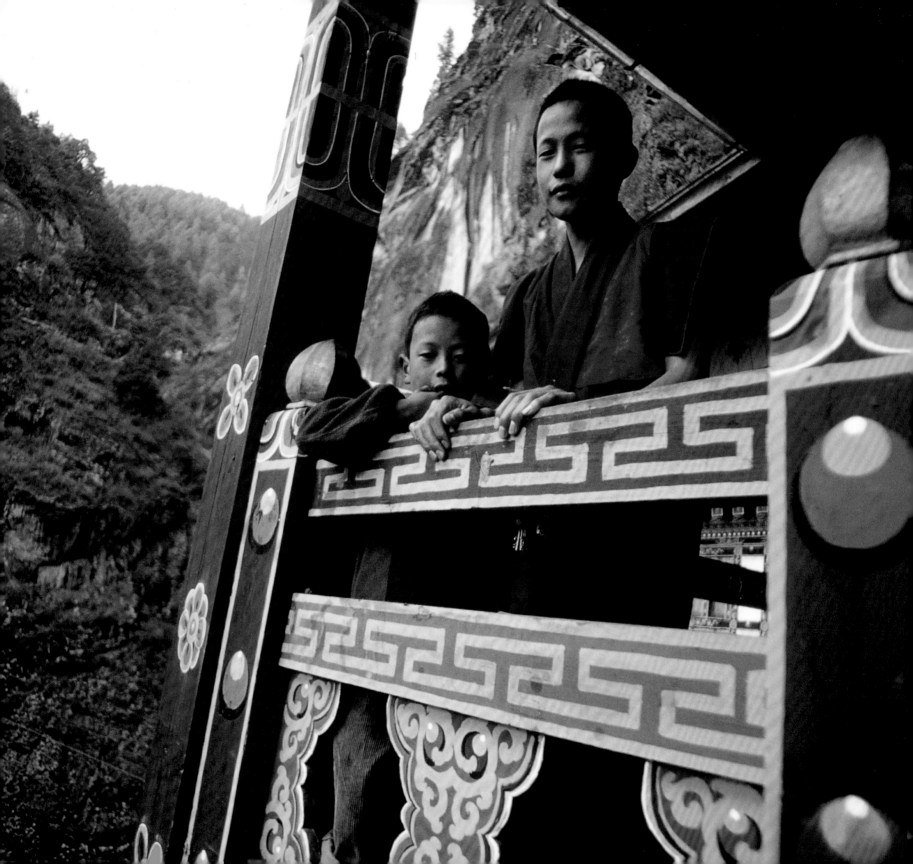

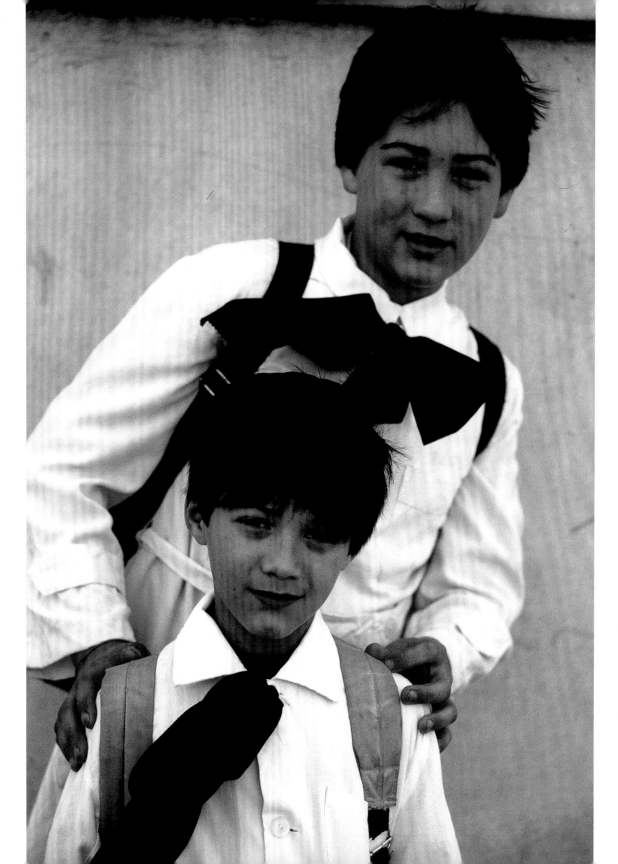

At the Tiger's Nest Monastery in Bhutan, two young monks on pilgrimage survey adjacent temples precipitously clinging to cliffs thousands of feet above Taktsang's valley floor.

In Montevideo, Uruguay, huge bows over white smocks are a standard school uniform for a nation whose high literacy rates go hand in hand with the laptops provided each student.

143

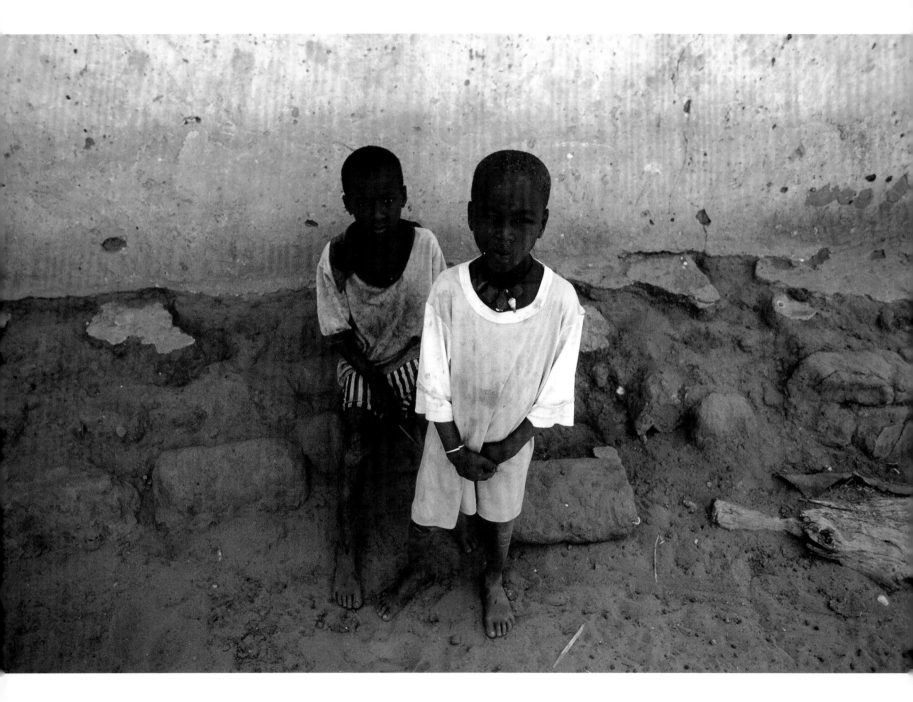

West African boys ponder their future in Juffure, a riverbank Gambian village renowned as the Mandinka origins of Alex Haley's past in the Pulitzer-winning novel Roots.

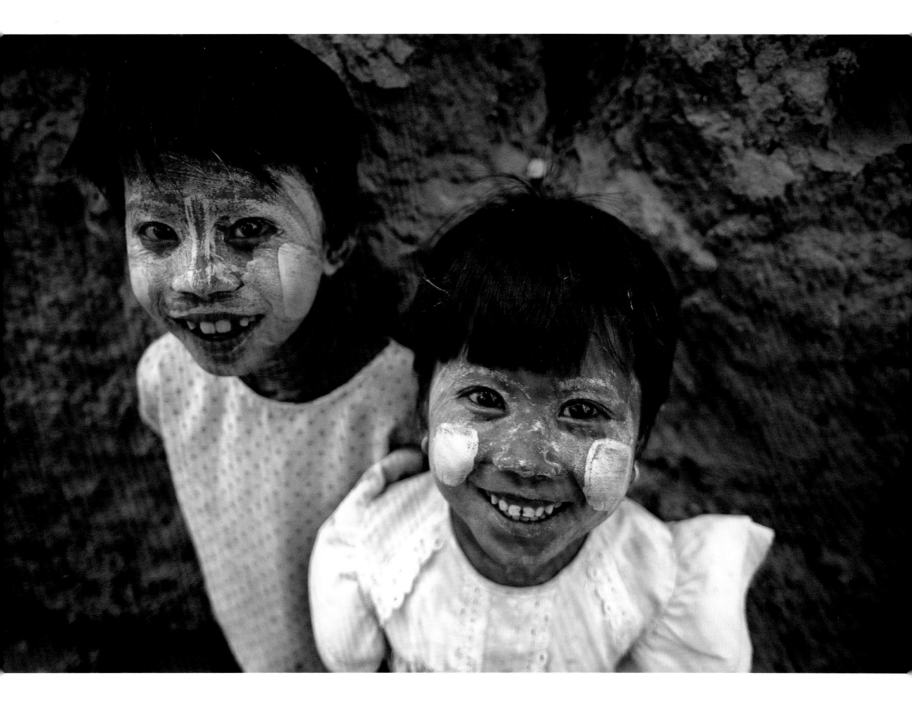

In Mandalay, ebullient Burmese eyes pierce through the moisturizing paste caking their faces, a custom in hot tropical lands to keep skin protected from equatorial scorching.

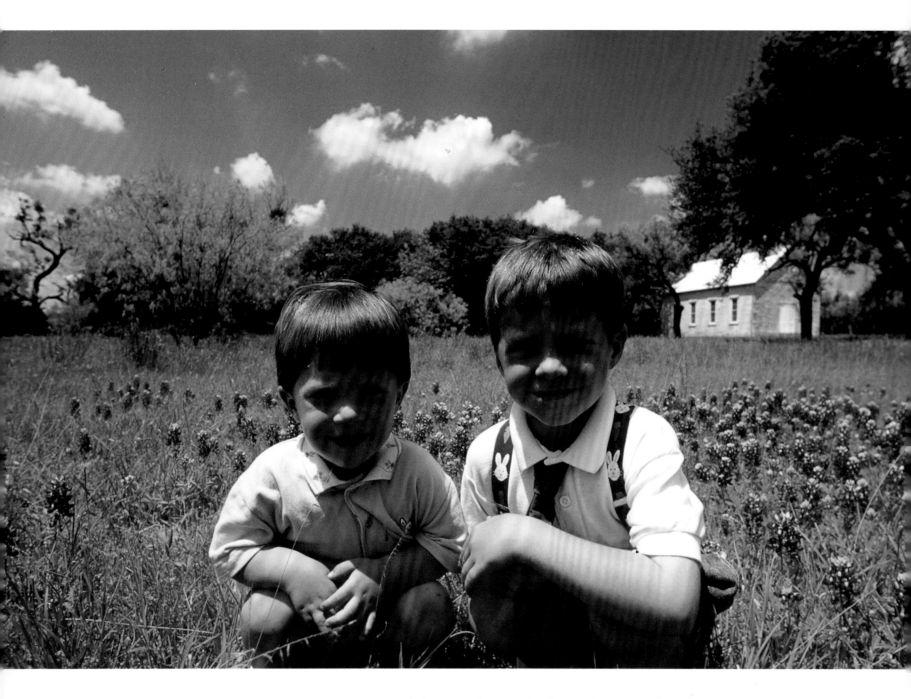

Lederhosen and suspenders hint at Germanic influences in
Texas hill country, where Fredericksburg's blooming bluebonnets
and bunny motifs signal Easter is around the corner.

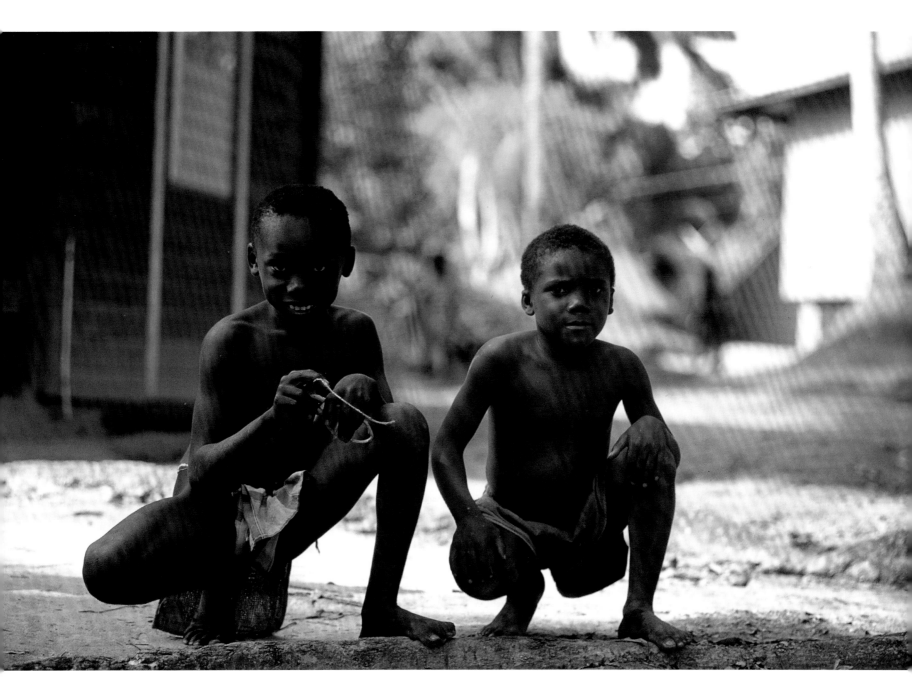

Loincloths provide a discreet uniform for Surinamese hunting
as a slingshot-equipped team prepares to leave their village of
Kumalu and find some birds as easy low-altitude targets.

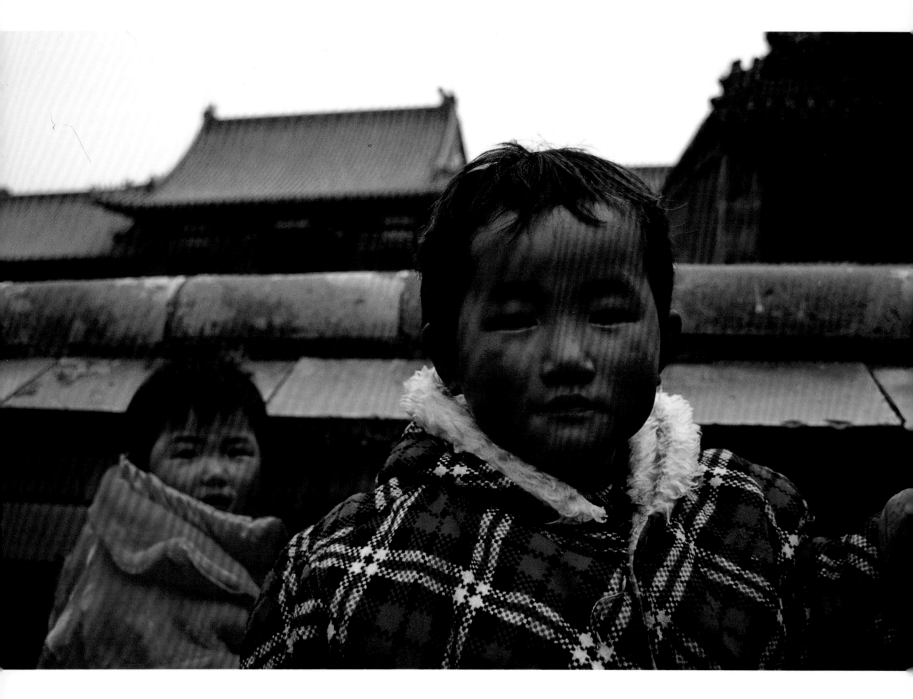

Rugged cheeks and calm eyes mark the face of China's future, seen along the gates of the six hundred-year-old imperial palace in Beijing's Forbidden City.

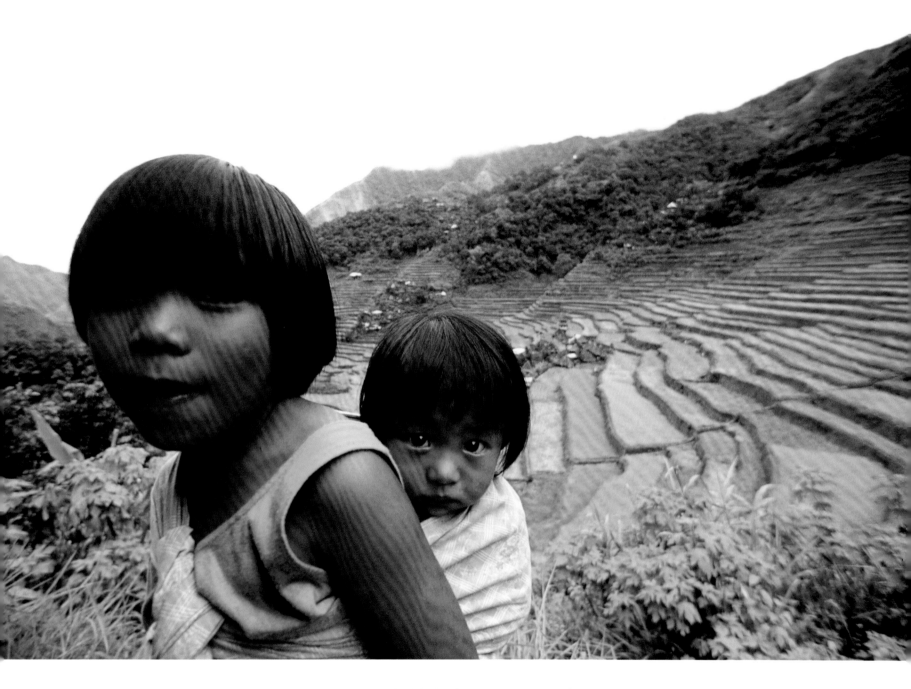

The blanket folds securing a soulfully-eyed Filipino back seat
passenger seem to be echoed in the layered, topographical
steps of Batad's gracefully contoured rice paddies.

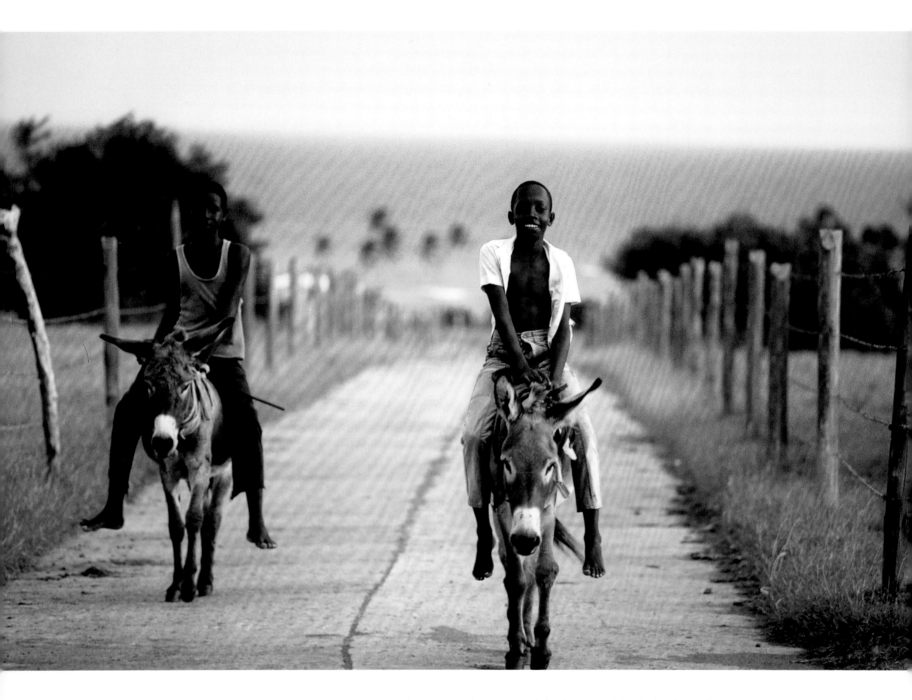

In the West Indies, a pair of donkeys ploddingly haul their human load up a fence-lined path from St. Kitts's palm-scratched Caribbean coastline.

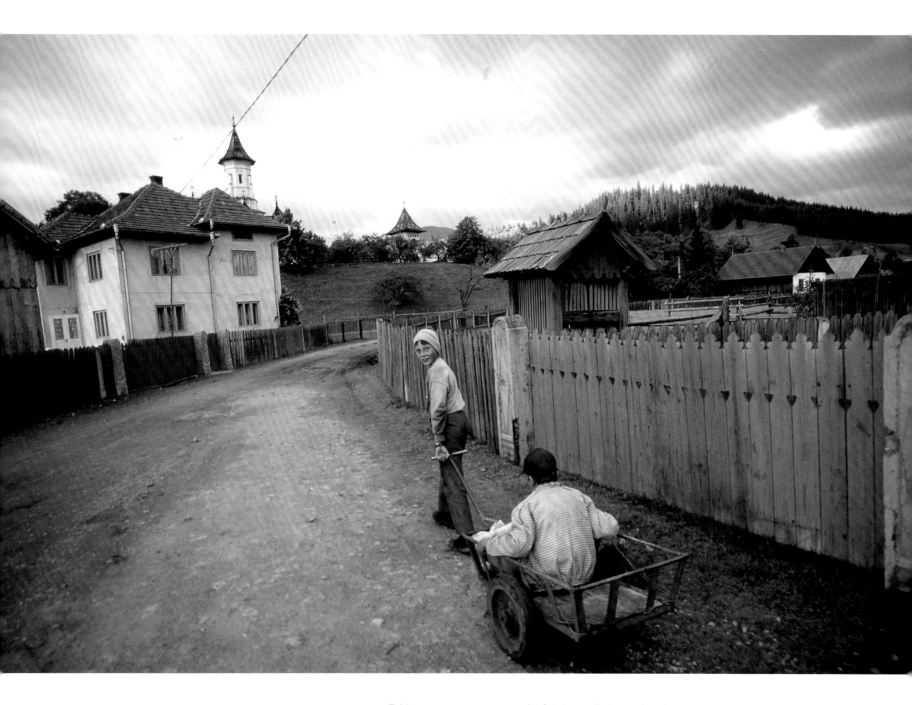

Taking turns as cargo, a playful duo roll down the dirt roads through one of the Romanian fairytale villages that sprout amongst the Transylvanian hills of Bucovina.

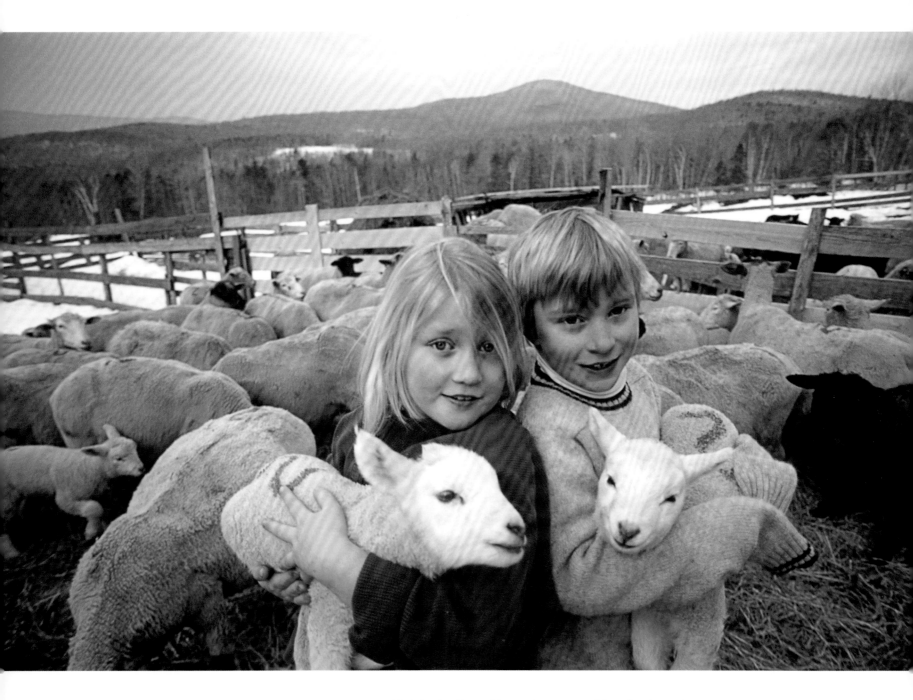

High in the Green Mountains, a pen of freshly shorn sheep hint at the probable source of these pair of sweaters cradling some newborn lambs on a Vermont farm near Ludlow.

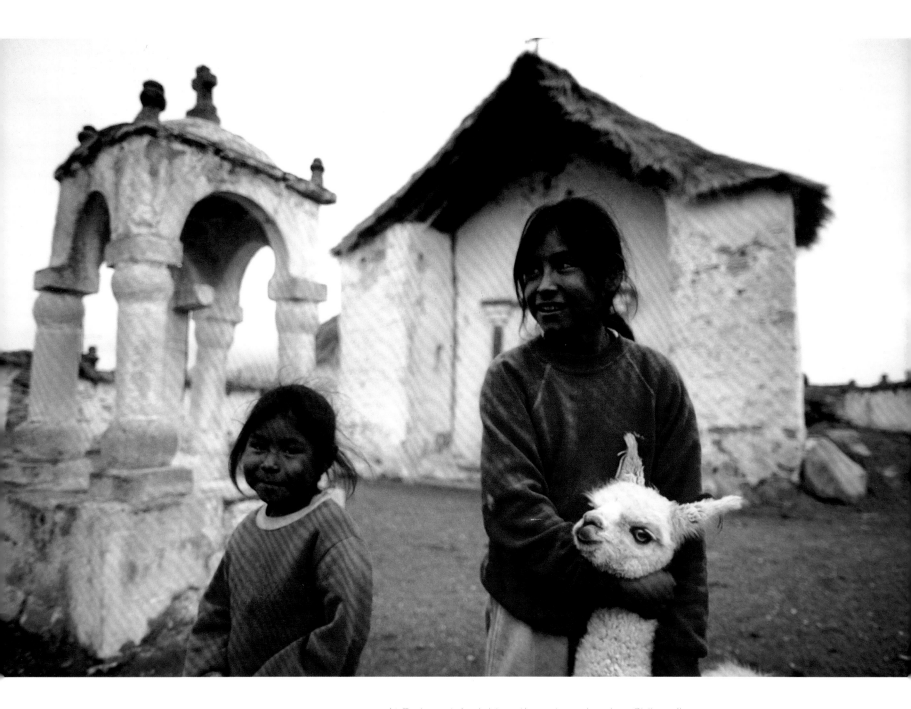

At Parinacota's eighteenth-century church, a Chilean llama
assists with packing chores in the thin 15,000-foot Andean
atmosphere of one of the world's highest villages.

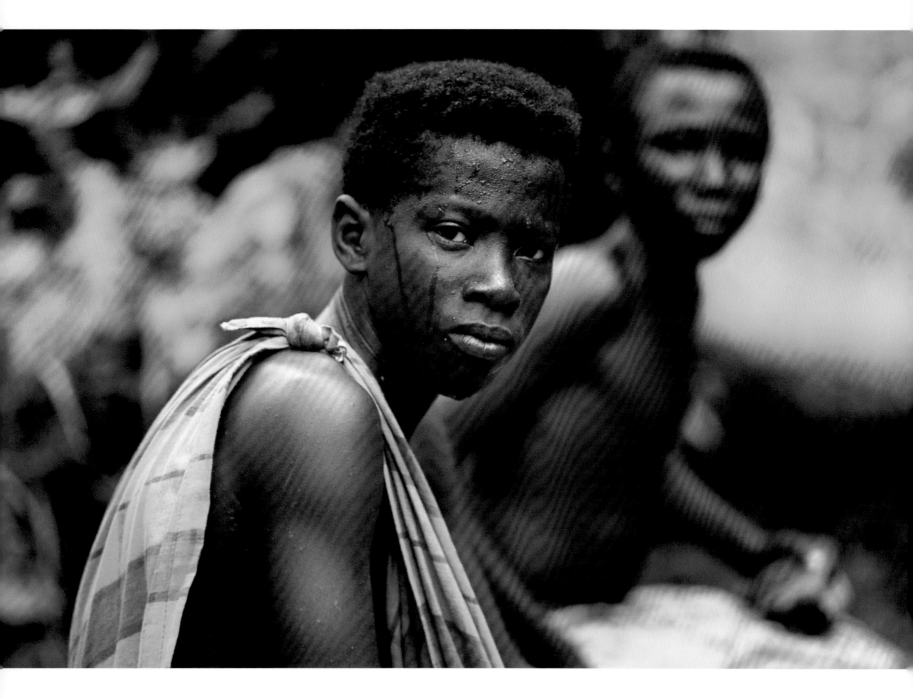

Loose garments and a sweaty forehead cloak a youthful Saramakan, descendant of escaped slaves, who embodies the displaced African culture thriving in the thick, sweltering rainforests of Surinam.

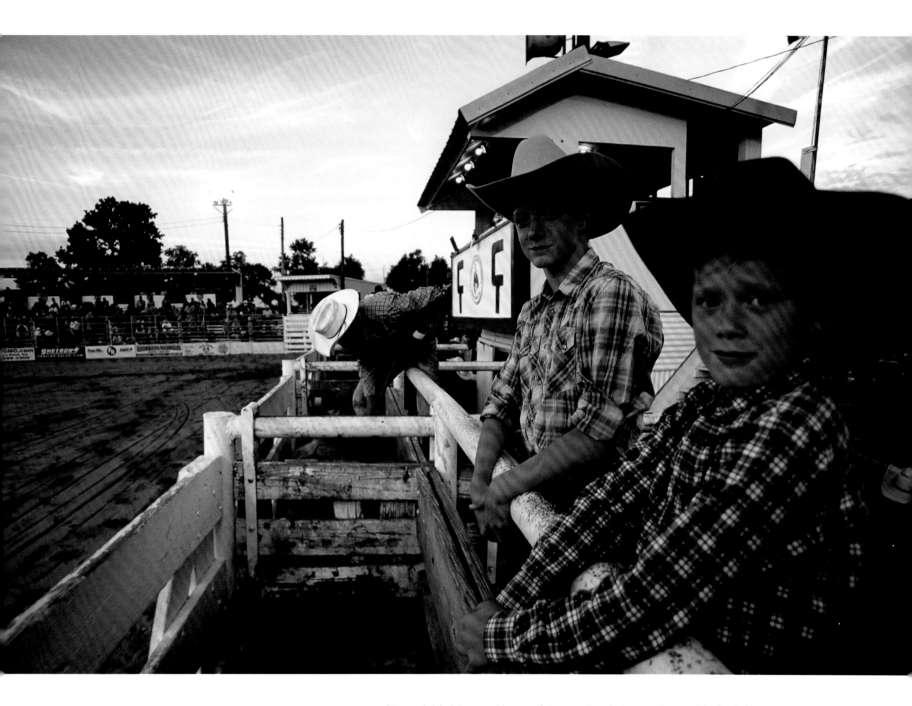

Atop plaid shirts and beneath ten-gallon hats, cowboy pride fuels the gaze of two aspiring rodeo champions clinging to chutes where bovine fury will be released for spectacle-thirsting crowds at Cowtown in New Jersey.

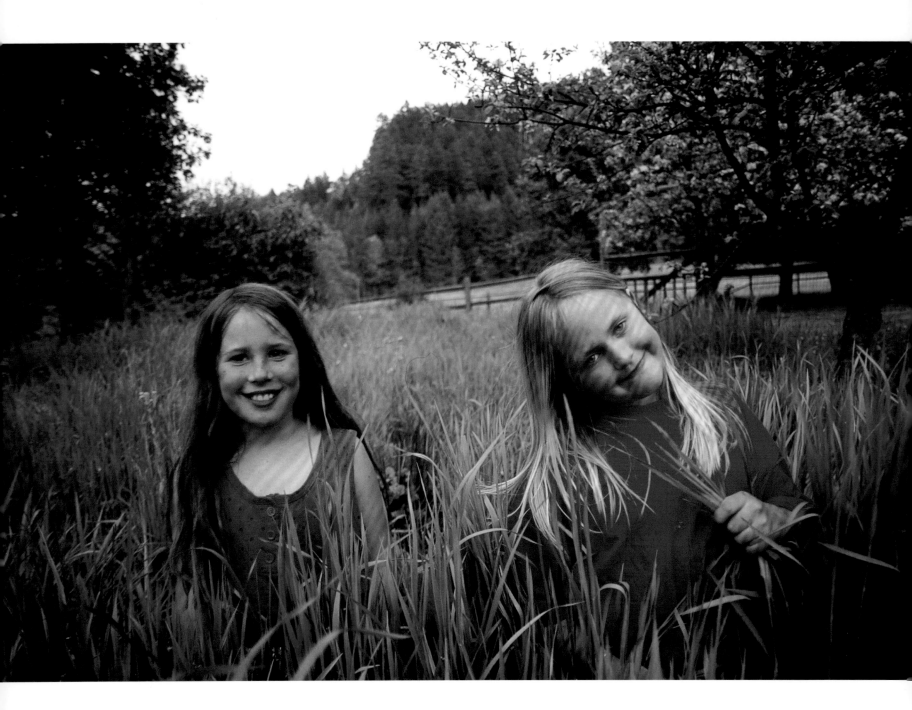

Grazing in the grass is a gas in the meadows of southern Oregon on the grounds of a hippie-inspired treehouse resort near Takilma.

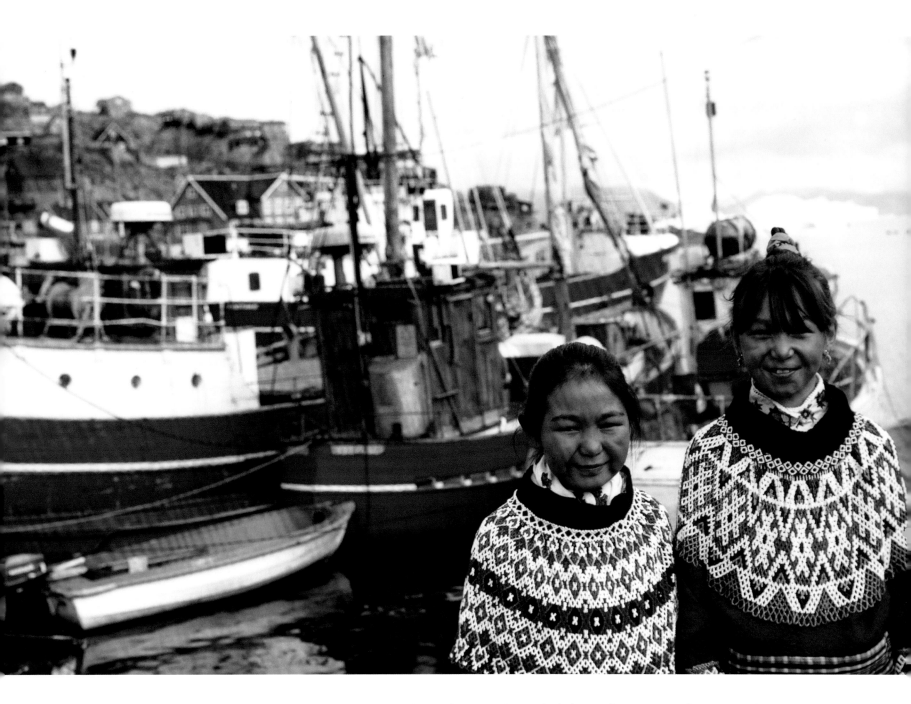

Weighing a few pounds, beaded glass collars are part of the national dress in Greenland and mirror the primary colors of fishing boats, soon heading into iceberg-choked waters off Uummannaq.

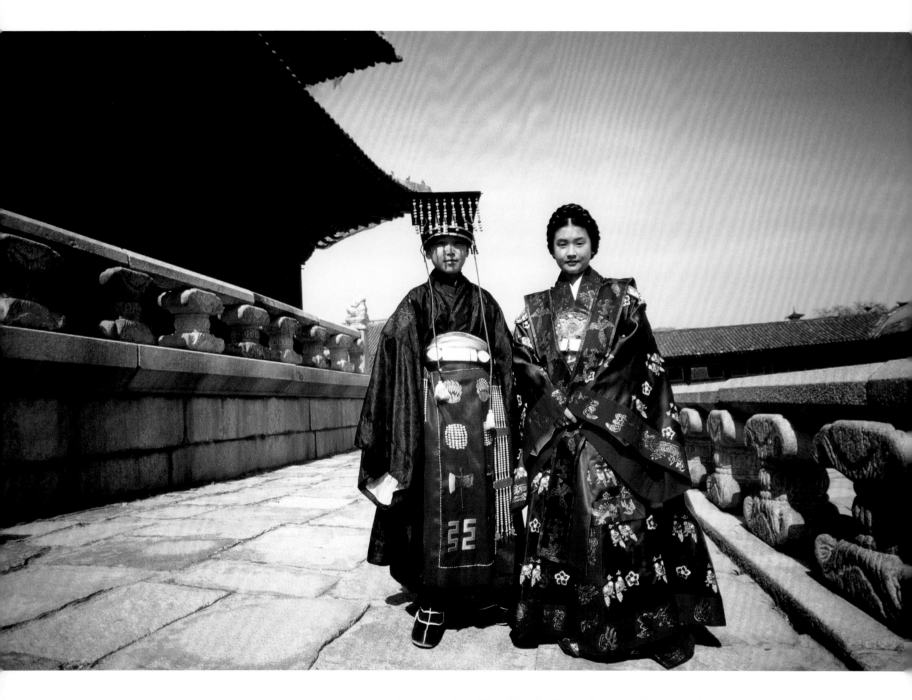

The splendor of the Chosŏn Dynasties are reflected in the dazzling outfits worn by a youthful Korean couple strolling the Seoul courtyard of the Kyongbok Palace.

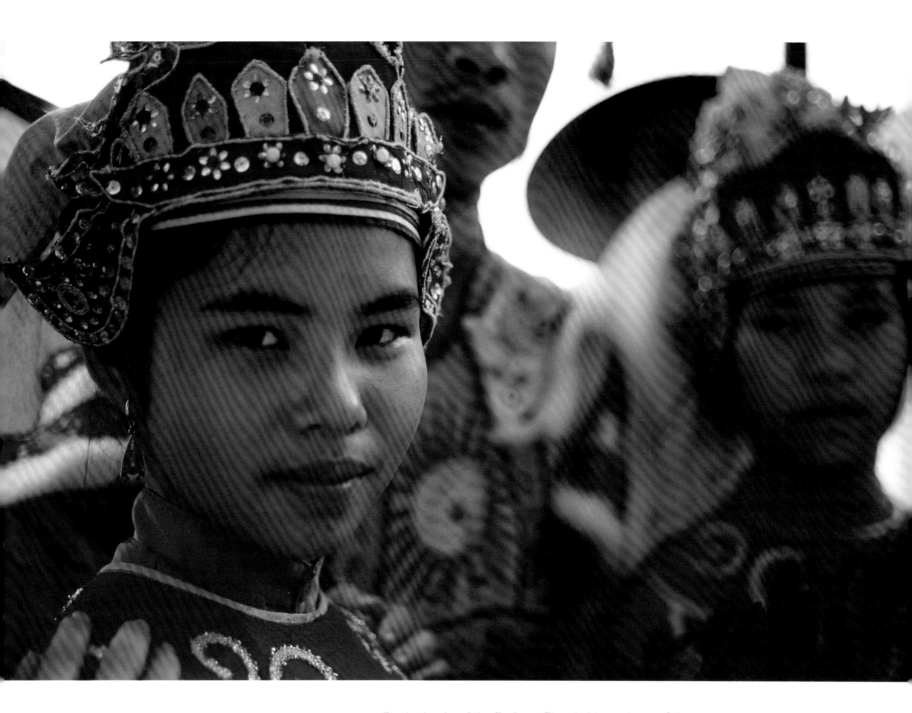

On the banks of the Perfume River in Hue, echoes of the
Nguyen dynasties may be glimpsed amongst Vietnamese
reenactors performing by the Citadel's forbidden city.

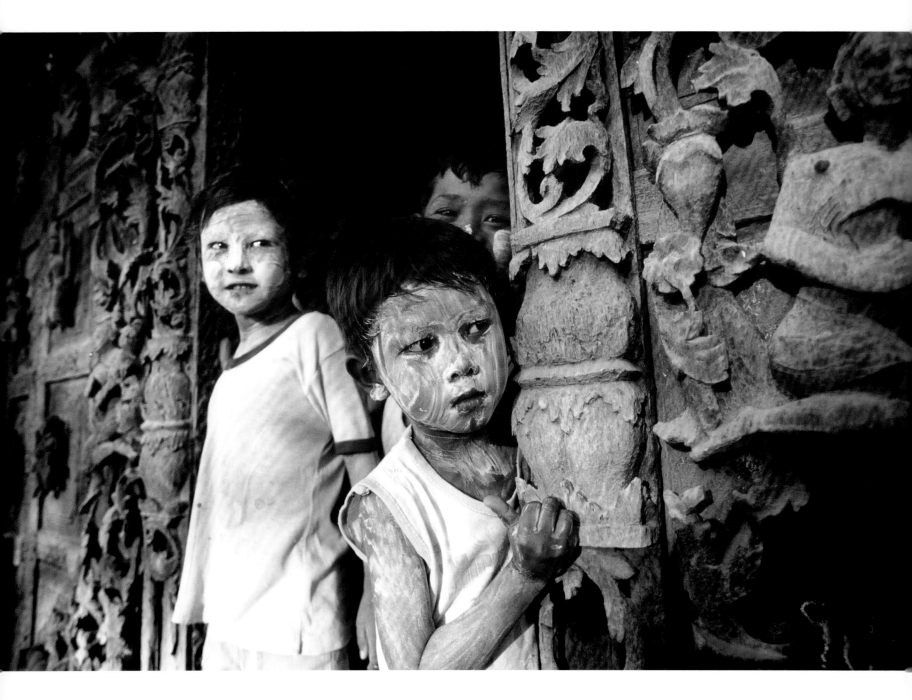

Burmese children play by a carved teak monastery in Mandalay, their bodies slathered in thanakha paste, a rural sunscreen made from grinding the tree's bark.

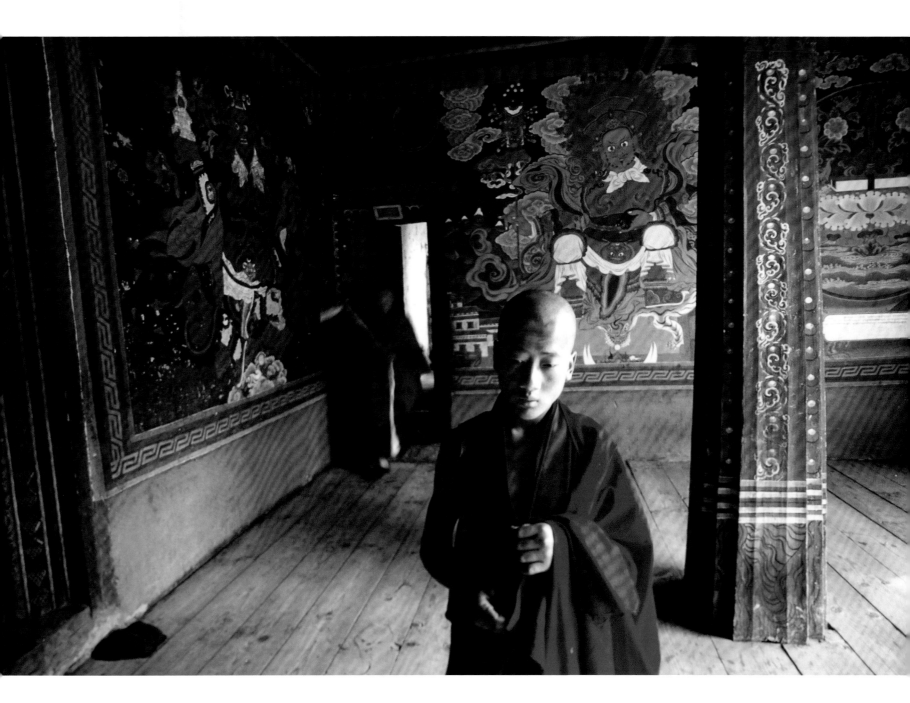

Deep in Bhutanese thought, a junior robed monk prepares for
Buddhist meditation amongst richly illustrated tangka murals
and the massive Rinpung Dzong monastery in Paro.

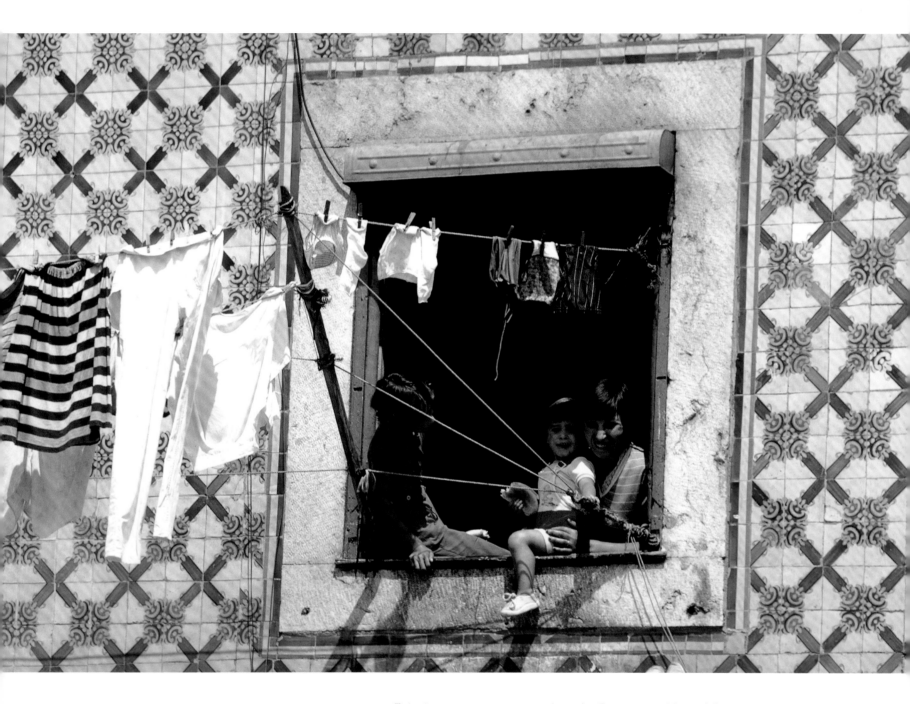

Enjoying some massa sweet bread, a Portugese girl straddles
her stage set frame windowsill, offering views of dazzling
tiled houses in the Alfama neighborhood below.

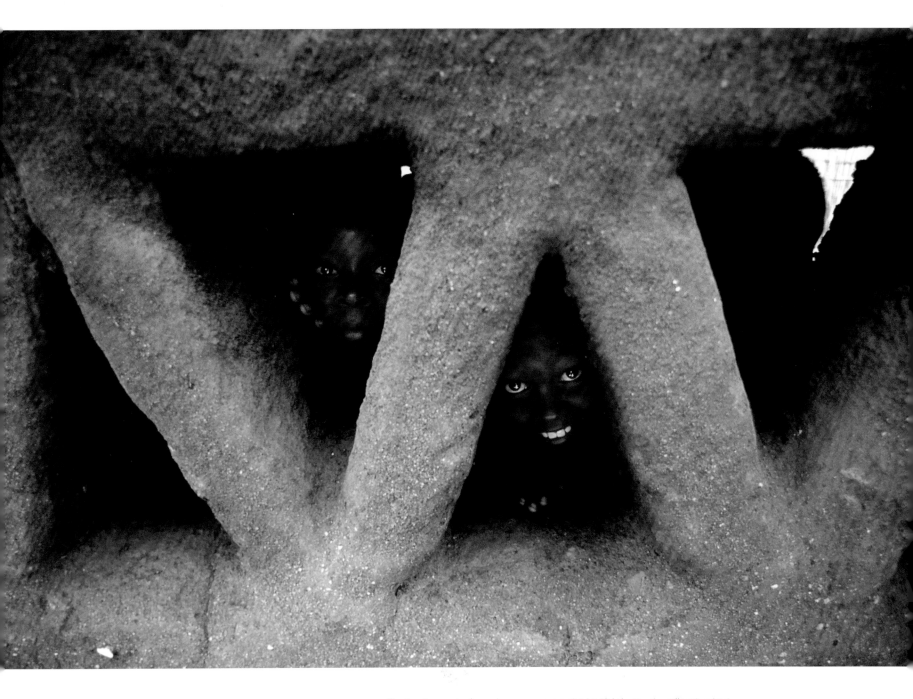

Curiosity and gleaming eyes penetrate thick mud walls at a hut compound in the fishing village of Kasankha on the shores of Lake Malawi, teeming with more species of fish than any other in the world.

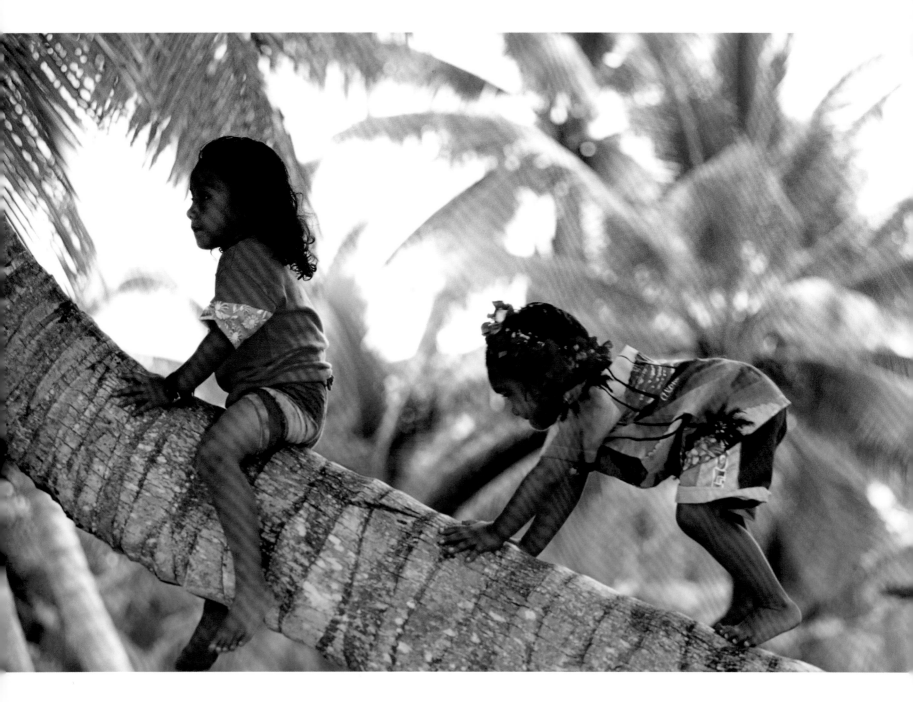

Tackling a gentle slope in a debut attempt, children learn to climb coconut trees at a young age, a handy lifetime skill on Palmerston Island where there are no grocery stores.

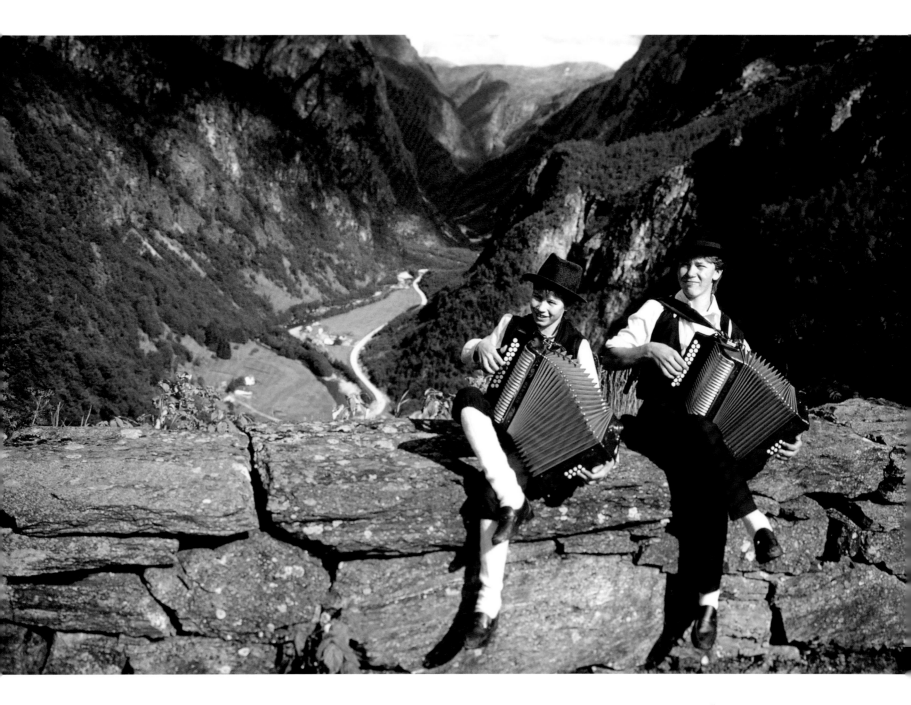

Rosy-cheeked Norwegian accordionists sit astride stone walls overlooking Stalheim's U-shaped glacially carved valleys, which further downstream empties into the stunning Nærøyfjord.

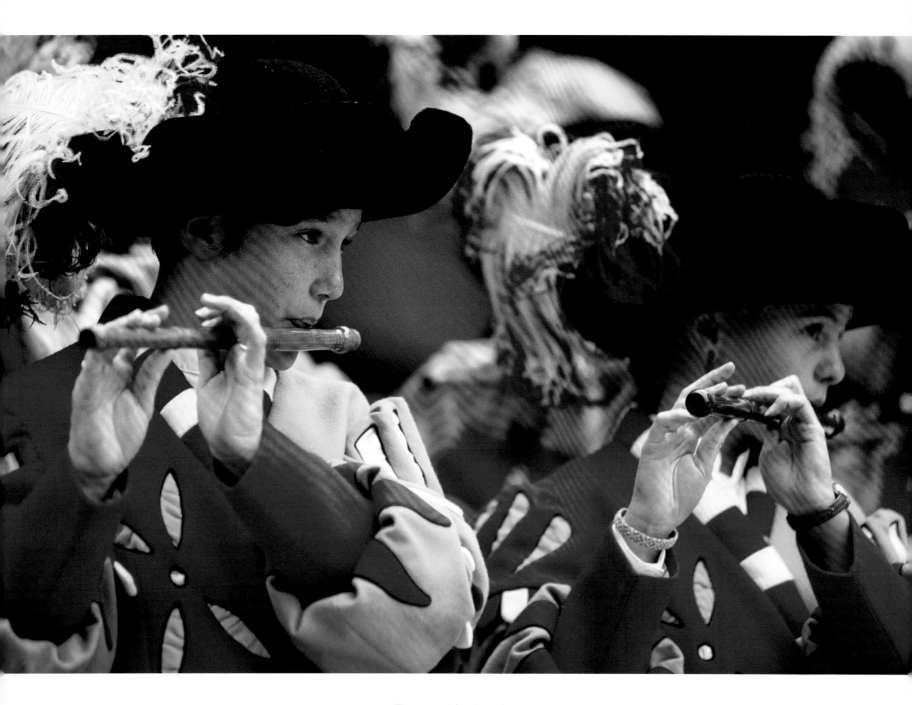

Flutes and feathers lead a Zermatt parade route where a thousand musicians, dancers, and yodelers fill the Swiss square, pungent with the aroma of cooking bratwurst.

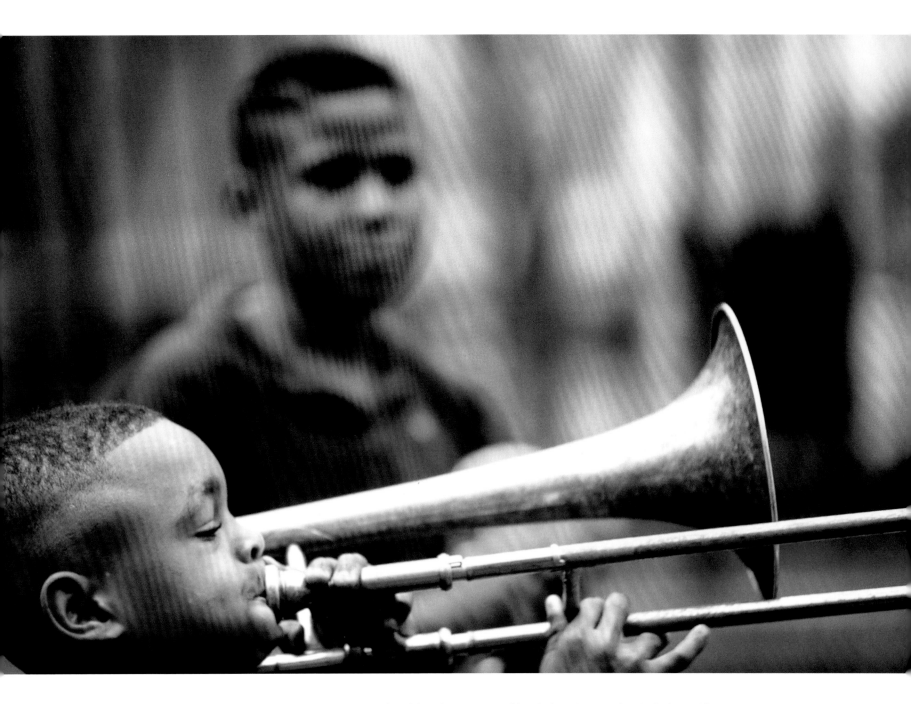

Invoking the specter of Louis Armstrong, cheeks bulge while a prodigal trombonist serenades the French Quarter and soulful echoes ricochet down the aromatic streets of New Orleans.

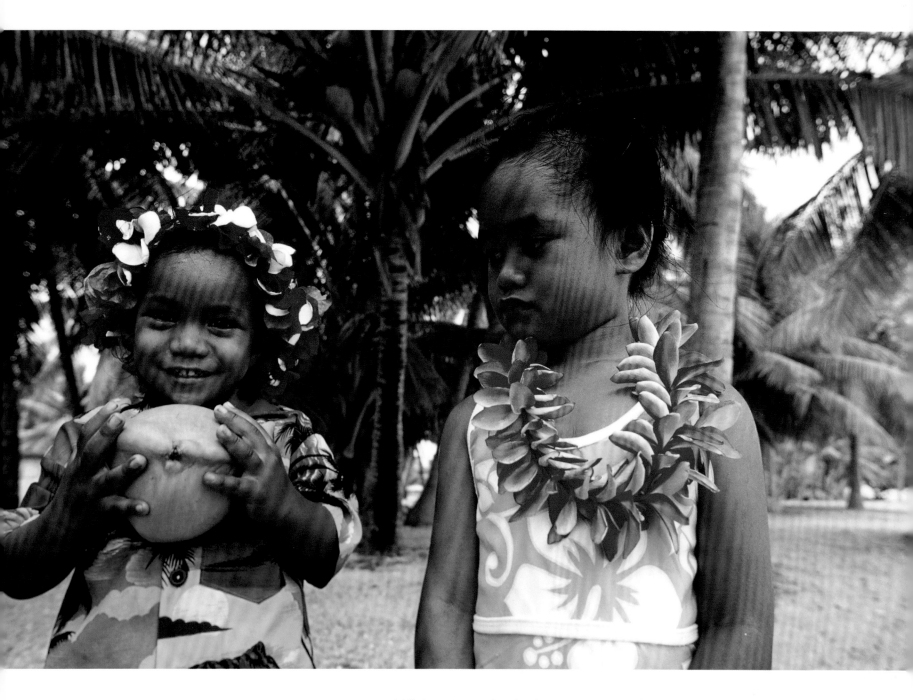

At Palmerston, a pint-sized coconut proves a handy beach ball for a game of catch atop a sandy field littered with the fruit, providing drinks and protein for needy Cook Islanders.

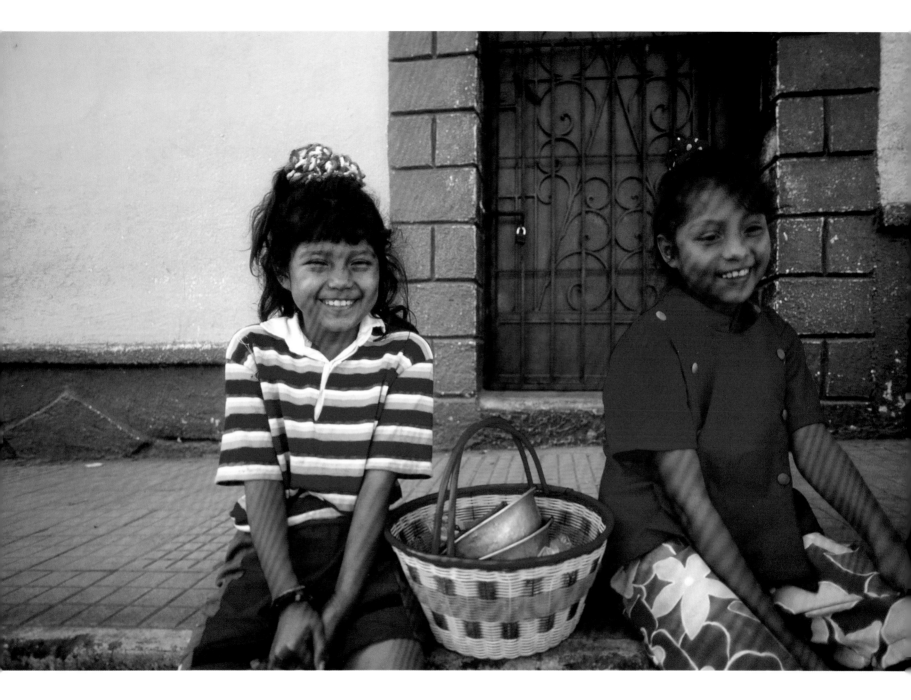

In El Salvador, the smallest, most densely populated country
in Central America, vivid basketry and clothing enlivens
Izalco, once lit at night by its namesake volcano.

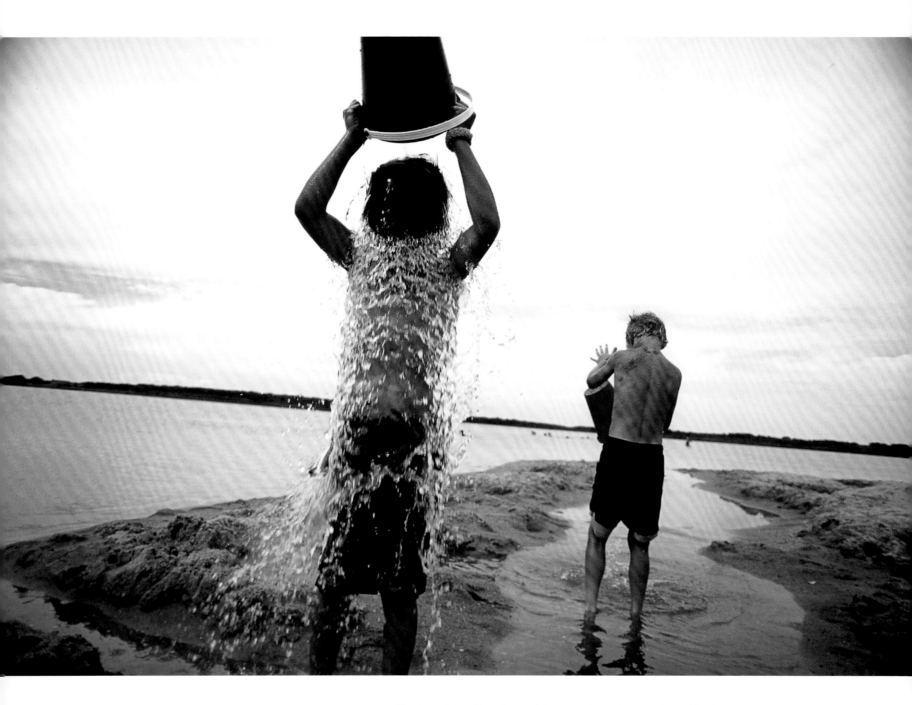

Playing with a friend, a self-imposed seaside dunking fills the warmer waters of Ripley Cove, a mere sandspit away from chilly Atlantic surf pounding the coast of Martha's Vineyard in Massachusetts.

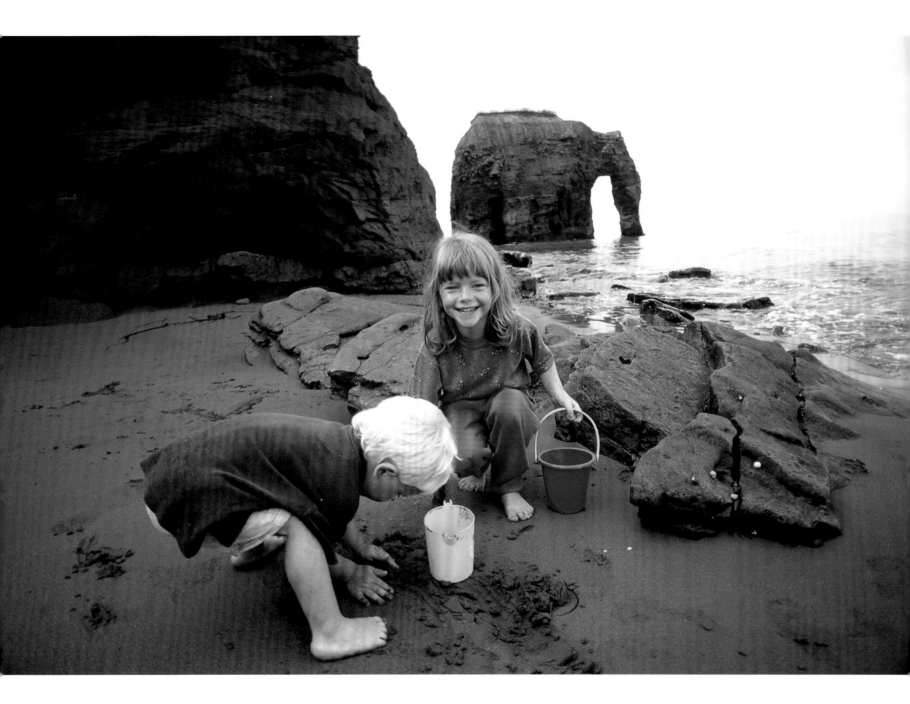

A sandy construction project at Seacow Pond plows ahead on schedule before the presumed eternal profile of Elephant Rock, losing its trunk after a recent Canadian storm battering Prince Edward Island.

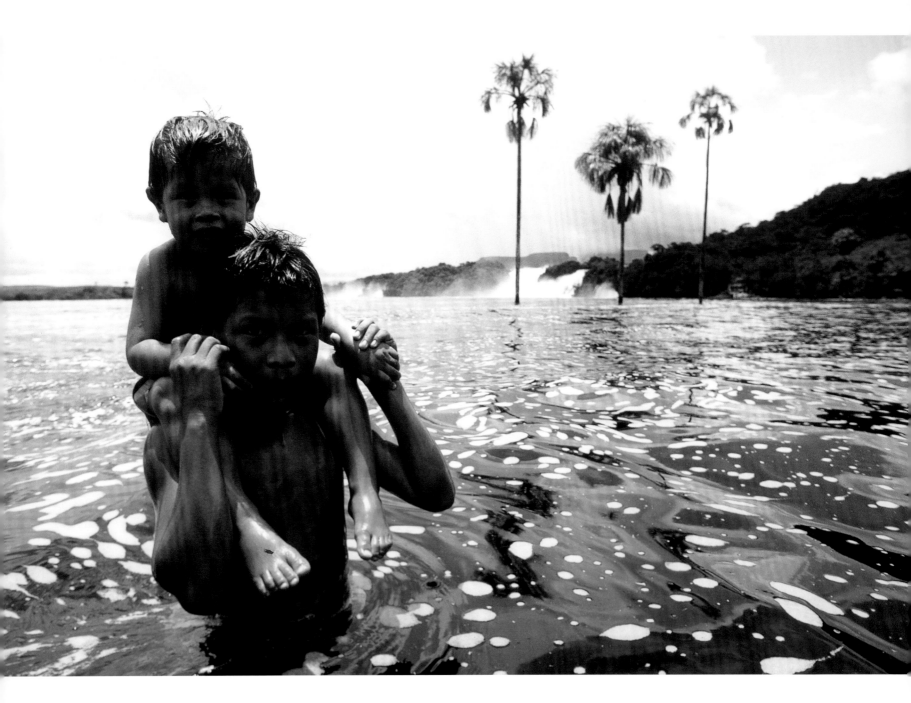

A piggybacking perch keeps feet dry and provides fine views of the foam-splotched Canaima lagoon, from where upstream cascades amidst the soaked Venezuelan forests lead to the world's very highest waterfall.

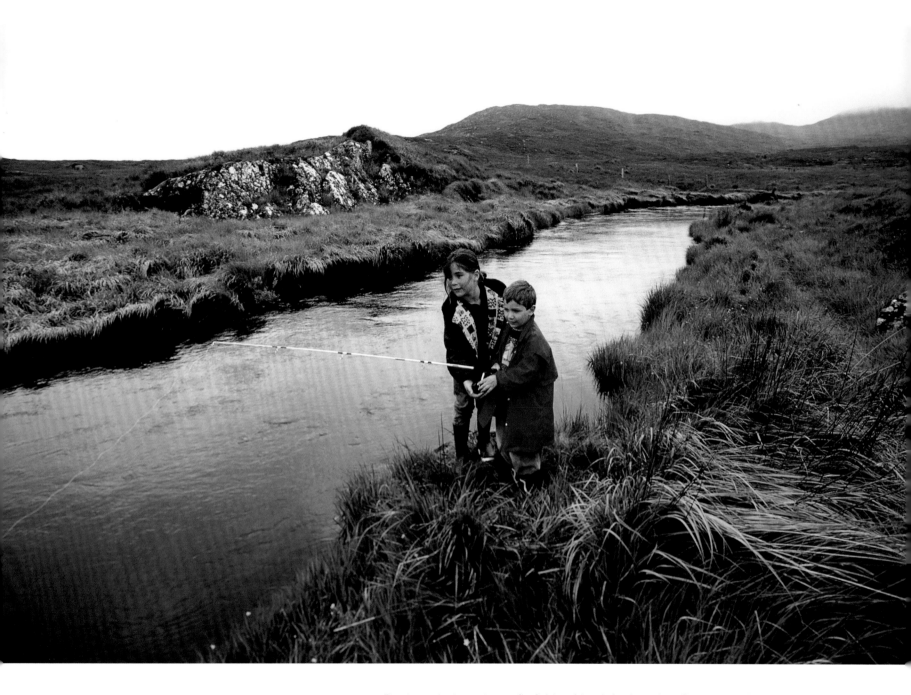

Boots and raincoats are fly-fishing friends in the misty Connemara District,
where salmon is plentiful within the vast Irish networks of loughs and streams.

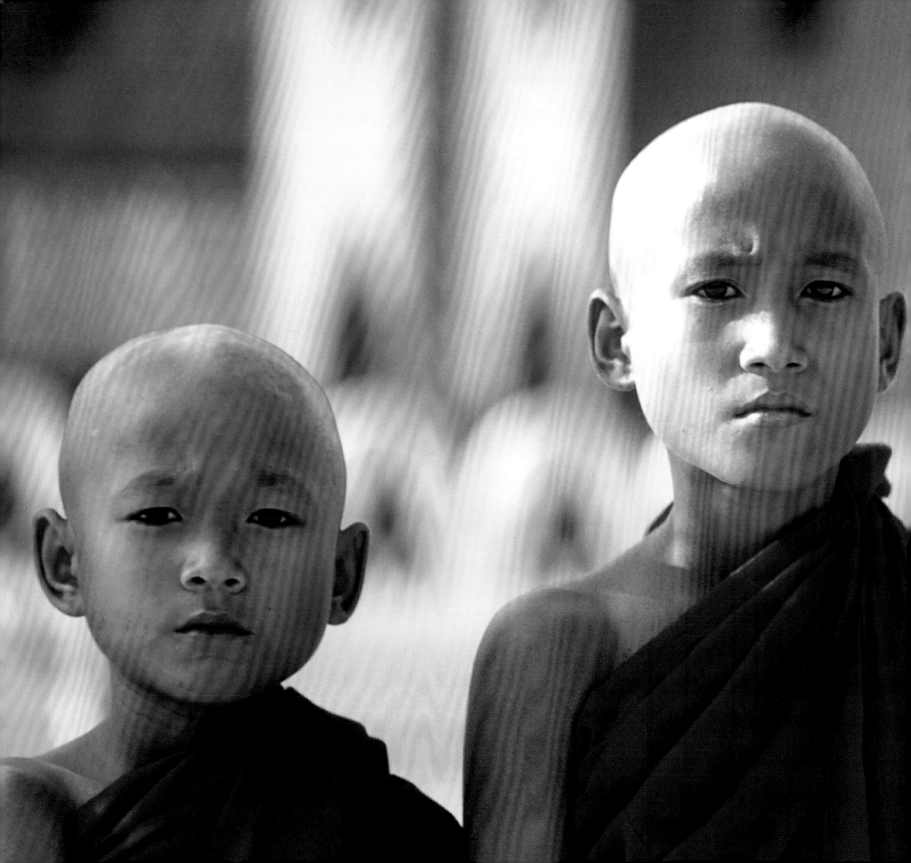

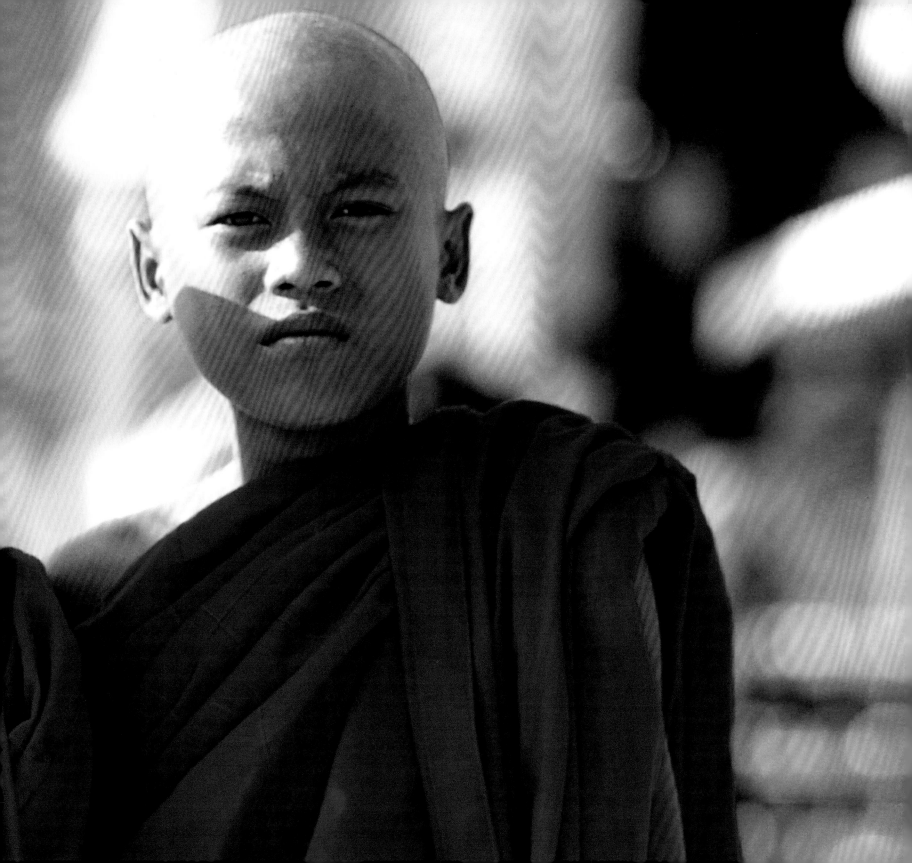

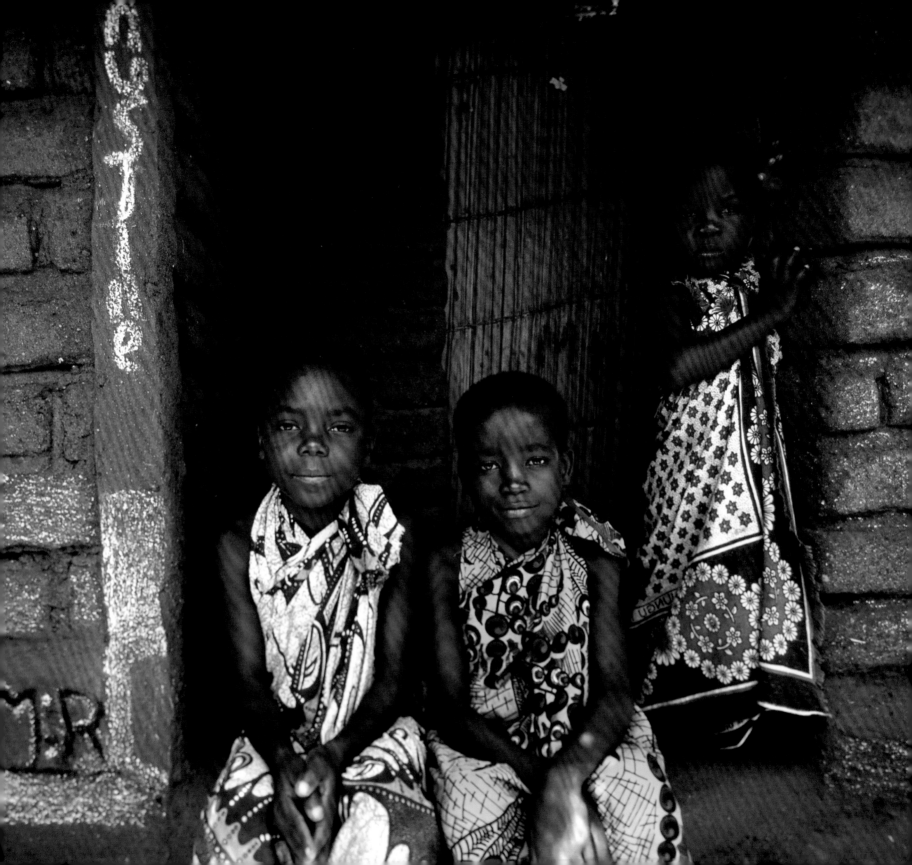

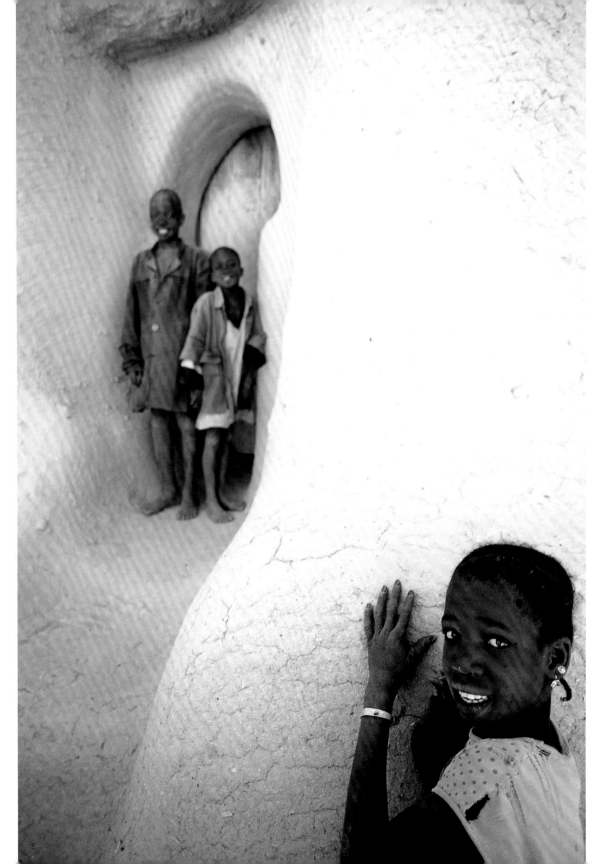

Amongst a forest of pagodas, a triad of shaved skulls and robed torsos pay Burmese respects to the kingdom's once ancient cosmopolitan centers of Buddhism in Bagan (preceding page).

Chalked inscriptions and mud-baked bricks clad a Malawian dwelling's exterior in the lakeside fishing village of Kasankha, where insouciant serenity seems stamped on the expressions of its residents.

The shade of a Malian heat-cooked mud mosque is a cooling refuge in Kotaka, with sensually sculpted portals into a spiritual world that's not yet grasped by children.

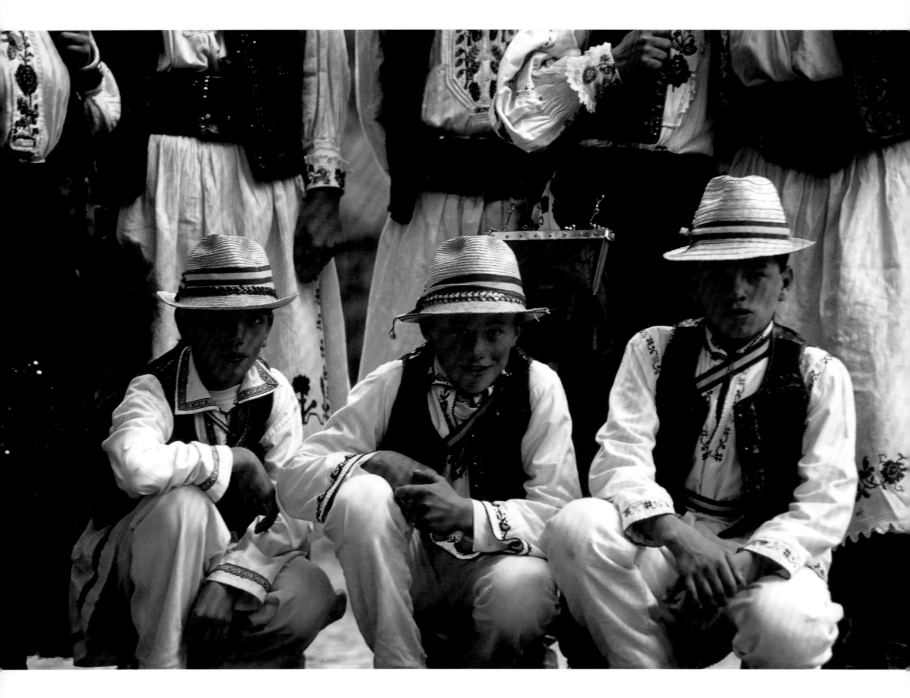

Ready to spring into action, the youngsters of this Sinaia dance troupe rehearse in the Carpathian mountains of Romania, a land shrouded in mist and superstition.

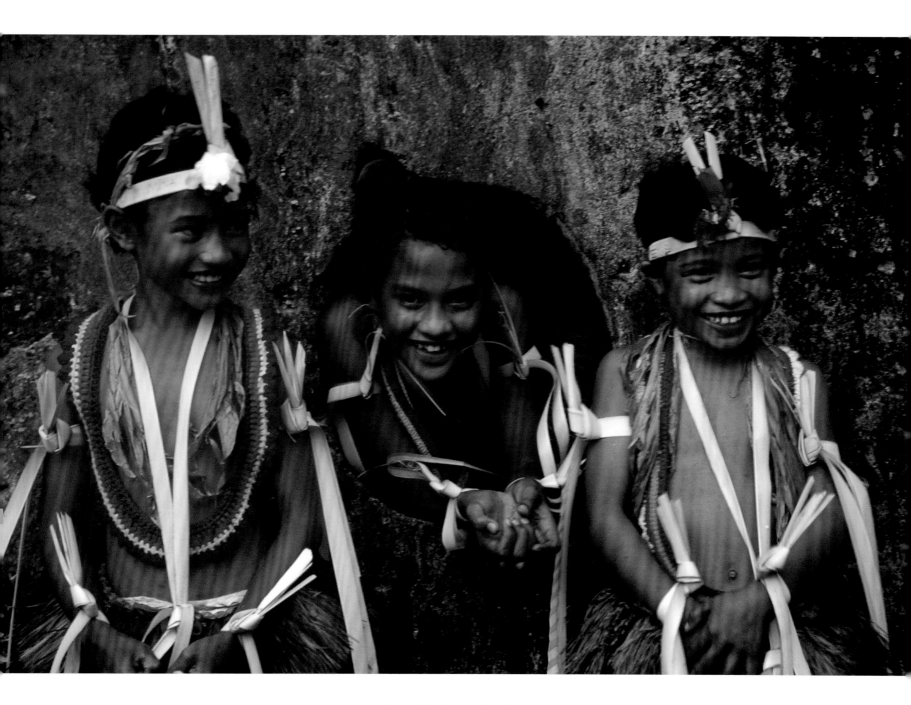

In an island paradise, a huge stone rau, used as the world's largest money, is also employed as a necklace by one of these Micronesian dancers, relaxing after their strenuous bamboo stick ceremony on Yap.

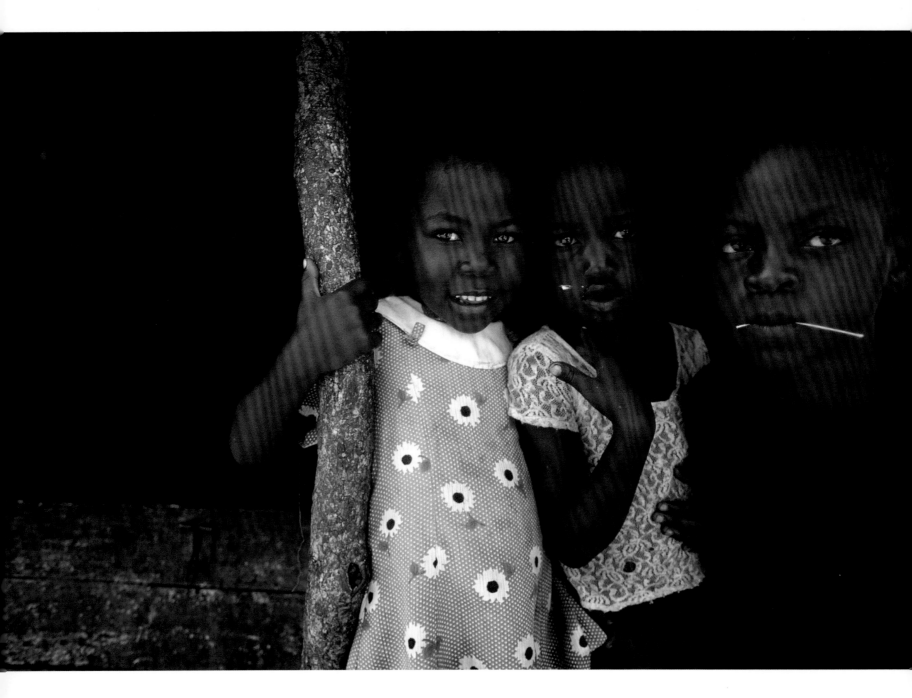

A trio of varying attitudes inhabit their Zambian village, a collection of conical huts organized for access to Mukuni's nourishing pumpkin fields.

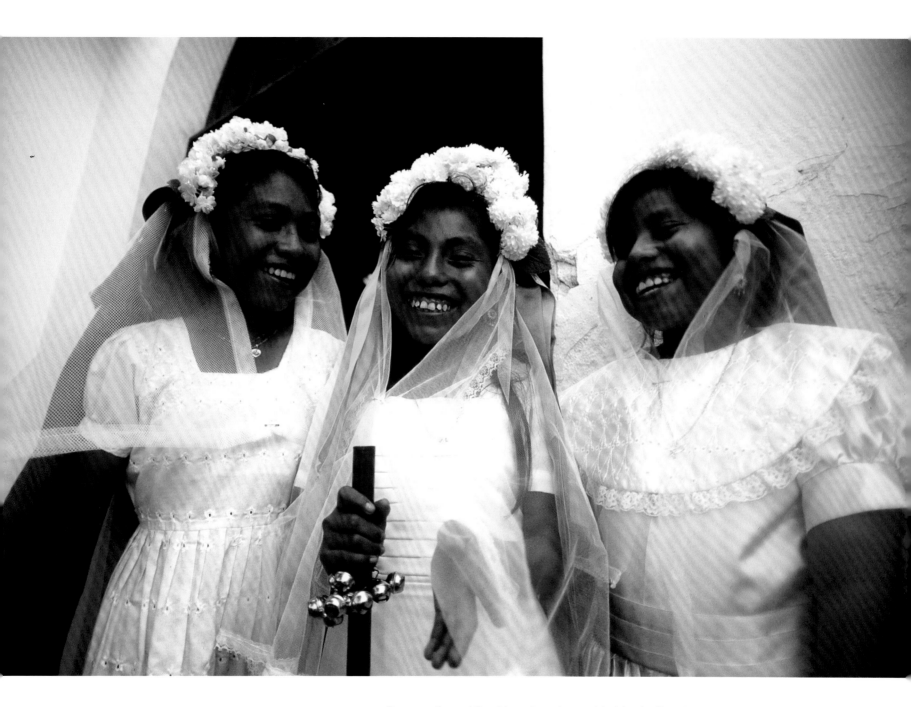

Gauzy veils and floral headbands garnish this ebullient Mexican wedding party threesome as services end and are about to spill out onto Zihuatanejo's streets in this Pacific coast village.

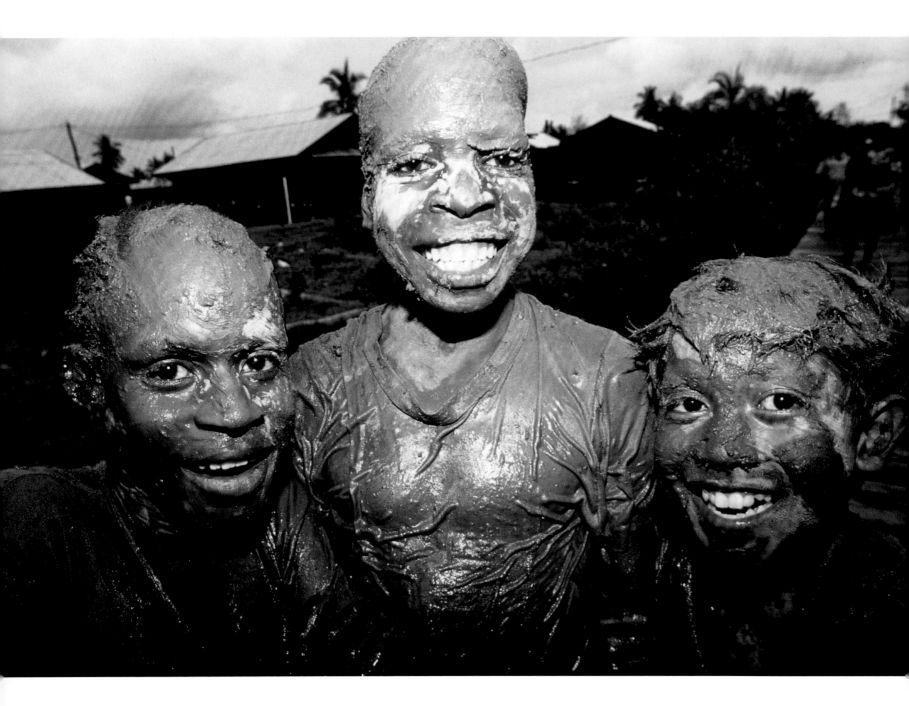

By the swampy, mangrove coast in Agats, children delight in their masquerades with mud, which serves a dual purpose as protection from malarial mosquitoes swarming Irian Jaya.

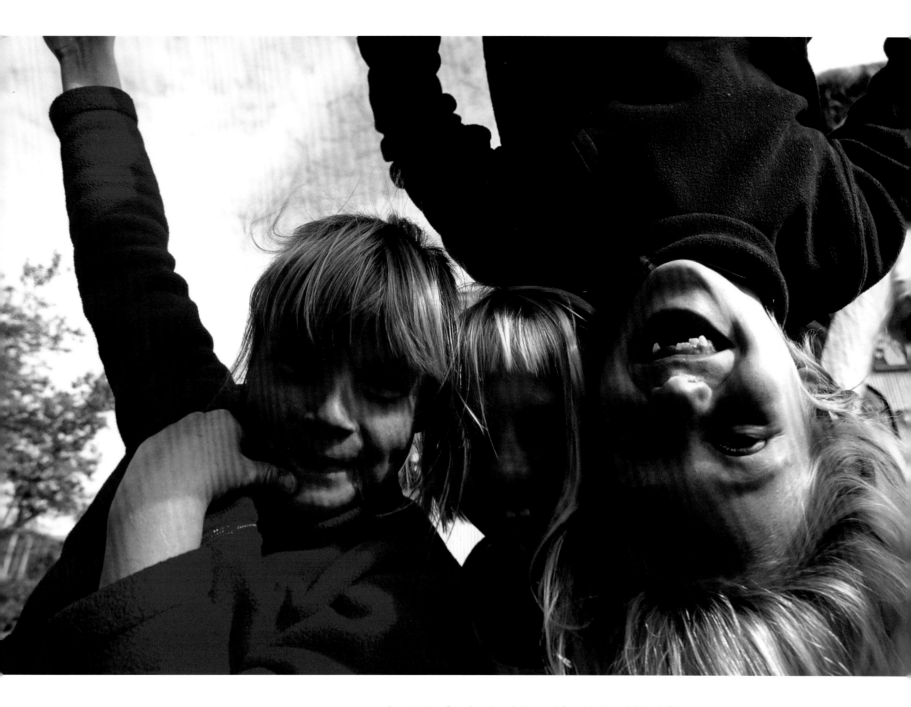

A curtain of Icelandic platinum blond hair exhibits Viking genetics of kids hanging from monkey bars in the sun-starved precincts of Reykjavik, just below the Arctic Circle.

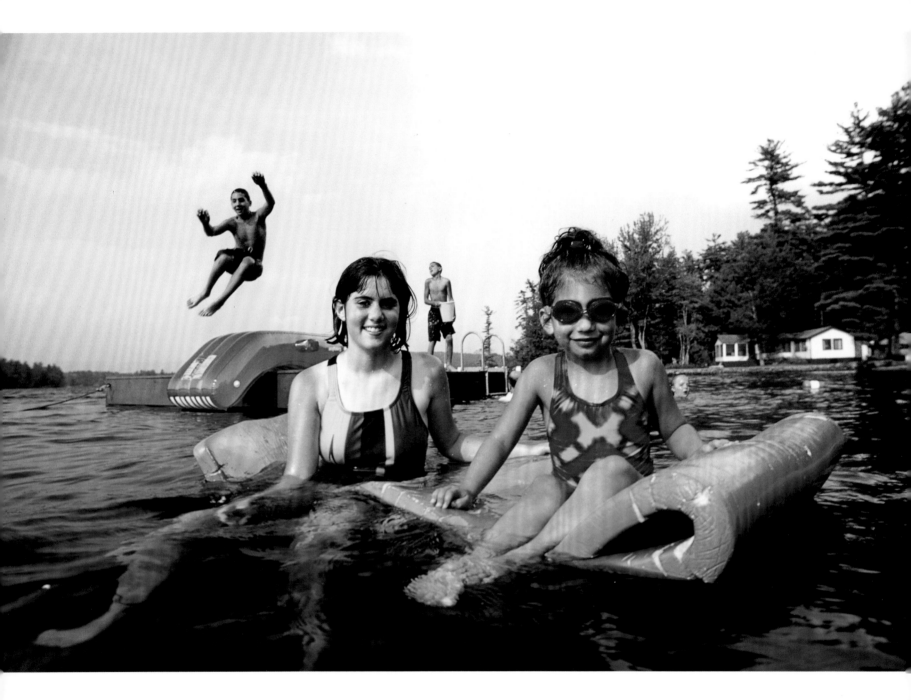

A buoyant couch proves an inviting destination to a swimmer leaping for joy from a raft amidst Maine's jewel-like Lake Kezar, hosting a music-themed summer resort at Quisisana.

184

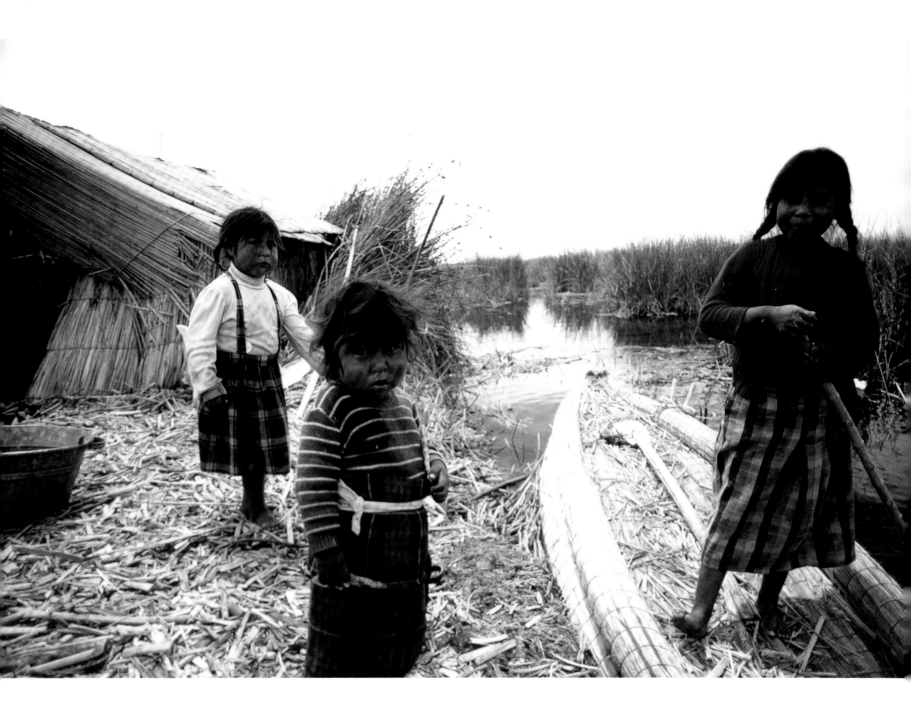

Amidst the continent's largest lake, an Uros girl prepares to launch
a balsa down watery streets that access neighboring floating isles
of torturo, edible reeds that fashion both boat and home.

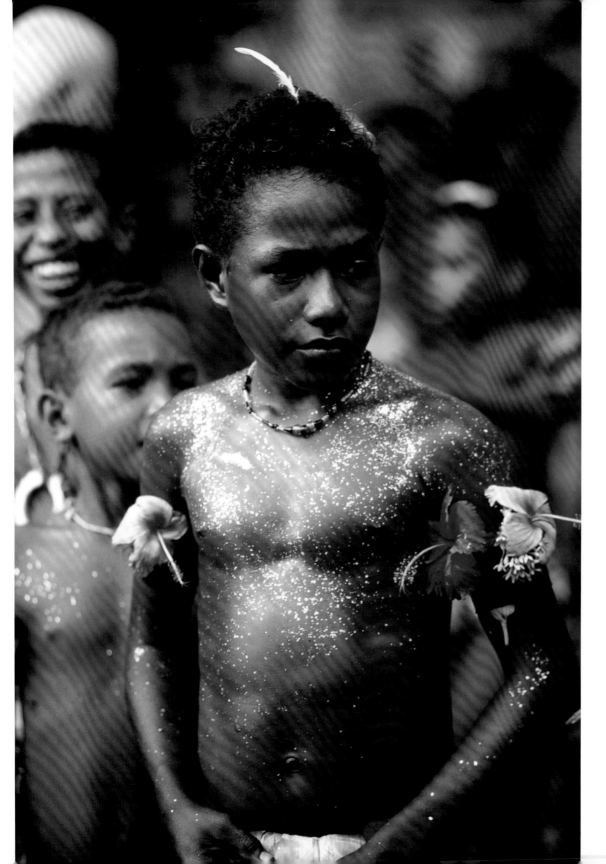

Resplendent in hibiscus
armbands, ceremonial glitter
and a single-feathered
hairpiece, a young Kitava
villager prepares for a
colorful Trobriand ritual
aspiring for imminent
South Pacific puberty.

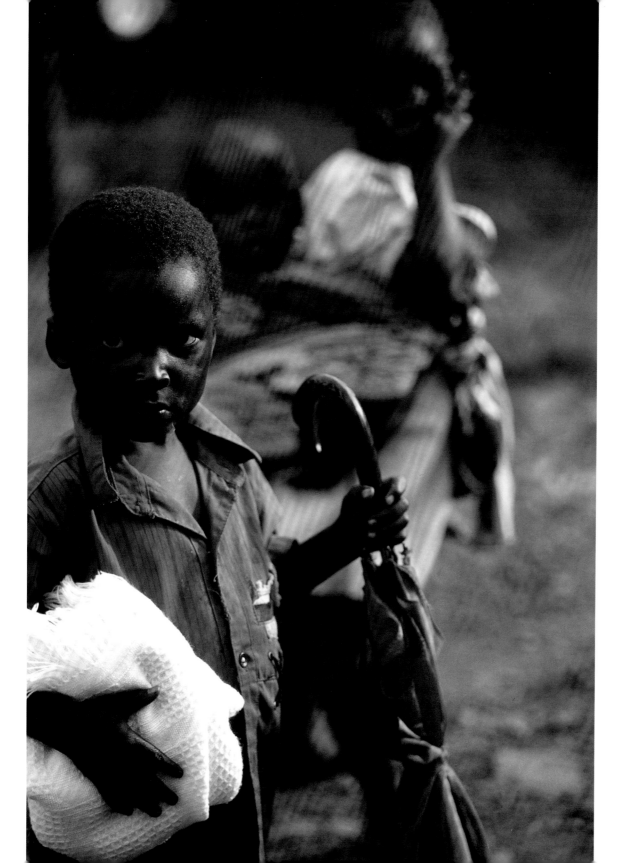

An umbrella might provide less than hoped for shelter in Kisoro, Uganda. Mountain gorillas roam the nearby forests, skirted by central Africa's equatorial belt squeezing soaking daytime humidity into driving evening rain.

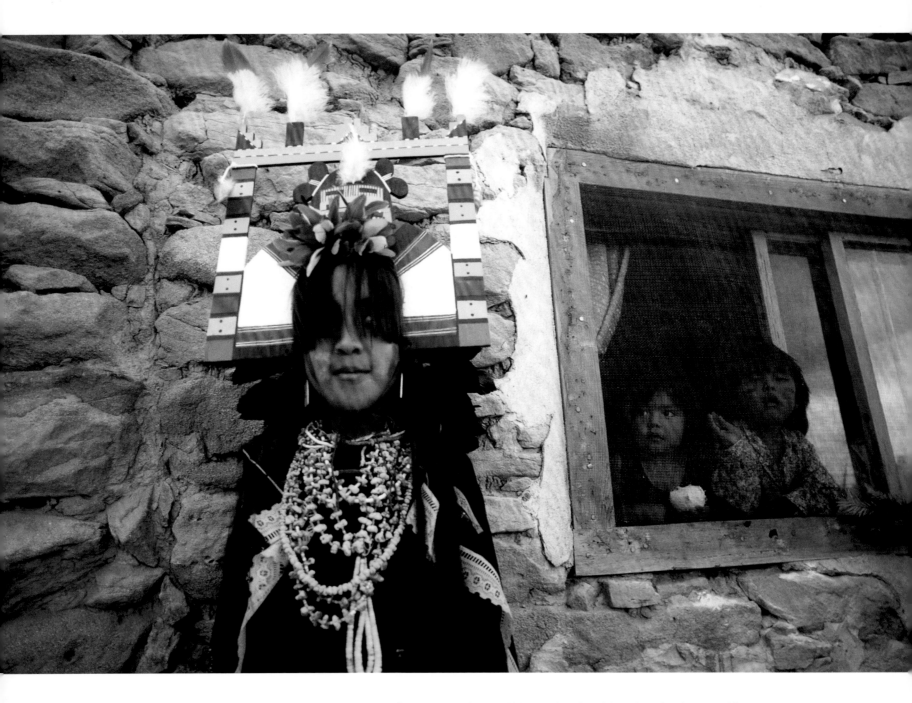

On Arizona's Second Mesa, a Hopi maiden dons her kopatsoki headdress in excited anticipation of an elaborate Butterfly Dance, meant as a thanksgiving for corn and prayer for rain.

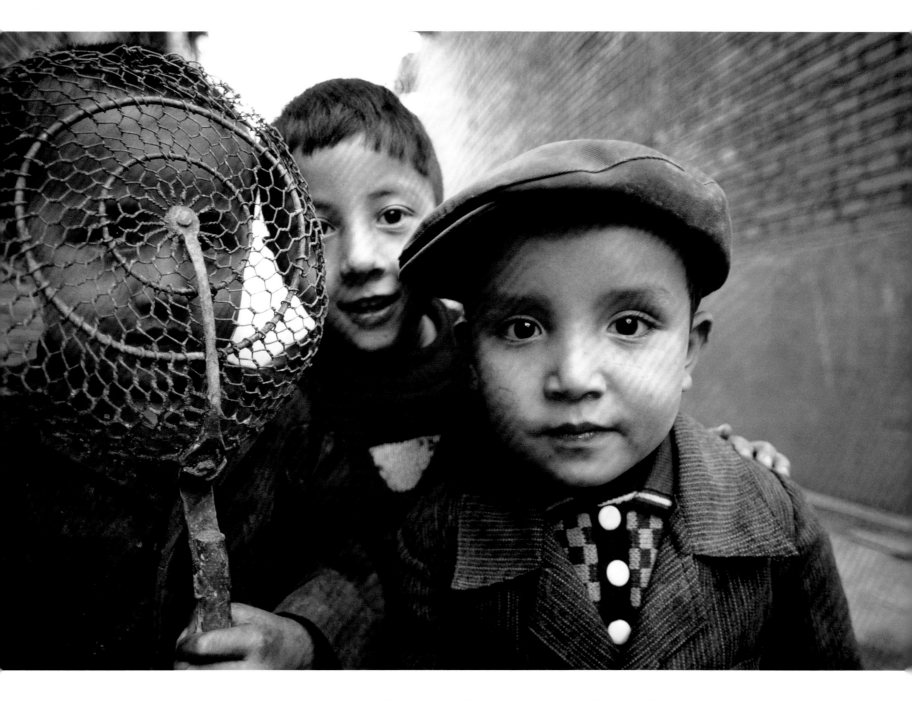

Perhaps mimicking his Uyghur mom's Muslim fashion habits, a boy peeks through an improvised veil by Kashgar's Silk Road market, once Marco Polo's destination in China.

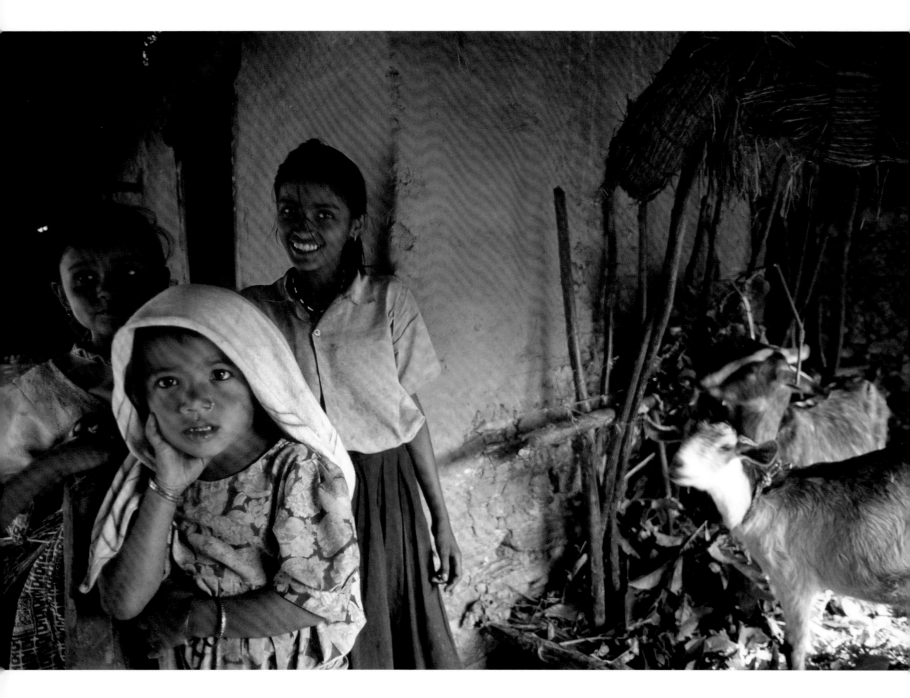

All in the family, goats chow down on dinner before three
Himalayan sisters head for a meal of their own, awaiting just
on the other side of this rustic wall in Gandruk, Nepal.

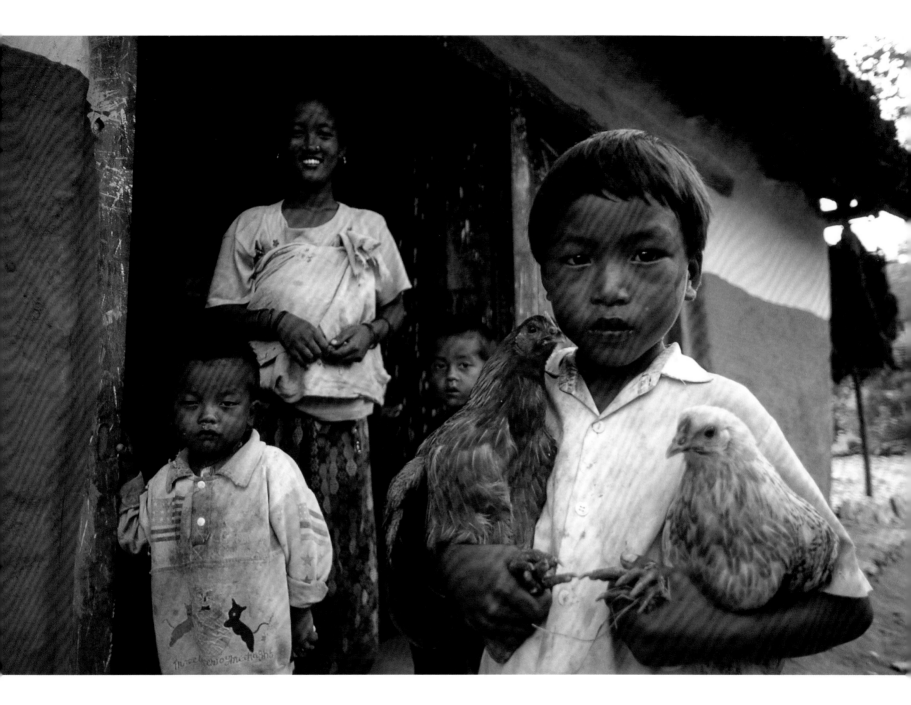

Off of Nepal's Annapurna trail, smells of eggs being fried
inside are courtesy of these two hens, perpetual breakfast
machines for hungry mountain hikers passing Gandruk.

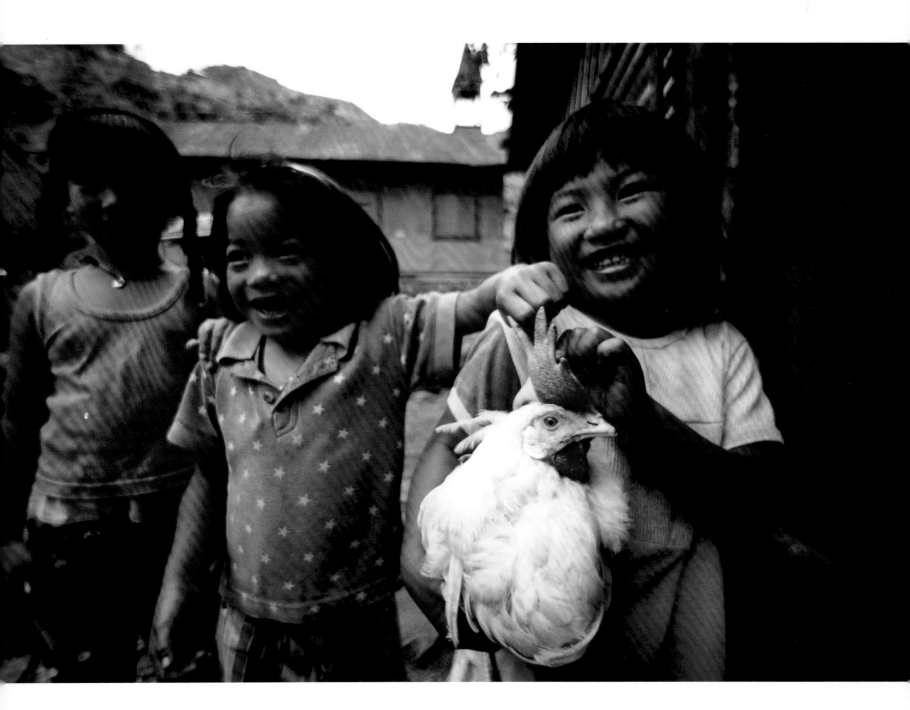

Only momentarily in captivity, a village rooster and his red-crested cockscomb provides a source of amusement for young Filipino girls at their village play station in Batad.

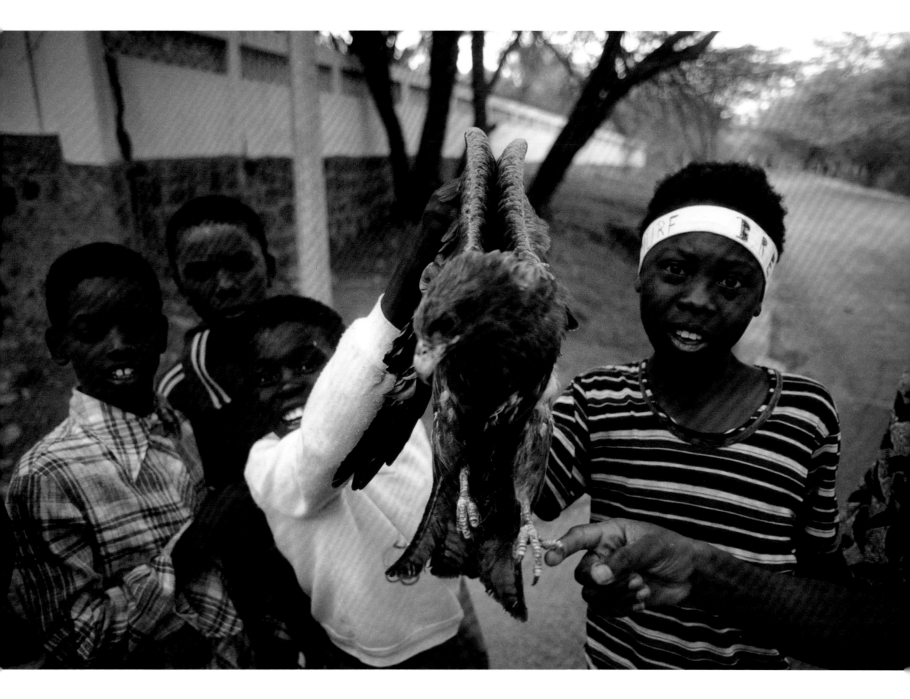

For an excited Senegalese boy, a bird in the hand is worth two in the African bush just beyond the outskirts of Dakar, near the continent's easternmost point.

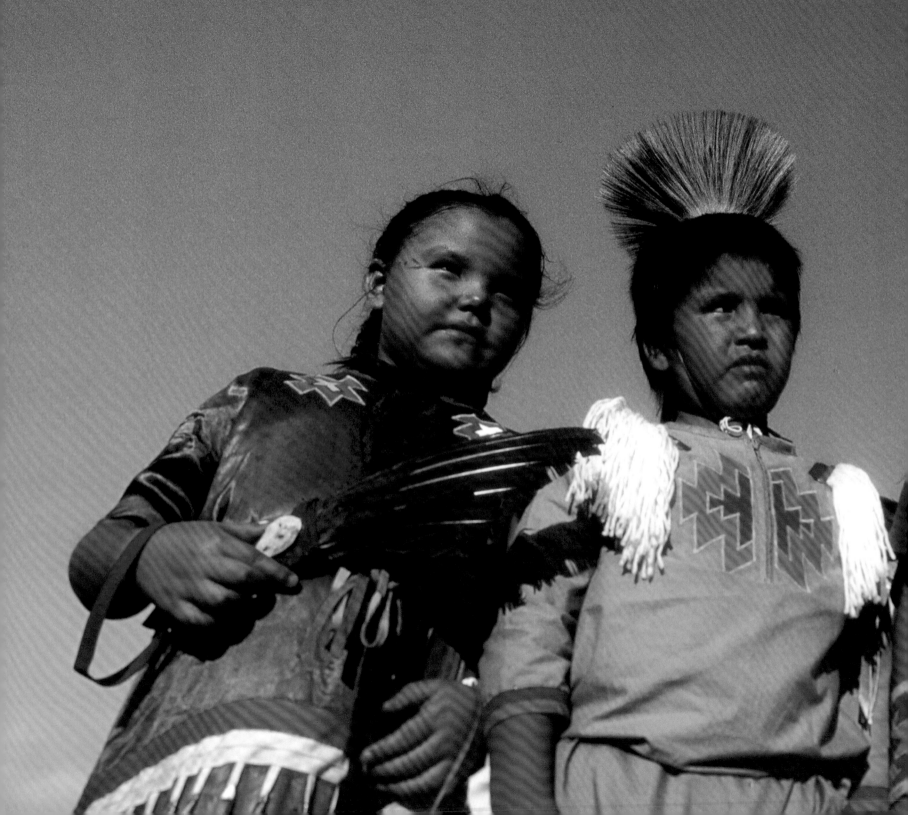

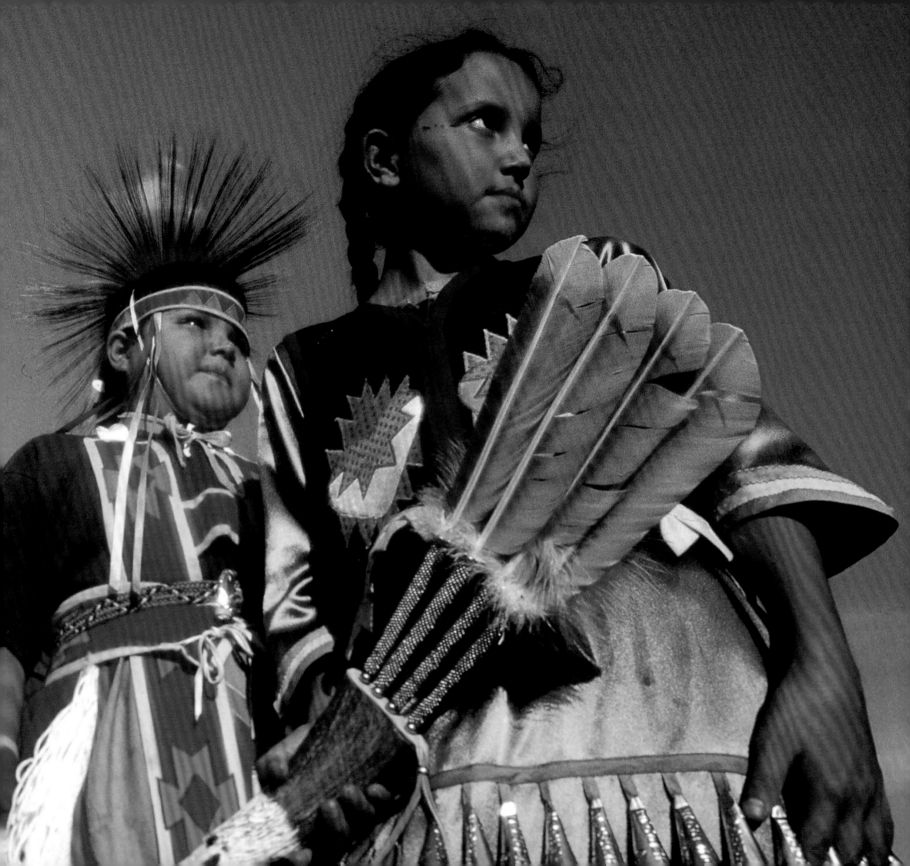

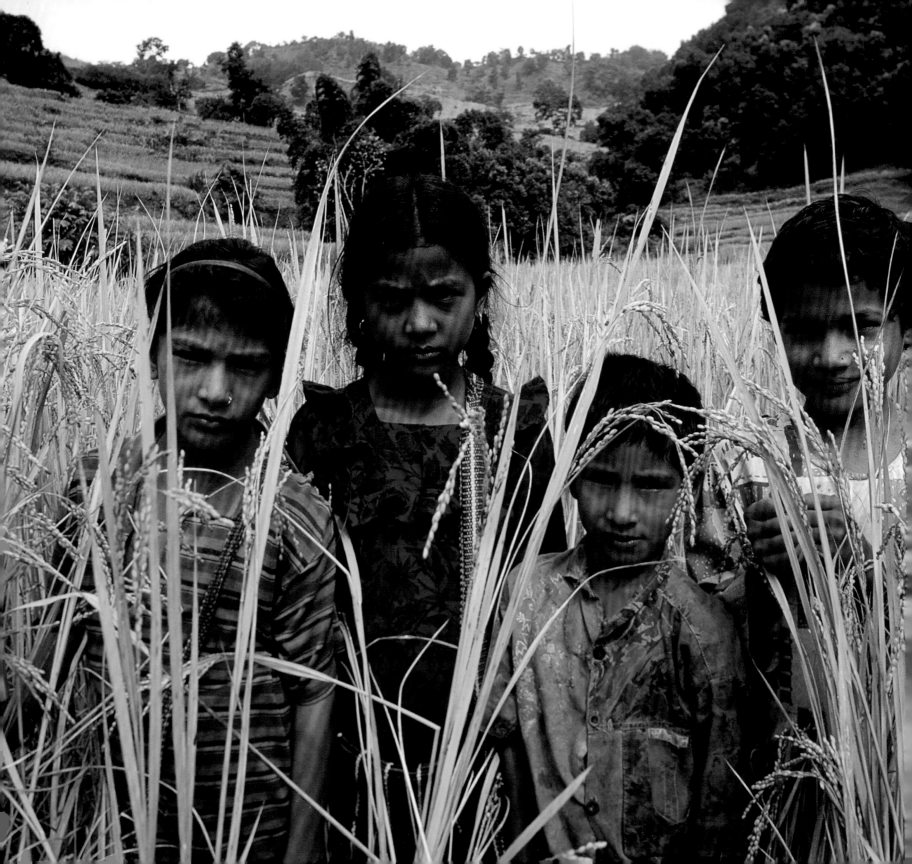

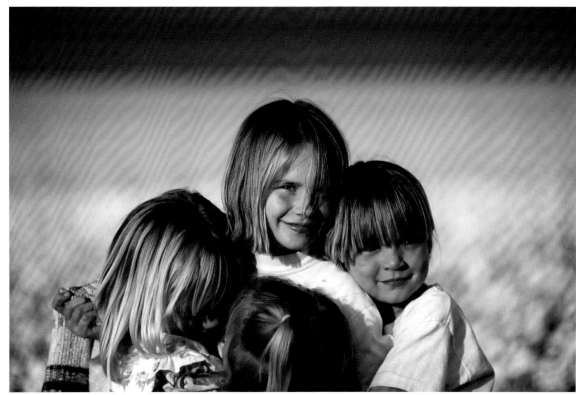

Beneath the poster blue skies of Canada's Great
Plains, eagle feather plumage and jingle dresses
distinguish a Saskatchewan quartet of powwow
participants awaiting their turn (preceding page).

———

A curtain of rice blows in the Filipino wind, revealing a quartet
of kids destined to spend their lives working in the labor-
intensive paddies amongst Banaue's sculpted hills.

Californian faces glow with the reflected colors of Lompoc's
blooming springtime field, where rows of marigolds and
sunflowers stretch to the horizon, cultivated for urban dwellers.

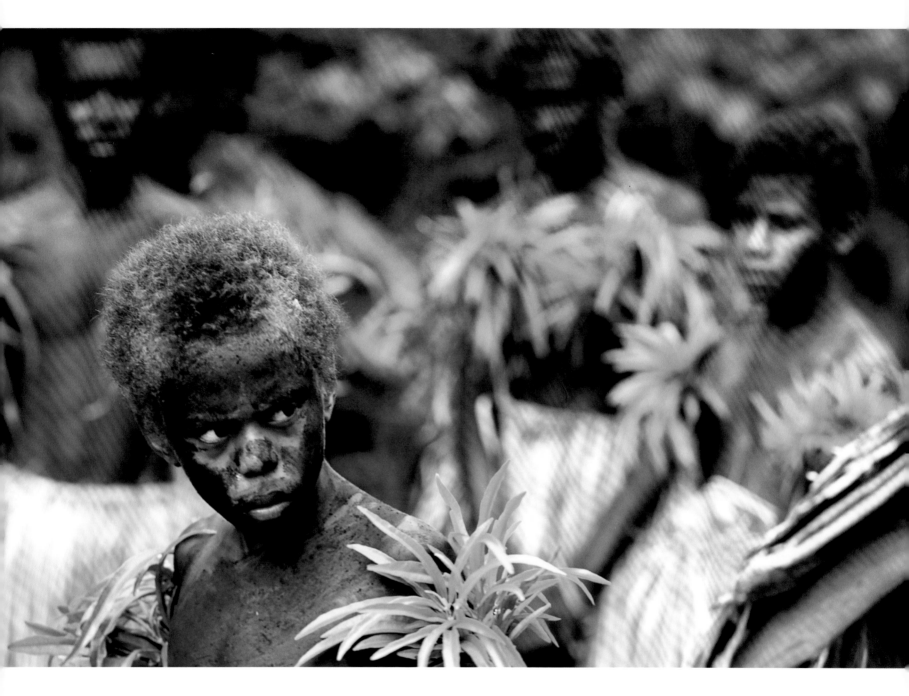

Bromeliad epaulets garnish bodies smeared with Vanuatu's volcanic soil for a ceremonial dance on Ambryn, an archipelago isle noted for its incantations of magic.

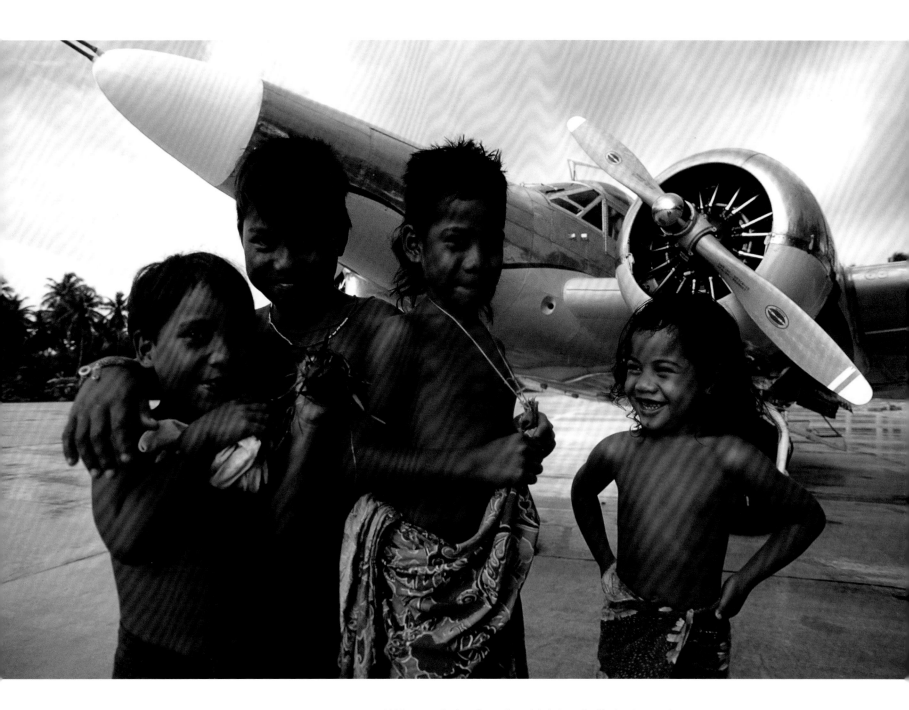

With permission from the chief, Amelia Earhart-era planes access remote Ulithi Atoll off of Yap, time-forgotten North Pacific islets that virtually disappear at low tide.

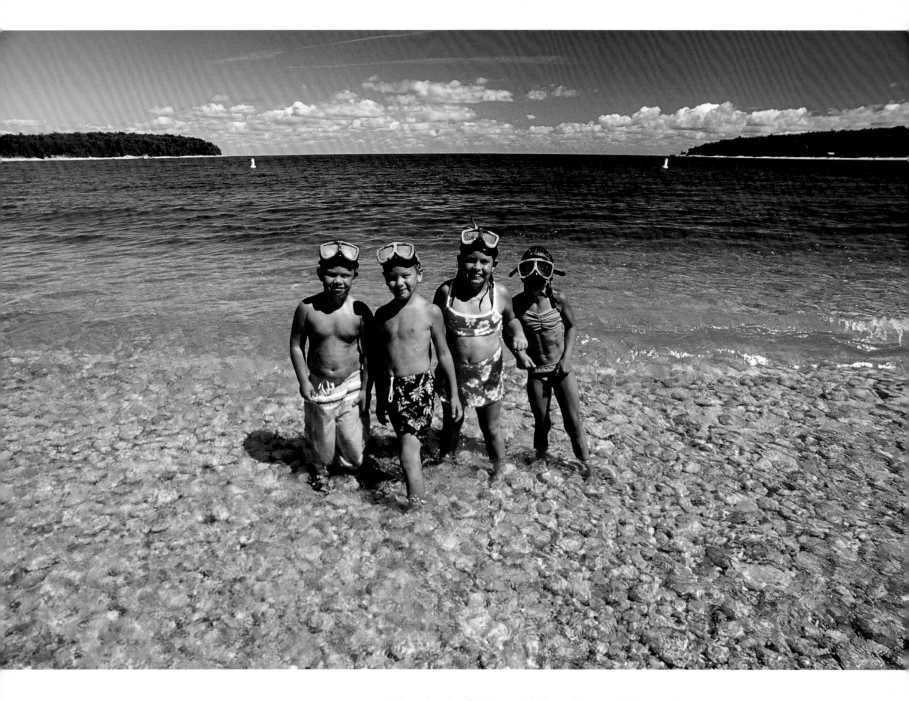

Near the tip of Wisconsin's Door County, jade-tinted waters inspire intrepid snorkelers to explore the frigid Washington Island coast just off of Lake Michigan, the world's fifth largest.

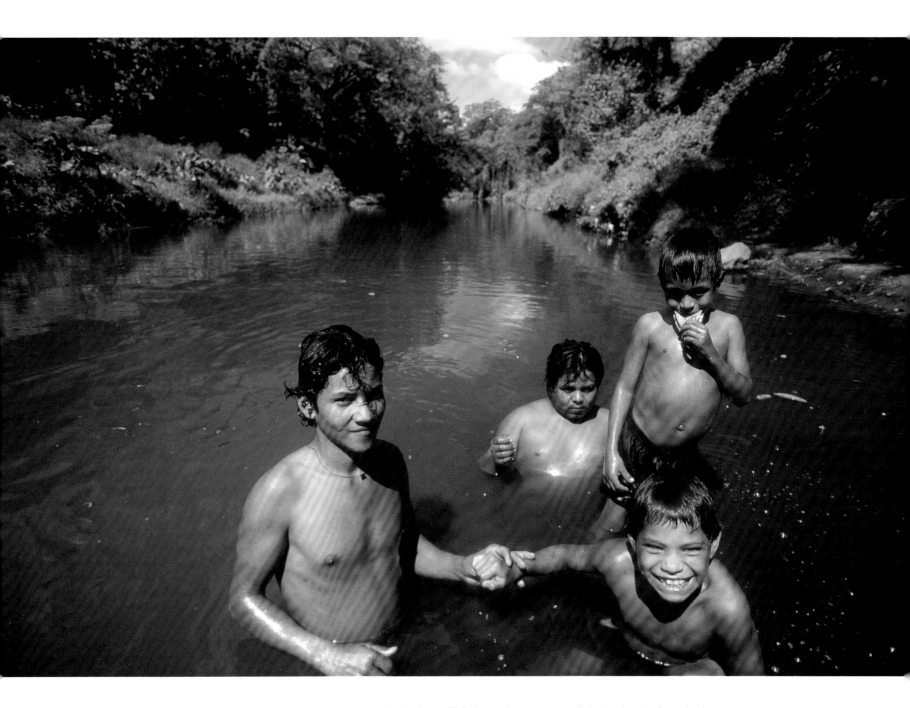

An inviting El Salvadorian water park in the heat of tropical sunshine, this languid river near Jayuca splices rain forest and provides its animals with an early morning drinking source.

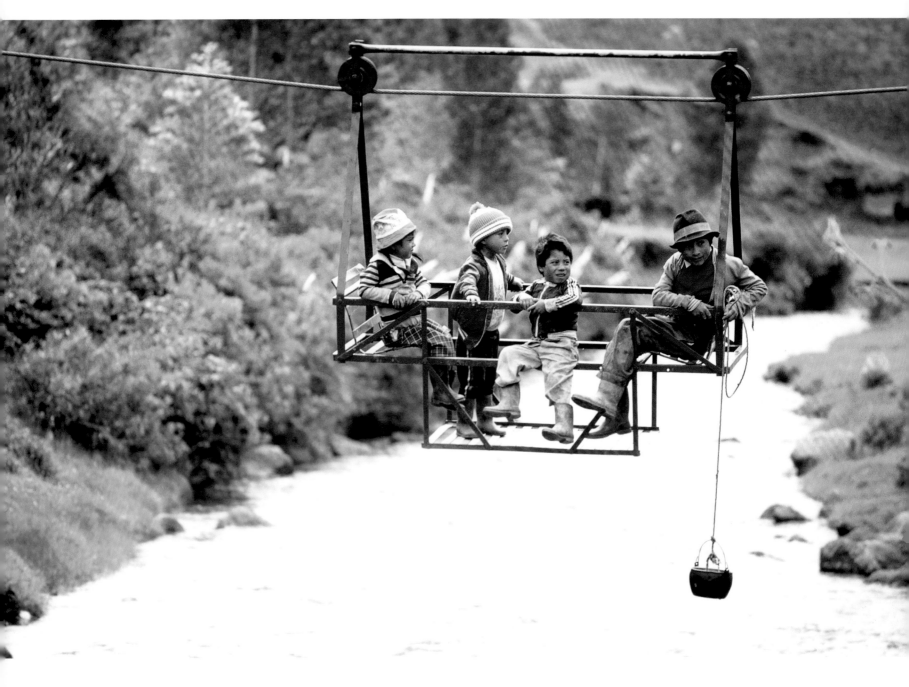

A youthful Ecuadorean quartet improvises a fishing outing from their pulley-drawn ferry cart, built to provide access across an Andean gorge near Calacali.

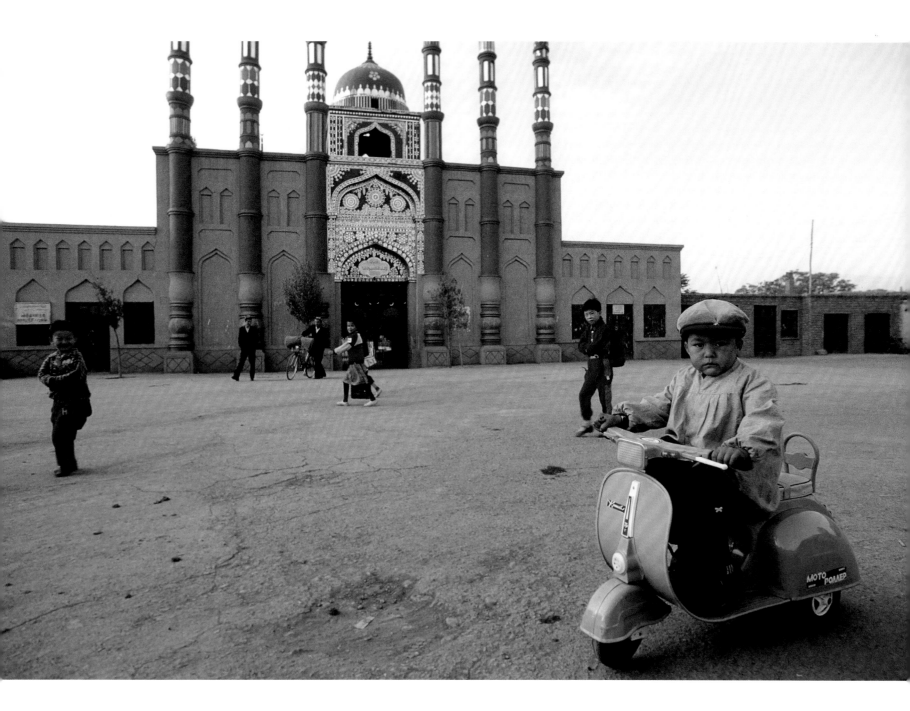

Perhaps not born to be wild, a future motorcyclist cruises by a Silk Road mosque in Turpan, where as an older Uyger, he'll be bowing to a Muslim god.

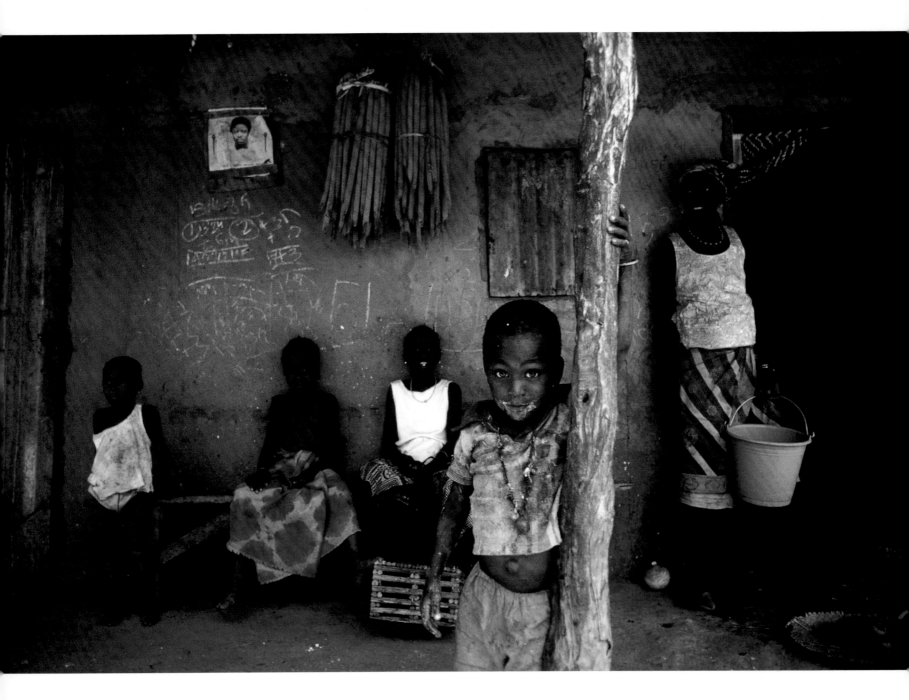

Wearing his last meal as lipstick, a full child takes a break from his meal in Juffure and greets a visitor to his simple Gambian home in a riverside African village.

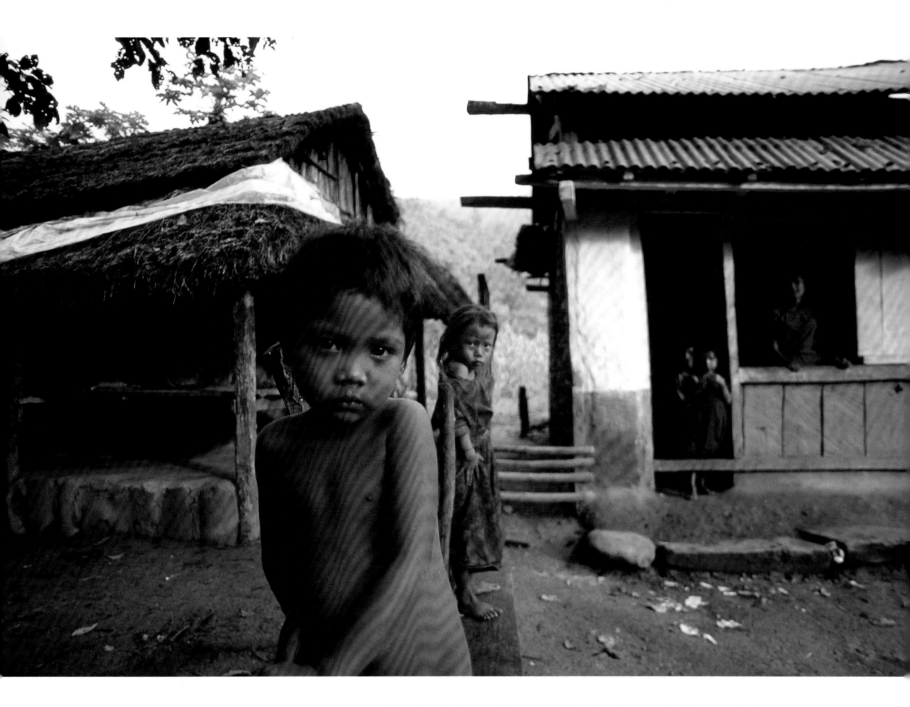

Almost ready for a bath, a young Nepalese boy meets hikers on the Annapurna trail, winding through Ghandruk's mountainous terrain in the Himalayan foothills.

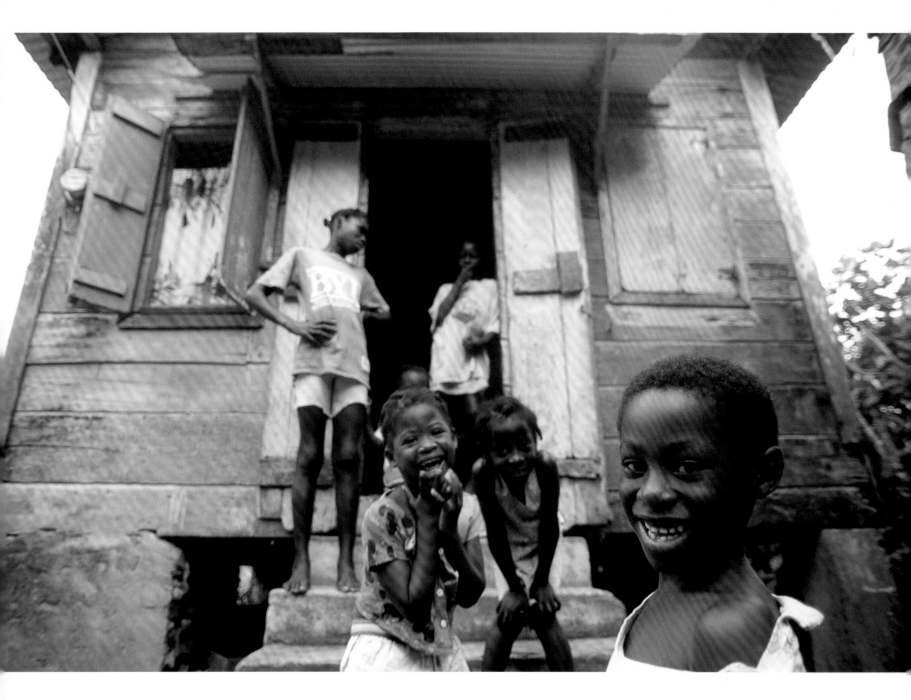

Stoop-side play spills outdoors, relieving pressure and any sense
of deprivation from a tropical coexistence within the dense
quarters of Castries' tiny St. Lucian clapboard house.

206

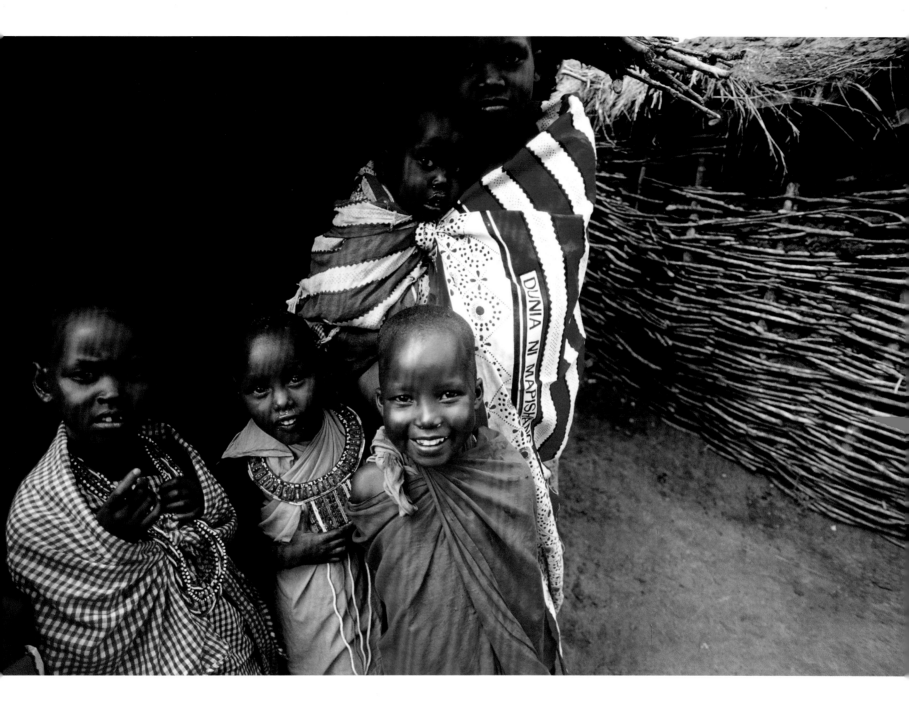

A tightly woven Maasai family in Arusha seems to thrive within the firmly stitched walls of a manyatta compound, organized to keep out threatening Tanzanian wildlife.

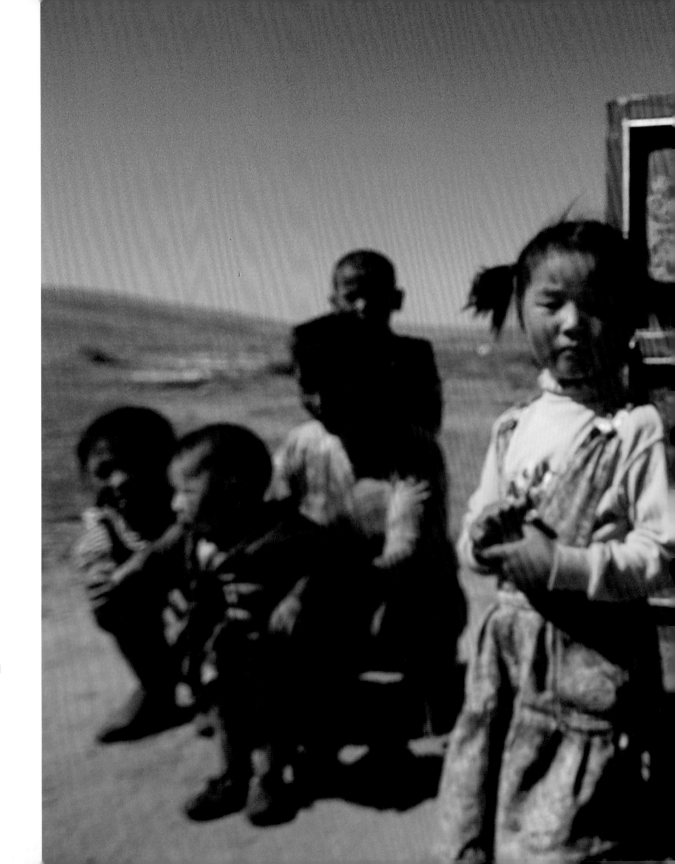

In the empty Mongolian steppes of Hogno Han's infinite grassland, civilization is counted by the occasional sightings of remote felt-covered gers, where horse milk meals make all the difference for survival.

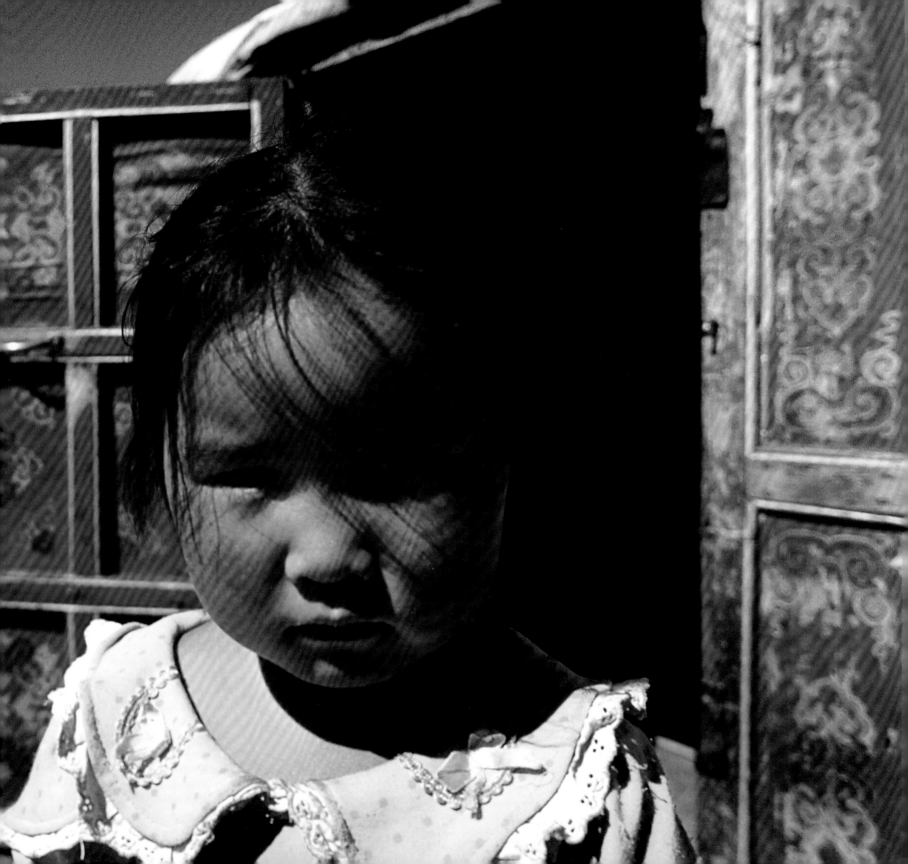

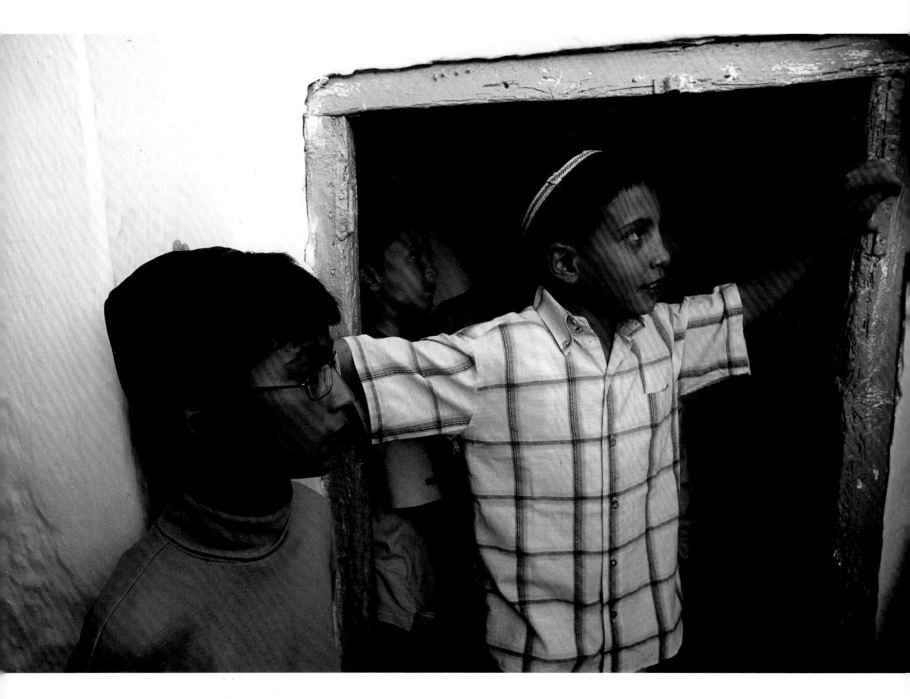

Beneath yarmulke skullcaps, oversized curiosities congregate
by Djerba's undersized doorway where Jewish students
study Hebrew in a unique Tunisian enclave.

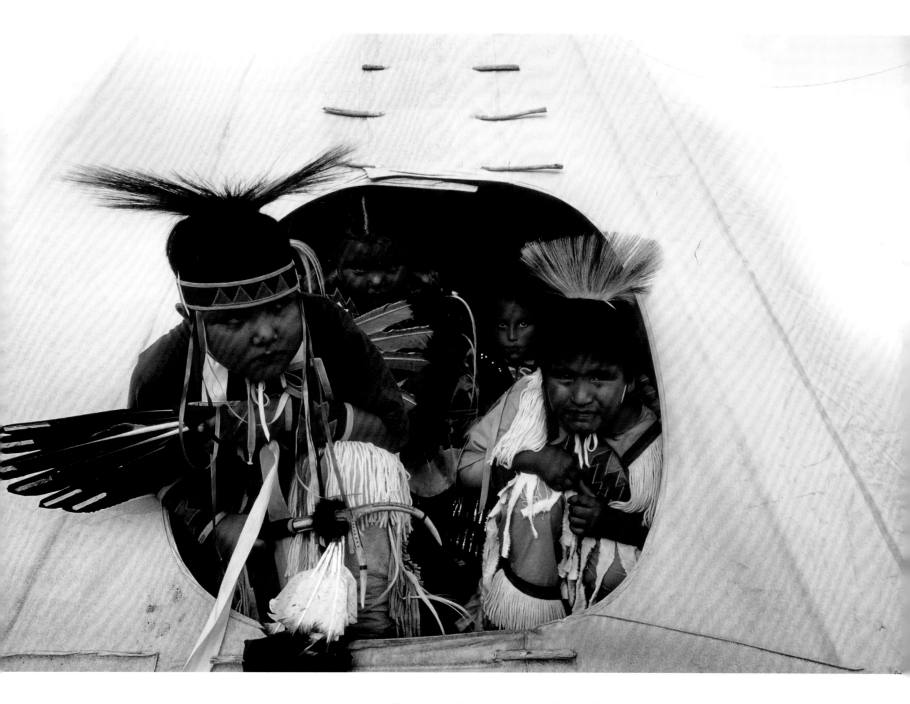

In Duck Lake, Saskatchewan, a flurry of beads, porcupine quills, and feathers spill from a First Nations teepee to catch the percussive jingle dress at a powwow's fancy dancing.

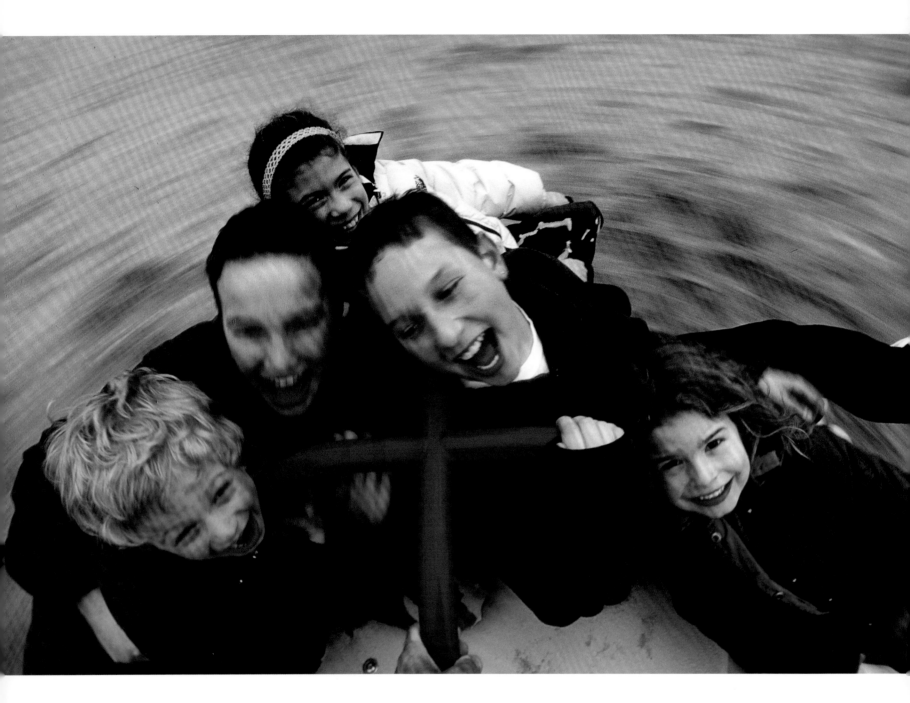

A circular blur of screaming cousins discovers the delirious joy in centrifugal force at a Bayville beach playground near New York's shoreline on the Long Island Sound.

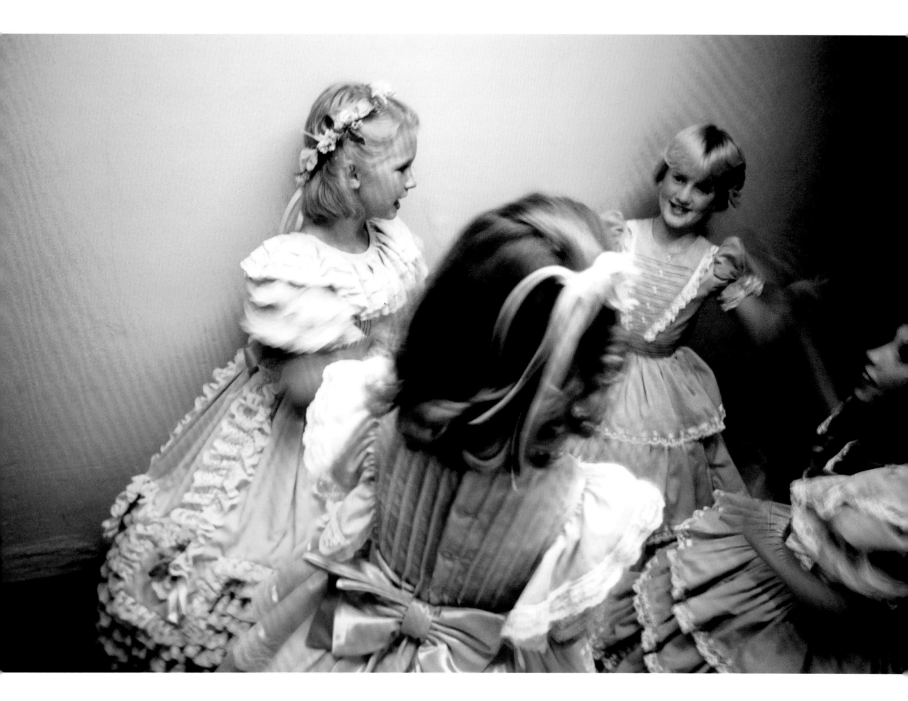

Backstage at a Natchez springtime pageant, lyrical rhymes
and hand-clapping gentility spark a game of patty cake
amongst a Mississippi bevy of young southern belles.

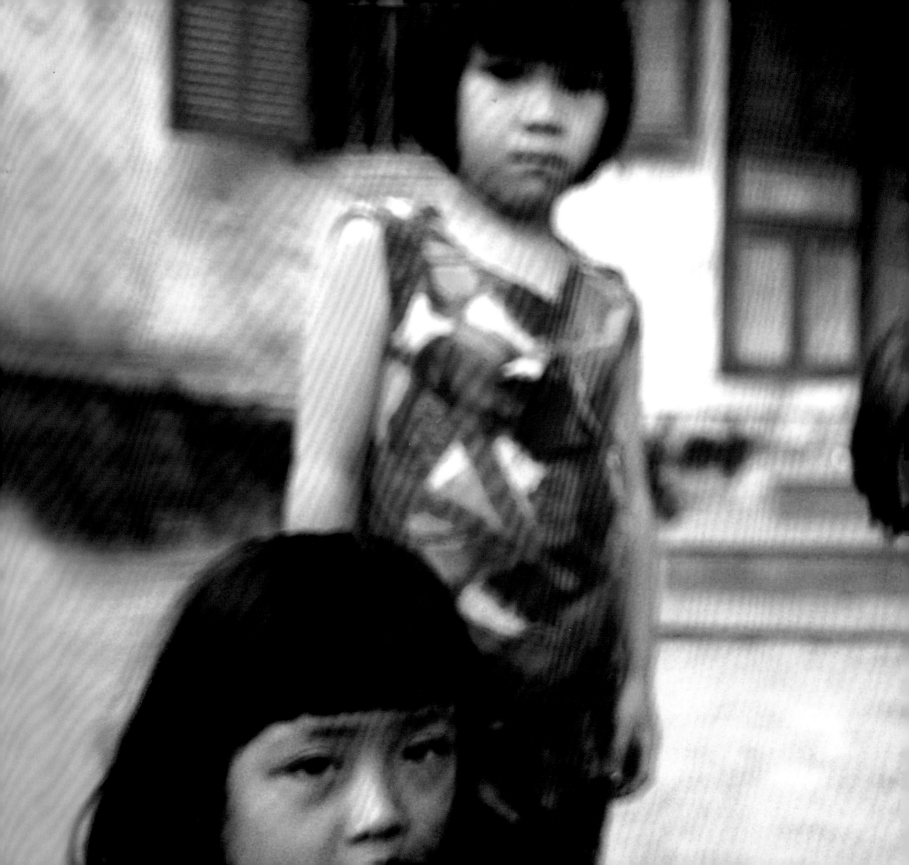

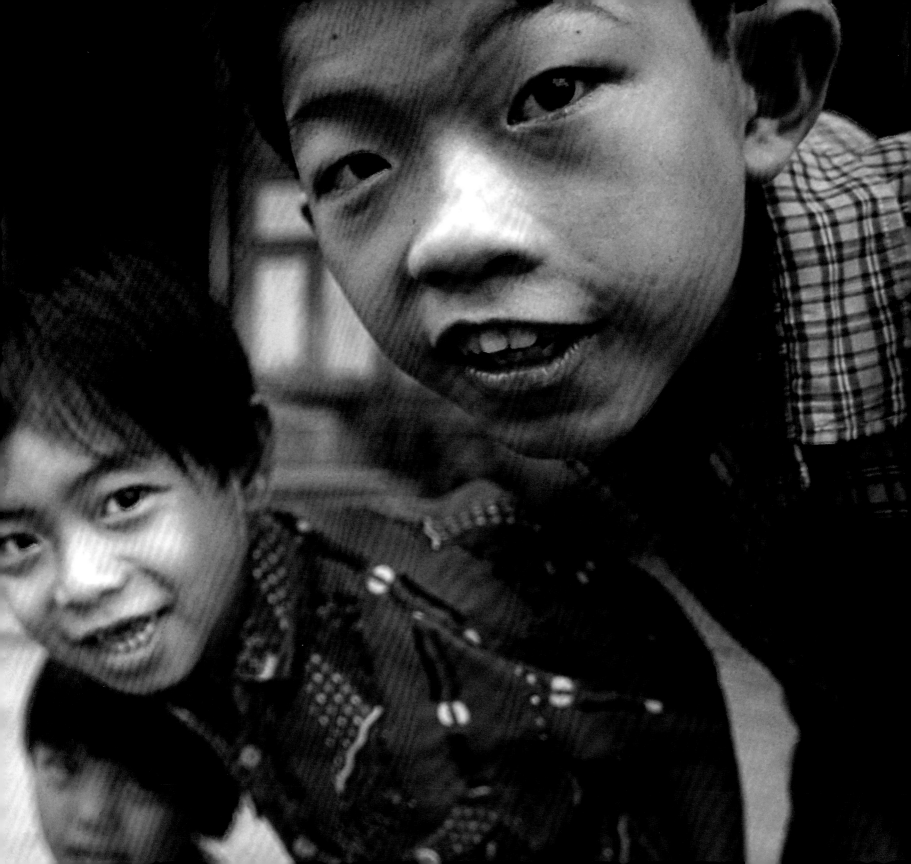

Curious eyes inspect a foreigner in the rural spice trade town of Hoi An, whose silted harbor turned the region into a forgotten Vietnamese backwater, thus preserving its traditional architecture (preceding page).

Smiles are understandably absent on the faces of these costumed Turkish boys, en route to their Istanbul circumcision ceremony in the heart of a city straddling two continents.

216

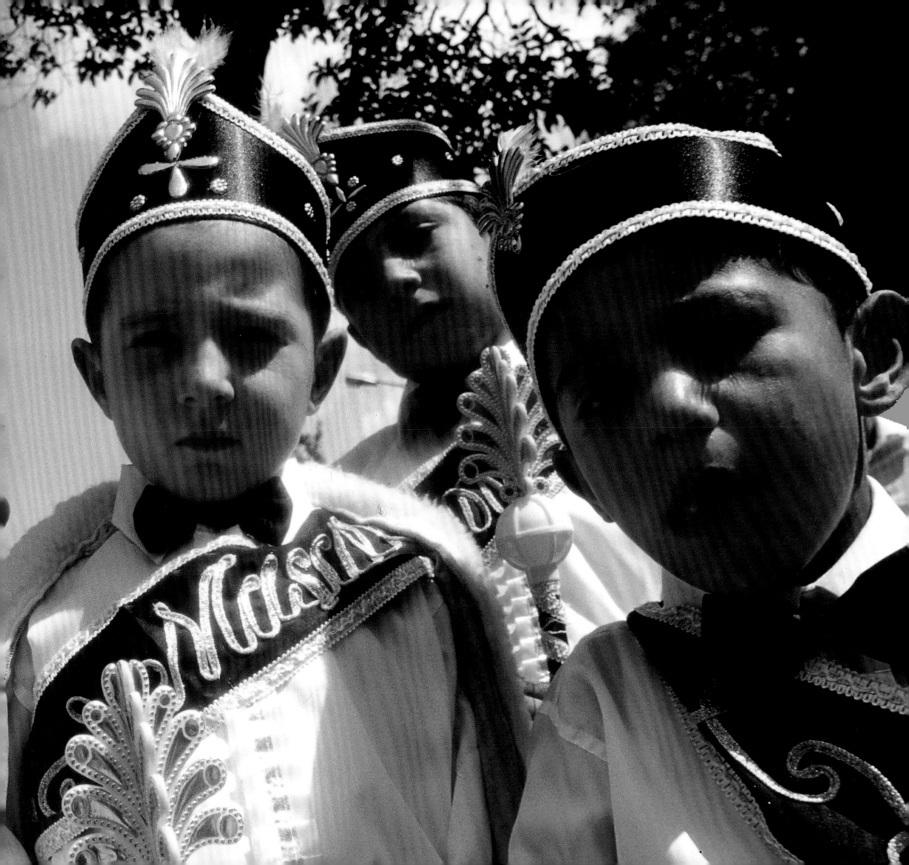

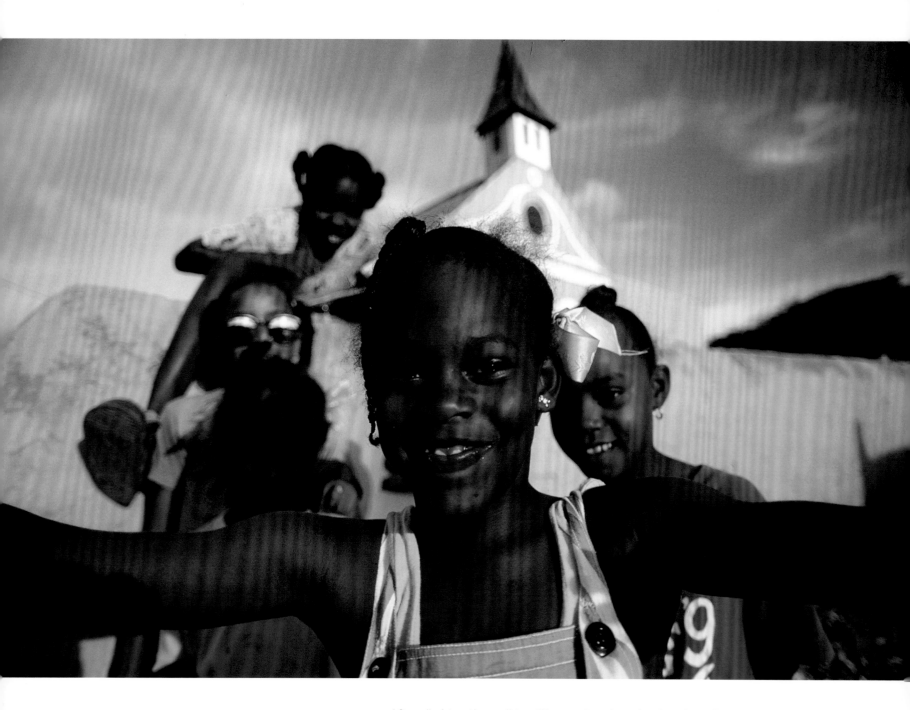

After climbing the wall in a Rincon churchyard at her tiny village,
fellow school friends complete the tableau, glowing faces
reflective of the intense tropical sunshine in Bonaire.

218

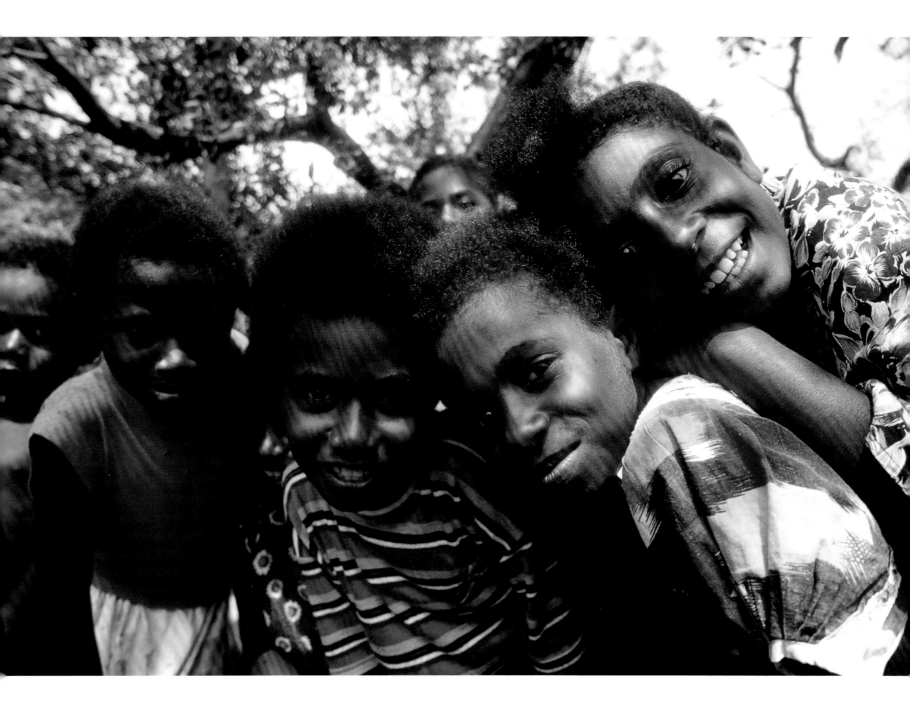

Inquisitive children crane their necks for the camera, an object not known on Ambryn in Vanuatu, a chunk of volcanic archipelago adrift in the remote precincts of the South Pacific.

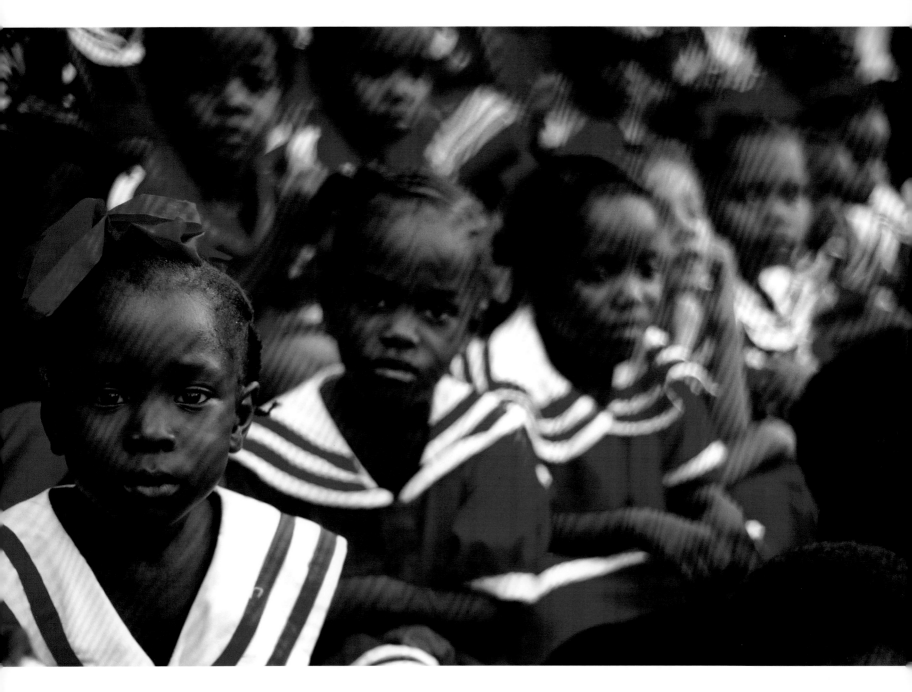

Portraits of a Guyanese future, school children at recess wear striking red and white patterns of their Georgetown school uniform in the country's largest city.

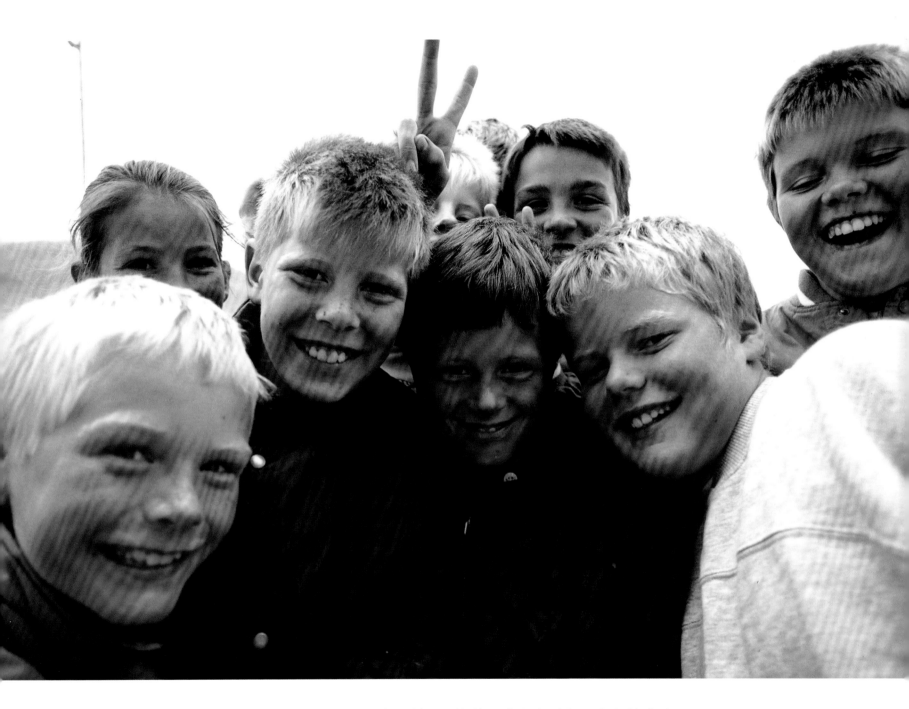

As evidenced in Husavik, Iceland, the palest skin features
on earth may be found in northern Scandinavia where
geographical separation maintains the Viking genes.

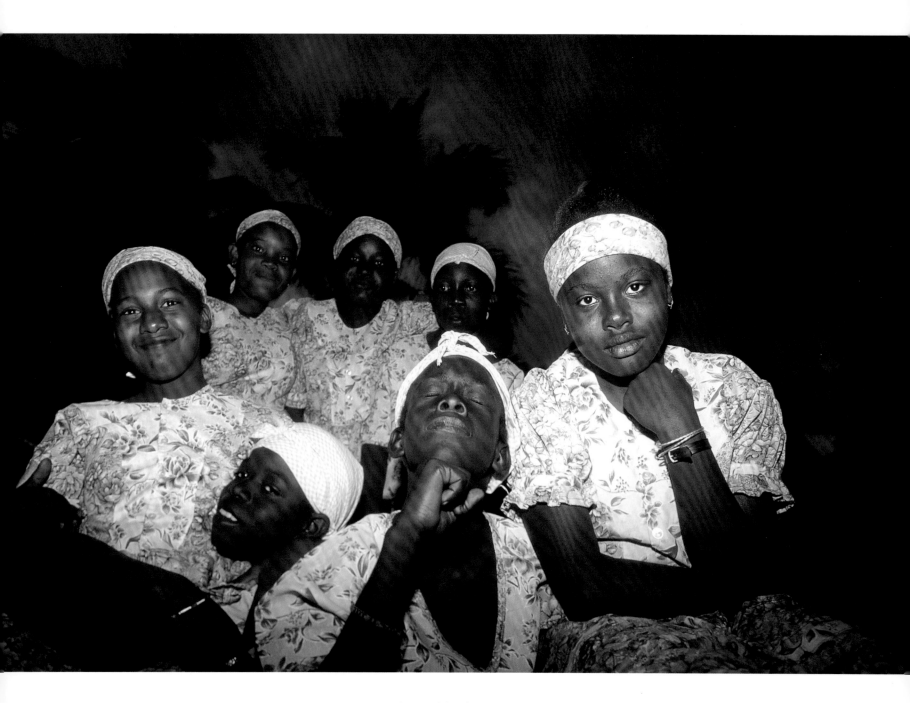

A proud Garifuna community thrives in Seine Bight, where the descendants of the original Carib people interbred with African slaves to create a vibrant fishing culture in Belize.

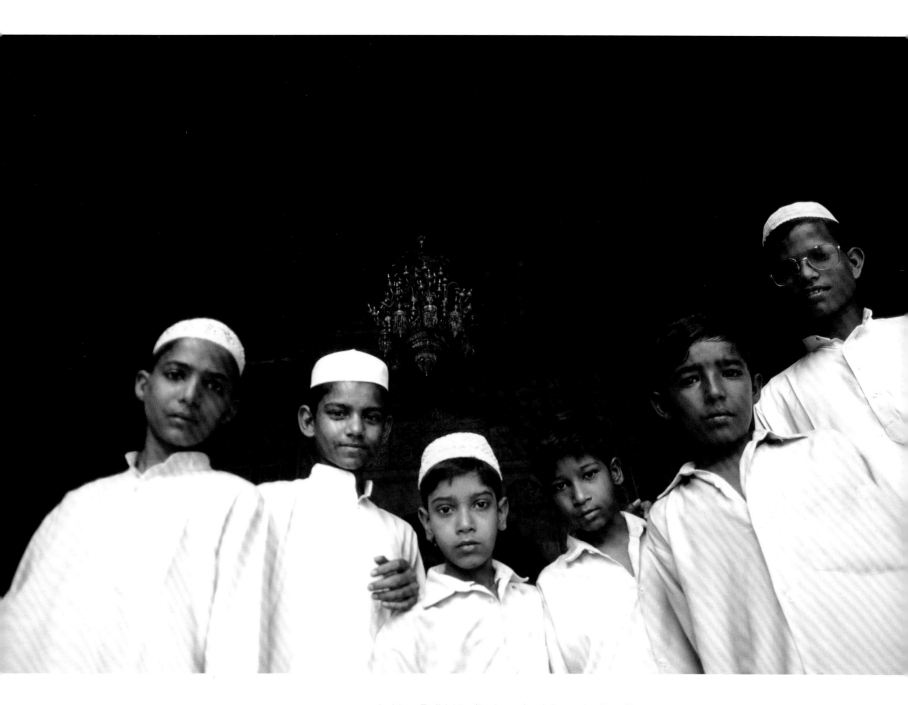

In New Delhi, Muslim boys huddle at the Red Fort, meant as the Qu'ran's imitation of paradise and built by the Indian emperor who ordered construction of the Taj Mahal.

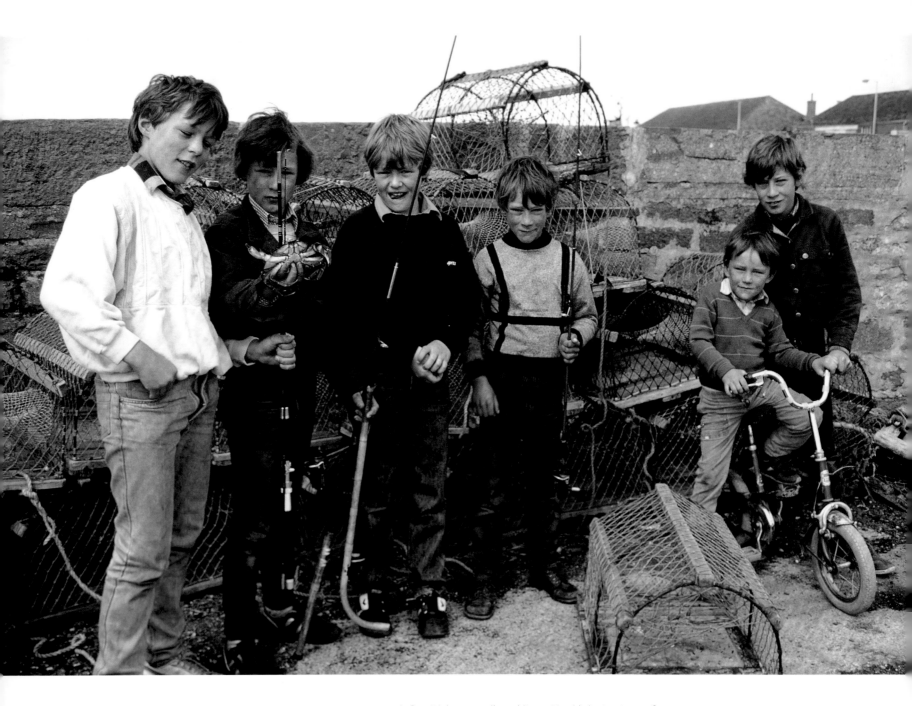

A Scottish seawall and its netted lobster traps form a
backdrop for these salty Norse fishermen about to yank
some seafood from their North Sea harbor at Kirkwall.

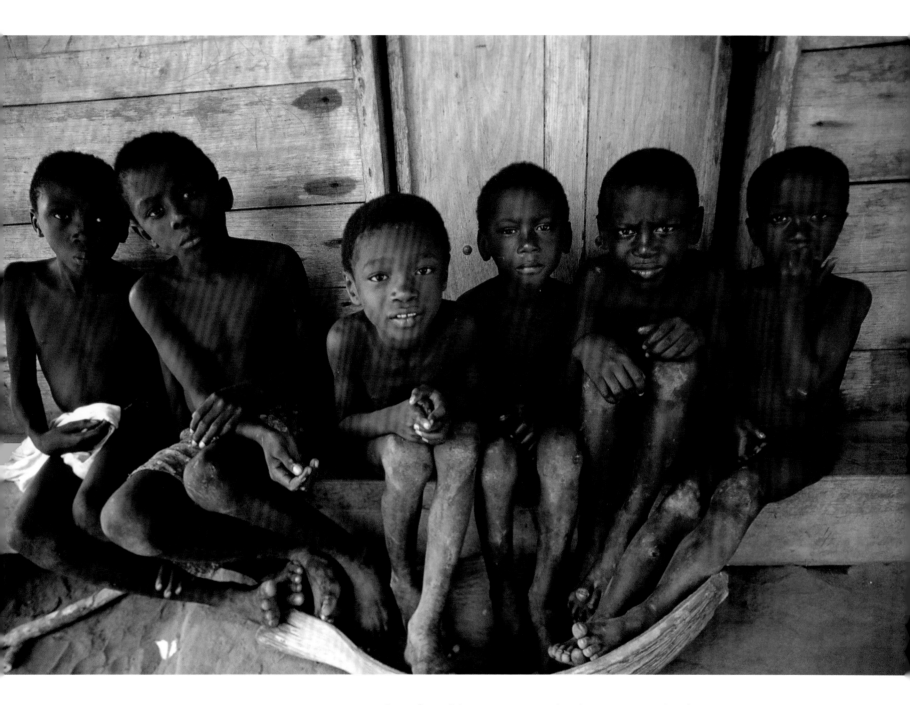

Dress formalities appear somewhat inconsequential to the young doormen guarding their unpainted Surinamese clapboard dwelling in the small rainforest village of Arrawadam.

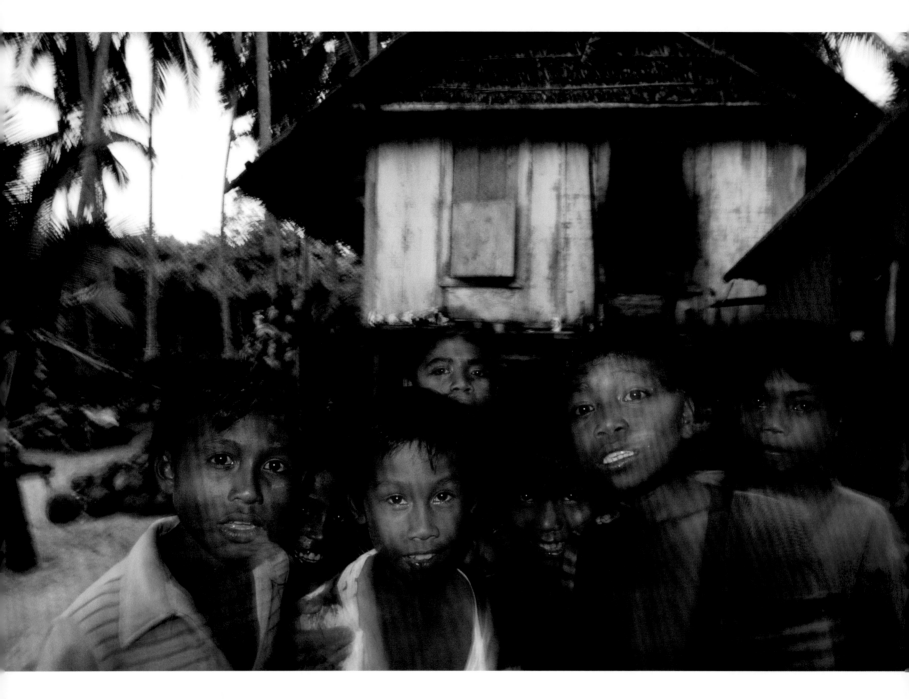

Excited to meet someone from an altogether different village, this intrigued Indonesian group on Sulawesi gathers by the front of their coconut-strewn Gulf of Boni beach house in Bau Bau.

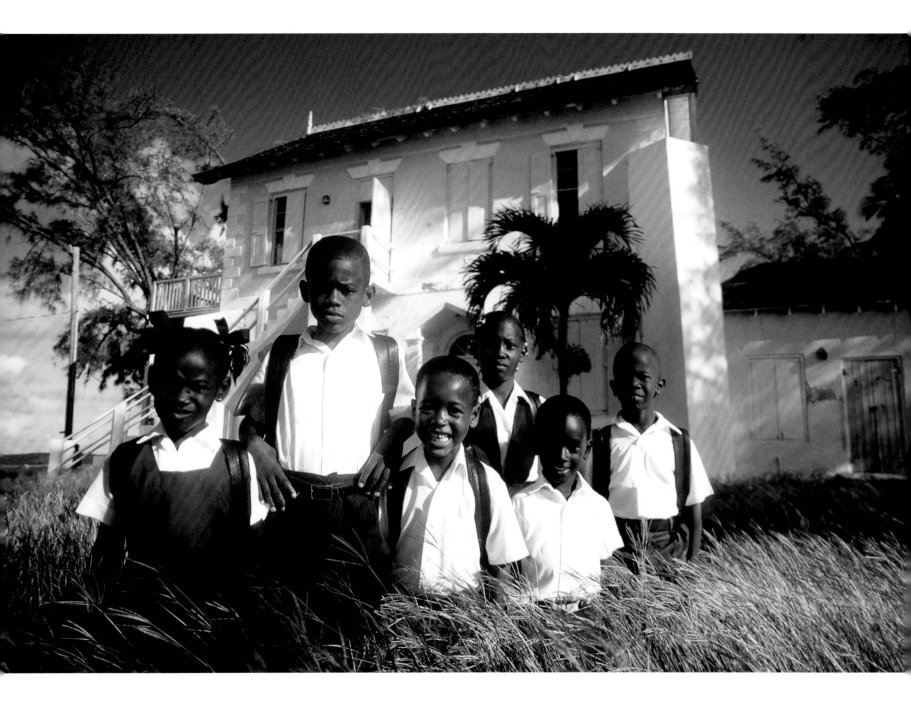

A mixture of Bahamian expressions and crisp uniforms
dress the children en route to school amongst the shuttered,
pastel houses that line the grassy path in Eleuthera.

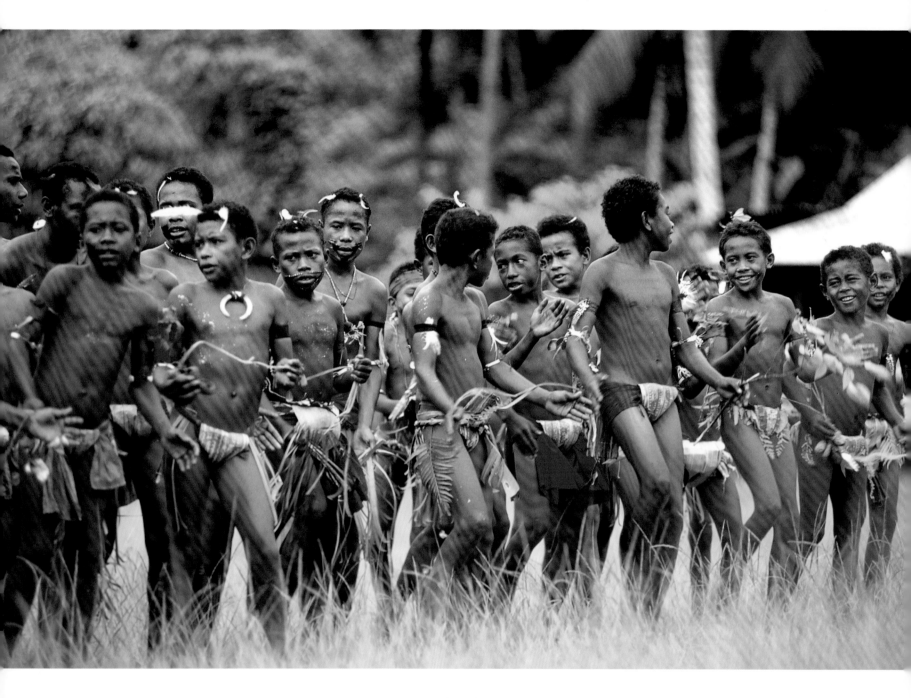

In Kitava, loin cloths and banana leaves offer cover while
stomping during dances on this Trobriand island of love, where
yams are used as currency and magic spells are cast.

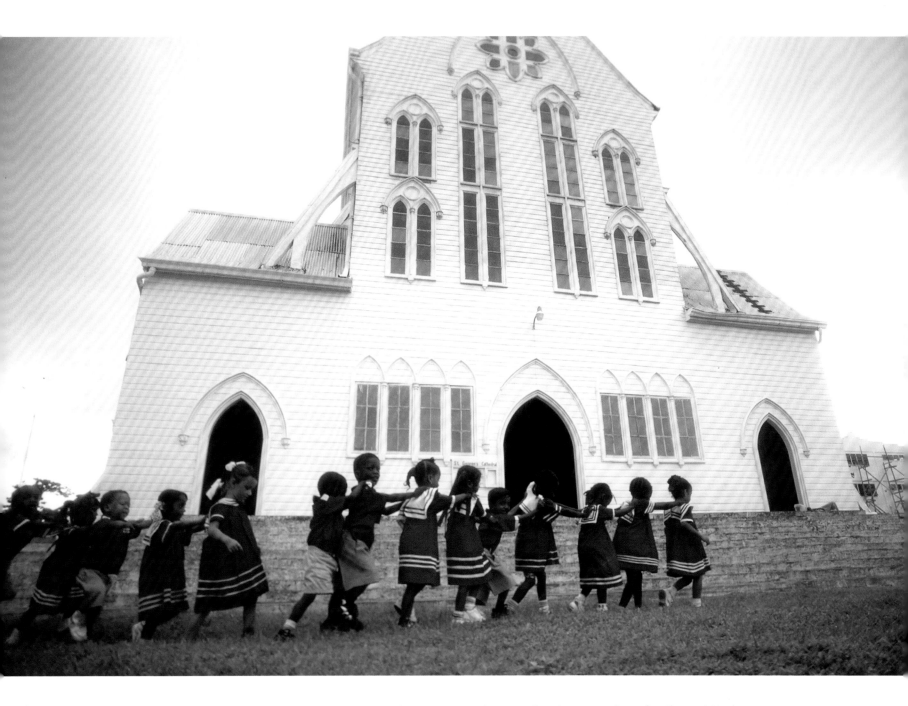

In Guyana's capital city, a Lilliputian conga line of uniformed kindergarteners sashay past Georgetown's wooden cathedral, the world's largest.

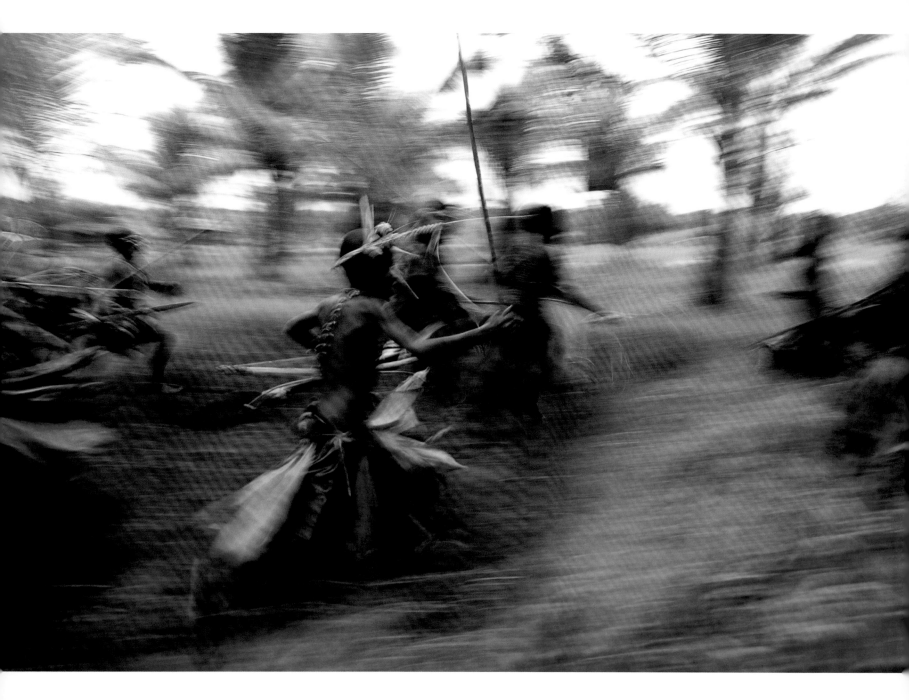

In a blur of fevered attack, indigenous village children charge across the soggy Murik Lakes swamplands fed by the Sepik River, their jungle-leafed skirts flapping toward a stilted Papuan settlement.

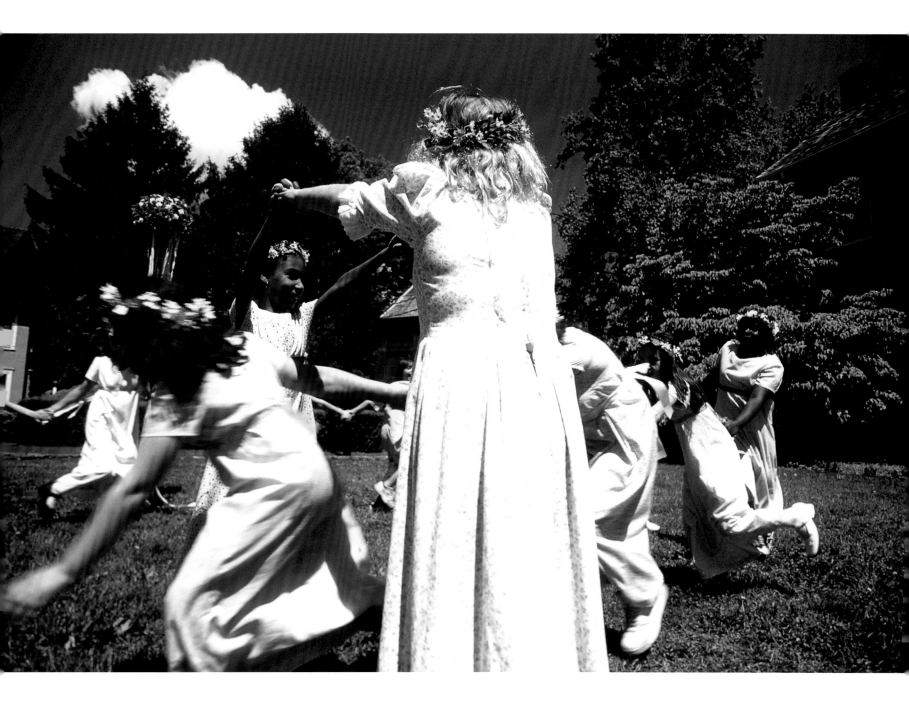

In Delaware, fragrant wreaths crown joyous dancers engaged
in the singing game of London Bridge before weaving ribbons
around the maypole on Dover's Village Green.

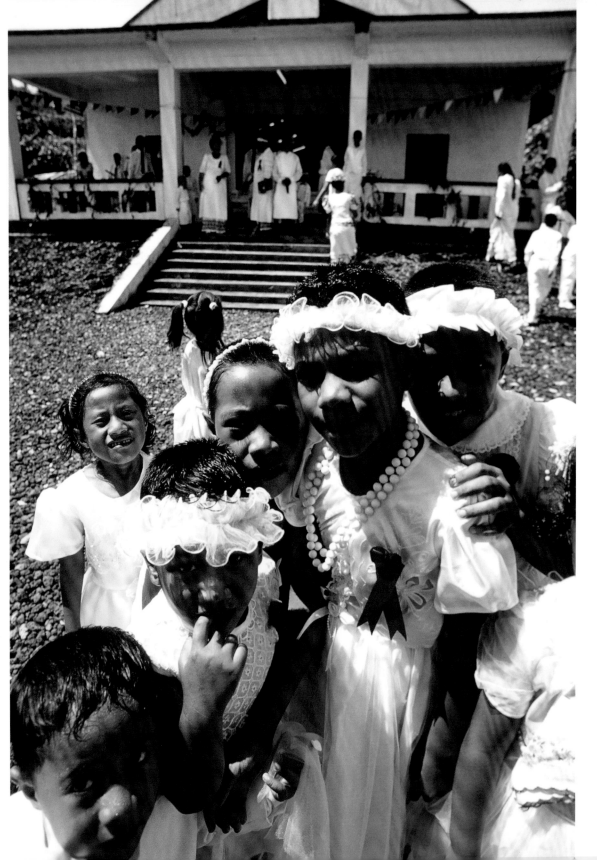

In Apia, congregations clad in alabaster colors flock toward churches to participate in the island's celebration of White Sunday, honoring the children of Samoa.

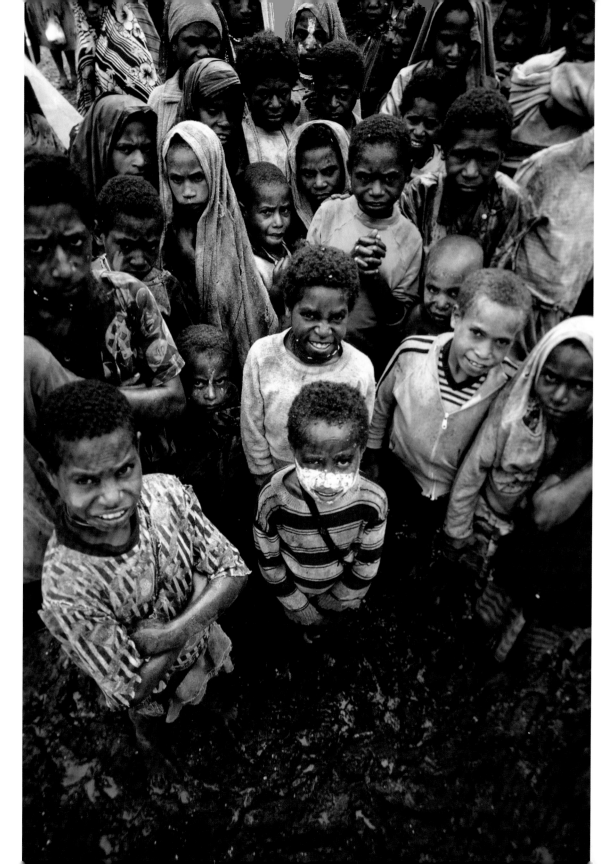

A diverse people gathers in Papua New Guinea's West highland interior where steep, corrugated valleys formed the numerous topographic prisons that cultivated development of separate languages.

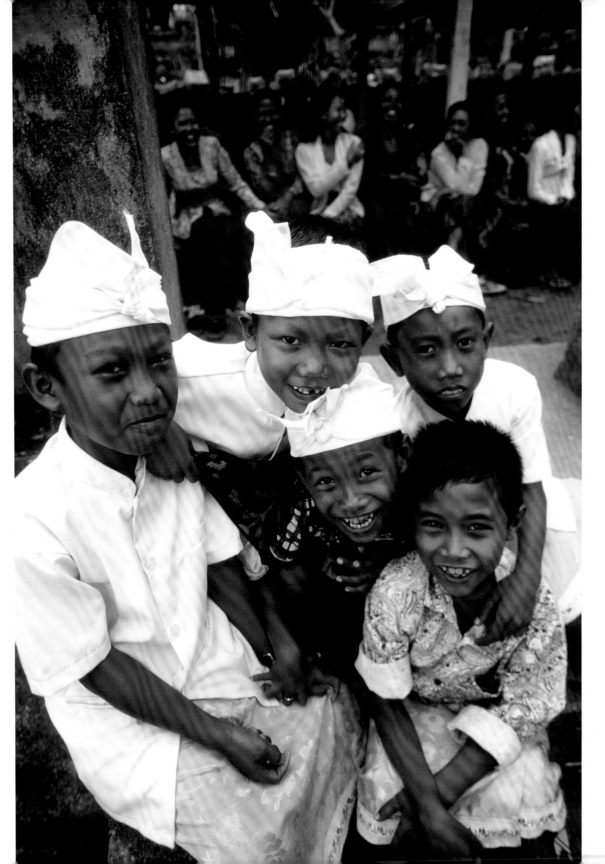

With Balinese waists wrapped in the island's kamen sarong and hair covered by udeng head gear, specific clothing identifies rank for these gentle Hindu people gathering in Ubud.

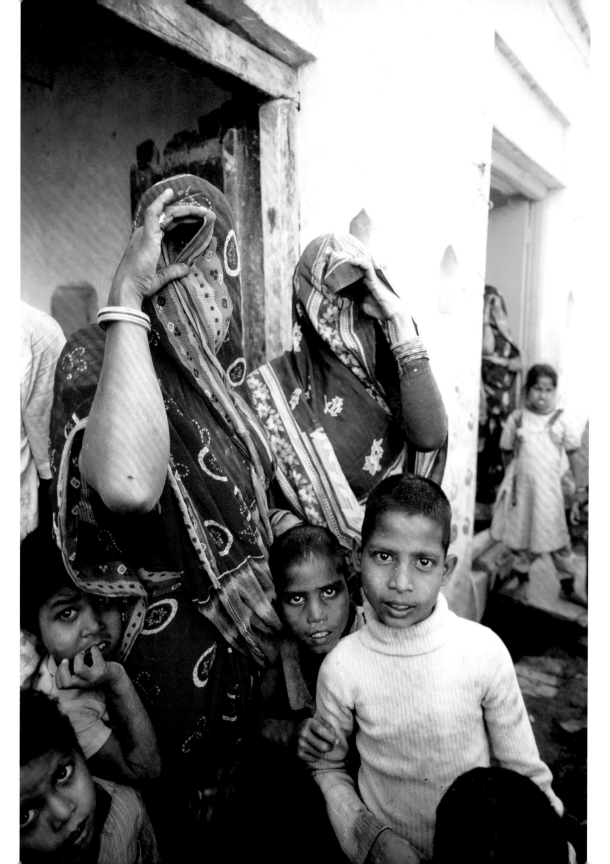

While adult Indian eyes are shielded through their own narrow peep holes, wide-eyed kids in Ranakpur investigate the arrival of a newcomer to their village, majestically edged by royal palaces.

235

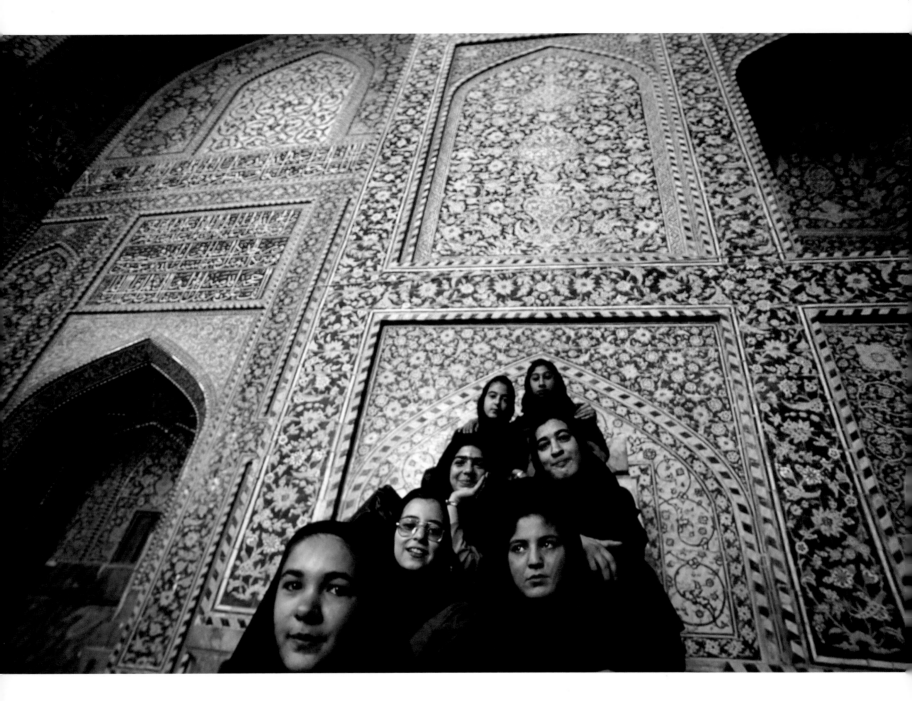

Appearing to be stacked on each other's shoulders, a covey of Iranian girls visit Imam Mosque in Esfahan, a gem of Persian architecture. They sit upon the mihrab altar steps by the niche that must always face Mecca.

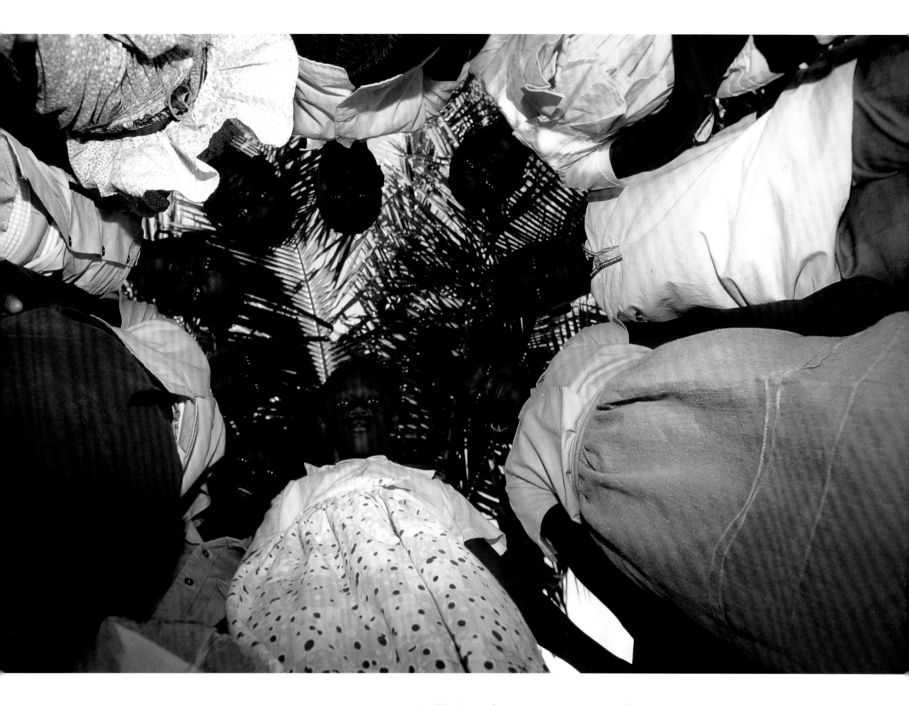

A circle of Belizean friends returning home after school
wear the colors of their uniform and gather beneath tropical
palms that line the Caribbean beach near Hopkins.

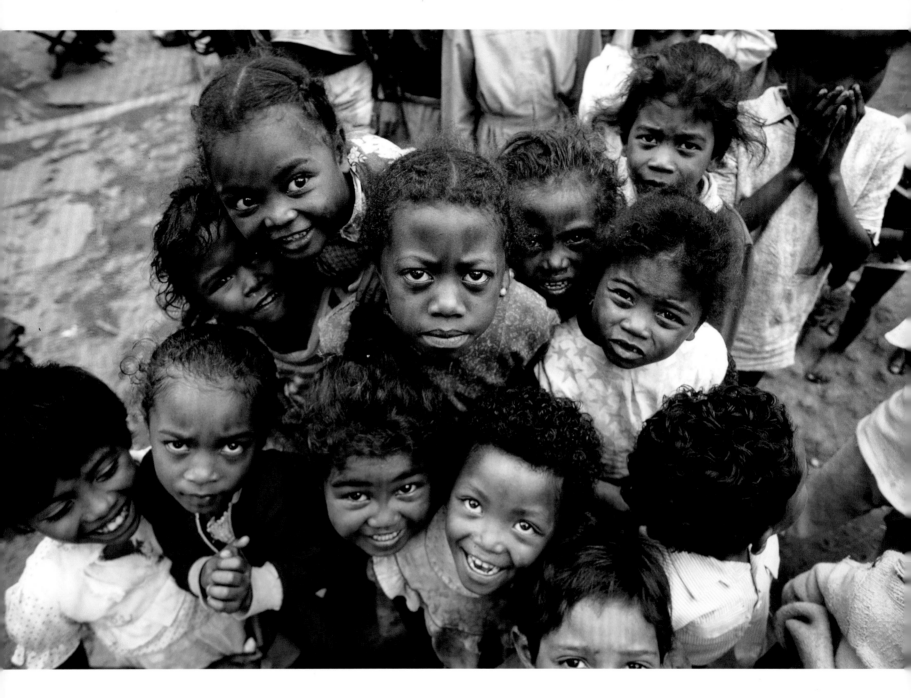

In Antananarivo, a variety of expressions on Malagasy children represents the assimilated features of a people descended from Indonesian sailors from across the ocean.

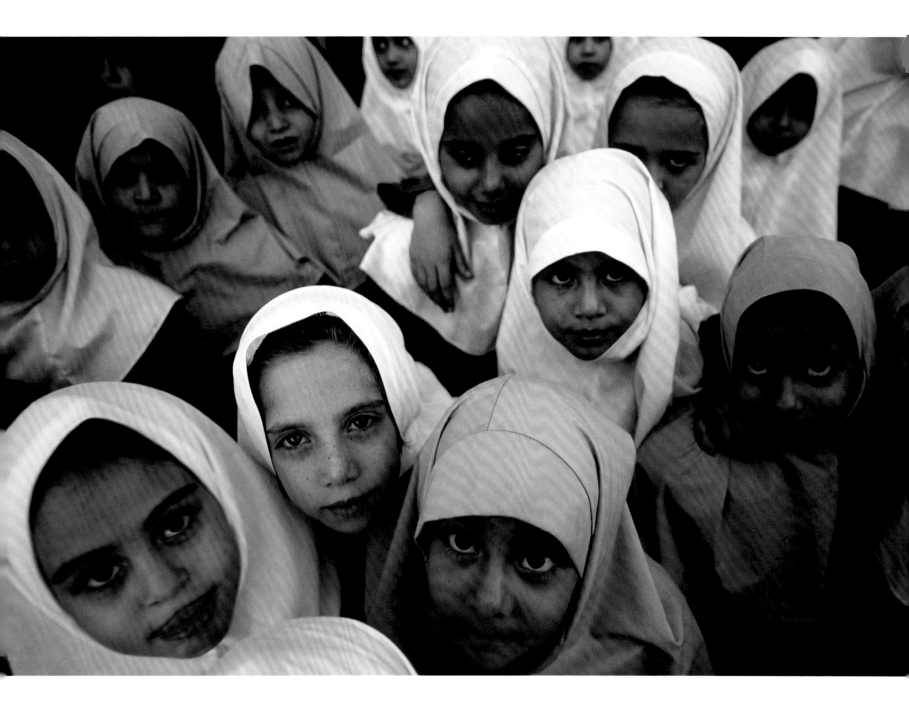

Hopeful eyes congregate beneath their hijab, a head scarf covering mandated by Qu'ranic interpretation for women in public, a law in both Saudi Arabia and here in Teheran, Iran.

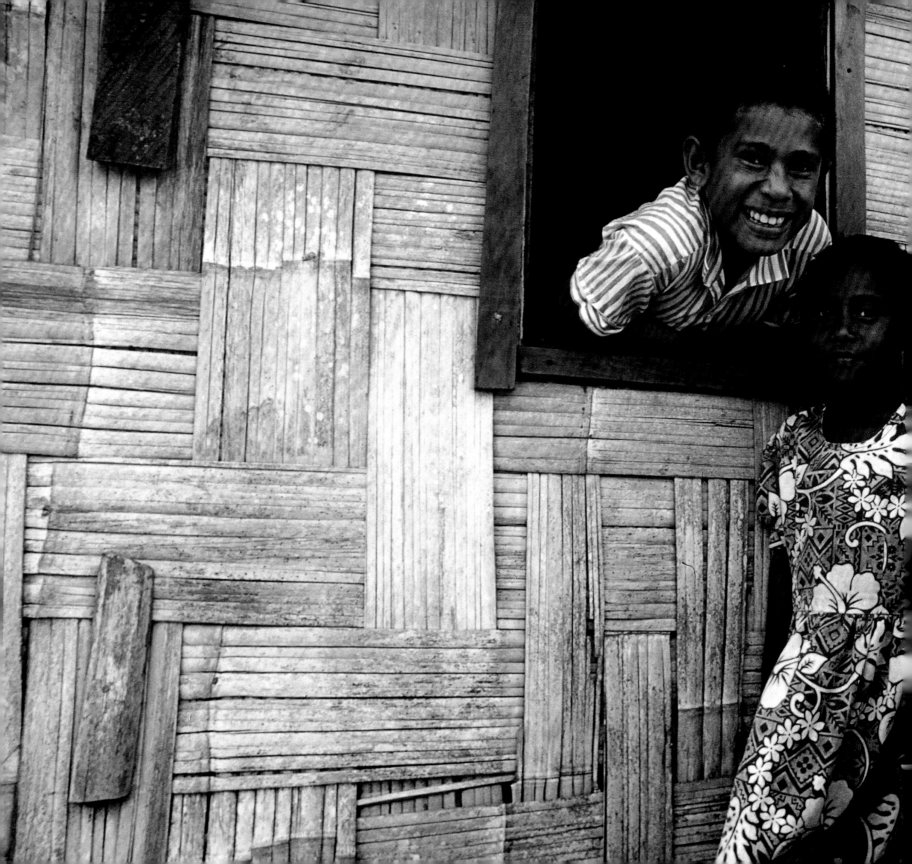

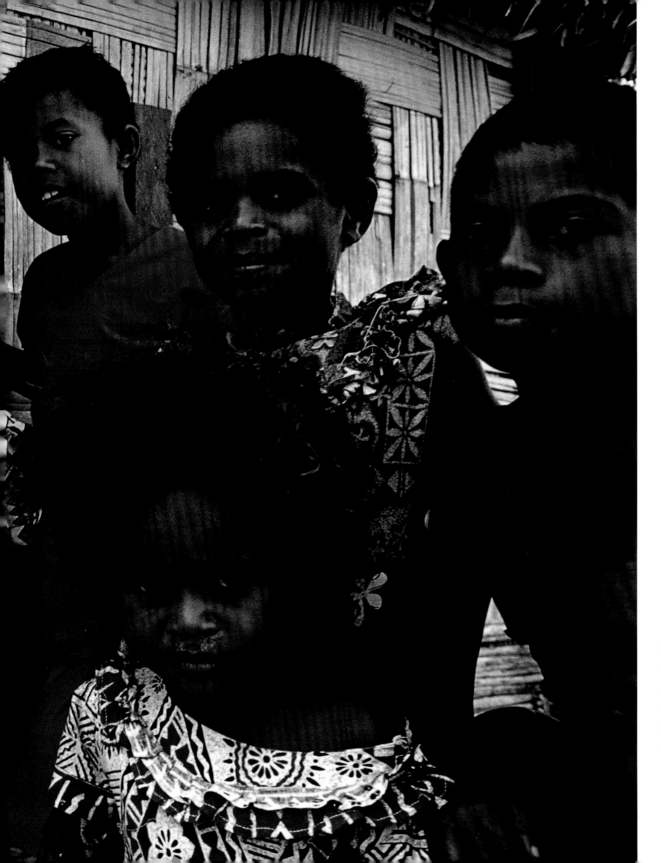

Near Nadi, bright colors of
tapa cloth-motif dresses
are matched by the shining
Fijian smile in the window of a
traditional straw bure, hosting
an elder's kava drinking ritual.

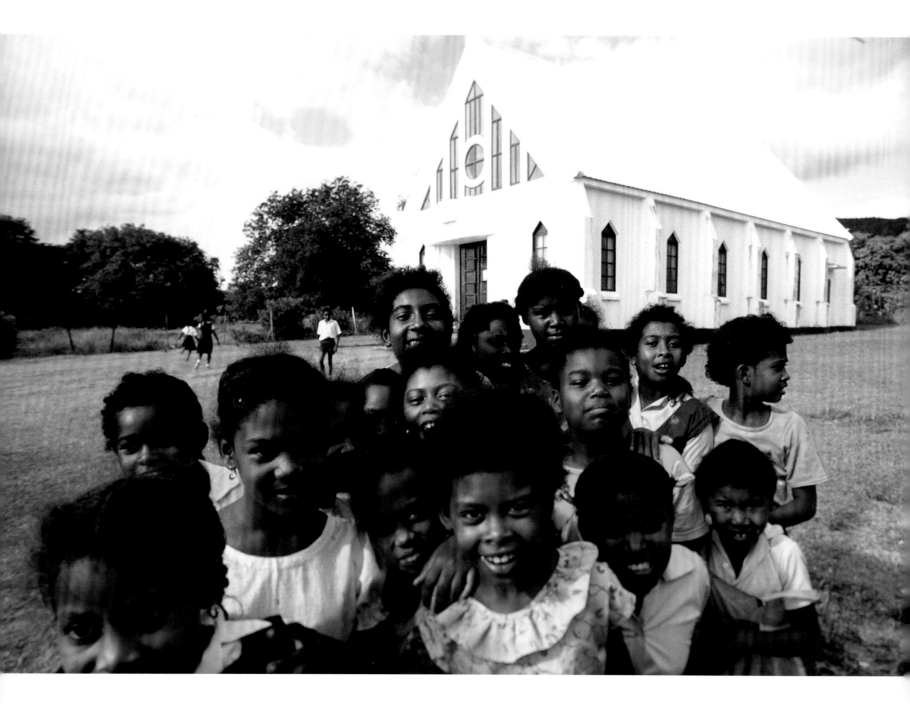

Enthralled Sunday schoolers leave church in Chemin Grenier, one of many religious groups on the Indian Ocean island of Mauritius, which became a traffic circle of cultures and converging sailing routes.

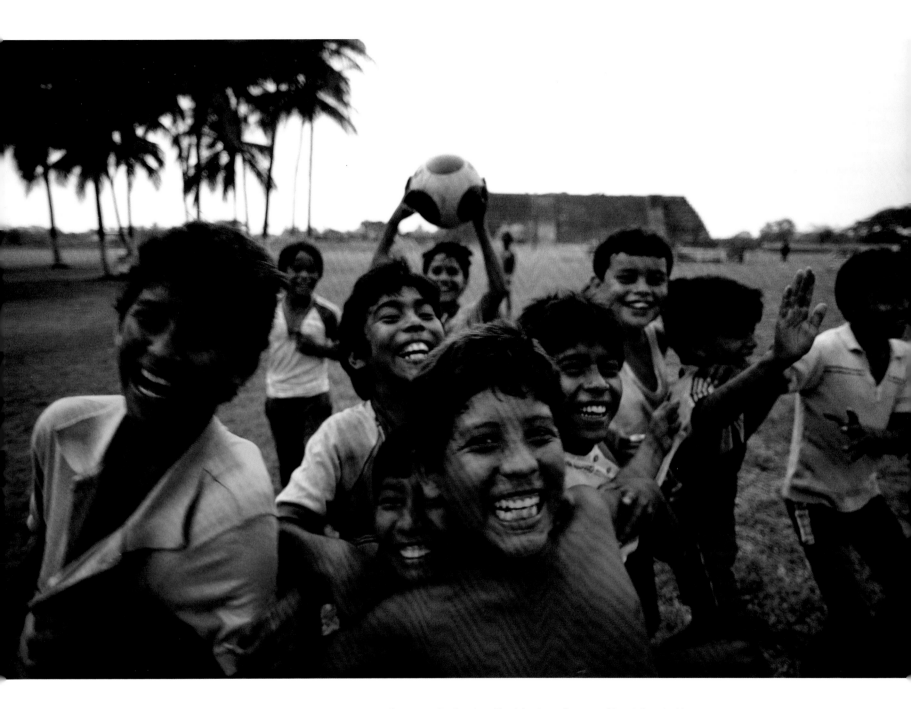

A soccer ball sets off a Mexican frenzy of budding Latin
American testosterone on Cholula's vast fields stretching
below pre-Columbian pyramids, the New World's largest.

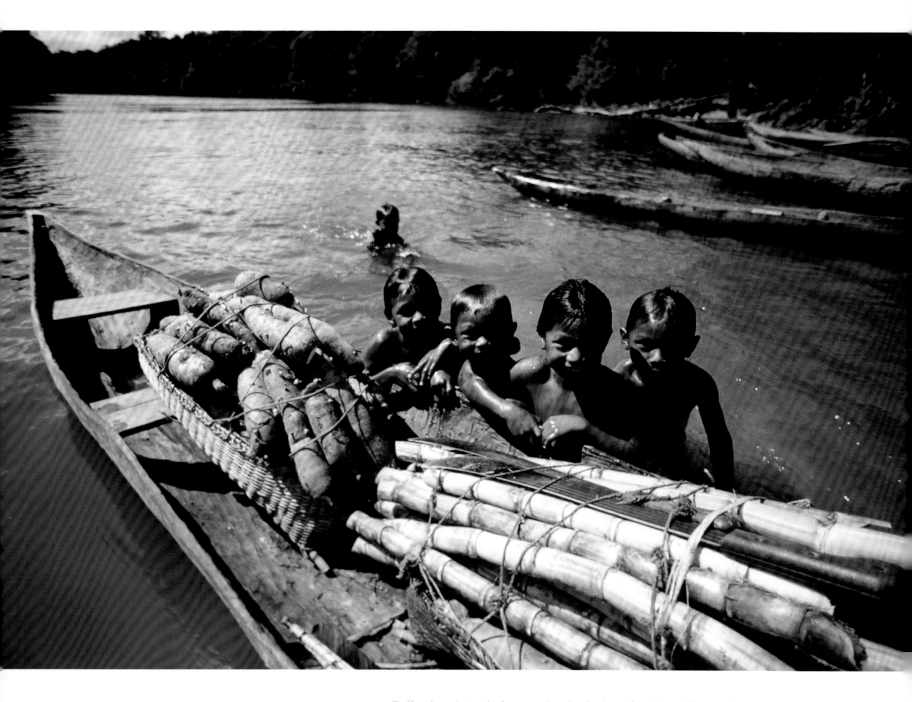

Coffee-hued tannin from upriver bark dyes the Upper Essequibo,
where a young Guyanese quartet guards a dugout about to deliver
its sugar cane and root vegetables farther downstream.

244

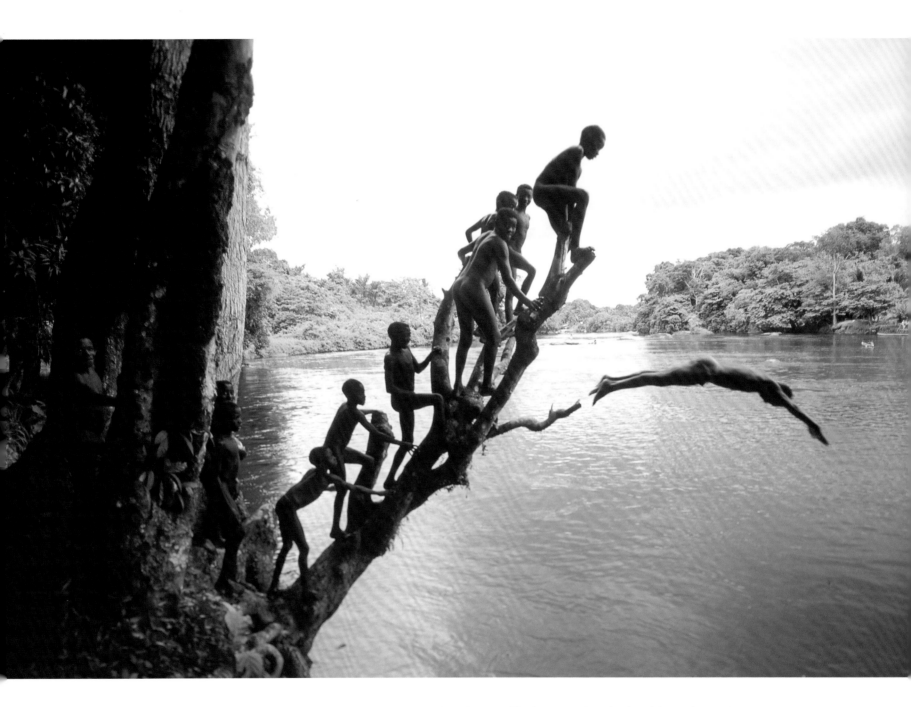

A knotted sculpture of limbs ascends a riverbank branch, used as a launch pad for lively, overheated Saramakans seeking relief in the cooling South American currents of Surinam's Gran Rio.

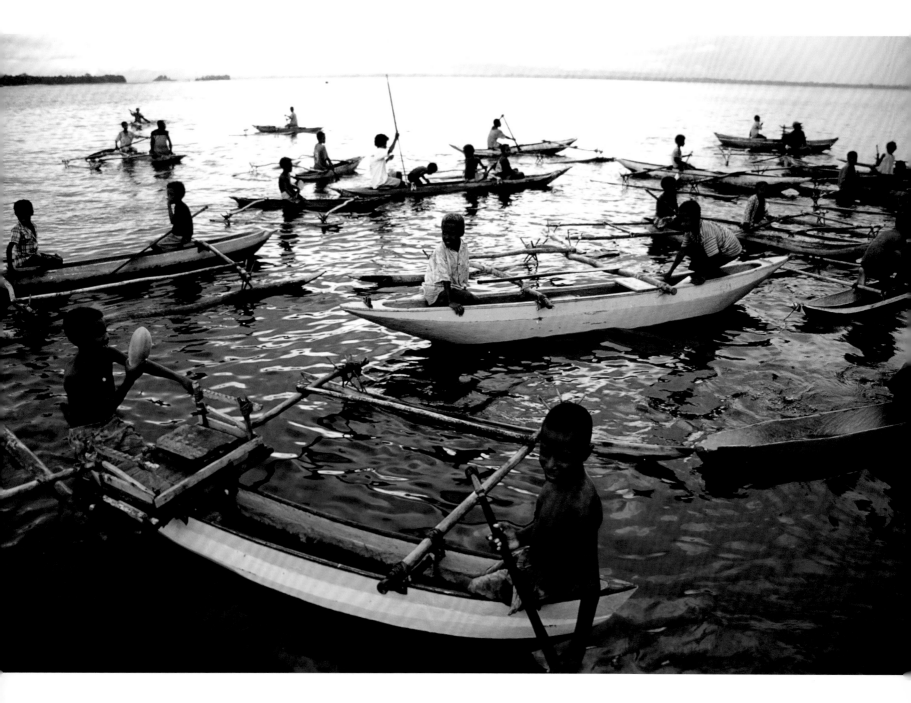

Bobbing in the Bismarck Sea off the coast of Papua New Guinea, a small navy of children converge from nearby Ali Island to sell their mangos and other goods from tiny wooden outriggers.

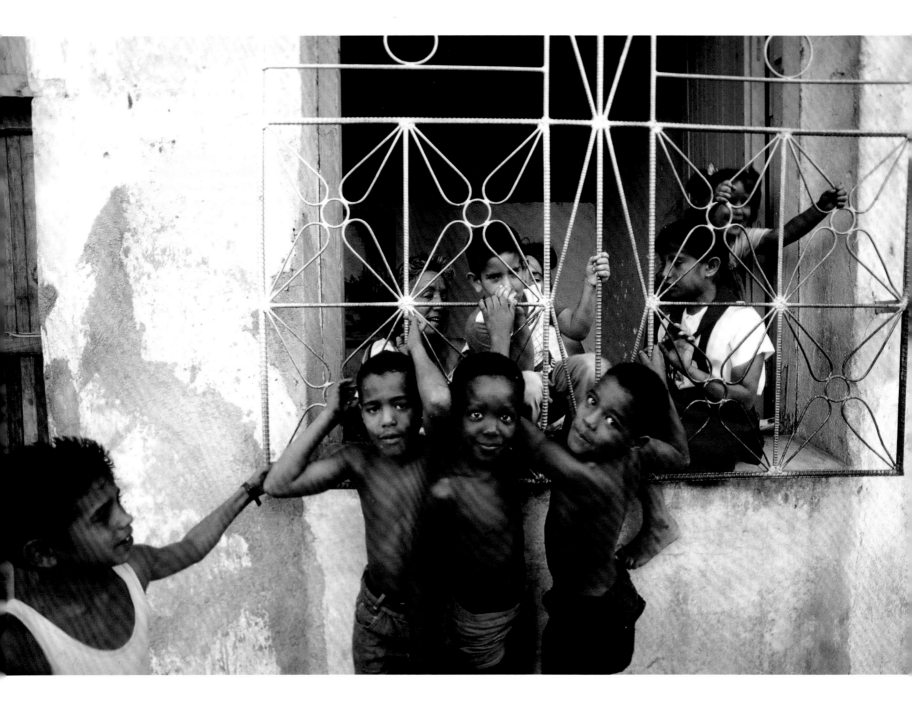

Pent-up Cuban energy clings to the glass-free window's decorative rebar, where the evening's pastime will be eyeing classic automobiles as they slowly rumble down Old Havana's colonial streets.

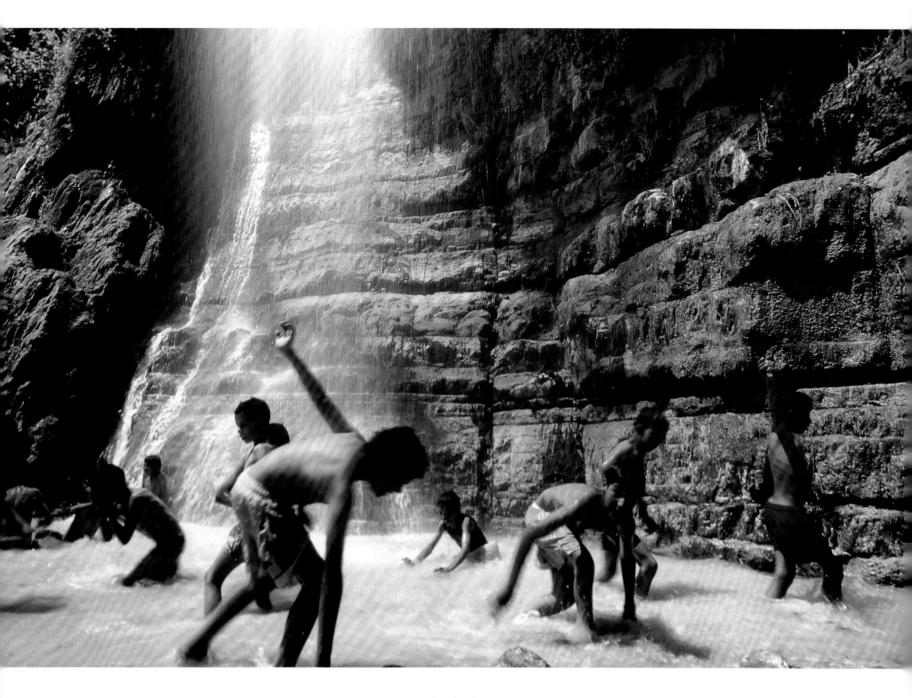

Limbs akimbo frolic in an Ein Gedi wadi at a Judean desert oasis,
where a biblical David once hid from Saul, and now for a moment,
tribal struggles dissolve amidst Palestine's amphibious fun.

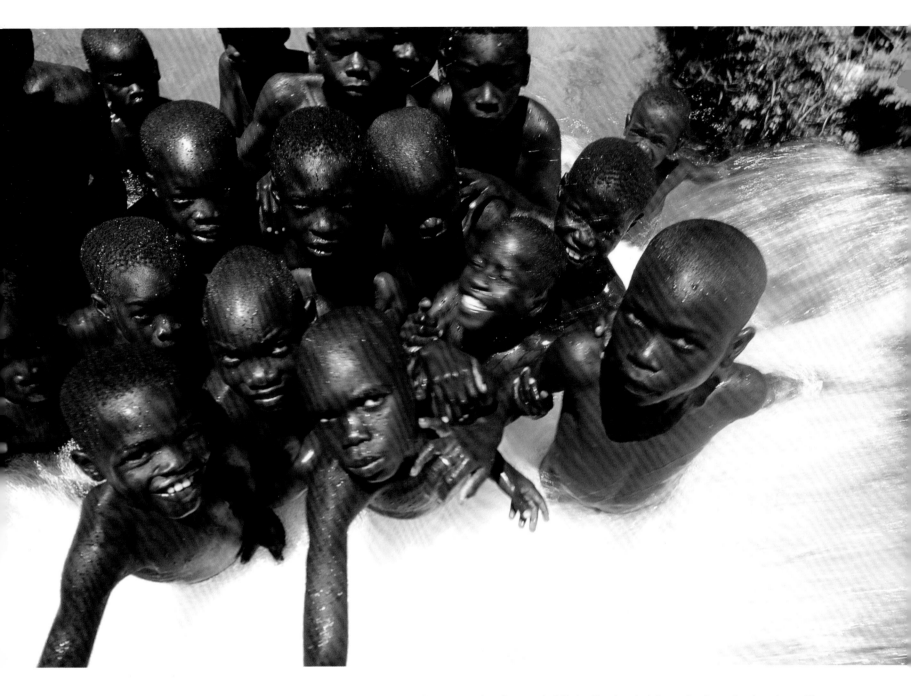

A cooling cascade of water in Milot affords a brief respite from the harsh realities of rampant deprivation in Haiti, buffeted further by earthquakes and social unrest.

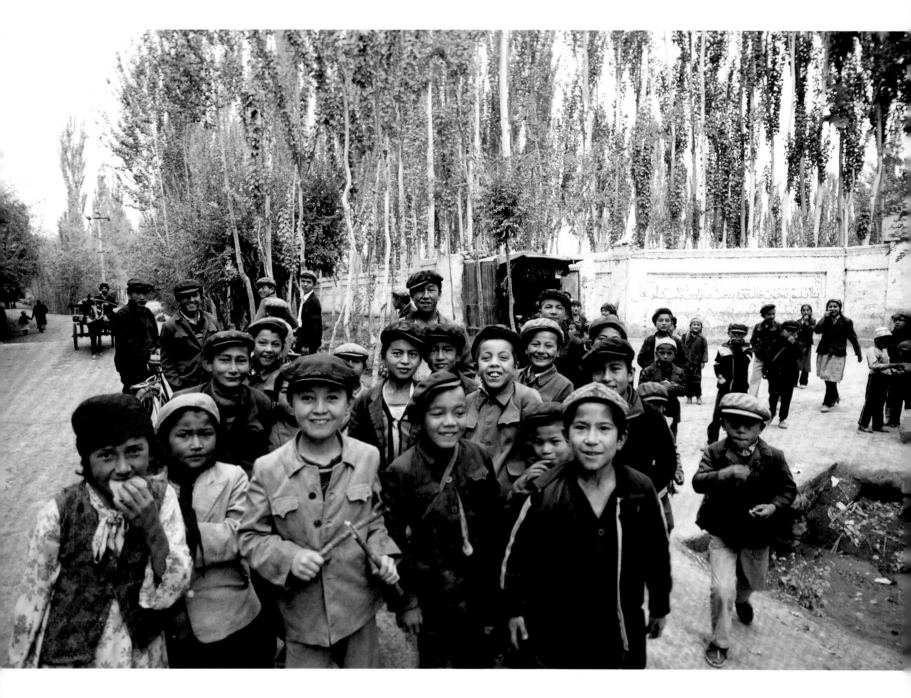

A thoroughly capped swarm of children are beguiled by the
rare sight of a visitor to remote Kashgar, a fabled market town
that lured Marco Polo during legendary sojourns.

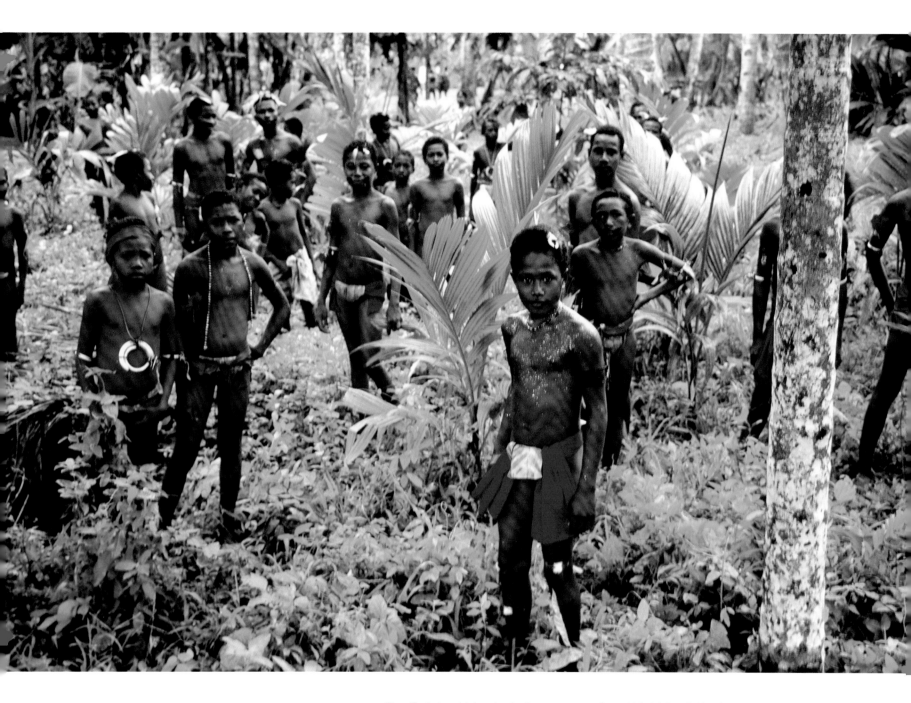

The Trobriand Islands shelter an army of youthful, loin-clothed villagers who emerge from the forests of Kitava, noted for their precocious sexuality and matrilineal society.

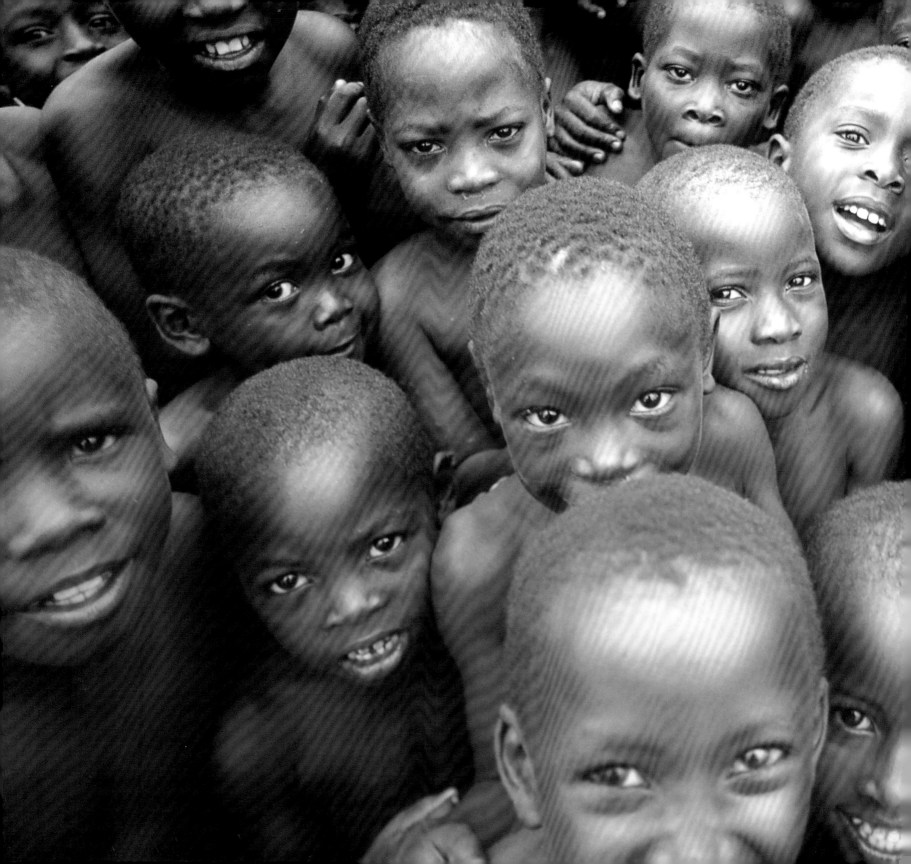

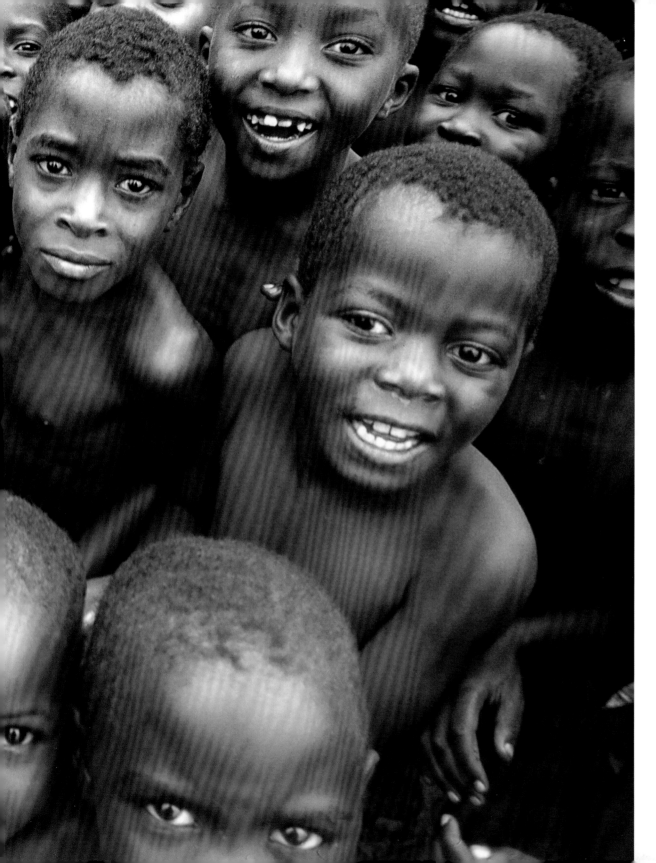

In Kisoro, Uganda, a field of
eyeballs represent imagination
and passion for a new
generation, populating the
planet with unlimited potential
for creating a better world.